THE SOCIAL HISTORY OF ART
VOLUME III

'As much a work of intellectual history as art history, Hauser's work remains unparalleled in its scope as a study of the relations between the forces of social change and western art from its origins until the middle of the 20th century.'

Johanna Drucker, Professor of Art History, State University of New York

'Harris's introductions to each volume – dealing with Hauser's aims, principles, concepts and terms are extremely useful. . . . This edition should bring Hauser's thought to the attention of a new generation of readers.'

Whitney Davis, Professor of Art History, Northwestern University

First published in 1951 Arnold Hauser's commanding work presents an account of the development and meaning of art from its origins in the Stone Age through to the 'Film Age'. Exploring the interaction between art and society, Hauser effectively details social and historical movements and sketches the frameworks within which visual art is produced.

This new edition provides an excellent introduction to the work of Arnold Hauser. In his general introduction to *The Social History of Art*, Jonathan Harris assesses the importance of the work for contemporary art history and visual culture. In addition, an introduction to each volume provides a synopsis of Hauser's narrative and serves as a critical guide to the text, identifying major themes, trends and arguments.

Arnold Hauser was born in Hungary and studied literature and the history of art at the universities of Budapest, Vienna, Berlin and Paris. In 1921 he returned to Berlin to study economics and sociology under Ernst Troeltsch. From 1923 to 1938 he lived in Vienna where he began work on *The Social History of Art*. He lived in London from 1938 until 1977, when he returned to his native Hungary. He died in Budapest in 1978.

Jonathan Harris is Senior Lecturer in Art History and Critical Theory at the University of Keele. He is the author of *Federal Art and National Culture: The Politics of Identity in New Deal America* (1995), co-author of *Modernism in Dispute: Art Since The Forties* (1993) and co-editor of *Art in Modern Culture: An Anthology of Critical Texts* (1992).

The Social History of Art

Arnold Hauser, with an introduction by Jonathan Harris

Volume I – From Prehistoric Times to the Middle Ages
Volume II – Renaissance, Mannerism, Baroque
Volume III – Rococo, Classicism and Romanticism
Volume IV – Naturalism, Impressionism, The Film Age

THE SOCIAL HISTORY OF ART

VOLUME III

Rococo, Classicism and Romanticism

Arnold Hauser

with an introduction by Jonathan Harris

Taylor & Francis Group

LONDON AND NEW YORK

First published in two volumes 1951

Second edition published in four volumes 1962
By Routledge

Published 1989, 1995
by Routledge
2 Park Square, Milton Park, Abingdon, Oxon OX14 4RN
711 Third Avenue, New York, NY, 10017, USA

Routledge is an imprint of the Taylor & Francis Group, an informa business

Third edition 1999

© 1951, 1962, 1999 The Estate of Arnold Hauser
Introductions © 1999 Routledge

British Library Cataloguing in Publication Data
A catalogue record for this book is available from the British Library

Library of Congress Cataloging-in-Publication Data
A catalog record for this book has been requested

ISBN 0–415–19947–6 (Vol. III)

ISBN 0–415–19945–X (Vol. I)
ISBN 0–415–19946–8 (Vol. II)
ISBN 0–415–19948–4 (Vol. IV)
ISBN 0–415–21386–X (Set)

CONTENTS

CONTENTS

CONTENTS

CONTENTS

ILLUSTRATIONS

GENERAL INTRODUCTION

Jonathan Harris

Contexts of reception

Arnold Hauser's *The Social History of Art* first appeared in 1951, published in two volumes by Routledge and Kegan Paul. The text is over 500,000 words in length and presents an account of the development and meaning of art from its origins in the Stone Age to the 'Film Age' of Hauser's own time. Since its publication, Hauser's history has been reprinted often, testament to its continuing popularity around the world over nearly a half-century. From the early 1960s the study has been reprinted six times in a four-volume series, most recently in 1995. In the period since the Second World War the discipline of art history has grown and diversified remarkably, both in terms of the definition and extent of its chosen objects of study, and its range of operative theories and methods of description, analyses and evaluation. Hauser's account, from one reading clear in its affiliation to Marxist principles of historical and social understanding – the centrality of class and class struggle, the social and cultural role of ideologies, and the determining influence of modes of economic production on art – appeared at a moment when academic art history was still, in Britain at least, an élite and narrow concern, limited to a handful of university departments. Though Hauser's intellectual background was thoroughly soaked in mid-European socio-cultural scholarship of a high order, only a relatively small portion of which was associated directly with Marxist or neo-Marxist perspectives, *The Social History of Art* arrived with the Cold War and its reputation quickly, and inevitably, suffered within the general backlash against political and intellectual Marxism which persisted within mainstream British and American society and culture until at least the 1960s and the birth of the so-called New Left. At this juncture, its first 'moment of reception', Hauser's study,

actually highly conventional in its definition and selection of arte-
facts deemed worthy of consideration, was liable to be attacked
and even vilified because of its declared theoretical and political
orientation.

By the mid-1980s, a later version of Marxism, disseminated pri-
marily through the development of academic media and cultural
studies programmes, often interwoven with feminist, structuralist
and psychoanalytic themes and perspectives, had gained (and
regained) an intellectual respectability in rough and ironic propor-
tion to the loss of its political significance in western Europe and the
USA since the 1930s. Hauser's study was liable to be seen in this
second moment of reception as an interesting, if, on the whole,
crude, antecedent within the development of a disciplinary special-
ism identified with contemporary academic art and cultural histor-
ians and theorists such as Edward Said, Raymond Williams, Pierre
Bourdieu and T.J. Clark. By the 1980s, however, Hauser's orthodox
choice of objects of study, along with his unquestioned reliance on
the largely unexamined category of 'art' – seen by many adherents of
cultural studies as inherently reactionary – meant that, once again,
his history could be dismissed, this time primarily on the grounds of
its both stated and tacit principles of selection. Yet *The Social His-
tory of Art*, whatever its uneven critical fortunes and continuing
marginal place in most university courses, has remained an item, or
an obstacle, to be read – or at least dismissively referred to – within
the study of the history of art. Why should this be the case?

There are several different, though related, answers to this ques-
tion. The sheer extent and relative detail of reference in Hauser's
study – despite the narrowness of selection – has commanded a cer-
tain amount of respect and attention. No comparable study exists in
the English language, though many attempts at a one-volume 'his-
tory of art' have been made since Hauser's *magnum opus* appeared.
Most famous of these and certainly better known, especially outside
the Academy, is Ernst Gombrich's *The Story of Art*, which was actu-
ally published just before Hauser's study.[1] Unlike Hauser, however,
Gombrich, probably aware of the charge of reckless megalomania
likely to be levelled at anyone attempting such a task, shrewdly
adopted the term 'story' for his title which connoted, amongst other
things, a modest declaration of unreliability. Gombrich admitted, by
using the word, that his pithy tale was evidently 'made up', an
invention, and therefore, after a point, 'not to be trusted'. Hauser's
pleonastic *History*, on the other hand, offered no such self-
effacement and its seriousness was liable to be represented, especially

in the Cold War, as another dreary facet of doctrinal Marxism pro-
mulgated by one of its apologists in the Free West. And Hauser's text
is undoubtedly hard-going, unrelieved by regular and frequent sec-
tion sub-divisions, only sparsely (and sometimes apparently arbitrar-
ily) illustrated, and with no specific references to illustrations in the
text. In addition to these failings the text itself was translated from
German into English in usually a merely adequate manner by
Stanley Goodman, though with Hauser's collaboration. Long
Germanic sentences, piling qualifying sub-clause upon sub-clause,
within arguments mounted at usually quite high levels of abstraction
make reading *The Social History of Art* sometimes seem like the
exhausting ascent of a literary Everest, in painful contrast to what
amounts to an afternoon skip up Gombrich's sunny and daisified
hillock.

If it is the case that Hauser's sheer ambition (megalomaniacal or
not) to attempt to write meaningfully on art from the Stone Age to
the Film Age almost in itself warrants a certain amount of cautious
interest, however, and his command of research materials ostensibly
indicates a more than superficial understanding of the dozens of
fields of study necessarily implicated in such an account, then there
is another reason for taking the history seriously. This is the issue of
the significance of his claim, finally stated clearly only in the ultimate
volume, that the entire effort is really directed towards trying to
understand ourselves and the present. However, Hauser omitted –
and this was a serious error – to begin his study with an introduction
which might have made the intended purpose and value of his work
manifest for readers at the start of their arduous climb. Though it
might not have been at all evident from his first pages on cave paint-
ing and paleolithic pottery, Hauser was trying, he says retro-
spectively, to use history to understand the present. 'What else could
the point of historical research be?', he asks rhetorically. Although
'we are faced with new situations, new ways of life and feel as if we
were cut off from the past', it is knowledge of 'the older works', and
knowledge of our alienation from them, which can help us to find
'an answer to the question: How can we, how should one, live in the
present age?' (vol. IV: pp. 1–2). One may, relatively productively,
simply 'dip into' Hauser – in a way that one can not simply experi-
ence a portion of Mount Everest at will (say, the atmosphere and
footholds around 20,000 feet) and then return to a temperate and
well-oxygenated sitting-room when tired. But reading the whole text,
appreciating the historical developments and disjunctions Hauser
identifies over the four volumes, ending up with the place of art and

culture after the Second World War, is really necessary in order for the 'ground' of the past to be as clearly visible as possible – be it only fleetingly, obscured by cloud and rain-bursts, from the vertiginous summit of the present. The higher one goes up, or further on, the more there is to see, potentially at least, below, or behind.

Hauser's motivation, from this point of view, was truly sanguine, and reflected a belief held by socialists and Marxists around the world after 1945 that revolutions in society would surely follow those in knowledge brought about by Marxism's purported science of historical materialism. But the development of anti-communism in the USA, Cold War politics there and in Europe, along with Stalinization in the USSR and the Eastern Bloc states, would bring popular disillusionment with traditional notions of socialist revolution and transformation during the 1950s and 1960s, along with loss of faith in the grand vision of history, society and culture exemplified by Hauser's scholarly ambitions. Confidence in Marxism's 'scientific' status, historical understanding and map of the future dissipated gradually, though continuously, during the post-war decades. Although temporarily enlivened, within French academic theory at least, by association with structuralist ideas which themselves claimed objective status for a while during the 1960s, or with socialist-feminists who attempted to theorize the relations between class and gender identity in the 1970s, by the mid-1980s Marxism as a unitary theoretical system, and socialism as a practical political doctrine, was discredited, almost as much by some of its own previous protagonists as by its long-standing and traditional enemies.[2]

Though still a thriving specialism in some university arts and social studies departments, Marxism has been cut off as effectively from civic culture and politics in the West as definitively as Hauser claims in his third volume that German idealist philosophy was in the eighteenth and nineteenth centuries. The loss of the intellectual as 'social activist' paralleled, Hauser argues, in fact, the development of modern aestheticism ('art for art's sake') and the refashioning of the artist as estranged outcast, the artistic persona predominant still in his own time. Hauser's history, from one perspective then, is an account of this transformation or decline, from art as social instrument of authority and propaganda of one sort or another – the Church, the State – into an expensive plaything of the cultured bourgeoisie and philosophical rebus of the academic and critical intelligentsia. Yet Hauser's time is *not* our own: though Marxism certainly has lost its political role and intellectual centrality, many

other forms of politics and modes of analyses of social life and history have become important, both in academia and in the general polity. Feminist, racial, sexual, regional and ecological concerns, for instance, are *not*, singularly or together, a 'false consciousness' that has simply usurped the fundamental and prior place of class analysis and politics in historical and social understanding. Rather, they have provoked and reflected a renewed, though disparate, 'left-libertarianism' in the West – inside and outside the Academy – but have also helped to catalyse a range of art forms, utilizing both traditional and new media, that have restored a variety of social activisms to contemporary culture. Hauser, writing in the late 1940s, could not have predicted this development, although he probably hoped for it. His own perspective inevitably limited what he could see and, from our situation in the late 1990s, his study may seem extremely dated. We are, of course, now further up the mountain than Hauser, although, in one sense, the near half-century since the publication of his study is a mere trifle compared with the ten thousand or more years of history he tried to encompass.

Reasons and strategies for reading

On the other hand, the specifics of the moment in which one writes determine absolutely what we can see and why we want to see it. Ten years later, in 1961, Hauser might have produced a very different book, in the light of, say, the critical hegemony achieved by US-based Abstract Expressionist painters (the full-blown abstractions of whom were claimed to make completely obselete Picasso's still highly mimetic, and in Hauser's sense, *naturalistic* 'modernism'), or the extensive erosion of popular and intelligentsia faith in Marxism and Soviet socialism (though Hauser is implicitly critical of the Soviet state and quietly derisive on the value of socialist realist art). Reading Hauser is important and instructive now, then, also because his text itself has achieved historical significance: it tells us about his values, representative, as they were, of an influential stratum of left-wing intellectuals active in Britain in the early 1950s.[3] On the whole, it is also the case that his account is far less crude, in fact far less straightforwardly 'Marxist' altogether, than many have assumed.

Reading Hauser may also inform us about the current terrain of the discipline of art history, and enable us to register and evaluate, through a process of systematic comparison, the continuities and ruptures in the post-war development and present configuration of the subject. Reading is usually, and certainly most valuably, an active

process: we search for meaning and significance in a text because our reading is specifically motivated, and we have a conscious sense of purpose in mind. Far less attentive and productive readings occur when we have little or no sense of *why* reading a text is worthwhile. In approaching Hauser's study, due to its length and complexity, readers – in addition to sheer stamina – require a particularly clear sense of their own intentions, as well as a knowledge of which parts of the text might be most useful. If a reader wishes to find material relevant to, for example, an essay question on ecclesiastical art commissions in early Renaissance Florence, or on the changing social status of artists in the French revolutionary period, then it is easy enough to find the appropriate sections. This is an entirely valid use of Hauser's text and one he probably envisaged. But a careful reading of the *whole* study produces, and, arguably, was intended to produce, much more than a simple sum of all the separate historical sections. For the study attempts to show us how what is called 'art' began, and how it has become – along with Western society – what it appeared to its author to be in the mid-twentieth century.

Hauser does not make this understanding easy. The book contains no general overview of its aims and methods, nor any succinct account of its values and assumptions, nor a defence or definition of key concepts (such as 'art' or 'style'), nor of its principles of selection. Inclusion of this kind of introductory material has become part of the 'reflexivity' of academic theory in the humanities over the past twenty-five years and constitutes a real advance on the complacency present in earlier traditions of art and cultural history, those identifiable both as 'traditional' or 'radical'. Hauser does not indicate either whether his study is directed at any particular readership and appears almost completely unself-conscious about the general intelligibility of his arguments. Though any person *might* benefit from reading his history, the complexity of his language, assumptions about prior knowledge (particularly knowledge of visual examples), and discussion of a vast range of issues in economic, social, cultural and intellectual history presumes a readership already highly educated and in agreement with Hauser on basic principles, and involved rather in engaging with his abstract 'connective logic' and manipulation of Marxist analytical tools.

The tone and rhetoric Hauser deploys may also appear unattractive, because doctrinaire. Generally he writes, especially in the earlier volumes, in an authoritative and declamatory manner, seemingly with little or no sense of open investigation, or of any doubt over the credibility of his account. Reflexivity in recent theory has

come to value scepticism and 'explanatory modesty' over this kind of authorial certainty. The apparent unassailability of Hauser's argument in large part reflects the character of Marxist history and theory in the late 1940s, its proponents still sure of its 'scientific' basis – philosophically water-tight in its dialectical materialism – and confident that the veracity of its understanding of the world was somehow confirmed by the existence of an 'actual' socialist society erected on its principles. It transpires that Hauser's certitudes, however, are more apparent than real, and begin to break down fundamentally as his account moves through to the nineteenth and twentieth centuries. He not only subjects many *other* theories and traditions of cultural analysis to withering critique – for instance, the 'liberal' concept of the Renaissance, the 'formalist' method of art historians such as Alois Riegl or Heinrich Woelfflin, or the previously mentioned 'social escapism' of German idealism. By the end of the fourth volume Hauser's historicization of Marxism *itself* – part of which locates it as an item alongside other, specifically nineteenth-century symptomatic 'ideologies of unmasking', such as those produced by Nietzsche and Freud – suggests that his, and Marxism's, 'mastery' of history is tentative, corrigible, and inadequate in many ways. This sense partly reflects his understated, though serious, qualms expressed in the final volume over the place of art and culture in the Soviet Union.

Hauser's inclusion of artefacts, or artists, or periods or geographical regions is, necessarily, drastically selective and therefore narrow – after all, how could *any* history of art from the Stone Age be otherwise? Yet some attempt to justify or simply to acknowledge this selection as such would have mitigated the doctrinaire quality to his writing, particularly evident in the first two volumes which deal with many thousands of years of history in little over 500 pages. Presumably he included what he felt was most important, though even this is not said directly and the effect is to feel too often as if one is being lectured at, rather than being invited to engage in an extended explanation. 'Facts', at times, seem to overwhelm his text and its reader, particularly when he includes extensive socio-historical, contextual material at what seem like relatively arbitrary points in the text, or when he lurches, without clear reasons, from France to England, or from Russia to Germany, in his discussion of the late nineteenth century. Certainly a quite orthodox outline description of the history of art subsists in Hauser's text, despite his Marxist perspective, and this account is squarely based on the use of traditional art-historical terms, methods of description of artworks

(thought these are relatively few and far between), and a defence of the conventional canon of Great Works. Hauser's history of art is also clearly and unapologetically 'Western' or 'eurocentric' – especially, definitively perhaps, in its 'cultural-imperialist' assimilation of Egyptian, Byzantine and Babylonian works to this tradition – and for this reason would count as what Edward Said calls, critically, an 'orientalist' text, despite its Marxism.[4]

Given its massive historical sweep and gross selectivity it should not be surprising that Hauser's study presents little in the way of specific 'technical' information or analysis of particular paintings or sculptures or prints (or any other artefacts). The level of abstraction generally precludes him from discussing anything below, in most cases, what one might call an identifiable 'social style' – that is, a consistent form of representation he claims is characteristic of a group of producers at a certain moment. Hauser, by the way, at no point subjects the term 'style' to any sustained analysis; instead he allows it to proliferate a range of different and sometimes confusing senses which come to co-habit throughout his account. Though he does occasionally discuss individual artefacts, though never for more than a few paragraphs at the most, his narrative is carried forward in terms of a conventional art historical litany of familiar style abstractions, such as 'mannerism' (though he claims to identify several distinct varieties of this), or 'the baroque' (similarly variegated), or 'impressionism' (a term he uses highly promiscuously to discuss an extensive range of painting, literature, music and drama in nineteenth-century France). This analytic and narrative device persists until he moves to the late nineteenth century when he claims that 'social style' in the arts more or less breaks down altogether – for complex historical reasons – and that from this point the 'history of art' becomes really the history of the work of disparate individuals, living in an ostensibly common world, but driven by radically incommensurate motivations and methods. Hints, prefigurations, of this claimed development occur much earlier in the study – within his account of the high Renaissance persona and work of Michelangelo, for instance. Hauser is open to the charge, however, that, given the sheer density of detail available on more recent art cautioning the analytic reduction of such particularity to homogenizing 'social styles', all his earlier abstracted notions (the style-labelling stretching back to the 'gothic' and before) could equally be shown to be untenable if sufficient historical evidence was adduced.

Hauser and the 'New Art History'

If Hauser's narrative of producers and products in large part reproduces that of mainstream art history, the qualification in his superior title for each volume (*The* Social *History of Art*) suggests that the account goes on to offer something different, and presumably better, or truer, than an ordinary, unqualified 'history'. In many respects, however, Hauser's study faithfully – even dogmatically – continues much of art history's traditional descriptive terminology. As noted, he uses the same style labels, both for relatively historically-specific forms of representation (e.g. 'mannerist', 'rococo', 'baroque', etc.), as well as those for 'transhistorical' or 'epochal' depictive modes. These, such as 'naturalistic', 'stylized', 'classicistic', etc., according to Hauser again following art-historical orthodoxy, have remained relatively constant within many centuries of human culture. Hauser's novel analytic extension *beyond* the typical art-historical procedures of what might be called 'style-nomination' and 'style-mutation description', is to attempt to correlate such claimed stylistic features and changes with a range of socio-economic developments. He wishes to see, and attempts to show, that 'development' and 'progress' in art is related, necessarily – though abstrusely – to a corresponding dynamism, a 'historical logic', active in the organization of human societies since the Stone Age. This identification, or correlation, is the basis of his Marxist, 'social', art history.

The traditional, painstaking, 'footsoldier' work of art-historical methods rooted in the careful form of specific 'visual analysis' – connoisseurship, Erwin Panofsky's 'pre-iconographical' and iconographical protocols, reconstructions of artists' intention, etc. – are supplanted in Hauser's account with this work of correlation between style and socio-economic development.[5] Given that the discussion usually takes place at a quite high level of abstraction and involves complex, and sometimes highly questionable, notions of 'equivalence' or 'agreement' between apparently quite disparate economic, institutional, political and artistic phenomena, it should not be surprising that many conventionally trained art historians have quickly run out of patience with Hauser's intentions and arguments. Those art historians indifferent or actually antagonistic to his intellectual and political motivations have found, and continue to find, many of his claims, by turns, either truistic – because pitched at such a high level of abstraction – and therefore banal, or simply empirically unverifiable – given that Hauser's undoubtedly grandiose project

inevitably eschews specific historical detail – and therefore unproductively ineffable.

In the 1960s and 1970s most critiques of Hauser's account were liable to proceed from the assumption that 'authentic' art history meant precisely a kind of detailed descriptive and analytic work on specific works of art, or on an artist's *oeuvre*, or on a group of artists or artefacts thought to constitute an identifiable school or style or tendency. General problems of explanation and evaluation in art history – the meanings of 'romanticism', say, or the question of the figurative 'autonomy' of an abstract painting – were certainly beginning to be taken seriously at the level of conference debate and published diatribe between peer academics. The study of the 'history of art history' had also begun to be taught in universities and this indicated the opening up of debate over the status and value of key assumptions, ideas and values in the subject generally. In the early 1980s the Open University in Britain inaugurated an art history course specifically designed to introduce complex theoretical and philosophical problems relevant to the study of modern art, approached however, and wisely, through a series of specific historical case-studies.[6] One of Hauser's errors in *The Social History of Art* was really not sufficiently to have related his 'meta-historical' and theoretical concerns to specific case-studies that could be recognized as examples of what stood, in the 1950s and 1960s at least, as 'proper' art history. This was, and remains, a very reasonable objection, particularly in relation to the productive use of Hauser's text in undergraduate teaching, where students, with perhaps only scant knowledge of the artworks to which Hauser often anyway only indirectly refers, are expected to follow, and presumably then assess, the highly complicated relations he draws between such empirical material and claimed abstract societal developments.[7]

Hauser's refusal to clarify his aims, objectives, and methods in a general introduction, along with his adoption, generally, of a dictatorial tone (however much subverted in later stages of the account) meant that his study was likely to meet another critical response when the so-called New Art History emerged in the mid-1980s. If previously attacked by traditional art historians for the crudity, or vapidity, of his abstractions and lack of meaningful engagement with specific artworks and their contexts of production and reception, Hauser's text was now, in addition, liable to be judged reactionary, sexist, racist and élitist by recently politicized groups responsible for the New Art History's attempted reconstruction of the discipline over the past fifteen years or so. Once again the charges are, on the

whole, sustainable. Hauser, because of his mid-century gender, class, political and scholarly characteristics and inclinations, manifestly is *not* concerned, for instance, with an investigation of the presence or absence of women as significant or jobbing artists in history, nor with the sociological reasons why they did or did not achieve such positions – perhaps the two most important issues that have pre-occupied feminist art historians for many years now.[8] (He does, how-ever, discuss several times the place of women as part of a changing public for art, or even, occasionally, as patrons, and their status as 'muse'. In addition, and interestingly, the question of a presumed relationship between 'femininity' and creativity crops up in his dis-cussion in volume I of the production of craft artefacts in ancient societies where he is quick to refuse any simplistic relationship.)

Hauser is similarly, though again predictably, 'blind' to the ques-tions or significances of race, of sexual orientation, and of ethnicity in artistic production and reception, all issues core to the 'subject-position' or 'life-style'-oriented politics and theory of many of those involved with New Art History in Europe and the US. But this revi-sionist phase in the discipline has included not just those represent-ing New Left libertarian politics (including some who believe 'art' is an intrinsically élitist designation which should be replaced by study of those images and artefacts deemed to constitute 'popular cul-ture'). Novel academic techniques of textual or visual analysis – most with French provenances, some claiming to be scientifically objective – also found an important place, initially at least, in New Art History. So-called 'structuralist' and 'post-structuralist' methods and philosophies would make mince-meat of Hauser's Marxism, convicting it endlessly of such analytic crudities as 'reflectionism', 'mechanistic reduction' and 'teleological projection'. However, revivified post-structuralist, academic Marxism itself can play this game as well as (if not better than) the followers of Foucault, Lacan and Derrida, finding Hauser's concepts, analyses and values stranded in the crudities of 'Second International' and 'Third International' Marxist protocols of ideologues such as Karl Kautsky, Franz Mehling, George Plekhanov and even Georg Lukács.[9]

The point, however, is to understand Hauser's text itself *historic-ally* and to assess its significance on this basis. It can not be claimed – though neither can any other single book for that matter – as a viable basis for constructing an entire art-historical method, or for regener-ating a 'cultural Marxism', or anything else. Its overleaping ambition certainly tells us, however, that Hauser nursed a belief that Marxism did possess a unique explanatory potential, a set of sureties, and a

cluster of values superior to anything else available in the discipline in 1951. But this confidence becomes systematically and increasingly undermined within his own text and what would now be called Hauser's 'auto-deconstruction' constitutes the book's most interesting feature. The vast text is heterogeneous, uneven, fragmented – composed of many genuine insights and genuine idiocies; full of active and productive revisions and complacent reproductions; it is hectoring and vituperatively authoritiarian, yet also interrogative and prone to dubiety.

Hauser, like Marx himself, is sometimes, when it suits, effectively prepared to declare himself 'not a Marxist'. Many times, actually, throughout his text he will criticize *others* for attempting the same task of correlating art and social development – Wilhelm Hausenstein, for instance, who attempts, illicitly Hauser believes, to claim an identity between ancient art's geometric style and the 'communistic outlook of the early "agrarian democracies"' (vol. I: p. 16). Such fallacious connections Hauser dismisses repeatedly as 'equivocation', the use of ambiguity to avoid or conceal the truth. But his own correlations necessarily perform an identical analytic operation: they draw on one set of features claimed to be immanent in an artwork or group of artworks (for instance, an identifiable 'social style') which are then mapped upon, claimed to organically 'reflect' and partially 'constitute', another set of selected features claimed to be immanent in an identifiable social development. Though Hauser is right to condemn simplistic or 'essentialist' correlations that posit necessary and inevitable relations – such as that of H. Hoernes-O. Menghin, who contends, in contrast to Hausenstein, that 'the geometric style is . . . feminine in its character' (vol. I: p. 19), Hauser's own analytic house – a veritable skyscraper at that – is built fundamentally with the same bricks. Reading his text runs the danger of becoming a game of deciding whether one happens to 'like', or 'find pleasing', the correlation that entertains the author at a particular moment. Is the 'social order' of French revolutionary society under Napoleon justifiably 'correlated' (confirmed) in the formal and narrative 'visual order' of a painting by David? Are both equally 'facts' about French art and society at the time? Is the fractured, reversible space and time of film an 'objective' facet of the 'experiential dimension' to early twentieth century modernity? Such claims, ultimately, can not be either 'proved' or 'disproved'; they become a bit like artworks themselves, which we can admire or not, depending on taste. This is to say, actually, that the credibility of Hauser's account is, to an important degree, a matter of 'faith' in the end, or commitment to a certain

notion of the purpose of history and meaning of culture. If Marxism was still able to command this fidelity in the early 1950s, amongst intellectuals and popular movements in favour of social revolution, it certainly can not recruit such support now. The implications of this are mixed.

The New Art History – at least in its manifest political variants which brought the issues of women, race, sexuality, popular culture and ethnicity into some kind of generally productive relation with the pre-existing discipline of art history – importantly challenges these absences in Hauser's text. But although *The Social History of Art* cannot – should not – be used as the basis for teaching the subject, it can provide many valuable insights and observations. These may be used to support the interests of feminists, scholars concerned with non-Western culture, and gay or lesbian revisionists, as well as those of the dwindling ranks of Marxists still haunting universities – those largely forgotten within the New Art History now, who can similarly integrate some of Hauser's valuable work into their own studies.[10] But the radical fragmentation of the discipline's theoretical bases, along with the loss of faith in Marxism, both as a superior intellectual system, and as a practical means of transforming capitalist societies, has an ambiguous legacy when it comes to assessing Hauser's study. On the one hand, it is definitely an advance for left-liberal scholarship and culture no longer to maintain that 'class' and 'economics' have singularly, or most significantly, determined the social development and value of art. On the other hand, contemporary art history is balkanized and no longer contains *any* kind of what Jean-François Lyotard famously called a 'metanarrative of legitimation' – an accepted overarching principle – able to unite all the theories and methods with putative disciplinary status. To be sure, of course, there was never a time in the past when art history experienced a pristine, transparent, golden age of community and consensus. Methods of description and analysis have always been heterogeneous, in large part reflecting the institutional dualism of its core knowledge-producers, whose interests have been half curatorial and market-oriented (connoisseurial and provenance-hunting), half academic and pedagogic ('style and civilization' studies). But up until the mid-1970s the subject, arguably, exhibited a relative unity based on the general stability of the canon of artworks deemed worthy of study. This quickly broke down in the 1970s and 1980s as media, film and popular-cultural studies burgeoned.

Hauser's text, in large part manifestly Marxist and therefore 'radical' in method was also, as noted, traditional, and therefore

'conservative', in its selection of cultural artefacts. 'Cultural Marxism' in the 1980s was, in contrast, highly sceptical of 'aesthetic value' understood either as a defensible analytic category or as a datum of human experience believed to 'guarantee' the canon, and saw both as examples of ideological delusion or 'false consciousness'. Canons were claimed to be simply duplicitious; partisan preferences masquerading as neutral and objective categories. Such extreme relativism over the issue of cultural value was characteristic of parallel forms of structuralist, post-structuralist and reception theory. Relativism of this kind had found no place at all in the writings of Marxists active before the 1970s and Hauser's text is full of judgements, asides and reflections which indicate his highly conventional taste and values (often labelled 'bourgeois' by the ideologues of academic Cultural Studies), identical or close to those of earlier influential Marxist critics and cultural commentators including Theodor Adorno, Herbert Marcuse, A.S. Vasquez, Lukács, and Marx and Engels themselves.[11] Hauser, whatever his declared 'sociological method', will repetitively uphold a mysterious phenomenon called the 'human spirit', reiterate his belief in the ineffability of quality in art, and even, by the end of the fourth volume, seem to sometimes replace his Marxist 'objectivity' with a variant of judgemental subjectivism reminiscent of the kinds found in the prose of Marcel Proust, the philosophy of Henri Bergson, or the paintings of the Surrealists.

In addition to this reliance on conventional canonical selection, advocacy of the 'autonomy of the aesthetic' in art in matters of experience and evaluation, Hauser also often attacks the crudity of others claiming to mobilize Marxist principles and methods. As we have seen, this is sometimes a criticism of those exhibiting 'essentialist' tendencies (such as those who Hauser thinks reduce analytic complexity to a single sociological or psychological determinant), or of those who claim correlations between style and socio-economic developments based on what he regards as 'equivocations'. Though Hauser several times attacks historians such as Riegl or Woelfflin for reliance on a 'formalist' notion of 'internal laws' operating in art styles, Hauser himself mobilizes a variant of this idea when it seems necessary. For instance, reflecting on the complexity of interpretation involved with assessing broad style designations, such as 'naturalistic' or 'classicist', he remarks:

> The greater the age of an art, of a style, of a genre, the longer are the periods of time during which the development proceeds according to immanent, autonomous laws of

its own, unaffected by disturbances from outside, and the longer these more or less autonomous episodes are, the more difficult it is sociologically to intepret the individual elements of the form-complex in question.

(vol. I: p. 21)

Hauser's own 'equivocation' here – what does he really mean by 'immanent' or 'autonomous'? – exemplifies the nature of his text as a whole, which does not present a single or unified argument, or a stable set of concepts and ideas, or a homogeneous sense of value or purpose. Its semantic openness, in fact, makes it in many ways definitively 'post-modern': it is best read as fragmented, split, undecided. Its ambitions and claims are unbalanced, unreasonable and unverifiable, evidenced in a lurch from a discussion of ten thousand years of art in two volumes, to the last two hundred years in another 500 or so pages, often at a level of rarefied and quite suffocating abstraction. Yet its rhetoric and grand historical sweep, often overblown, at the same time is quite magisterial. Hauser's study is an excitedly written history of the world, of ideas, of human social development, as well as of art and culture more broadly. From one perspective his sources and selections are narrow and highly partial, yet from another quite extensive and diverse, and the treatment belies his ostensible Marxist method. The text tells us as much about Hauser's own intellectual and class formation (in all its gender, ethnic and other specificities) as it does about art and its history.

We may read *The Social History of Art*, then, for all this which it offers, from our own very different moment, which it also throws into relief. Lapsing, or rising, often into the present tense, as he races through the Stone Age, the Renaissance, the Romantic movement and the dawn of the Film Age, Hauser above all communicates a sense of urgency and commitment to understanding the past as a means of knowing about the present. The medium of film itself, to which he refers many times in his text – often when its use as a comparison seems virtually historically meaningless – indicates his excitement precisely with the dynamism of the present, signified in film, and partly explains the 'teleology' or sense of 'necessary development' which permeates his narrative. For Hauser the past – in art, in social organization and change generally – has 'made' the present what it is, made us what we are. If one exhaustedly closes *The Social History of Art* with this insight, which we may then decide to qualify as much as Hauser himself does, then a reading of his account has surely been worthwhile.

Notes

1 *The Story of Art* (London: Phaidon, 1950). See Gombrich's review of Hauser's study, 'The Social History of Art', in Ernst Gombrich, *Meditations on a Hobby Horse and Other Essays* (London: Phaidon, 1963), pp. 86–94. This article was originally published in *The Art Bulletin*, March 1953.

2 See Ernesto Laclau and Chantal Mouffe, *Hegemony and Socialist Strategy: Towards a Radical Democratic Politics* (London: Verso, 1985) and Stanley Aronowitz, *The Crisis in Historical Materialism: Class, Politics and Culture in Marxist Theory* (New York: Praeger, 1981).

3 See Tom Steele, *The Emergence of Cultural Studies 1945–1965: Cultural Politics, Adult Education and the English Question* (London: Lawrence & Wishart, 1997).

4 See Edward Said, *Orientalism: Western Conceptions of the Orient* (Harmondsworth: Penguin, 1991), Martin Bernal, *Black Athena: The Afroasiatic Roots of Classical Civilization* (London: Vintage, 1991) and Edward Said, *Culture and Imperialism* (London: Chatto & Windus, 1993).

5 See Eric Fernie, *Art History and its Methods: A Critical Anthology* (London: Phaidon, 1995) and Marcia Pointon, *History of Art: A Students' Handbook* (London and New York: Routledge, 1994).

6 *Modern Art and Modernism: Manet to Pollock* (Milton Keynes: The Open University, 1983). Thirteen course books and associated materials.

7 See, in contrast, however, Hauser's *Mannerism: The Crisis of the Renaissance and the Origin of Modern Art* (London and New York: Routledge & Kegan Paul, 1965).

8 See Rozsika Parker and Griselda Pollock, *Old Mistresses: Women, Art and Ideology* (London: Pandora, 1987) and Griselda Pollock, *Vision and Difference: Femininity, Feminism and the Histories of Art* (London and New York: Routledge, 1988)

9 See Raymond Williams, *Marxism and Literature* (Oxford: Oxford University Press, 1977).

10 See A.L. Rees and F. Borzello (eds), *The New Art History* (London: Camden Press, 1986).

11 See Roger Taylor, *Art: An Enemy of the People* (Brighton: Harvester, 1978).

INTRODUCTION TO
VOLUME III

Jonathan Harris

Contents, concepts, principles and problems

This, the third book of Arnold Hauser's four-volume series *The Social History of Art*, deals with the period in Western art between the seventeenth and early nineteenth centuries. Though the book's subtitle 'Rococo, Classicism and Romanticism' appears to offer as the basis of its subject matter the orthodox art-historical narrative of abstract stylistic sequence, Hauser's analysis actually starts from the premise that 'style' and 'society' constitute a unified, though complex and sometimes opaque, whole. 'Romanticism' has long been understood as a term not just applicable to a kind of painting, or poem, or even a feeling or sensibility. It encompasses an entire intellectual culture and even, beyond that, the tensions, shifts and transformations of all society in the development of the modern industrial world. Hauser attempts to provide not just a Marxist perspective on Romanticism thus conceived, but to show that the preceding terms in his subtitle may also productively be read as cyphers for broad cultural and societal change in the period before the French revolution. Though his account deals with the visual arts in detail, he also discusses a wide range of other artistic forms, including drama, poetry, the novel and music. A further section is devoted to developments in philosophy in this period, with a particular emphasis on German idealism.

One of Hauser's central claims in this volume is that 'aestheticism' and 'social disinterestedness' increasingly came to shape the development of art and intellectual production generally in this period, an outcome brought about by the widespread dislocation, or alienation, of artists and intellectuals in the post-medieval world. No longer chiefly working as propagandists for the Church or State, their new-found 'freedom', born in the Renaissance, engenders a subjectivism still characteristic of art in Hauser's own time of writing (1951). This

tendency to 'social escapism', Hauser believes, is particularly active in German culture and philosophy, and he holds it partly, but importantly, responsible for the growth in 'irrationalism' there that saw, as its culmination, the rise of Hitler and the Nazi Party in the 1930s. In contrast to his discussion of the situation in Germany, however, Hauser also includes an important section on 'The New Reading Public', mainly in England, showing how, in a different economic, social and political context, art and ideas developed in close relationship with that country's limited but expanding cultural democracy.

Though Hauser's analysis, given this range of coverage, is highly ambitious, and partly explains why he calls his study a work of 'social history' – a qualification intended to suggest an elevation above, and presumably an improvement upon, 'mere' history – he does not make the understanding of his arguments easy for the reader. Typical of the entire series, in fact, is a level of abstraction in discussion sometimes hard to follow. In addition to this, the exegesis is not accompanied by extensive, or detailed, illustration. Though occasionally Hauser refers specifically to a painting or sculpture, there is no direct reference to any pictures bound with the text, and, because of this, the attentive reader must flick back and forwards from Hauser's argument to the illustrations in order to attempt to clarify the author's claims and observations. Hauser's style, partly enforced by the enormous range of developments he seeks to include, is sweeping and sometimes rather doctrinaire, prone to gen-eralization and the non-definition of some absolutely core concepts. 'Classicism', for instance, perhaps one of the most used (and over-used) words in the art-historical lexicon, does not receive a thorough theoretical examination, though he shows how some of its particular historical meanings were elaborated in different social, national and cultural moments in the period up to the 'July revolution' in France in 1830.

Hauser's discussion of poetry, the novel, drama and music prob-ably could never have received entirely adequate illustration in such a conventional format, but his account still demandingly assumes that the reader is familiar with a very wide range of examples, in a number of languages. Hauser's erudition is certainly impressive, but it can also feel quite *oppressive* because most readers are very unlikely to have an equal grasp of the fields of knowledge the author quite nonchalantly brings together. The purpose of this introduction, then, is to suggest a path through the text and signposts along the way to major themes, claims and problems. It does not, however,

provide a comprehensive synopsis of Hauser's narrative. Rather it offers a set of contexts – historical, political, intellectual – for interpreting its shape and assessing its value, for Hauser's text, like that of the artworks he discusses, is an artefact produced in a particular time and place, and for specific reasons.

Hauser's social history of art is, ostensibly, Marxist in principle and method, though he states clearly, on numerous occasions throughout the series, that aesthetic *judgements* have, apparently, no relation to the kinds of sociological and social-historical questions and protocols that actually occupy him most of the time (see, for example, vol. II: pp. 45 and 149). The 'aesthetic autonomy' of art, Hauser claims, was established in the 'high' Renaissance, and the freedom of art from ideological control by the Church or the State contributes towards its characteristic subjectivism, still the condition of modern art in the mid-twentieth century. Though he accepts, and confirms without qualification, art history's canon of great artists and artworks, his understanding of stylistic development is, he claims, based upon the explanatory schema present within the Marxist philosophy of 'historical materialism'. Towards the end of his third volume Hauser makes a valuable attempt to define this. The 'real meaning of historical materialism', he observes:

> . . . and at the same time, the most important advance of the philosophy of history since the romantic movement, consists . . . in the insight that historical developments have their origin not in formal principles, ideas and entities, not in substances which unfold and produce in the course of history mere 'modifications' of their fundamentally unhistorical nature, but in the fact that historical development represents a dialectical process, in which every factor is in a state of motion and subject to constant change of meaning, in which there is nothing static, nothing timelessly valid, but also nothing one-sidely active, and in which all factors, material and intellectual, economic and ideological, are bound up together in a state of indissoluble interdependence, that is to say, that we are not in the least able to go back to any point in time, where a historically defineable situation is not already the result of this interaction.
>
> (vol. III: p. 161)[1]

This might epigrammatically be represented as 'always historicize, always link!' and important elements of both Hauser's style and his

analytic attention are devoted to showing the radical, and inveterate, connectedness of developments in styles of art, ideas, economic, social and political events and circumstances. His definition of historical materialism appears to suggest that ideas and material phenomena are of *equal*, inter-active significance historically – a view at some variance with the traditional Marxist emphasis on the determining role of 'economic circumstances' (however defined) in history. In practice, however, though convinced that man is not 'the mere function of his environment' since such a view 'deprives man of all autonomy and, therefore, to some extent of responsibility for his actions' (vol. III: pp. 84–5), Hauser usually assumes that cultural and intellectual forms and activities in any given society have to be 'correlated' with *antecedent* socio-economic structures and transformations, though – complicatedly – with pre-existent artistic styles and themes as well, whose original meanings have been superseded through re-use in later phases.

The status of 'classicism' is an important case in point. Art's history is always, for Hauser, partly a return to previous visual modes and means, though the meanings generated in the constant reappropriation of past styles or motifs are always novel: a process of semantic reconfiguration. 'The new classicism' of the eighteenth century, he observes:

> ... does not arrive so unheralded as has often been assumed. Ever since the end of the Middle Ages conceptions of art had developed between the two poles of a strictly tectonic trend and formal freedom, that is, between an outlook related to classicism and one opposed to it. No change in modern art represents a completely new beginning; they all link up with one or other of these two tendencies, each of which takes over the lead from the other, but neither of which is ever entirely supplanted.
>
> (vol. III: p. 129)

Hauser's radical historicization of art unfortunately runs the risk of appearing 'teleological' – that is, of giving the impression that the elements and features described, of whatever kind, are simply 'moments' or 'phases' in the inevitable unfolding of a process with its own logic and dynamism. Though this notion of history is virtually the opposite of the view that Hauser consciously wishes to convey – he says several times, for example, that different outcomes in art, society and politics may, and have, followed similar sets of historical

circumstances – 'historicism', the belief in a necessary end-point in history, has always characterized much Marxist thinking.[2] Hauser's own political beliefs find an increasingly clear presence in his third and fourth volumes and appear equally anti-teleological, conveying no sense that a socialist future will arrive like the morning milk on the doorstep. Unlike the romantic, Hauser asserts, the Marxist dialectician grasps that his own time 'stands midway between the past and the future and represents an indissoluble conflict of static and dynamic elements' (vol. III: p. 154). Hauser, the art historian, however, in looking self-consciously back at the eighteenth century from the mid-twentieth, attempting to assess the relationship between the two eras, will talk 'teleologically' about 'the two centuries before [Watteau's] *arrival* ' (vol. III: p. 13), and about the decadence of art in post-revolutionary France before romanticism 'could be *realized*' (vol. III: p. 153, my italics). Reliance on these, and other loaded terms, such as 'transition', 'precursors' and 'pioneers' – standard usage in art history – similarly tends to imply an evolutionary process of immanent unfolding.

If Hauser's basic faith in the Marxist philosophy of history as the development of class struggle provides his certainty that style-formation and change are necessary correlates of socio-economic structures, he is, nevertheless, prepared to signal warnings about the dangers of crudity in the work of showing such connectedness. Hauser's rhetorical tone thus shifts back and forth from quite authoritative, even rather dictatorial passages, to a much more interrogative, and eventually implicitly self-critical, introspection. His attack on the 'formalist' art historian Alois Riegl for maintaining the 'romantic view' that sees the history of art simply as a 'contiguity and succession of . . . stylistic phenomena', thereby personifying historical forces and hypostasizing 'artistic intention', is, after all, nothing more than would be expected of a Marxist (vol. III: pp. 160–1). But Hauser develops an unease with *any* form of determinism, 'social' or 'formalist', observing, for instance, that the classification of the philosopher Rousseau sociologically 'is not easy'. By the eighteenth century, he says, social relationships 'are now so complicated that a writer's subjective attitude is not always an adequate criterion when it is a question of considering his role in the social process' (vol. III: p. 72). Eighteenth-century classicism, similarly, he remarks, was sustained by quite different and even antagonistic social groups, those both 'courtly-aristocratic' and middle-class, and it ended by developing into 'the representative artistic style of the revolutionary bourgeoisie' (vol. III: p. 123). To take another

example, the German 'storm and stress' movement, formed in the period between the Enlightenment and Romanticism, is opaque socially and politically partly because 'it is impossible simply to identify rationalism and anti-rationalism with progress and reaction . . . [because] modern rationalism is not an unequivocal and specific phenomenon, but, to some extent, a general characteristic of modern history' (vol. III: p. 114).

This dissatisfaction with unequivocal explanation arguably finds its full and final elaboration in Hauser's fourth, and final, volume on art in the late nineteenth and twentieth centuries, in which occurs a kind of dissipation of his Marxist method, replaced by – if anything coherent – a variant of the very subjectivism he sees as characteristic of the modern art with which he is attempting to come to terms. In his third volume, however, Hauser makes a statement which indicates, implicitly, both the interrogative, open and authentically investigative aspect of his intelligence, but also the danger a too radical 'openness' incurs of slippage into vacuous explanatory indeterminacy:

> The assumption that men and women are merely social beings results in just as arbitrary a picture of experience as the view according to which every person is a unique and incomparable individual. Both conceptions lead to a stylization and romanticizing of reality. On the other hand, however, there is no doubt that the conception of man held in any particular epoch is socially conditioned and that the choice as to whether man is portrayed in the main as an autonomous personality or as the representative of a class depends in every age on the social approach and political aims of those who happen to be the upholders of culture.
>
> (vol. III: p. 84)[3]

The last insight, of course, would include Hauser's own aims and betokens his acceptance – at least in such parentheses as these – of a relativism Marxists had traditionally rejected. But Hauser's text is genuinely heterogeneous, in tone and analysis: split between certainties and doubts, theoretical orthodoxy and discontent, ideological agreement and apostasy. Class may be central (though questions and issues of gender and race are almost entirely absent), the 'bourgeoisie is always rising', both within and against Romanticism, for Hauser, in the clichéd Marxist fashion (see, for example, his discussion of music and drama, vol. III: pp. 50 and 90), and 'democracy'

without socialism remains always a mask for social inequalities, even in 'progressive' eighteenth-century England whose parliament both parties regarded 'merely as the guarantee of their own privileges against the Crown' (vol. III: p. 37). At the same time, however, Hauser's ever-increasing complication of the work of 'society-style' correlation, his rejection of determinism of any kind, and acceptance of the relativity of aims and perspectives obscures the clarity of the Marxist explanatory principle, dilutes its analytic thrust, and undermines the faith upon which it has previously rested.

Style, society and revolution

As Hauser's narrative proceeds towards the twentieth century he pays more and more attention to particular artists and their individual styles. Although he continues to perform the work of correlating these 'signatures' with social circumstances, this analysis has a very different character from that predominant in earlier volumes, in which Hauser relies upon a much more abstract, generalized notion of 'style', such as 'gothic' or 'naturalistic'. The particularities of a Watteau or a David, indeed of their specific paintings, are not easily 'ironed out' into an unproblematic 'rococo' or 'neoclassicism'. This shift in focus contains a puzzle: while Hauser claims that artistic individuality, like 'bourgeois individualism', is actually a creation of the Renaissance, with the consequence that the history of art actually becomes the history of these irreducibly individual styles (a claim which is certainly partly true), it is possible to argue simply that much more information had become available on recent artists and their artworks. This is also true. The difficulties in 'society-style' correlation, therefore, which Hauser claims are due to the sheer complexity of post-Renaissance art and its social frameworks might simply be a function of the superabundance of relevant material, the existence of which has required Hauser to qualify the kind of explanation he believes Marxism can defensibly offer.

At any rate, Hauser becomes increasingly circumspect. Though the rococo, he claims, is 'still a very aloof, very refined, and essentially aristocratic art' (vol. III: p. 1), art and literature up till the mid-eighteenth century are 'in a state of transition and are full of contradictory, often scarcely reconcilable tendencies; they waver between tradition and freedom, formalism and spontaneity, ornamentalism and expression' (vol. III: p. 11). That 'essentially' seems particularly suspect, given that Hauser has argued previously that meanings, within the flux of history, have shifted continuously and

are dependent anyway on the relative values of those observing them. This opacity to pre-revolutionary French culture continues after 'liberalism and emotionalism' have got the upper hand after 1750, when classicism, previously 'a courtly-aristocratic style, becomes the vehicle of the ideas of the progressive middle class' (vol. III: p. 12). This so-called 'Quarrel between the Ancients and the Moderns' is, for Hauser, a symptom of much more than a debate over styles: it 'marks the beginning of conflict between tradition and progress, classicism and modernism, rationalism and emotionalism, which was to be settled in the pre-romanticism of Diderot and Rousseau' (vol. III: p. 4). However, although Hauser is eloquent on the historical significance and aesthetic virtues of Watteau, whose 'profundity', he says, is due 'to the ambivalence of his relationship to the world, to the expression of both the promise and the inadequacy of life' (vol. III: p. 14) and is, therefore, clearly 'proto-romantic', who is to say this man's paintings tell us anything about the period's art or culture as a whole? Hauser has sewn the seed of doubt himself that such a sure knowledge is possible.

Hauser then makes the claim, in fact, that the 'rococo' style, however internally complicated and diverse, is the 'last universal style of Western Europe; a style which is not only universally recognized ... but is also universal in the sense that it is the common property of all gifted artists, and can be accepted by them without reserve' (vol. III: p. 31). The break between this style and what comes after occurs, he says, between 1750 and 1790, and marks the beginning of the modern era dominated by middle class morality and attitudes towards life in general (vol. III: pp. 32–3). Hauser's account of the French revolution and the place of art and artists within it – and of David in particular – is the most interesting section of the volume, if not the entire series. This is because in the discussion Hauser brings the complex theoretical insights of his general perspective into alignment with a comparatively historically detailed case-study. He explains the 'multi-accentuality' of 'classicism' through the example of David's paintings from the 1780s and 1790s, stressing, in addition, the varieties of idiom which mobilized Greek and Roman motifs for different publics in the broader period in France between 1750 and 1830. By 1789 a number of competing styles had emerged, each appealing to certain classes and class fractions: the 'sensualistic-colouristic' rococo of Fragonard, the 'sentimentalism' of Greuze, the 'bourgeois naturalism' of Chardin and the 'classcism' of Vien (vol. III: pp. 134–5).

David's own brand of 'monumental' classicism, instanced in such

paintings as *The Oath of the Horatii* (1784), though it had been too severe for contemporary taste in the early 1780s, succeeds in becoming the model of revolutionary art, not because it contains any immanent meanings or values, but because it is believed to be best able to convey 'the ethos of the Revolution with its patriotic-heroic ideals, its Roman civic virtues and republican ideas of freedom' (vol. III: p. 135). It comes to mean 'the triumph of the ideas which were being proclaimed in the attempts to destroy the rococo' (vol. III: p. 136) and Hauser believes this painting is no less than 'one of the greatest successes in the history of art' (vol. III: p. 136). For the first time, he says, art has become the very 'confession of political faith' (vol. III: p. 138) and he observes that the 'greatness' of David's paintings was directly linked to, indeed dependent upon, their propagandist role in the revolution, a fact contradicting the contemporary critical orthodoxy that creative achievement has always been an individual, asocial phenomenon (vol. III: p. 142).

Though Hauser accepts that 'romanticism' in painting also became associated with the progressive ideals of the Revolution – after they have been betrayed in the Terror, then by Napoleon's autocracy and the eventual restoration of the monarchy – this was equally a matter of contingency and connotation, at least in matters of style and theme in art. 'Classicism' after 1815, in the work of David's epigones, then comes to symbolize conservative social and political beliefs (vol. III: p. 145). The most significant shift involved in the coming to predominance of Romanticism, however, is 'the replacement of objective and normative by more subjective and less restrained forms' (vol. III: p. 73); a supremacy of subjectivism and aetheticism, in which the 'subject-matter of pictures gradually loses all aesthetic value, all artistic interest. . . . What is painted becomes quite unimportant; the only question is how it is painted', be it a head or a cabbage (vol. III: p. 207).

This subjectivism had a range of determinants, amongst which, he says, was the influence of the growth in the market for visual art and books. This engendered competition and the need for producers to signal their particular virtues. The romantic literature of Richardson, Fielding and Sterne is, he says, 'only the literary form of the individualism which also finds expression in *laissez-faire* and the Industrial Revolution' (vol. III: pp. 51–2). The 'only' here sounds rather dogmatic, and contrary to the principle of multi-valence and multi-cause espoused in a number of Hauser's theoretical asides. This is Hauser, then, in his declarative mode again, confidently identifying when the 'era of high capitalism truly begins' (vol. III: p. 54),

reliably establishing that the 'Storm and Stress' movement saw 'the world as fundamentally incomprehensible, mysterious and . . . without meaning' (vol. III: p. 110), and anatomizing firmly the decay of David's art in his Empire style when, like the Empire, an 'unbalanced synthesis of contradictory tendencies' came to the fore (vol. III: p. 140).

German idealist philosophy, culminating in Kant's phenomenology, is for Hauser merely another form of subjectivism reflecting the dislocation of intellectuals in that country, in which the social and political aims of the enlightenment had never become popularized sufficiently to create a socially-active intelligentsia. The 'irrationalism' of this subjectivism is here linked to 'socially and politically reactionary ends' (vol. III: p. 93). Symptomatic of this development in cultural life is the growth in the aestheticism of artists and critics, which is 'partly the expression of their aloofness from the world in which the "mind" had proved itself to be powerless, partly the roundabout way towards the realization of a human ideal that could not be realized by the direct ways of political and social education' (vol. III: p. 109). Though the future of such irrationalism in Germany holds a particular fascination for Hauser, he sees aestheticism – the 'social escapism' of artists and writers in the late nineteenth century – as a pan-European development, as well as a feature of art in his own time. Film, the modern medium *par excellence*, provides for him a direct continuity in its cult of solitude, loss of faith, cultural weariness and ennui symbolized in a star like Humphrey Bogart, cinema's own 'Byronic hero' (vol. III: p. 200). The soporific tendencies in film itself, he says, like those of alcohol and opium, have their origins 'in romantic art in general' (vol. III: p. 165).

The transformation in the status of the artist is both a cause and a consequence of the rise of subjectivism and aestheticism. Though David had been a member of the Convention, a confidant and mouthpiece of the revolutionary government in all matters of art and had declared that '[e]ach one of us is responsible to the nation for the talents he has received from nature' (vol. III: p. 138), within the space of a few decades the romantic persona will have achieved predominance as artists *en masse* rejected social and political involvement. Hauser believes this attitude, and the social basis for it, is tendentially present in the 'proto-romanticism' of the eighteenth century, although Goethe, for example, was an important exception to it (vol. III: p. 120–1). Though the early and mid-nineteenth century sees the emergence of the first artists and writers explicitly

committed to socialist politics, and by the 1870s a general disdain or even disgust with bourgeois society and its hypocritical morality characterizes the attitude of the new avant-gardes in painting and literature, such disdain is not matched by any social re-engagement. The romantic, Hauser says, 'acknowledged no external ties, was incapable of committing himself, and felt himself to be defencelessly exposed to an overwhelmingly powerful reality; hence his contempt . . . for reality' (vol. III: p. 164).

A greater gulf than ever before opens up between dislocated cultural avant-gardes – dependent on the bourgeoisie for their income, but thoroughly alienated from it – and the rest of the population. This is the now familiar chasm between 'the genius and ordinary men, between the artist and the public, between art and social reality' (vol. III: p. 183). Though the earlier romantic movements in France and Germany had yearned for community, if not actually constituted one, 'this symbiotic urge is only the reverse side of their individualism and the compensation for their loneliness and rootlessness' (vol. III: p. 180). The avant-gardes affect anti-bourgeois manners, trying to shock, but also to abandon the social mores of the respectable middle classes. There are some exceptions here – the upper-bourgeois Delacroix, for example, who nevertheless retains contempt for the public (vol. III: p. 209) – but Hauser's narrative begins to include lists of those, such as Byron, Verlaine, Mallarmé, Rimbaud, Paganini, Van Gogh and Gauguin, who try to 'avoid other men and seek zealously for the remote, the exotic, and the unknown' (vol. III: p. 164).

Passages in the text concerning these figures are amongst the most interesting because Hauser has to confront within them the apparent consequence of the development of artistic genius and the aesthetic autonomy of art in the Renaissance – a development he has confirmed and celebrated previously without qualification. In discussing Goethe he remarks, for instance, that to 'be allowed to be "genius-like" was a symptom of the attainment of independence' (vol. III: p. 121) – a genuine liberation, no doubt, from constricting ideologies or authorities such as the Church or the State – but this independence has led (teleologically or not) to a mania for individualism and originality. Ironically, though also tragically, for Hauser, the 'genius is rescued from the wretchedness of everyday life into a dream-world of boundless freedom of choice' (vol. III: p. 111). The intellectual and aesthetic autonomy of art, product also of the Renaissance, has led to great works, but their apparent separateness or alienation from the social world, mirrored in their status as pure commodities in

capitalism's 'free' market, also signalled 'tendencies opposed to the Enlightenment' (vol. III: p. 108).

Though the public for art of all kinds had grown enormously since the Renaissance, and the beginning of socialist politics heralds the coming, eventually, of a nominal universal suffrage and later the creation of the 'welfare state', the kind of art likely to be produced for the enfranchised masses is not, as far as Hauser is concerned, a 'high' one. Industrial, urban capitalism will begin to manufacture a 'popular' or 'low' culture – such as the melodrama, mime and vaudeville forms of early nineteenth-century Parisian theatre – a kind of inverse of the élite, and increasingly unintelligible art, produced by the romantics and aesthetes for their patrons and buyers in the cultivated fraction of the bourgeoisie.[4] Formal institutions for artists' training and exhibition of their works have begun to lose their economic, social and ideological significance, as the powers of the churches, the aristocracies and even the governments of the nation-states recede before the more disparate authority of the forces driving industrial, and later, monopoly capitalism. The anti-academic, avant-garde groups of the mid-nineteenth century had their antecedents, Hauser says, in the proto-romantic 'salons' and *cénacles* of the eighteenth century (vol. III: p. 179). These included as members some of the new types of 'art expert' created in the wake of post-Renaissance art – the art critic, the literary expert, the collectors, dealers and entrepreneurs. But, after David, these circles will have no leader, he says: 'the master's place remained unoccupied. Artistic aims had become much too personal, the criteria of artistic quality much too differentiated, for schools in the old sense to arise' (vol. III: p. 209). Art, in its full modernity, seemingly had at last arrived.

Art, autonomy and alienation

Hauser signals the unfolding of the character and situation of 'modern art' throughout his third volume, though he traces the implicated concepts of artistic genius and the autonomy of aesthetic criteria even further back, to the Renaissance in Italy. A kind of 'art for art's sake', for that matter, he says, had come into existence many centuries before that, in the lost cultures of ancient societies. Though this claim seems virtually impossible to verify, or even relate meaningfully to the recent past, Hauser's urge 'to historicize, to link' wants always to see continuities far more than disjunctions, and meanings in art and society primarily as a question of sequence and contrast.

Rococo art, he observes, was itself a courtly form of 'art for art's sake', a frivolity of wealth and privilege, which Diderot, representative of the reforming Enlightenment, wanted to see superseded by another that was, instead, to 'honour virtue and expose vice' (vol. III: p. 33). Kant's version of 'art for art's sake', his philosophical 'disinterestedness' in matters of aesthetic experience and value, had been renounced, Hauser claims, by the social activism of the Enlightenment's lay-pulpit (vol. III: p. 79). David's art and role in the French Revolution was a paradigm of the engagement of culture in the modern polity.

But the later Romantic disillusionment with social and political involvement led to artists reconstructing themselves as a kind of 'new aristocracy above the rest of men', and their aestheticism created a fantasy sphere 'withdrawn from the rest of the world in which they could reign unhindered' (vol. III: p. 168). Hauser's anatomy of this aestheticism – its causes, character and consequences – is complex, because he accepts, and wants to stress, that it had its positive, progressive aspect, even if its overall significance was to confirm traditional authority rather than threaten it. The writers Gautier, and later Flaubert and Baudelaire, renounced all political and social activity as part of a rejection of middle-class society, and therefore 'art for art' sake' is 'an extremely complex phenomenon, and gives expression, on the one hand, to a liberal, on the other, to a quietistic-conservative attitude' (vol. III: p. 184). Its origin, though, lies 'in the protest against bourgeois values. When Gautier stresses the pure formalism and play character of art, when he desires to free it from all ideas and all ideals, his supreme wish is to emancipate it from the dominion of the bourgeois order of life' (ibid.). Gautier's *cénacle* is an anti-philistine colony of modern bohemianism in which 'art for art's sake' is nurtured. The 'bad manners and impertinences of the bohemians ... [are] merely the expression of the desire to isolate themselves from middle-class society, or rather of the desire to represent the already accomplished isolation as intentional and acceptable' (vol. III: p. 183).[5]

However, Hauser believes (with Flaubert and Baudelaire in mind) that the 'parvenu bourgeoisie' welcome the artists shutting themselves up in their ivory towers and 'not bothering any further about the course of the world' (vol. III: p. 184). This constitutes a double historical irony for Hauser as he believes that literary Romanticism, in England, had originally been a middle-class movement, a form of individualism and emotionalism enabling the middle class to express 'its intellectual independence of the aristocracy' (vol. III: p. 57),

which had then become a universally valid 'protest against the mechanization, levelling-down and depersonalization of life connected with an economy left to run itself' (vol. III: p. 56). Though it is impossible to establish a definite beginning to Romanticism and its forms, which at different times in different European countries had irreducibly different emphases and characteristics, by the 1830s the common feature of all under the nomination was, Hauser says, their 'whole hatred, their whole contempt [which] was now heaped on the middle class. The avaricious, narrow-minded, hypocritical bourgeois became their public enemy No. 1, and, in contrast to him, the poor, honest, open-hearted artist struggling against all the humiliating ties and conventional lies of society appears as the human ideal par excellence' (vol. III: p. 182).

Though artists' parallel self-regard and self-abasement represent two particularly significant subjectivist legacies of Romanticism – under which aestheticism and bohemia are really subheadings – Hauser stresses two theoretically important insights which he attributes to the movement. The first concerns the shift in our perspective on history which he says the Romantics brought about. For the first time, he claims, 'the nature of man and society begin to appear as essentially evolutionary and dynamic. The idea that we and our culture are involved in eternal flux and endless struggle, the notion that our intellectual life is a process with a merely transitory character, is a discovery of romanticism and represents its most important contribution to the philosophy of the present age' (vol. III: p. 158). To the extent that Marxism and, for that matter, Hauser himself may be said to subscribe to this 'modern' belief, then both might also be called 'Romantic', a description still carrying both positive and derogatory connotations. The second insight concerns the effective eradication of any hierarchy *within* the genres of a particular art, and of any *between* different arts. This is also a Romantic achievement, Hauser believes, as the 'dividing line between aesthetic orthodoxy and unorthodoxy is gradually obliterated and the distinction ultimately loses all its significance. Soon there are merely literary [or artistic] "parties" and something approaching a democracy of literary [or artistic] life comes into being' (vol. III: p. 177).

It has often been claimed that naturalism in art similarly has an essentially 'democratic' aspect, in that its proponents have always attempted to show how the world 'really is' rather than how a certain dominant group within it – a clerisy, a monarch, a State élite – might wish to have it portrayed. (Of course, throughout history artists have had very different ideas of what the 'really is' really is, and different

ways of depicting it as well.) Hauser subscribes to this orthodoxy and sees 'modern art', beginning in the Renaissance, as the long elaboration of naturalist theory and method – though it should really be understood as a 'tendency', along with classical stylization, which coexist and compete together, in varying positions of relative significance in post-Renaissance art. Nevertheless, Hauser claims, the 'history of modern art is marked by the consistent and almost uninterrupted progress of naturalism; the tendencies towards rigorous formalism emerge comparatively seldom and never for more than a short period at a time, although they are always present as an undercurrent' (vol. III: p. 124). The term 'progress' drags with it a range of political connotations and Hauser is rightfully circumspect about the complexion of the radicalisms espoused by the artists of the new avant-gardes. Though all shared a belief in a desire for something called 'freedom' from prior forms of constraint in matters of art, social and political life – William Godwin's circle, the Brotherhood of St. Luke, the Pre-Raphaelite Brotherhood, the Impressionists – 'freedom' for each means something very different and their art is partly a measure of this difference.

By the end of the eighteenth century, Hauser asserts, the only important art is 'bourgeois', though its specific character may be 'classicist-revolutionary', or 'sentimentalist', or 'bourgeois-naturalist'. The bourgeoisie has both a progressive and conservative strand and it fashions art to mirror this, but 'a living art expressing aristocratic ideals and serving court purposes no longer exists' (vol. III: p. 2). Art is bourgeois and 'democratic' in the sense also that it is made no longer 'for demi-gods and supermen, but for ordinary mortals, for weak, sensual, pleasure-seeing individuals' (vol. III: p. 12). 'Grand manner' painting of mythological, biblical, and monarchist-historical scenes declines, replaced by pastoral, landscape, still-life and portraiture genres. The latter, in particular, is evidence for Hauser of the emergence of a new 'impressionist psychology', leading eventually to a 'new conception of psychological probability' (vol. III: p. 25) – a new sense of what the world is, and of the place of human action within it.

Developments in dramatic conventions embody and reflect this experience of what might be called 'secular modernity'. Though dramas of domestic life, such as those by Molière and Lillo, still showed people as the victims of 'tragic fates and the representatives of high moral ideas' the decisive turning point was, according to Hauser, that 'ordinary middle-class citizens [were now] the protagonists of serious and significant dramatic action' (vol. III: p. 81). A

further innovation was that dramatic conflict no longer took place between single individuals but between 'the hero' and institutions. In this convention the hero 'was now fighting against anonymous forces and had to formulate his point of view as an abstract idea, as a denunciation of the prevailing social order' (vol. III: p. 79). The later plays of Ibsen and Shaw depict the same attitude of hostility to the bourgeoisie as that adopted by the bohemian artists and poets. This is also an historical irony because the dramatic forms invented originally to give the middle class an effective weapon against courtly society are now turned into 'the most dangerous instrument of its self-estrangement and demoralization' (vol. III: p. 92). The pastoral novel, radical mutation of chivalric literature, though entirely fictitious, Hauser claims, is equally concerned with 'problems of real life . . . and real contemporary people' (vol. III: p. 23).

The later novels of Balzac and paintings by Courbet mark for Hauser a brief interregnum before the disaster of aestheticism becomes effectively generalized in Western culture. Though Balzac, unlike Courbet, had not been a socialist, his narratives on the hypocrisies and inequalities of middle-class society had, like Courbet's paintings *The Stone Breakers* (1848) or *Burial at Ornans* (1849–50), concreted the presumed alliance between leftwing political radicalism and naturalism. Hauser, disappointingly, shies away from discussing the concept of 'realism' and its usefulness in assessing the perspective on the world adopted by declared socialist artists and writers. An interesting observation within his account of post-Romantic art is, however, that the desire to depict what is believed to be the 'truth' of appearances – in painting, drama, the novel, music – effectively severs the connection, maintained for centuries, between the 'artistic' and the 'beautiful'. Though this severing takes place at different times in different arts Beethoven, Stendhal and Delacroix all have in common the desire to make art which is 'active, combative . . . [in which] the striving for expression violates the formal structure' (vol. III: p. 31).

Agreement, of course, on what might be said to constitute 'beauty' or, indeed, 'ugliness', has also broken down, as part of the relativization of standards and values issued in by fluctuations in taste and the acceptance that fashions in art, as in everything else, change. 'Bad taste' also arrives, with the industrialization of culture as a facet of general capitalist production. '"Good taste"', Hauser observes importantly, 'is not merely an historically and sociologically relative concept, but it has also only limited significance as a category of aesthetic valuation' (vol. III: p. 67). Taste and judgement are

relativized even more as art becomes internationalized through trade between countries and continents. 'World literature', Hauser remarks, with Goethe's observations on the process in mind, reflects 'the "velociferic" character of intellectual and material production and the accelerated tempo with which intellectual and material goods are exchanged . . . [a process] directly . . . connected with the experience of the Industrial Revolution' (vol. III: p. 122). Acceptance of such relativism can only mean an undermining of Hauser's own aesthetic evaluations, previously defended without qualification.

Relativism's most dangerous potential consequence is the eradication of any secure sense of value – in art, in life, in living at all. Modernity and modern art has its share of this annihilation of meaning and Hauser traces part of the 'sickness' back to the Romantics for whom 'the present age seemed to have become stale and empty' (vol. III: p. 166). Aestheticism is the Romantic terminal, instanced for Hauser in German idealism, French 'art for art's sake' and English dandyism. 'Everywhere the struggle ends', he says, 'with a turning away from reality and the abandonment of any effort to change the structure of society'. Keats's melancholy is a foreshadow of Flaubert's renunciation, 'the resignation of the last great romantic' (vol. III: p. 199). Art ceases to be a 'social activity' and becomes instead 'an activity of self-expression creating its own standards; it becomes, in a word, the medium through which the single individual speaks to single individuals' (vol. III: p. 144). In this judgement Hauser is wrong, or at least seriously misleading. Contemporary art, such as painting, has become, rather, a *marginal* facet of culture and social life (compared to, say, television or film), through clearly it maintains its own support structures, both in terms of economic relations of production and a range of new institutions, including both State- and privately-owned museums and galleries, in which it can be sold, curated, taught, and exhibited. Its public is a set of identifiable specific groups with different interests and values – professional critics, historians, scholars, teachers, as well as 'lay' art-appreciators, collectors, and gallery-goers.[6]

Hauser's point is really that modern art overwhelmingly addresses its public *as if it were* simply an aggregation of isolated individuals, equipped (or not) with their particular – and incommensurate – tastes, sensibilities and values, who imagine themselves to be attempting a kind of communion with the subjectivity of the maker of the artwork they face, which has become the phenomenal trace or expression of that creative artistic personality. Modern artists and

their art – that made in Hauser's time, for example – owes this set of assumptions and entailed values to the Romantics. The legacy, as usual, is ambivalent. The Romantics, freed from belief in a divine order and able to claim the 'autonomy of the mind' since Kant's philosophy (vol. III: p. 167), brought about 'the constant questioning of the meaning of the present' which led to all the nineteenth-century historicisms – including Marxism. This development is nothing less for Hauser than 'one of the deepest revolutions in the history of the human mind' (vol. III: pp. 157–8). The belief in the possibility of total human emancipation, through socialism, is part of the same romantic heritage. The nightmare that Romanticism also constitutes, however, is the belief that the experience of modern human history – the events of the Terror in the French Revolution, the slaughter of the First and Second World Wars, Nazism, the Holocaust, Stalinism, the Atomic Age – gives 'expression to a psychotic fear of the present and an attempt to escape into the past' (vol. III: p. 157).

German Romantic irrationalism Hauser indicts as a seedbed of National Socialism. The eighteenth and nineteenth centuries' intelligentsia there, in the absence of a bourgeois revolution and the spread of Enlightenment values, had 'lost all contact with social reality and became more and more isolated, eccentric and crack-brained' (vol. III: pp. 98–9). Germany's civil service made a 'cult of discipline' and regarded their 'superiors as spiritual directors' (vol. III: p. 101). Finally, Hauser says, 'they developed those ideas of submissiveness and unquestioning loyalty which made it possible for any cringing philistine [a failed house-painter, such as Hitler, for example?] to think of himself as the servant of a "higher Idea"' (vol. III: p. 96). Modern art's primitivist dream of an escape 'to the state of nature . . . a leap into the unknown' was infected with a similar urge, Hauser says, to see 'reason . . . commit suicide' (vol. III: p. 69). Yet Hauser's own belief in great art's transcendent value, expressed over and over in all four volumes of *The Social History of Art*, surely is a kind of irrationalism, or at least 'ineffabilism', in itself – a kind of surrogate religious fervour or faith. It exists unrelated – as he accepts – to his analysis of art's social and historical circumstances. Against his wishes, then, Hauser is also a Kantian. But he also understands, as Kant could not, that the 'autonomy of mind' is a form of modern illusion. The 'second self' of the Romantic mind, that 'irresistible urge to introspection', to rush 'headlong into everything dark and ambiguous, chaotic and ecstatic, demonic and dionysian' is a precursor of the idea of the modern unconscious – source of somatic drives and sabotager of the mind's 'autonomy' (vol. III: pp. 169–70).

Psychoanalysis, like Marxism, then, is another nineteenth-century 'unmasker' of values and illusions, though modern art's subjectivism is also conceived as a route to the carnal bases of human life and conduct.

Acknowledgement

In the preparation of this introduction I have realized how much my own biography is implicated in my account of Hauser's text and the history of art history after 1951. I would like to acknowledge and thank two individuals influential within this biography: Eric Fernie was prepared to give me my first proper job as an art historian. Marcia Pointon first pointed out to me that 'the bourgeoisie was always rising'!

Notes

1 Compare with Raymond Williams's definition of cultural analysis in *The Long Revolution* (Harmondsworth: Penguin, 1980), pp. 61–2.
2 See Karl Popper, *The Poverty of Historicism* (London and New York: Routledge & Kegan Paul, 1961).
3 For a more recent discussion of related theoretical problems, see Anthony Giddens, *Central Problems in Social Theory* (London: Macmillan, 1979).
4 For a related argument, see Clement Greenberg, 'Avant-Garde and Kitsch', *Partisan Review*, vol. vi, no. 5, Fall 1939, pp. 34–49; reprinted in Francis Frascina (ed.), *Pollock and After: The Critical Debate* (London: Harper & Row, 1985).
5 See Renato Pogglioli, *The Theory of the Avant-Garde* (Cambridge, MA., and London: Harvard University Press, 1968) and Peter Bürger, *Theory of the Avant-Garde* (Minneapolis: University of Minnesota Press, 1984).
6 See Meyer Schapiro, 'The Social Bases of Art', in Mathew Baigell and Julia Williams (eds), *Artists Against War and Fascism: Papers of the First American Artists' Congress* (New Brunswick, NJ: Rutgers University Press, 1986; first published 1936).

ROCOCO, CLASSICISM AND ROMANTICISM

1. THE DISSOLUTION OF COURTLY ART

THE fact that the development of courtly art, which had been almost uninterrupted since the close of the Renaissance, comes to a standstill in the eighteenth century and is superseded by the bourgeois subjectivism which, on the whole, still dominates our own conception of art today, is well known, but the fact that certain features of the new trend are already present in the rococo itself and that the break with courtly tradition really takes place in the first half of the eighteenth century is not so generally familiar. For, although we do not enter the bourgeois world before Greuze and Chardin appear, Boucher and Largillière already bring us very close to it. The tendency towards the monumental, the ceremonious and the solemn already disappears in the early rococo and makes room for a more delicate and intimate quality. In the new art preference is given to colour and shades of expression rather than to the great, firm, objective line and the note of sensuality and sentiment is to be heard in all its manifestations. Therefore, although in some respects the 'Dixhuitième' is nothing more than the continuation, indeed the consummation, of baroque splendour and pretension, the uncompromising way in which the seventeenth century insisted on the 'grand goût' as a matter of course is foreign to it. Even when they are intended for the highest classes of society, its creations lack the grand heroic mould. But, naturally, the art we are dealing with here is still a very aloof, very refined and essentially aristocratic art, an art which regards the criteria of the pleasant and the conventional as more decisive

1

than those of spirituality and spontaneity, an art in which work is performed in accordance with a fixed, universally acknowledged and constantly repeated pattern, and of which nothing is more characteristic than the masterly, though all too often purely external technique of the execution. These conventional elements of the rococo, which derive from the baroque, are only gradually dissolved and replaced by the characteristics of bourgeois taste.

The attack on the baroque-rococo tradition ensues from two different directions, but is based in both cases on the same opposition to courtly taste. The emotionalism and naturalism represented by Rousseau and Richardson, Greuze and Hogarth, is one, the rationalism and classicism of Lessing and Winckelmann, Mengs and David, the other. Both oppose the ideal of simplicity and the earnestness of a puritan outlook on life to the courtly taste for ostentation. In England the transformation of courtly into bourgeois art takes place earlier and is carried out more thoroughly than in France itself where the baroque-rococo tradition continues underground and is still perceptible in the romantic movement. But, at the close of the century, the only important art in Europe is bourgeois. It is possible to differentiate between a progressive and a conservative trend within the middle class, but a living art expressing aristocratic ideals and serving court purposes no longer exists. In the whole history of art and culture, the transfer of leadership from one social class to another has seldom taken place with such absolute exclusiveness as here, where the aristocracy is completely displaced by the middle class and the change in taste, which puts expression in the place of decoration, could not possibly be any clearer.

To be sure, this is not the first time that the middle class appears on the scene as the upholder of taste. As early as the fifteenth and sixteenth centuries a leading position was held all over Europe by an art of a predominantly middle-class character. It was not until the later Renaissance and the age of mannerism and baroque that its place was taken by works in the courtly style. But in the eighteenth century, when the middle class again attains economic, social and political power, the ceremonial art of the courts, which had meanwhile come into its own, breaks up

again and yields to the unrestricted sway of middle-class taste. It was only in Holland that there was already a middle-class art of high standing in the seventeenth century and one much more thoroughly and consistently middle-class than the Renaissance, which was interspersed with chivalric-romantic and mystical-religious elements. But this Dutch middle-class art remained an almost completely isolated phenomenon in the Europe of the time and, when the eighteenth century established modern middle-class art, it did not link up directly with this earlier manifestation. There could be no question of a continuous development, if only because Dutch painting itself lost much of its middle-class character in the course of the seventeenth century. Both in France and England, the art of the modern middle class had its real origins in social changes at home; these had inevitably to be the basis of the displacement of the courtly conception of art, and the stimulation received from contemporary philosophical and literary movements was bound to be stronger than that from the art of countries remote in time and space.

The development which reaches its political climax in the French Revolution, and its artistic objective in romanticism, begins in the Régence with the undermining of the royal power as the principle of absolute authority, with the disorganization of the court as the centre of art and culture and the dissolution of baroque classicism as the artistic style in which the power-strivings and power-consciousness of absolutism found their direct expression. The ground for this process is already prepared for during the reign of Louis XIV. The endless wars throw the finances of the country into confusion; the public exchequer becomes empty and the population impoverished, since it is impossible to create tax-payers by whippings and imprisonment and economic supremacy by wars and conquests. Even during the lifetime of the *roi soleil* critical remarks about the consequences of autocracy are heard. Fénelon is already quite candid in this respect, but Bayle, Malebranche and Fontenelle go so far that it has been rightly maintained that the 'crisis of the European spirit', the history of which fills the eighteenth century, was in full swing from 1680 onwards.[1] Simultaneously with this tendency, criticism of classicism also gains ground and prepares the

way for the dissolution of courtly art. By about 1685 the creative period of baroque classicism has come to an end; Le Brun loses his influence, and the great writers of the age, Racine, Molière, Boileau and Bossuet, have spoken their last or their last decisive words.[2] The 'Quarrel between the Ancients and the Moderns' marks the beginning of the conflict between tradition and progress, classicism and modernism, rationalism and emotionalism, which was to be settled in the pre-romanticism of Diderot and Rousseau.

In the last years of Louis XIV's life the state and the court were governed by the devout Mme de Maintenon. The aristocracy no longer felt comfortable in the atmosphere of gloomy solemnity and narrow-minded piety at Versailles. When the King died a sigh of relief was uttered by everyone, above all by those who expected the regency of Philip of Orléans to bring liberation from despotism. The Regent had always considered his uncle's administrative system out of date,[3] and began his reign by reacting against the old methods all along the line. In the political and social spheres he strove for a renaissance of the nobility, in the economic sphere he favoured individual enterprises, such as that of Law, for example, he introduced a new style in the way of life of the upper classes and made a vogue of hedonism and libertinism. A condition of general disintegration began, which none of the old ties was able to resist. Some of them were reconstituted later on, but the old system was now shattered once and for all. The first act of state of Philip of Orléans was to annul the will of the departed king, which provided for the recognition of his illegitimate children. That was the beginning of the decline of the king's authority, which, in spite of the continuance of the absolute monarchy, was never to be restored to its former greatness. The exercise of supreme power became more and more arbitrary, but the confidence of those in power became more and more unsettled—a process best described in the often quoted words of Marshal Richelieu to Louis XVI: 'Under Louis XIV no one dared open his mouth, under Louis XV everyone whispered, now everyone speaks aloud and in a perfectly free and easy way.' To think of assessing the real power of the state on the basis of government orders and decrees would be, as Tocqueville remarks, a ridiculous error. Sanctions, such as the

4.

famous death penalty for the writing and spreading of books against religion and public order, remained on paper. The worst penalty the guilty had to pay was to leave the country, and they were often warned and protected by the very officials whose duty it was to prosecute them. In the age of Louis XIV the whole intellectual life was still under the protection of the king; there was no defence apart from him, much less any defence against him. New protectors, new patrons and new centres of culture now arise; art develops very largely, literature entirely, away from the court and the king.

Philip of Orléans transfers the residence from Versailles to Paris and, by so doing, virtually dissolves the court. The Regent loathes all restrictions, formalities and constraint; he feels really happy only in the company of his closest friends. The young King lives in the Tuileries, the Regent in the Palais Royal, the members of the nobility are dispersed in their castles and palaces and amuse themselves in the theatres, at balls and in the *salons* of the city. The Regent and the Palais Royal themselves represent the more unrestrained, more fluid taste of Paris, in contrast to the 'grand goût' of Versailles. The life of the 'city' is no longer subsidiary to that of the 'court', it displaces the court and takes over its cultural functions. The melancholy exclamation of the Countess Palatine Elizabeth Charlotte, the mother of the Regent, 'there is no longer a court in France!', is absolutely in accordance with the facts. And this situation is no passing episode; the court in the old sense has, in fact, now vanished for ever. Louis XV has similar tastes to the Regent, he, too, favours a small society of friends, and Louis XVI likes above all to live within the family circle. Both kings shun ceremony, etiquette bores and annoys them, and although it is still preserved to a certain extent, it, nevertheless, loses much of its solemnity and grandeur. At the court of Louis XVI the dominant tone is one of decided intimacy, and on six days of the week the social gatherings achieve the character of a private party.[4] The only place where anything like a court household develops during the Régence is the castle of the Duchess of Maine at Sceaux, which becomes the scene of brilliant, expensive and ingenious festivities and, at the same time, a new centre of art, a real Court of the Muses. But the

entertainments arranged by the Duchess contain the germ of the ultimate dissolution of court life: they form the transition from the old-style court to the *salons* of the eighteenth century—the cultural heirs of the court. In this way, the court breaks up again into the private societies out of which it had developed into the centre of art and literature.

Philip's attempt to restore the old political rights and public functions of the aristocracy subdued by Louis XIV was one of the most important parts of his programme. From the members of the feudal nobility he formed the so-called 'Conseils', which were intended to take the place of the middle-class ministers. But the experiment had to be given up after only three years, because the nobles had lost the habit of conducting state affairs and no longer took any real interest in the government of the country. They stayed away from meetings and willy-nilly a return had to be made to the system of Louis XIV. Outwardly, therefore, the Régence marked the beginning of a new turn in the direction of aristocracy, as expressed in the growing rigidity of social barriers and the increasing isolation of the estates, but inwardly it represented the continuation of the triumphant progress of the middle class and the further decline of the nobility. A peculiar characteristic of the social development of the eighteenth century, already noted by Tocqueville, was the fact that, in spite of all the emphasis on the barriers dividing the various estates and classes, the process of cultural levelling could not be halted and that people, who were so anxious to keep themselves isolated from one another externally, were becoming more and more alike internally,[5] so that in the end there were merely two big groups: the common people and the community of those who stood above the common people. Those belonging to this latter group shared the same habits, the same taste and spoke the same language. The aristocracy and the upper bourgeoisie amalgamated into one single cultural élite, and in so doing the former upholders of culture were giving and taking at the same time. The members of the high nobility did not visit only occasionally and condescendingly the houses where the representatives of high finance and the bureaucracy were guests, on the contrary, they crowded into the *salons* of the rich middle-class gentlemen and

6

cultured middle-class ladies. Mme Geoffrin brings together in her home the intellectual and social élite of her time, sons of princes, counts, watchmakers and small tradesmen, she corresponds with the Empress of Russia and with Grimm, she is friendly with the King of Poland and with Fontenelle, she declines the invitation of Frederick the Great and bestows the distinction of her personal attention on the plebeian d'Alembert. The adoption by the aristocracy of middle-class patterns of thought and moral conceptions and the intermingling of the highest classes with the bourgeois intelligentsia begins, moreover, precisely at the moment when the social hierarchy makes itself felt more sharply than ever before.[6] Perhaps there is, in fact, a causal relationship between the two phenomena.

Of all its feudal privileges, the nobility had retained in the seventeenth century only the property rights in its own land and its exemption from taxation; it had ceded its judicial and administrative functions to Crown officials. Ground-rent had lost a good deal of its value because of the steady diminution, before 1660, of the purchasing power of money. The nobility was forced in an increasing measure to sell its property; it became impoverished and decayed. This was certainly more the case in the medium and lower ranks of the landed nobility than amongst the high and court nobility, which was still very rich and regained its influence in the eighteenth century. The 'four thousand families' of the court nobility remained the only usufructuaries of the court offices, the high ecclesiastical dignities, the commissioned ranks in the army, the gouverneurs' posts and royal pensions. Almost a quarter of the total budget accrued to them. The old resentment of the Crown against the feudal nobility had cooled down; under Louis XV and Louis XVI, ministers were again chosen mostly from the hereditary nobility.[7] But the latter remained antidynastic in its outlook all the same, was insubordinate and a source of supreme danger to the monarchy in the hour of peril. It made a common stand with the middle class against the Crown, although the good relations between the two classes had greatly suffered since the beginning of centralization. Previously they had not only often felt themselves menaced by the same danger, they had frequently had common administrative

problems to solve, and this had automatically brought them closer together. But the relationship deteriorated when the nobility realized that the middle class was its most dangerous rival. From then on the king had to intervene again and again and to reconcile the jealous nobility; for, although he apparently dominated both parties, he had to make constant concessions and show favour now to one now to the other.[8] A token of this policy of appeasement towards the nobility is also to be seen, for example, in the fact that under Louis XV it was already much more difficult for a commoner to attain a commission in the army than under Louis XIV. Since the Edict of 1781 the middle class had been totally excluded from the army. The situation with regard to high ecclesiastical posts was similar: in the seventeenth century there was still a number of Church leaders of plebeian origin, such as Bossuet and Fléchier, for example; in the eighteenth century that was hardly any longer the case. The rivalry between the aristocracy and the bourgeoisie became, on the one hand, more and more critical, but, on the other hand, it assumed the sublimated forms of intellectual emulation and created a complicated network of spiritual relationships in which attraction and repulsion, imitation and rejection, respect and resentment, were intermingled. The material equality and practical superiority of the middle class provoked the nobility to stress the unlikeness of their descent and the difference of their traditions. But with the increasing similarity of the external conditions of both classes, the hostility of the bourgeoisie towards the nobility also became more intense. So long as they were excluded from climbing the social scale, it never occurred to them to compare themselves with the upper classes; it was not until the possibility of rising was given them that they became really aware of the existing social injustice, and began to regard the privileges of the nobility as intolerable. In a word, the more the nobility lost of its real power, the more obstinately it clung to the privileges which it still enjoyed and the more ostentatiously it displayed them; on the other hand, the more material goods the middle class acquired, the more shameful it considered the social discrimination from which it was suffering and the more exasperatedly it fought for political equality.

DISSOLUTION OF COURTLY ART

As a result of the great state bankruptcies of the sixteenth century, the middle-class wealth of the Renaissance had been dispersed and was not able to recover during the golden age of absolutism and mercantilism when the monarchs and states themselves were doing the big business.[9] Not until the eighteenth century, when the world policy of mercantilism was given up and 'laissez-faire' introduced, did the middle class, with its individualistic economic principles, come into its own again and although the traders and industrialists were able to derive considerable advantages for themselves from the absence of the aristocracy from business life, big middle-class capital first arose during the Régence and the succeeding period. This régime was in fact the 'cradle of the third estate'. Under Louis XVI the bourgeoisie of the *ancien régime* reached the zenith of its intellectual and material development.[10] Trade, industry, the banks, the *ferme générale*, the liberal professions, literature and journalism, that is to say, all the key posts in society, with the exception of the leading positions in the army, the Church and at court, were in its possession. Commercial activities developed on an unprecedented scale, industries grew, the banks multiplied, enormous sums flowed through the hands of the employers and speculators. Material needs increased and spread; and not merely people like bankers and tax-farmers climbed higher up the social ladder and vied with the nobility in their style of life, but the middle sections of the bourgeoisie also profited from the boom and took an increasing part in cultural life. The country in which the revolution broke out was, therefore, by no means economically exhausted; it was rather merely an insolvent state with a rich middle class. The bourgeoisie gradually took possession of all the instruments of culture—it not only wrote the books, it also read them, it not only painted the pictures, it also bought them. In the preceding century it had still formed only a comparatively modest section of the art and reading public, but now it is the cultured class par excellence and becomes the real upholder of culture. Most of Voltaire's readers already belong to this class, and Rousseau's almost exclusively. Crozat, the greatest art collector of the century, comes from a commercial family, Bergeret, the patron of Fragonard, is of still more humble origin, Laplace is

the son of a peasant, and no one knows whose son d'Alembert was. The same middle-class public that reads Voltaire's books also reads the Latin poets and the French classics of the seventeenth century and is just as decided about what it rejects as it is in the choice of its reading. It is not much interested in the Greek writers and these now gradually disappear from libraries; it despises the Middle Ages, Spain has become a more or less unknown territory, its relationship to Italy has not yet properly developed, and will never become so cordial as the relations between court society and the Italian Renaissance in the preceding two centuries. The *gentilhomme* has been considered the intellectual representative of the sixteenth century, the *honnête homme* that of the seventeenth, and the 'cultured' man, that is to say, the reader of Voltaire, that of the eighteenth.[11] It has been asserted that one cannot understand the French bourgeois without knowing Voltaire, whom he took for his eternal model;[12] but one cannot understand Voltaire, if one does not see how deeply rooted he is in the middle class not only by heredity but also in his whole outlook, despite his seignorial demeanour, his royal friends and his enormous fortune. His sober classicism, his renunciation of the solution of the great metaphysical problems, indeed his mistrust of anyone who even discusses them, his acute, aggressive and yet thoroughly urbane mind, his anticlerical religiosity, with its dislike of any kind of mysticism, his anti-romanticism, his distaste for everything obscure, unclarified and inexplicable, his self-confidence, his conviction that everything can be grasped, everything solved, everything decided by the powers of the reason, his wise scepticism, his sensible acceptance of the nearest and the accessible, his understanding of the 'demands of the day', his 'mais il faut cultiver notre jardin', all that is middle-class, profoundly middle-class, even if it does not exhaust the characteristics of the bourgeoisie, and even if the subjectivism and sentimentalism, which Rousseau is to proclaim is the other, perhaps just as important side of the bourgeois mind. The great antagonism within the middle class was a given fact from the very beginning; Rousseau's later supporters had not yet become a regular reading public, when Voltaire was acquiring his readers, but they were already an exactly definable section of

society and they merely had to discover their spokesman in Rousseau.

The French middle class of the eighteenth century is by no means any more uniform than was the Italian middle class of the fifteenth and sixteenth centuries. To be sure, there is nothing corresponding to the struggle for the control of the guilds, but there is just as intense a conflict between the various economic interests as there was then. It is only that the habit has grown of speaking of the struggle for liberation and the revolution of the 'third estate' as a homogeneous movement, but, in reality, the unity of the middle class is restricted to its common front against the aristocracy and against the peasantry and the urban proletariat; within these frontiers it is divided into a positively and negatively privileged section. There is never any mention in the eighteenth century of the privileges of the middle class, people pretend never to have heard of them, but the privileged resist every reform that would extend their opportunities to the lower classes.[13] All the middle class wants is a political democracy, and it leaves its fellow-combatants in the lurch as soon as the revolution begins to take economic equality seriously. The society of the time is, therefore, full of contradictions and tensions; it produces a royal house which is forced to represent the interests of the nobility and those of the bourgeoisie by turns, and ends by having both against it; an aristocracy which is inimical to both the Crown and the middle class, and adopts ideas which lead to its own downfall; and, finally, a middle class which brings its revolution to a triumphant conclusion with the help of the lower classes, but makes a stand against its own allies and on the side of its former enemies. So long as these elements dominate the intellectual life of the nation in equal proportions, that is, until the middle of the century, art and literature are in a state of transition and are full of contradictory, often scarcely reconcilable tendencies; they waver between tradition and freedom, formalism and spontaneity, ornamentalism and expression. And even in the second half of the century, when liberalism and emotionalism get the upper hand, the ways only divide more sharply, but the different tendencies remain side by side. To be sure, they undergo a change of function, and classicism in particular, which

11

was a courtly-aristocratic style, becomes the vehicle of the ideas of the progressive middle class.

The Régence is a period of extraordinarily lively intellectual activity, which not only criticizes the previous epoch but is highly creative and raises questions which are to occupy the whole century. The dissolution in art of the 'grand', ceremonial style goes hand in hand with the slackening of general discipline, the growing lack of religion, the more unrestrained and personal conduct of life. It begins with the criticism of the academic doctrine, which attempted to represent the classical ideal in art as a timelessly valid principle established, as it were, by God himself, quite in the same terms as the official political theory of the time interpreted the absolute monarchy. Nothing better describes the liberalism and relativism of the new age than the statement made by Antoine Coypel, which no previous director of the Academy would have approved, that painting, like all human things, is subject to the change of fashion.[14] The new outlook expressed in these words makes itself felt everywhere in art production; art becomes more human, more accessible, more unassuming—it is no longer intended for demigods and supermen, but for ordinary mortals, for weak, sensual, pleasure-seeking individuals. It no longer expresses grandeur and power but the beauty and grace of life, and no longer wants to impress and overwhelm but to charm and please. In the final period of the reign of Louis XIV, circles are formed at the court itself, in which the artists find new patrons, who are often more generous and have more feeling for art than the monarch, who is already struggling against material difficulties and is dominated by Mme de Maintenon. The Duke of Orléans, the nephew of the King, and the Duke of Bourgogne, the son of the Dauphin, are the leading personalities in these circles. The later Regent already turns against the artistic trend favoured by Louis XIV and demands more lightness and fluidity from his artists, a more sensual and more delicate formal language than is in use at the court. Often the same artists work for the King and the Duke and change their style according to the particular patron, as, for example, Coypel, who decorates the palace chapel in Versailles in the correct court style, paints the ladies in the Palais Royal

in coquettish négligé and sketches classicistic medals for the 'Académie des Inscriptions'.[15] The 'grande manière' and the grand, ceremonial genres decay during the Régence. The religious devotional picture, which even in the days of Louis XIV had already become a mere pretext to portray the King's relations, and the great narrative painting, which was, above all, an instrument of monarchist propaganda, are neglected. The place of the heroic landscape is taken by the idyllic scenery of the pastorals, and the portrait which hitherto had been intended for the public, becomes a trivial, popular genre serving mostly private purposes; everybody who can afford it has his portrait painted now. Two hundred portraits are exhibited in the Salon of 1704, as compared with fifty in the Salon of 1699.[16] Largillière already prefers to paint the bourgeoisie and no longer the court nobility as did his predecessors; he lives in Paris, not in Versailles, and thereby again gives expression to the victory of the 'city' over the'court'.[17]

The galant social scenes of Watteau take the place of the religious and historical ceremonial pictures in the favour of the progressive art public, and this transition from Le Brun to the master of the 'fêtes galantes' expresses in the most acute fashion the change of taste which occurs at the turn of the century. The formation of the new public made up of the progressively-minded aristocracy and the art-minded upper middle class, the doubt that is now cast on hitherto acknowledged authorities in the world of art, the bursting of the bounds of the old, narrowly restricted subject-matter, all this contributes to make possible the emergence of the greatest French painter before the nineteenth century. The genius whom the age of Louis XIV, with its state commissions, scholarships and pensions, its Academy, its school of Rome and its royal manufactory, was not able to produce, is begotten by the bankrupt, headless, frivolous Régence with its lack of piety and discipline. Watteau, who was born in Flanders and continues the Rubens tradition, is, incidentally, also the first thoroughly 'French' master of painting since the Gothic period. In the last two centuries before his arrival, art had been under foreign influence in France: the Renaissance, mannerism and the baroque were imported from Italy and the Netherlands. In France, where the whole court life was guided, to begin with, by

foreign models, court ceremonial and monarchist propaganda were also expressed in foreign, especially Italian art forms. These forms then became so intimately bound up with the idea of royalty and the court that they acquired an institutional tenacity and remained valid as long as the court was the centre of artistic life.

Watteau painted the life of a society into which he could look only from outside, he portrayed an ideal that obviously had only external points of contact with his own aims in life, and he gave form to a Utopia of freedom which was probably no more than merely analogous to his own subjective idea of freedom, but he created these visions from the elements of his own direct experience, from sketches of the trees in the Luxembourg, of theatre scenes which he could and certainly did see every day, and of types of character of his own, albeit enchantingly disguised environment. The profundity of his art is due to the ambivalence of his relationship to the world, to the expression of both the promise and the inadequacy of life, to the always present feeling of an inexpressible loss and an unattainable goal, to the knowledge of a lost homeland and the Utopian remoteness of real happiness. In spite of the delight in the senses and the beauty, the joyful surrender to reality and the pleasure in the good things of the earth, which form the immediate theme of his art, what he paints is full of melancholy. In all his pictures he describes a society menaced by the unrealizable nature of its desires. But what is expressed here is still by no means the Rousseauish feeling, by no means the yearning for the state of nature, but, on the contrary, a longing for the perfect culture, for the tranquil and secure joy of living. In the 'fête galante', the conviviality of lovers and courts of love, Watteau discovers the appropriate form for the expression of his own attitude to life, which is a compound of optimism and pessimism, joy and boredom. The predominant element of the 'fête galante', which is always a 'fête champêtre' and portrays the amusements of young people leading the carefree life of Theocritan shepherds and shepherdesses with music, dancing and singing, is bucolic. It describes the peace of the countryside, the haven of security from the great world and the self-forgetting happiness of lovers.

It is, however, no longer the ideal of an idyllic, contemplative and frugal life that the artist has in his mind's eye, but the Arcadian ideal of the identity of nature and civilization, beauty and spirituality, sensuousness and intelligence. This ideal is, of course, by no means new; it is merely a variation on the formula of the poets of the Roman Empire, who combined the legend of the Golden Age with the pastoral idea. The only novelty, as compared with the Roman version, is that the bucolic world is now disguised in the fashions of polite society, the shepherds and shepherdesses wear the stylish costume of the age, and all that remains of the pastoral situation are the conversations of the lovers, the natural framework and the remoteness from the life of the court and the city. But is even all that new? Was not the pastoral from the very beginning a fiction, a playful dissimulation, a mere coquetting with the idyllic state of innocence and simplicity? Is it conceivable that ever since there has existed a pastoral poetry, that is, since the existence of a highly developed urban and court life, anyone has ever really wanted to lead the simple, modest life of shepherds and peasants? No, the shepherd's life in poetry has always been an ideal in which the negative features, the tearing of oneself away from the great world and the disregarding of its customs, have been the decisive elements. It was a kind of sport to imagine oneself in a situation which held the promise of liberation from the fetters of civilization whilst retaining its advantages. The attractions of the painted and perfumed ladies were intensified by attempting to represent them, painted and perfumed as they were, in the guise of fresh, healthy and innocent peasant maidens, and by enhancing the charms of art with those of nature. The fiction contained from the outset the preconditions which allowed it to become the symbol of freedom in every complicated and sophisticated culture.

It is not without good reason that the literary tradition of pastoral poetry can look back on an almost uninterrupted history of over two thousand years since its beginnings in Hellenism. With the exception of the early Middle Ages, when urban and court culture was extinguished, there have been variants of this poetry in every century. Apart from the thematic material of the novel of chivalry, there is probably no other subject-matter

that has occupied the literature of Western Europe for so long and maintained itself against the assaults of rationalism with such tenacity. This long and uninterrupted reign shows that 'sentimental' poetry, in Schiller's sense of the word, plays an incomparably greater part in the history of literature than 'naïve' poetry. Even the idylls of Theocritus himself owe their existence not, as might be imagined, to genuine roots in nature and a direct relationship to the life of the common people, but to a reflective feeling for nature and a romantic conception of the common folk, that is, to sentiments which have their origin in a yearning for the remote, the strange and the exotic. The peasant and the shepherd are not enthusiastic about their surroundings or about their daily work. And interest in the life of the simple folk is, as we know, to be sought neither in spatial nor social proximity to the peasantry; it does not arise in the folk itself but in the higher classes, and not in the country but in the big towns and at the courts, in the midst of bustling life and an over-civilized, surfeited society. Even when Theocritus was writing his idylls, the pastoral theme and situation were certainly no longer a novelty; it will already have occurred in the poetry of the primitive pastoral peoples, but doubtless without the note of sentimentality and complacency, and probably also without attempting to describe the outward conditions of the shepherd's life realistically. Pastoral scenes, although without the lyrical touch of the *Idylls*, were to be found before Theocritus, at any rate, in the mime. They are a matter of course in the satyr plays, and rural scenes are not unknown even to tragedy.[18] But pastoral scenes and pictures of country life are not enough to produce bucolic poetry; the preconditions for this are, above all, the latent conflict of town and country and the feeling of discomfort with civilization.

But Theocritus still took a delight in simple descriptions of pastoral life, whereas his first independent successor, Virgil, no longer takes any pleasure in realistic description, and the pastoral poem acquires with him that allegorical form which marks the most important turning point in the history of the genre.[19] If the poetic conception of the pastoral life represented merely an escape from the bustle of the world even in earlier times, and the desire

16

to live a shepherd's life was never to be taken quite literally, the unreality of the motifs is now intensified still further in so far as not only the yearning for the pastoral life but also the pastoral situation itself becomes a fiction which enables the poet and his friends to appear disguised as shepherds and to be, thereby, poetically removed from ordinary life, although the initiated are still able to recognize them straight away. The attraction of this new formula, already heralded by Theocritus, was so great that Virgil's *Eclogues* not only had the greatest success of all the poet's works, but there is probably no literary masterpiece the influence of which has been so lasting and so deep. Dante and Petrarch, Boccaccio and Sannazzaro, Tasso and Guarini, Marot and Ronsard, Montemayor and d'Urfé, Spenser and Sidney, and even Milton and Shelley are directly or indirectly dependent on them in their pastoral poetry. It appears that Theocritus only felt alarmed by the court with its constant struggle for success and the big city with the agitated pace of its life; Virgil already had more grounds for escaping from his contemporary world. The century-long civil war was hardly over, his own youth was contemporaneous with the bloodiest of the fighting, and the Augustan peace was more a mere hope than a reality, when he was writing his *Eclogues*.[20] His escape into the world of idyll was in perfect accordance with the reactionary movement initiated by Augustus, which, in representing the patriotic past as the Golden Age, tried to divert attention from the political events of the present.[21] Virgil's new conception of the pastoral poem was actually nothing more than the fusion of his own wish-fulfilment dream of peace with the propaganda for a policy of appeasement.

The medieval pastoral links up directly with the Virgilian allegory. It is true that there are only scanty remains of pastoral poetry from the centuries between the downfall of the ancient world and the rise of medieval court and city culture, and what has come down to us of the genre is the product of mere learning and the deposit of mere reminiscences of classical poets, above all of Virgil. Even Dante's eclogues are learned imitations and there are still traces of the old pastoral allegory in Boccaccio, the author of the first modern idyll. Simultaneously with the rise of the pastoral novel, which gives a new turn to the development,

bucolic motifs also occur in the Italian Renaissance short story, but they lack the romantic traits with which they are connected in the idyll, the pastoral novel and the pastoral drama.[22] This phenomenon is readily understandable, however, if one considers that the short story is middle-class literature par excellence and as such has a naturalistic tendency, whereas pastoral poetry represents a courtly-aristocratic genre and inclines to romanticism. This romantic tendency is predominant throughout the pastorals of Lorenzo di Medici, Jacopo Sannazzaro, Castiglione, Ariosto, Tasso, Guarini and Marino, and proves that literary fashion at the courts of the Italian Renaissance, whether in Florence, Naples, Urbino, Ferrara or Bologna, conforms to one and the same model. Pastoral poetry is everywhere the mirror of court life and serves the reader as a sample of courtly manners. No one any longer takes the shepherd's life literally; the conventionality of the shepherd's costume is obvious and as the original purpose of the genre, the repudiation of over-civilized life, falls into the background, courtly forms are rejected only on account of their constraint, but not on account of their artificiality and sophistication. It is understandable that this pastoral poetry with its refinement and allegory, its intermingling of the far and near, of the immediate and the unusual, is one of the most popular genres of mannerism and that it is cultivated with particular affection in Spain, the classical land of courtly etiquette and mannerism. To begin with, the Italian models, which spread all over Europe along with courtly modes of life, are followed even here; but the individuality of the country soon breaks through and is expressed in the combination of the elements of the novel of chivalry and the pastoral. This Spanish hybrid of romantic and bucolic elements then becomes the bridge between the Italian and the French pastoral novel by which the further development of the genre is dominated.

The beginnings of French pastoral poetry go back to the Middle Ages and first appear in the thirteenth century in a complicated, heterogeneous form, dependent on the courtly-chivalric lyric. As in the idylls and eclogues of classical antiquity, the bucolic situation in the French *pastourelles* is also a wish-fulfilment dream of redemption from the all too rigid and con-

ventional forms of eroticism.[23] When the knight declares his love to the shepherdess, he feels exempt from the commands of courtly love, fidelity, chastity and discretion. His desire is thoroughly unproblematical and, in spite of all its impulsiveness, it makes an impression of innocence compared with the forced purity of high courtly love. But the scene where the knight tries to win the favour of the shepherdess is absolutely conventional and no longer bears a trace of the natural note sounded by Theocritus. Apart from the two principal figures, and maybe the jealous shepherd, the only stage properties are a few sheep; there is nothing left of the atmosphere of the meadows and woods, of the mood of harvest and vintage, of the smell of milk and honey.[24] Certain elements of classical bucolics will probably have percolated into the *pastourelles* with the drifting sand of reminiscences from classical poets, but it is impossible to establish a direct influence of classical pastoral poetry on French literature before the diffusion of the Italian Renaissance and Burgundian court culture. And this influence does not go deep until the universal vogue of the Italian and Spanish pastoral novels and the victory of mannerism.[25] Tasso's 'Aminta', Guarini's 'Pastor fido' and Montemayor's 'Diana' are the models imitated by the French, especially by Honoré d'Urfé, who, following the example of the Italians and the Spaniards, wanted his 'Astrée' to be, first of all, a manual of international social etiquette and a mirror of cultivated manners. The work is rightly regarded as the school in which the coarse feudal lords and soldiers of the age of Henri IV were trained to become members of a cultured French society. It owes its existence to the same movement that produced the first *salons* and from which the precious culture of the seventeenth century arose.[26] The 'Astrée' is certainly the climax of the development which began with the pastorals of the Renaissance. No one any longer dreams of thinking of simple folk as he watches the fine ladies and gentlemen who, disguised as shepherds and shepherdesses, carry on spirited conversations and discuss ticklish questions of love. The fiction has lost all relation to reality and has become a pure social game. The shepherd's life is nothing but a masquerade, which enables the reader to withdraw for a moment from triviality and the everyday self.

Of course, Watteau's 'fêtes galantes' bear little resemblance to this poetry. In the pastoral novel the rural love scenes, with their erotic fulfilments and love ritual, are the perfect happiness, whereas in Watteau's pictures the whole erotic situation is an intermediary station on the progress to the real goal—only the preparation for the journey to that 'Cythère' which always lies in a nebulously mysterious remoteness. But pastoral poetry in France is on the decline when Watteau is painting his pictures; the master receives no direct stimuli from it. Before the eighteenth century, scenes from pastoral life do not occur at all as the real theme of the representation in painting itself. It is true that bucolic motifs are no rarity as accessories in biblical and mythological pictures, but they have an origin of their own, absolutely different from the pastoral idea. The elegiac mood of the 'Giorgionesque' version is certainly strongly reminiscent of Watteau,[27] but it lacks both the erotic undertone and the tormenting feeling of tension between nature and civilization. Even in Poussin the relationship with Watteau is only apparent. Poussin portrays Arcadia very impressively but with no direct reference to the shepherd's life; the subject remains classical and mythological and makes an essentially heroic impression, in keeping with the spirit of Roman classicism. In seventeenth-century French art pastoral subjects appear independently only on tapestries which have always displayed a fondness for portraying scenes of country life. Such motifs are, of course, not in harmony with the official character of the great art of the baroque period. They are still admissible in pictorial representations of a decorative nature, as in a novel or an opera or a ballet, but they would seem just as out of place in a big ceremonial picture as in a tragedy. 'Dans un roman frivole aisément tout s'excuse . . . Mais la scène demande une exacte raison.'[28] Nevertheless, as soon as painting takes hold of it, the pastoral acquires a subtlety and a depth which it never possessed in poetry, where it was always merely a genre of second-rate importance. As a literary genre, it represented an extremely artificial form from the very beginning, and remained the exclusive possession of generations whose relationship to reality was thoroughly reflective. The bucolic situation itself was always merely a pretext, never the real purpose of the repre-

sentation, which had, in consequence, always a more or less allegorical, never a symbolical character. In other words, the pastoral had an all too clear purpose and allowed of only one valid interpretation. It was immediately exhausted, it kept no secrets back, and resulted, even in a poet like Theocritus, in a rather undifferentiated though extraordinarily attractive picture of reality. It could never overcome the limitations of allegory and it remained sportive, lacking in tension and pregnancy. Watteau is the first to succeed in giving it a symbolical depth, and he does so, above all, by excluding from it all those features which cannot also be conceived as a simple, direct reproduction of reality.

The eighteenth century was bound, by its very nature, to lead to a renaissance of the pastoral. For literature the formula had become too narrow, but in painting it still had enough life in it for a new beginning to be made. The upper classes were living in extremely artificial social conditions in which everyday relationships were very largely metamorphosed and sublimated; but they no longer believed in the deeper purpose of these forms, and merely regarded them as the rules of the game. Gallantry was one of the rules of the game of love, just as the pastoral had always been a sportive form of erotic art. Both desired to keep love at a distance, to divest it of its directness and passionateness. Nothing was, therefore, more natural than that the pastoral should reach the zenith of its development in the century of gallantry. But just as the costume worn by Watteau's figures became a fashion only after the master's death, so the genre of the 'fête galante' only found a wider public in the later rococo. Lancret, Pater and Boucher enjoyed the fruits of the innovation which they themselves merely trivialized. All his life, Watteau himself remained the painter of a comparatively small circle: the collectors Julienne and Crozat, the archaeologist and art patron Count Caylus, the art dealer Gersaint, were the only faithful supporters of his art. He was mentioned but seldom in contemporary art criticism and then usually reprovingly.[29] Even Diderot failed to recognize his importance and rated him lower than Teniers. The Academy did not make things difficult for him, it is true, even though, faced with an art such as his, it held fast to the traditional hierarchy of the genres and continued to regard the

'petits genres' with contempt. But it was in no way any more dogmatic than the educated public in general, which still conformed, in theory at least, to the classical doctrine. In all practical questions the attitude of the Academy was extremely liberal. The number of its members was unrestricted and admission was by no means dependent on acceptance of its doctrine. It was not perhaps so indulgent of its own accord, but, at any rate, it recognized that it was only by adopting such a liberal attitude that it could keep itself alive in this period of ferment and renewal.[30] Watteau, Fragonard and Chardin became members of the Academy without any difficulty, just like all the other famous artists of the century, to whatever school they belonged. To be sure, the Academy still represented the 'grand goût' as much as ever, but in practice it was only a small group of its members that kept to this principle. Those artists who could not count on public commissions, and had their buyers outside court circles, did not worry much about official recognition and cultivated the 'petits genres' which, although theoretically they did not enjoy much esteem, were all the more sought after in practice. To these belonged the 'fêtes galantes', which were intended from the very outset for a more liberal circle than the court, although it was only for a short time longer that those interested in this kind of picture represented the artistically most progressive section of the public.

But painting still kept to erotic subjects for a long time after literature, above all the novel, as the more mobile and, for economic reasons, more popular type of art, had already turned its attention to subjects of more general importance. The libertinism of the century did find its representatives in literature in Choderlos de Laclos, Crébillon *fils* and Restif de la Bretonne, but it played no decisive part in the work of the other novelists of the age. In spite of the audacity of their subjects, Marivaux and Prévost never attempt to produce grossly erotic effects. Whilst, therefore, in painting the connection with the upper classes continues unimpaired for the time being, the novel approaches the world-view of the middle classes. The transition from the novel of chivalry to the pastoral novel marked the first step in this direction, in which the foregoing of certain medieval-romanesque

22

elements was already expressed. The pastoral novel discusses, though in a thoroughly fictitious framework, problems of real life, and describes, though in a fantastic disguise, real contemporary people; from the historical point of view, these are important features, pointing to future developments. The pastoral novel also approaches modern realism in so far as the action, above all in d'Urfé, is historically localized.[31] But the most important fact in relation to the further history of literature is that d'Urfé writes the first genuine love novel. It goes without saying that love already occurs in the novel earlier than this, but before d'Urfé there is no work of any considerable size with love as the main subject. Only from now onwards does the love theme become and remain for over three centuries the driving force in the novel as well as in the drama.[32] Since the baroque, epic and dramatic literature has always been essentially love poetry; only in the most recent period are there any signs of a change. Love gets the better of heroism even in the 'Amadis', but Céladon is the first love-hero in our sense, the first unheroic, the first defenceless slave of his passions, the precursor of the Chevalier Des Grieux and the ancestor of Werther.

The French pastoral novel of the seventeenth century is the literature of a tired age; the society which has been exhausted in the civil wars rests from its exertions as it reads the beautiful and affected conversations of the amorous shepherds. But as soon as it has recovered and the wars of conquest of Louis XIV awaken it to new ambitions, the reaction against the precious novel begins, and this goes hand in hand with the attacks on preciosity which are being made by Boileau and Molière. The pastoral novel of d'Urfé is succeeded by the heroic and love novel of La Calprenède and Mlle de Scudéry, a genre which picks up the broken thread of the Amadis novels. The novel again deals with important events, describes foreign lands and strange peoples, represents significant and impressive schemes and characters. Its heroism is, however, no longer the romantic recklessness of the novels of chivalry but rather the stern sense of duty of the tragedies of Corneille. Like the court drama, La Calprenède's heroic novel set out to be a school of will-power and magnanimity; and the same tragi-heroic ethic was also expressed in Mme

de la Fayette's *Princesse de Clève*. Here, too, the question was one of the conflict between honour and passion, and here, too, duty was triumphant over love. In this age of heroic stimuli, we are everywhere confronted by the same clear analysis of volitional motifs, the same rationalistic dissection of the passions, the same stern dialectic of moral ideas. Perhaps there is to be found a more intimate trait, a more personal nuance, a more fleeting aspect of the development of the feelings in Mme de la Fayette occasionally, but even in her work everything seems to be moved into the sharp light of consciousness and analytical reason. The lovers never for a moment find themselves the defenceless victims of their passion; they are not incurably, not irretrievably lost, as are René and Werther, and even Des Grieux and Saint-Preux.

But in addition to all these bucolic-idyllic and heroic-amorous forms, there are certain phenomena even in the seventeenth century which herald the later middle-class novel. There is, above all, the picaresque novel, which differs from the fashionable types mainly in the everyday reality of its motifs and its preference for the lowlands of life. *Gil Blas* and the *Diable Boiteux* still belong to this genre and certain traits even in Stendhal's and Balzac's novels are reminiscent of the motley mosaic of the picaresque view of life. Precious novels are still read for a long time in the seventeenth century, they are actually read far into the eighteenth century, but they are no longer written after 1660.[33] The witty, artificial, aristocratically affected style yields to a more natural, more middle-class tone. Furetière already gives to his unheroic unromantic novel in the picaresque manner the specific title *Le Roman bourgeois*. This description is, however, justified only by the motifs dealt with, for this work is still a mere juxtaposition of episodes, sketches and caricatures, a form, in other words, which has nothing in common with the concentrated 'dramatic' novel of modern times, where the action revolves around the fate of a principal character completely absorbing the reader's interest.

The novel, which, despite its popularity, represents an inferior and in some respects still backward form in the seventeenth century, becomes the leading literary genre in the eighteenth, to which belong not only the most important literary works, but

in which the most important and really progressive literary development takes place. The eighteenth century is the age of the novel, if only because it is an age of psychology. Lesage, Voltaire, Prévost, Laclos, Diderot, Rousseau, are brimful of psychological observations, and Marivaux is obsessed with a mania for psychology; he explains, analyses and comments on the spiritual attitudes of his figures incessantly. He takes every manifestation of life as an occasion for psychological considerations, and he never misses an opportunity of exposing the motives of his characters. The psychology of Marivaux and his contemporaries, above all of Prévost, is much richer, finer and more differentiated than was the psychology of the seventeenth century; the characters lose much of their earlier stereotyped quality, they now become more complicated, more contradictory and make the character drawing of classical literature seem, for all its acuteness, somewhat schematic. Even Lesage still provides us almost exclusively with types, eccentrics and caricatures, and it is not until Marivaux and Prévost that we have real portraits with indistinct, fleeting contours and the graded, toned-down colours of real life before us. If there is any border-line at all separating the modern from the older novel, then it runs here. From now on the novel is spiritual history, psychological analysis, self-unravelling, previously it was the representation of external happenings and spiritual processes as mirrored in concrete actions. It is true that Marivaux and Prévost still move within the limitations of the analytical and rationalistic psychology of the seventeenth century and really stand closer to Racine and La Rochefoucauld than to the great novelists of the nineteenth century. Like the moralists and dramatists of the classical period, they still split up the characters into their components and develop them from a few abstract principles, instead of the total context of life in which they stand. It is not until the nineteenth century that the decisive step towards this indirect, impressionistic psychology is taken and, thereby, a new conception of psychological probability created, which makes the whole of previous literature seem out of date. What strikes us as modern in the writers of the eighteenth century is the de-heroizing and humanizing of their heroes. They reduce their size and bring them closer to us; therein lies the

essential progress of psychological naturalism since the description of love in the work of Racine. Prévost already shows the reverse side of the great passions, above all the humiliating and shaming situation for a man of being in love. Love is once again a disaster, a disease, a disgrace as it was described by the Roman poets. It gradually develops into the 'amour-passion' of Stendhal and takes on the pathological features which are to characterize love in the literature of the nineteenth century. Marivaux does not yet know the power of this love which attacks its victims like a ravenous animal and never leaves go of them again; but with Prévost it has already taken possession of the mind. The age of knightly love is over; the fight against mésalliance begins. The degradation of love here serves merely as a social defence-mechanism. The stability of medieval feudal society and even that of the courtly society of the seventeenth century was not threatened by the dangers of love; they needed no such defence against the excesses of prodigal sons. But now, when the frontiers between the social castes are crossed more and more frequently and not only the nobility but also the bourgeoisie has to defend a privileged position in society, the excommunication of the wild, incalculable love-passion, which threatens the prevailing social order, begins, and a literature arises which finally leads to the *Dame aux camélias* and to our Garbo films. Prévost is doubtless still the unconscious instrument of the conservatism which a Dumas *fils* already serves consciously and with conviction.

Rousseau's exhibitionism is already heralded in Prévost's *Manon Lescaut*. The hero of the novel no longer spares himself in the least with the description of his inglorious love and even shows a masochistic delight in making confession of the weakness of his character. The fondness for such 'mixtures of smallness and greatness, of the contemptible and the estimable', as Lessing was to call them, with special reference to Werther, is already shown in Marivaux. The author of the *Vie de Marianne* is already conversant with the little weaknesses of even great souls, and not only draws his M. de Climal as a nature in whom attractive and repulsive features are mixed, but also describes his heroine as a character who cannot be summed up on the spur of the moment. She is an honest and sincere girl, but she is never so

26

careless as to do or say anything that might injure her. She knows her trump-cards and plays them cleverly. Marivaux is the typical representative of an age of transition and reconstruction. As a novelist, he gives his full support to the progressive, middle-class trend, but as a writer of comedy, he clothes his psychological observations in the old forms of intrigue. The new departure, however, is that love, which had previously always played only a secondary rôle in comedy, moves into the centre of the action,[34] and, with the conquest of this last important stronghold, it completes its triumphal progress in modern literature, a development which is attributable to the fact that now even characters in comedy become more complicated and love itself acquires such a differentiated structure that the comic features which it receives are not able to damage its serious and sublimated quality. But the new characteristic in Marivaux the writer of comedy is, above all, his attempt to describe his figures as socially conditioned beings acting on impulses derived directly from their social position.[35] For, just as Molière's characters are in love, but their being in love is never the theme around which his plays revolve, so, too, the social conditioning of their nature is certainly evident, but never the origin of the dramatic conflict. In Marivaux's *Jeu de l'amour et du hasard*, on the other hand, the whole action hinges on a play with social appearances, namely on the question whether the principal characters are in fact the servants they disguise themselves to be or the masters whose identity they conceal.

Marivaux has often been compared with Watteau, and the similarity of their witty and piquant styles certainly suggests the comparison. But they also confront us with the same problem of art sociology, for they both express themselves, in full harmony with the conventions of good society, in extremely cultivated forms, and yet neither of them is so successful as one would expect in the circumstances. Throughout his life, Watteau was really appreciated by only a few, and it is well known that Marivaux repeatedly failed with his plays. His contemporaries found his language complicated, affected and obscure and stamped his glittering, sparkling, nimble dialogue as 'marivaudage', which was not intended as an appreciation, although Sainte-Beuve

27

asserts, with some justification, that it is no small matter when the name of a writer becomes a household word. And even if, in the case of Watteau, one were to allow the explanation, which is no explanation, to stand, that he was too great for his age, and that great art 'goes against human instincts', that kind of explanation is in no way applicable to Marivaux, who was not a great writer. They were both the representatives of an age of transition, and were never understood during their lifetime; this had nothing to do with their artistic quality, but was bound up with their historical rôle as precursors and pioneers. Artists of this kind never find an adequate public. Their contemporaries do not understand them, the next generation enjoys their artistic ideas usually in the diluted form of the epigones, and posterity, which is sometimes in a more favourable position to appreciate their works, can hardly any longer bridge the historical gap which separates them from the present. Both Watteau and Marivaux were not discovered until the nineteenth century, by connoisseurs whose taste was schooled by impressionism and at a time when their art had been long since out of date thematically.

The rococo is not a royal art, as was the baroque, but the art of an aristocracy and an upper middle class. Private patrons displace the king and the state in the field of building activity; 'hôtels' and 'petites maisons' are erected instead of castles and palaces; the intimacy and elegance of boudoirs and cabinets are preferred to cold marble and heavy bronze; grave and solemn colours, brown and purple, dark blue and gold, are replaced by light pastel colours, grey and silver, mignonette green and pink. In contrast to the art of the Régence, the rococo gains in preciousness and brilliance, playful and capricious charm, but also in tenderness and spirituality; on the one hand, it develops into the society art par excellence, but, on the other, it approaches the middle-class taste for diminutive forms. It is a highly-skilled decorative art, piquant, delicate, nervous, by which the massive, statuesque, realistically spacious baroque is replaced; but it is sufficient to think of artists like La Tour or Fragonard, to remember that the facility and the verve of this art is, at the same time, a triumph of naturalistic observation and representation. Compared with the wild, excited visions of the baroque, with their tumultuous

overflowing of the boundaries of ordinary life, everything produced by the rococo seems feeble, petty and trifling, but no master of the baroque can wield a brush with greater ease and assurance than Tiepolo, Piazzetta or Guardi. The rococo really represents the last phase of the development which starts with the Renaissance, in that it leads to victory the dynamic, resolving and liberating principle, with which this development began and which had to assert itself again and again against the principle of the static, the conventional and the typical. It is not until the rococo that the artistic aims of the Renaissance finally succeed in establishing themselves; now the objective representation of things attains that exactness and effortlessness which it was the aim of modern naturalism to achieve. The middle-class art, which begins after and partly even in the midst of the rococo, is already something fundamentally new, something absolutely different from the Renaissance and subsequent periods in the history of art. It marks the beginning of our present cultural epoch, which is conditioned by the democratic idea and by subjectivism and which is, no doubt, directly related to the élite cultures of the Renaissance, the baroque and the rococo from an evolutionary point of view, but is opposed to them in principle. The antinomies of the Renaissance and of the artistic styles dependent on it, the polarity of formal rigorism and naturalistic formlessness, of tectonics and pictorial dissolution, of statics and dynamics, are now replaced by the antagonism between rationalism and sentimentalism, materialism, and spiritualism, classicism and romanticism. The earlier antitheses very largely lose their meaning, since both forms of the artistic achievement of the Renaissance period have become indispensable; the naturalistic accuracy of the representation is taken for granted as much as the compositional harmony of the elements in a picture. The real question now is whether precedence is to be given to the intellect or the feeling, to the world of objects or the subject, to rationalistic insight or intuition. The rococo itself prepares the way for the new alternative, by undermining the classicism of late baroque and by creating with its pictorial style, its sensitiveness to picturesque detail and impressionistic technique an instrument which is much better suited to express the emotional contents of middle-

class art than the formal idiom of the Renaissance and the baroque. The very expressiveness of this instrument leads to the dissolution of the rococo, which is bent, however, by its own way of thinking on offering the strongest resistance to irrationalism and sentimentalism. Without this dialectic between more or less automatically developing means and original intentions it is impossible to understand the significance of the rococo; not until one comes to see it as the result of a polarity which corresponds to the antagonism of the society of the same period, and which makes it the connecting link between the courtly baroque and middle-class pre-romanticism, can one do justice to its complex nature.

The epicureanism of the rococo stands, with its sensualism and aestheticism, between the ceremonial style of the baroque and the emotionalism of the pre-romantic movement. Under Louis XIV the court nobility still extolled an ideal of heroic and rational perfection, even though in reality it mostly lived for its own pleasure. Under Louis XV the same nobility professes a hedonism which is also in harmony with the outlook and the way of life of the rich bourgeoisie. The dictum of Talleyrand: 'No one who did not live before 1789 knows the sweetness of life', gives one an idea of the kind of life which these classes lead. The 'sweetness of life' is, of course, taken as meaning the sweetness of women; they are, as in every epicurean culture, the most popular pastime. Love has lost both its 'healthy' impulsiveness and its dramatic passionateness; it has become sophisticated, amusing, docile, a habit where it used to be a passion. There is a universal and constant desire to see pictures of the nude; it now becomes the favourite subject of the plastic arts. Wherever one looks, whether at the frescoes in state apartments, the gobelins of the *salons*, the paintings in boudoirs, the engravings in books, the porcelain groups and bronze figures on mantelpieces, everywhere one sees naked women, swelling thighs and hips, uncovered breasts, arms and legs folded in embraces, women with men and women with women, in countless variations and endless repetitions. Nudity in art has become so habitual that the ingénues of Greuze produce an erotic effect merely by putting their clothes on again. But the ideal of female beauty itself has also changed, it has become more piquant, more sophisticated. In the age of the

baroque, mature and well-developed women were preferred, now slender young girls, often still almost children, are painted. The rococo is, in fact, an erotic art intended for rich and blasé epicureans—a means of intensifying the capacity for enjoyment, where nature has set limits to it. It is only to be expected that with the art of the middle classes, the classicism and romanticism of David, Géricault and Delacroix, the more mature, more 'normal' type of woman comes back into fashion again.

The rococo develops a striking form of 'l'art pour l'art'; its sensual cult of beauty, its affected and highly-skilled, graceful and melodious formal language, surpasses every kind of Alexandrinism. Its 'l'art pour l'art' is in some respects even more genuine and more spontaneous than that of the nineteenth century, since it is no mere programme and no mere demand but the natural attitude of a frivolous, tired and passive society, which turns to art for pleasure and rest. The rococo actually represents the final phase in a culture of taste, in which the principle of beauty still holds unrestricted sway, the last style in which 'beautiful' and 'artistic' are synonymous. In the work of Watteau, Rameau and Marivaux, and even in that of Fragonard, Chardin and Mozart, everything is 'beautiful' and melodious; in Beethoven, Stendhal and Delacroix this is by no means any longer the case—art becomes active, combative, and the striving for expression violates the formal structure. But the rococo is also the last universal style of Western Europe; a style which is not only universally recognized and moves within a generally speaking uniform system over the whole of Europe, but is also universal in the sense that it is the common property of all gifted artists, and can be accepted by them without reserve. After the rococo there is no such canon of form, no such universally valid trend of art. From the nineteenth century onwards the intentions of each single artist become so personal that he has to struggle for his own means of expression and can no longer accept ready-made solutions; he regards every pre-established form as a fetter rather than a help. Impressionism again acquires fairly universal recognition, but the relation of the individual artist to that movement is no longer wholly unproblematical, and there is no such thing as an impressionistic formula in the rococo sense. In the

second half of the eighteenth century a revolutionary change took place; the emergence of the modern middle class, with its individualism and its passion for originality, put an end to the idea of style as something consciously and deliberately held in common by a cultural community, and gave the idea of intellectual property its current significance.

Boucher is the most important name in connection with the rise of the rococo formula and the masterly technique which gives the art of a Fragonard and Guardi that quality of unfailing certainty in the execution. He is the individually insignificant representative of an extraordinarily significant artistic convention, and he represents this convention in such a perfect way that he attains an influence unlike that of any artist since Le Brun. He is the unrivalled master of the erotic genre, of the genre of painting most sought after by the *fermiers généraux*, the *nouveaux riches* and the more liberal court circles, and the creator of that amorous mythology which, next to Watteau's 'fêtes galantes', provides the most important subject-matter of rococo painting. He transfers the erotic motifs from painting to the graphic arts and the whole of industrial art, and makes a national style out of the 'peinture des seins et des culs'. Naturally, it is not the whole of the art-minded public in France that sees Boucher as its leading painter; there is a cultured middle section of the bourgeoisie, which has already been having its say in literature for a long time past, and which now goes its own ways in art. Greuze and Chardin paint their didactic and realistic pictures for this public. To be sure, their supporters do not all belong to the middle classes but also to those who provide the public of Boucher and Fragonard. Fragonard, for his part, often conforms to the taste which the 'bourgeois' painters strive to satisfy, and motifs are to be found even in Boucher which are not so far removed from the world of these painters. His 'Breakfast' in the Louvre, for example, can be described as a scene from middle-class, albeit upper middle-class life; it is, at least, already genre painting and no longer the representation of a ceremony.

The break with the rococo takes place in the second half of the century; the cleft between the art of the upper classes and that of the middle classes is obvious. The painting of Greuze

marks the beginning not only of a new attitude to life and a new morality, but also of a new taste—possibly a 'bad taste'—in art. His sentimental family scenes, with the cursing or blessing father, the prodigal or the good and grateful sons, are of little artistic value. They lack originality in the composition, they are unremarkably drawn, their colours are unattractive and, furthermore, the technique has an unpleasant smoothness. The impression they make is cold and empty, despite their exaggerated solemnity, and mendacious, despite the emotions they display. The interests they attempt to satisfy are almost entirely non-artistic, and they present their unpainterly, in most cases purely narrative, subject-matter quite crudely, with no attempt to transfer it into genuine pictorial forms. Diderot praises them for portraying events which contain the germs of whole novels;[36] but one might perhaps assert with more justification that they contain nothing that a story could not contain. They are 'literary' painting in the bad sense of the word, banal, moralizing, anecdotic painting, and as such the prototype of the most inartistic products of the nineteenth century. But the works of Greuze are not in bad taste merely on account of their 'middle-class' character, although the change in the groups which are the upholders of taste is, naturally, bound up with an undermining of the old well-tried albeit schematized standards. The pictures of Chardin are, at any rate, among the best artistic products of the eighteenth century, in spite of their bourgeois plainness. And they are a much more genuine and honest middle-class art than that of Greuze, who, with his stereotyping of simple, chaste folk, his apotheosis of the middle-class family, his idealization of the artless maiden, expresses more the ideas and conceptions of the upper than those of the middle and lower classes. In spite of that, the historical importance of Greuze is no less than that of Chardin; in the struggle against the aristocratic and upper middle-class rococo, his weapons proved even more effective. Diderot may have over-estimated him as an artist, but his recognition of the political propagandistic value of his painting was well grounded. He was, at any rate, aware that the 'l'art pour l'art' of the rococo was under fire here, and if he asserted that it was the task of art 'to honour virtue and expose vice', if he wanted

to make art, the great match-maker, a school of virtue, if he condemned Boucher and Vanloo on account of their artificiality, their empty, easy, thoughtless dexterity and their libertinage, then he always had in mind the 'punishment of the tyrants', or, more concretely, the introduction of the middle class into the world of art, in order to lead it to a place in the sun. His crusade against the art of the rococo was merely a stage in the history of the revolution which was already under way.

2. THE NEW READING PUBLIC

Intellectual leadership in the eighteenth century passes from France to economically, socially and politically more progressive England. The great romantic movement starts here about the middle of the century, but the enlightenment also receives its decisive impulse from this country. The French writers of the period see in English institutions the quintessence of progress and build up a legend around English liberalism—a legend which only partly corresponds to reality. The displacement of France as the upholder of culture by England proceeds hand in hand with the decadence of the French royal house as the leading European power and, hence, the eighteenth century sees the ascent of England both in politics and in the arts and sciences. The weakening of the king's authority, which in France results in national decline, becomes a source of power in England, where enterprising classes with an understanding of the trend of economic development and a capacity for adapting themselves to it stand ready to take over the reins of government. Parliament, which is now the expression of the liberal political aspirations of these classes and their strongest weapon against absolutism, supported the Tudors in their fight against the feudal aristocracy, the foreign foe and the Roman Church, since the commercial and industrial middle classes, represented in Parliament, as well as the liberal nobility, with interests in the commercial activities of the bourgeoisie, recognized that this fight was promoting their own designs. Until towards the end of the sixteenth century, there was a close community of interests between the monarchy

and these classes. English capitalism was still in a primitive, adventurous stage of its development and the merchants gladly supported the confidential advisers of the Crown in joint piratical enterprises. The parting of the ways took place only when capitalism began to follow more rationalistic methods and the Crown no longer needed the assistance of the middle class against the crippled aristocracy. The Stuarts, encouraged by the example of continental absolutism and believing that they had an ally in the French king, carelessly threw away both the loyalty of the middle classes and the support of Parliament. They rehabilitated the old feudal nobility as a court nobility and laid the foundations of a new period of ascendancy for this class, to whom they were bound by stronger feelings and more permanent common interests than to their predecessors' comrades in arms in the ranks of the middle class and the liberal gentry. Until 1640 the feudal nobility enjoyed considerable privileges and the state not only provided for the continuance of the latifundia, but tried to assure the great landowners of a share in the profit of capitalistic enterprises by monopolies and other forms of protectionism. This very practice, however, was fraught with disastrous consequences for the whole system. The economically productive classes were by no means prepared to share their profits with the favourites of the Crown and protested against interventionism in the name of freedom and justice, slogans which they continued constantly to use when they themselves had become the beneficiaries of economic privilege.

There is, as Tocqueville remarks, almost no political question which is not connected in some way with the imposition or the granting of taxes. At any rate, problems of taxation dominated public life in England from the end of the Middle Ages and became in the seventeenth century the immediate cause of the revolutionary movements. The same middle class that granted taxes to the Tudors without any fuss, and was ready to bear them in even greater measure in the years of the Civil War, refused them to Charles I because of his reactionary, anti-middle-class policy. When James II, a generation later, called on the council of the City of London to protect him against William of Orange, the citizens of London refused him their help and

preferred to supply the intruder with the means necessary for success. This was the beginning of that alliance between the monarchy and the commercial classes which guaranteed the victory of capitalism and the continuance of the royal house in England.[37] The remains of feudalism, of which a clean sweep was only made a hundred years later in France, were already destroyed in England in the period of revolution between 1640 and 1660; but in both countries the Revolution was a class struggle, in which the classes tied to capital defended their economic interests against absolutism, pure landed property and, above all, against the Church.[38]

The great conflict, which dominates the political life of the seventeenth and eighteenth centuries, was waged in England between the Crown and the court nobility, on the one side, and the classes interested in capitalism, on the other, but in reality at least three different, economically antagonistic groups stood against each other: the big landowners, the bourgeoisie in alliance with the capitalistically-minded nobility and the already very complex group of small tradesmen, town labourers and peasants. But in the eighteenth century this latter category was not mentioned much either in Parliament or literature.

The Parliament that met after 1688 was by no means a 'representation of the people' in our sense of the term; its task was to establish capitalism on the ruins of the old feudal order and to stabilize the predominance of the economically productive elements over the parasitic classes in sympathy with absolutism and the ecclesiastical hierarchy. The Revolution did not result in a new distribution of economic property, but it created rights to freedom which finally benefited the whole nation and the whole civilized world. For, even if these rights could at first be exercised only imperfectly, they signified, nevertheless, the end of absolute royal power and the beginning of a development which bore within it the seeds of democracy. Parliament wanted, above all, to exert a conserving influence, that is, to create conditions under which the elections would remain dependent on commercially based landed property and the commercial capital associated with it. The antagonism between the Whigs and Tories was a conflict of secondary importance within the common cause of the classes

represented in Parliament. Whichever of the two parties was at the helm, political life was led by the aristocracy, which had far-reaching influence on the elections and made the middle class its satellite. When power passed from the Tories to the Whigs, it merely meant that the administration encouraged commercialism and dissent rather than pure landed property and the Anglican Church; parliamentary government was, however, as much the rule of an oligarchy as ever. The Whigs no more wanted a Parliament without a monarch and without aristocratic privileges, than did the Tories a monarchy without a Parliament. Neither party thought of Parliament as a democratic corporation; they regarded it merely as the guarantee of their own privileges against the Crown. Furthermore, Parliament retained this class character throughout the eighteenth century. The country was ruled alternately by a few dozen Whig and Tory families who, with their first-born in the House of Lords and their younger sons in the Commons, monopolized the whole of political life. Two-thirds of the Members of Parliament were simply nominated and the rest chosen by not more than 160,000 electors, and some of their votes were acquired corruptly. The census, which made the franchise dependent in the first place on ground rent, secured a predominant place in Parliament for the land-owning classes from the very outset. But in spite of the limited franchise, the buying of votes and corruptibility of Members of Parliament, England was already in the eighteenth century a modern nation in gradual process of liberation from the relics of medievalism. At any rate, its citizens enjoyed a personal freedom still unknown in the rest of Europe; and the social privileges themselves, which in England were based on the mere ownership of land and not, as in France, on mystical birthrights,[39] made it easier to reconcile the lower classes to the intrinsically more elastic class distinctions.

The English social order of the eighteenth century has often been compared with conditions in Rome in the last period of the Republic; the fact, however, that the organization of Roman society, with its senator class, its *equites* and its plebeians, is repeated, to a certain extent, in the categories of the parliamentary aristocracy, the moneyed classes and the 'poor' in England, can hardly be said to be remarkable in itself—this tripartition is

in fact characteristic of all more advanced societies where the process of equalization has not yet begun. What gives special significance to the parallel between England and Rome is the emergence of the aristocracy as the class by which parliament is dominated, and the thoroughly fluid boundaries between the patricians and the capitalists. But the relationship between these classes and the plebs is rather different in the two countries. It is true that the Roman authors of the period mention the poor just as seldom as do the English writers of the eighteenth century,[40] but whilst the proletariat constantly occupies public attention in Rome, it plays almost no part at all in English politics. Another peculiarity distinguishing English from Roman society —and not only from Roman—is that the nobility, which normally becomes impoverished under similar conditions, increases its wealth and remains the well-to-do class in England.[41] The ruling class in this country shows its political wisdom not only by allowing the bourgeoisie to earn and by itself earning alongside of it, but by renouncing of its own accord the fiscal privileges to which the French aristocracy clings most firmly of all.[42] In France only the poor pay taxes, in England only the rich,[43] which does not mean that the situation of the poor is essentially any better, but the budget remains balanced and the most disgraceful privilege of the nobility disappears. In England power is held by a commercial aristocracy which probably does not feel and think more humanely than the aristocracy in general, but which, thanks to its business experience, has more sense of reality and understands in good time that its interests are identical with those of the state. The universal levelling tendency of the age, which influences everything except the difference between rich and poor, assumes more radical forms in England than elsewhere, and creates for the first time modern social relationships based essentially on property. The lack of distance between the different levels of the social hierarchy is guaranteed not only by a series of intermediary grades, but also by the indefinable nature of the individual categories themselves. The English 'nobility' is a hereditary nobility, but the title of a peer always passes only to the eldest son; there is hardly any difference between the younger sons and the ordinary gentry. But the

boundaries dividing the lower nobility from the immediately inferior classes are also fluid. Originally the gentry was identical with the 'squirearchy'; gradually, however, it absorbed not only the local notabilities but also all the elements of society which were differentiated from the manufacturing classes, the small tradesmen and the 'poor' by reason of property and culture. Hence the concept of the gentleman lost all legal significance and became indefinite even with reference to a certain fixed standard of life. Membership of the ruling class was more and more dependent on a common cultural level and ideological agreement. That explains, above all, why the transition from the aristocratic rococo to bourgeois romanticism in England was not bound up with the kind of violence to cultural values that occurred in France or Germany.

The cultural levelling process in England is expressed most strikingly in the rise of the new and regular reading public, by which is to be understood a comparatively wide circle reading and buying books regularly and thereby assuring a number of writers a livelihood free from personal obligations. The existence of this public is due, first of all, to the increasing prominence of the well-to-do middle class, which breaks the cultural prerogatives of the aristocracy and shows a lively and ever-growing interest in literature. The new upholders of culture can produce no individual personalities ambitious and rich enough to come forward as patrons on the grand scale, but they are numerous enough to guarantee a sale of books sufficient to provide writers with a living. The objection to the explanation of the existence of this public as being due to the presence of an economically, socially and politically influential middle class, and the argument that the middle class had already become important in the seventeenth century and that its cultural function in the eighteenth cannot, therefore, be derived simply from the improvement of its social position,[44] are easily refuted. In the seventeenth century artistic culture was limited to the court aristocracy above all because of the puritanical outlook of the middle class. Circles outside the court themselves gave up the function they had fulfilled in Elizabethan culture; they had first to regain their place in cultural life, that is, to traverse a road which could

follow on from their fresh economic and social rise only after a certain interval. The prosperity of the middle class had to spread and become firmly established before it could again become the basis of intellectual leadership. Finally, the aristocracy itself had to adopt certain aspects of the bourgeois outlook on life, in order to form a homogeneous cultural stratum with the middle class and in order adequately to strengthen the reading public, and this could not happen until after it had begun to participate in the business life of the bourgeoisie.

The former court aristocracy had not constituted a real reading public; it is true that it somehow looked after its writers, but it did not regard them as the producers of indispensable goods, only as servants whose service could also be dispensed with in certain circumstances. It supported them more for reasons of prestige than because of the real value of their accomplishments. At the end of the seventeenth century the reading of books was not yet a very widespread recreation; as far as secular belles-lettres were concerned, which consisted very largely of old-fashioned stories of love and marvels, only people of the upper classes with no other occupation could be considered potential readers; and learned books were read only by scholars. The literary education of women, who were to play such an important part in the literary life of the following century, was still defective. We know, for example, that Milton's elder daughter could not write at all and that Dryden's wife, who, incidentally, came from an aristocratic family, had a desperate struggle to master the grammar and spelling of her mother tongue.[45] The only kind of book that had a wider public in the seventeenth and the beginning of the eighteenth century was the edifying religious tract; secular fiction formed only an unimportant fraction of the total book-production.[46] The turning away of the reading public from devotional books to secular belles-lettres, which until about 1720 still dealt mainly with moral subjects and only later began to treat more trivial themes, can, contrary to Schoeffler's assumption,[47] be attributed only indirectly to Walpole's politicizing of the Church and to the free-thinking activities of the Anglican clergy. The liberal policy and secular outlook of the High Church were merely symptoms of the enlightenment,

40

which, in its turn, was nothing more than the ideological expression of the dissolution of feudalism and the arrival of the middle classes. But the evidence proving that the Protestant clergy played a highly important part in the dissemination of secular literature and the education of the new reading public[48] is, nevertheless, one of the most significant results of the modern sociology of literature. Without the publicity they received from the pulpit, the novels of Defoe and Richardson would scarcely have achieved the popularity accorded to them.

Towards the middle of the century the number of readers grows to a marked degree; more and more books appear which, judging by the prosperity of the book trade, must have found their buyers. Around the turn of the century reading is already one of the necessities of life for the upper classes, and the possession of books is, as has been noted, just as much taken for granted in the circles described by Jane Austen as it would have caused surprise in the world of Fielding.[49] Of the cultural media on which the new reading public thrives, the periodicals which spread from the beginning of the century onwards—the great invention of the age—are the most important. From them the middle class receives both its literary and its social culture, both of which are still based fundamentally on aristocratic standards. The aristocracy has also changed a good deal since the days of its absolute power, and has learnt its lesson from the victory of the urban middle-class over the courtly mind. A tension between the forms of thinking and feeling of the aristocratic and the middle classes still continues for a long time, however. The coolly intellectual, sceptically superior mentality of the aristocracy does not vanish from one day to the next; on the contrary, it still makes its influence felt in the affected style and stoic moral philosophy of the periodicals. In literature proper classicistic taste prevails longer than in the press; here intellect and wit, clever ideas and highly-skilled technique, clarity of thought and purity of language, as represented by the supporters of Pope and the 'Wits', are regarded as the literary qualities par excellence right up to the middle of the century. Nothing is more typical of the transitional character of this semi-court, semi-bourgeois culture, than the thin intellectual stratum of writers

and amateurs who try to distinguish themselves from ordinary mortals by their classical education, their fastidious taste and their playful and complacent wit. How these intellectuals then gradually disappear, how certain qualities of their mental equipment become the accepted precondition of literary culture, whilst others come to seem all the more ridiculous, how, above all, coquettish wit is displaced by common sense and formal elegance by emotional directness, all that belongs to the later development and to the complete emancipation of the middle-class spirit in literature. In the end the tension between the two directions ceases entirely and middle-class literature is no longer opposed by anything that could be called courtly. That does not mean, however, that all tension comes to an end and that literature is dominated by a single, undivided taste. On the contrary, a new antagonism develops, a tension between the literature of the cultured élite and that of the general reading public, and lapses of good taste are to be observed, in which the weaknesses of the light fiction of a later age are already discernible.

Steele's *Tatler*, which begins to appear in 1709, Addison's *Spectator*, by which it is replaced two years later, and the 'moral weeklies' which follow them, first create the preconditions of a literature which bridges the gap between the scholar and the more or less educated general reader, between the aristocratic *bel esprit* and the matter-of-fact bourgeois, a literature which is, therefore, neither courtly nor really popular, and which stands, with its stern rationalism, its moral harshness and its ideal of respectability, halfway between the knightly-aristocratic and the bourgeois-puritanical outlook on life. Through these periodicals, which, with their short pseudo-scientific dissertations and ethical enquiries, form the best introduction to the reading of real books, the public becomes accustomed for the first time to the regular enjoyment of serious literature; through them reading becomes a habit and a necessity for comparatively wide sections of society. But the periodicals themselves are already the product of a development connected with the alteration in the social position of the writer. After the glorious Revolution it is no longer at court that authors find their patrons; the court has ceased to exist in the old sense and will never again take up its earlier

cultural function.[50] The rôle of court circles as patrons of litera-
ture is taken over by the political parties and the government,
which is now dependent on public opinion. Under William III
and Anne, power is divided between the Tories and the Whigs
and the two parties have, therefore, to wage an incessant war
for political influence, in which they cannot forgo the weapon of
literary propaganda. The writers themselves are forced to under-
take this task, whether they like it or not, since, as the old form
of patronage is on the point of disappearing altogether and the free
book market cannot yet depend on a sufficient public, they have
no reliable source of income apart from political propaganda. Just
as Steele and Addison become journalists representing directly or
indirectly the interests of the Whigs, so Defoe and Swift are also
active as political pamphleteers and pursue political aims even in
their novels. The idea of 'l'art pour l'art' would have had some-
thing irresponsible and immoral about it for them, if they had
been able to conceive such an idea at all. *Robinson Crusoe* is a
novel with a socially instructive purpose, and *Gulliver* is a topical
social satire; both are political propaganda in the strictest sense
of the term and nothing but propaganda. This is probably not the
first time that we are confronted by a militant literature with
direct social purposes, but the 'paper canon-balls' of Swift and his
contemporaries would have been unthinkable before the intro-
duction of the freedom of the press and the public discussion of
political questions of the day. Now for the first time writers
emerge as a regular social phenomenon, making ad hoc weapons
of their pens and hiring them out to the highest bidder.

The fact that they no longer face a single compact phalanx
of power, but two different parties, makes them independent, for
they can now choose their employers more or less in accordance
with their own inclinations.[51] But if the politicians regard them
simply as their confederates, then in most cases that is based on
a pure illusion, the maintenance of which flatters and profits both
sides. Now, as for the two greatest publicists of the age, Defoe
usually defends his own real convictions, and, at any rate, the
hatred in Swift's passionate utterances is genuine. The former,
a Whig, is a profound optimist, whereas the latter, as goes with-
out saying for a Tory under Walpole, is a bitter pessimist; the

one proclaims a puritanical middle-class philosophy of life based on faith in the world and faith in God, the other exhibits a sarcastically superior, misanthropic and world-despising attitude to life. They are the most conspicuous literary representatives of the two political camps into which England is divided. Defoe is the son of a London butcher and dissenter; the suppressed but stubborn puritanism of his fathers still comes through in his writings. He himself suffered at the hands of High-Church-inspired Tory rule. The victory of the Whigs finally vindicates the expectations of his social compeers and co-religionists and it is the optimistic outlook of this middle class that is expressed through him for the first time in secular literature. Robinson, who, thrown back on his own resources, triumphs over the stubbornness of nature and creates prosperity, security, order, law and custom out of nothing, is the classical representative of the middle class. The story of his adventures is one long hymn in praise of the industry, endurance, inventiveness and common sense which overcomes all difficulties, in a word, the practical middle-class virtues; it is the confession of faith of a class with keen social aspirations and conscious of its strength, and it is, at the same time, the manifesto of a young, enterprising nation fighting its way to world-dominion. Swift sees only the reverse of all this; not only because he looks at it from another social standpoint from the outset, but also because he has already lost Defoe's simple confidence. He is one of the first to experience the disillusionment of the period of enlightenment and he moulds his experience into the super-Candide of the age. He is one of the minds that hatred turns into genius, and he sees things that others cannot see, because he hates better than others and because, as he writes to Pope, he wants to torment and not delight the world. Hence he becomes the author of the most cruel book of a century which, for all its humanity and sentiment, is by no means lacking in cruel books. It is hardly possible to imagine anything more opposed to the philanthropic 'Robinson' than this second great 'youth novel' of English literature, the cruelty of which is perhaps surpassed only by the third classical example of the genre, *Don Quixote*. Nevertheless, there are certain features common to *Gulliver* and *Robinson Crusoe*. First

of all, they both have their literary origin in those phantastic travel novels and Utopian stories of marvels, which were so popular in the Renaissance and the best-known representatives of which are Cyrano de Bergerac, Campanella and Thomas More. But they also hinge on the same philosophical problems, namely the origin and validity of human culture. These problems could become so important, as they did become for Defoe and Swift, only in an age in which the social foundations of civilization had begun to totter, and it was only under the direct impact of the passing of leadership in cultural affairs from one class to another, that it was possible to formulate so pointedly the idea of the dependence of civilizations on social conditions.

With the development of political propaganda in literature, the economic and social position of writers undergoes a fundamental change. Now that they are compensated for their services with high office and abundant reward, their moral value also rises in the estimation of the public. Addison marries a Countess of Warwick, Swift stands in friendly relationship with such personalities as Bolingbroke and Harley in the 'Kitcat Club', a Count of Sunderland and a Duke of Newcastle associate with Vanbrugh and Congreve on equal terms. But one must not forget that these writers are appreciated and rewarded solely on account of their political services and not because of their literary or moral qualities.[52] And since the politicians now have the means of reward, above all, high office, at their disposal, the parties and the government take over the position in literature once occupied by court coteries and the king. Only the price they pay is higher and the honours they award to their authors greater than the rewards formerly bestowed on a writer. Locke is a Commissioner of the Court of Appeal and the Board of Trade, Steele holds a similar office at the Stamp Office, Addison becomes a Secretary of State and retires with a pension of £1,600, Granville is a member of the House of Commons, becomes Minister of War and Treasurer of the Royal Household, Prior obtains the post of an ambassador and Defoe is entrusted with various political missions.[53] At no other time and in no other country have writers been honoured with so many high offices and dignities as in England at the beginning of the eighteenth century.

This exceptionally favourable situation for authors reaches its climax in the last years of the reign of Queen Anne, and comes to an end completely when Walpole enters office in 1721. The assumption of office by the Whigs creates conditions in which writers become unprofitable to the government and which bring political patronage to a sudden end. The power of the government party seems so consolidated that it is able to forgo all propaganda; the influence of the Tories, on the other hand, is so small that they are not in a position to pay authors for their services. Walpole, who has no personal relation to literature, also does not find any surplus money and vacant offices for authors. The more lucrative appointments have to be given to Members of Parliament whose support is needed, or to constituencies it is desired to reward for services rendered. It has been realized, after all, that there are always dissatisfied writers, however many have been satisfied, and that Halifax, the most generous of all patrons, had the greatest number of literary enemies.[54] Public interest in writers cools down. Pope, Addison, Steele, Swift, Prior, withdraw from the capital and from public life and continue to write, if at all, in rural solitude. The economic situation of the younger writers becomes worse from day to day. Thomson is so poor that he is forced to sell one canto of his 'Seasons', in order to buy himself a pair of shoes, and Johnson fights against the most bitter poverty at the beginning of his career. The man of letters is no longer a gentleman; and his public esteem and self-respect decline along with the security of his existence. He acquires bad manners, falls into untidy habits, becomes unreliable and, finally, breeds types like Savage, who would have been impossible in the age of courtly culture, and who are really already the precursors of the modern bohemian.

Fortunately, private patronage does not stop so abruptly as political subvention. The old aristocratic tradition had never entirely broken down, and now that writers can and must turn again to private customers, it experiences a kind of renaissance. The new system of patronage is not so widespread as the old, but, in general, it is guided by more adequate considerations, so that sooner or later every gifted writer finds a patron if he tries.[55] At any rate, there were few authors who would have been in a

position to forgo private support in this transitional period between the age of political propaganda and free-lance activity in the literary world. Complaints about the system of patronage are constantly heard, but there is hardly any mention of a writer ever having had the courage to part from his patron. Being dependent on a patron was after all less uncomfortable than being dependent on a publisher, although it was a more personal relationship and, therefore, often seemed to be more humiliating. Even Johnson, who struggled throughout his life against the system of canvassing for patrons and did not think much of the institution, admitted that it was, nevertheless, possible to be the protégé of a lord and yet preserve one's independence. Fielding's relationship to his protector proves that it actually was feasible. Writers who had not enjoyed any private support usually had to hire themselves out as day-labourers and take on the work of translation, making excerpts, preparing revised editions, proof-reading, writing contributions to periodicals and popular works of reference. Even Johnson, the later arbiter of English literature, begins his career as a hack. Pope cannot, it is true, be included in any of these categories, and seems to remain free of external ties, but, in fact, he is in the service of the aristocracy that sub-scribes to his books and that rightly regards him as its own. With the revival of private patronage, the esteem in which the pro-fessional author is held declines once again, as even the attitude of men with such a high literary culture as Horace Walpole and Lord Chesterfield proves. The latter's famous words: 'We, my lords, may thank Heaven that we have something better than our brains to depend upon', are a perfect expression of the dominant view. But some authors also share this view and pre-tend that for them writing is simply a noble passion. Congreve, who desired Voltaire to regard him, above all, as a 'gentleman' and not as a writer, belongs to this category.

After the middle of the century, patronage comes to an absolute end, and round about the year 1780 no writer any longer counts on private support. The number of independent poets and men of letters living on their writing increases from day to day, just as does the number of people who read and buy books and whose relation to the author is purely impersonal. Johnson and

Goldsmith now write only for such readers. The patron's place is taken by the publisher; public subscription, which has very aptly been called collective patronage, is the bridge between the two.[56] Patronage is the purely aristocratic form of the relationship between author and public; the system of public subscription loosens the bond, but still maintains certain features of the personal character of the relationship; the publication of books for a general public, completely unknown to the author, is the first form of the relationship to correspond to the structure of a middle-class society based on the anonymous circulation of goods. The publisher's rôle, as the mediator between author and public, begins with the emancipation of middle-class taste from the dictates of the aristocracy and is itself a symptom of this emancipation. It forms the historical starting point of literary life in the modern sense, as typified not only by the regular appearance of books, newspapers and periodicals, but, above all, by the emergence of the literary expert, the critic, who represents the general standard of values and public opinion in the world of literature. The forerunners of the eighteenth-century men of letters, especially the humanists of the Renaissance, were not in a position to fulfil that kind of function, because they had no periodical press at their disposal and, therefore, no appropriate means of influencing public opinion.

Until the middle of the eighteenth century writers did not live on the direct profit accruing from their works but on pensions, beneficies and sinecures, which often bore no relationship to the intrinsic value or general attraction of their writings. Now, for the first time, the literary product becomes a commodity, the value of which conforms to its saleableness on the free market. One can welcome or deplore this change; but the development of authorship into an independent and regular profession would have been unthinkable in the age of capitalism without the transformation of personal service into an impersonal commodity. It was only in this way that authorship was able to attain a firm material footing and its present public esteem; for the buyer of a book that appears in an edition of a thousand copies is obviously not doing the author a favour, whereas rewarding him for a manuscript always seems like making a present. In an age of

courtly and aristocratic society a man's reputation depended on the standing of his protector, but now, in the epoch of liberalism and capitalism, the freer he is from personal ties and the more successful he is in his impersonal dealings with other people, based on mutual service, the greater is the esteem he enjoys. The literary hack does not disappear entirely, it is true, but there is such a great demand for literary entertainment and instruction, especially for historical, biographical and statistical encyclopaedias, that the average author can count on an assured income.[57] In organizations like Smollet's 'literary factory', where work is in progress, at one and the same time, on a translation of *Don Quixote*, a *History of England*, a *Compendium of Voyages* and a translation of the works of Voltaire, there is employment for anyone who can write.[58] A lot is heard about the exploitation of writers in this period, and the publishers were certainly in no sense charitable institutions; but Johnson says to their credit that they were punctilious and generous partners and we know that recognized and marketable authors received considerable sums for their works even judged by present-day standards. Hume, for example, earned £3,400 from his *History of Great Britain* (1754–61) and Smollett £2,000 from his historical work (1757–65). Conditions have undergone a big change since the days of Defoe, who, to begin with, could not find any publisher at all for his *Robinson Crusoe* and, in the end, received £10 for the manuscript. With the achievement of material independence, the moral esteem of writers now rises to unprecedented heights. In the age of the Renaissance famous writers and scholars were certainly extolled, but the average man of letters was put in the same category as the clerk and the private secretary. Now for the first time the writer as such enjoys the regard due to the representative of a higher sphere of life. 'Nous protégeons les grands, protecteurs d'autrefois' says a philosopher in a comedy by Dorat.[59] Now for the first time the ideal of the creative personality arises, of the artistic genius with his originality and subjectivism, as already characterized by Edward Young in his *Conjectures on Original Composition* (1759).

The element of genius in artistic creation is in most cases merely a weapon in the competitive struggle, and the subjective

49

mode of expression often only a form of self-advertisement. The
subjectivism of the pre-romantic poets is partly, at any rate, a
consequence of the growing number of writers, of their direct
dependence on the book market and their competition against
one another, just as the romantic movement in general, with its
middle-class emphasis on the sentiments, is nothing more than
the product of intellectual rivalry and an instrument in the fight
against the classicistic world-view of the aristocracy with its ten-
dency to the normative and the universally valid. Hitherto the
middle class had striven to adopt the artistic idiom of the upper
classes, now, however, that it has become so well-to-do and
influential that it can afford a literature of its own, it tries to
make its own individuality felt, in opposition to these upper
classes, and to speak its own language, which, if only out of mere
antagonism to the intellectualism of the aristocracy, develops into
a language of sentimentality. The revolt of the emotions against
the coldness of the intellect is as much a part of the ideology of
the ambitious and progressive classes in their fight against the
spirit of conservatism and convention, as is the rebellion of the
'genius' against the constraint of rules and forms. The rise of the
modern middle class is connected, like that of the *ministeriales* in
the Middle Ages, with a romantic movement; in both cases the
redistribution of social power leads to the dissolution of formal
ties and produces a sudden heightening of sensibility.

The turning away from the intellectual culture of classicism
to the emotional culture of romanticism has often been described
as a change of taste expressing the weariness and disgust felt by
the cultured circles of society with the sophisticated and decadent
art of the period. Against this view it has rightly been pointed
out that the mere desire for novelty plays a relatively small part
in the alternation of styles, and that the older and the more
developed a tradition of taste is, the less liking for change it shows
of its own accord. Hence a new style can make its way only with
difficulty, if it does not address itself to a new public.[60] At any
rate, the aristocracy of the eighteenth century would have had
small reason for surrendering its old aesthetic discernment, if the
middle class had not taken over the intellectual leadership in
Western Europe. It was also by no means prepared to entrust

itself to this new leadership and to share the emotionalism of the lower classes. But, as we know, the dominant tendency of an age often presses the very classes into its service that it threatens with destruction. And the eighteenth century offers the classical example of precisely this phenomenon. The aristocracy played an outstanding part in the preparatory stages of the Revolution and shrunk back from it only when it became clear what its victory would entail. The upper classes played a similar part in the development of anti-classical culture. In the assimilation and propagation of the ideas of the enlightenment they vied with the middle class and often even surpassed it; it was only Rousseau's frankly plebeian and irreverent way of thinking that brought them to their senses and drove them into opposition. Voltaire's dislike for Rousseau is already an expression of the resistance of this social élite. But in most of the leading personalities the elements of rationalism and emotionalism are intermingled from the very outset; their intellectual sensibility makes them, to some extent, indifferent to their own class interests. The development of art, which was already rather heterogeneous in the seventeenth century, becomes now, in the age of pre-romanticism, even more complicated and presents an even more obscure picture than in the succeeding period. The nineteenth century is, in fact, already absolutely dominated by the middle class, in which there are certainly acute differences of wealth, but no very acute differences in cultural standards; the only deep rift here is between the classes that share the privileges of culture and those that are wholly excluded from them. In the eighteenth century, on the other hand, both the aristocracy and the bourgeoisie are divided into two camps; in both there is a progressive and a conservative group, with many points of contact but with its own personal identity intact.

In its origins, romanticism is an English movement, just as the modern middle class, which here speaks for itself for the first time in literature independently of the aristocracy, is a result of English conditions. Thomson's nature poetry, Young's 'Night Thoughts' and Macpherson's Ossianic laments as well as the sentimental novel of manners of Richardson, Fielding and Sterne are all only the literary form of the individualism which also

finds expression in *laissez-faire* and the Industrial Revolution. They are phenomena of the age of commercial wars, which brings the thirty years' peaceful hegemony of the Whigs to an end and leads to the loss of French leadership in Europe. At the end of the struggle the British Empire is not only the leading world power and not only plays the same part in world commerce as Venice in the Middle Ages, Spain in the sixteenth century and France and Holland in the seventeenth, but remains strong internally, in contrast to its predecessors,[61] and is able to continue the fight for economic supremacy with the technical acquisitions of the Industrial Revolution. England's military triumphs, the geographical discoveries, the new markets and ocean-routes, the relatively great capital sums on the look-out for investments, all that is part of the background which is the precondition of this revolution. The mass of new inventions cannot be explained by the mere progress of the exact sciences and the sudden emergence of technical abilities. The inventions are made because they can be put to good use, because there is a mass demand for industrial goods which it is impossible to satisfy with the old production methods and because the material means for effecting the necessary technical alterations are available. In the previous history of the sciences, considerations for industry had played a relatively small part; it is not until the last third of the eighteenth century that research comes to be dominated by the technological outlook. Nevertheless, the Industrial Revolution does not signify an absolutely new beginning. It is, in fact, the continuation of a development which had already started at the end of the Middle Ages. Neither the divorce between capital and labour nor the businesslike organization of goods production is new; machines had been known for centuries, and ever since there had existed a capitalistically based economy, the rationalization of production had been constantly progressing. But the mechanization and rationalization of production now enters a decisive phase of its development in which the past is entirely liquidated. The gulf between capital and labour becomes unbridgeable; the power of capital, on the one hand, and the suppression and misery of the working class, on the other, reach a stage in which the whole atmosphere of life is changed. However old the beginnings of this

development are, at the end of the eighteenth century it leads to a new world.

The Middle Ages, with all its relics, its corporative spirit, its particularistic forms of life, its irrational, traditional methods of production, disappears once and for all, to make room for an organization of labour based solely on expediency and calculation and a spirit of ruthless competitive individualism. With the thoroughly rationalized factory, run on these principles, the 'modern age' in the real sense of the word—the machine age—begins. There arises a new type of working system conditioned by mechanical methods, the strict division of labour and an output adapted to meet the needs of mass consumption. As a consequence of the depersonalization of labour, its emancipation from the personal capacities of the worker, a far-reaching matter-of-factness in the relationship between employee and employer arises. Harder conditions and more constrained forms of life arise with the concentration of the working class in the industrial cities and their dependence on the fluctuating labour market. As a result of being tied to one definite factory, the capitalist develops a new and stricter morality of work; for the labourer, however, who feels no kind of personal link between himself and the factory, the ethical value of work disappears. Finally, a new social structure comes into being: a new capitalist stratum (the modern employers), a new urban middle class, threatened with extinction (the heirs of the small and medium tradesmen and manufacturers), and a new working class (the modern industrial proletariat). Society loses the former differentiation of professional types and, especially in the lower grades, the levelling process is terrifying. Craftsmen, day labourers, propertyless and uprooted peasants, skilled and unskilled workmen, men, women and children, all become mere drudges in a great, mechanically functioning factory run on the lines of a barracks. Life loses its stability and continuity, all its forms and institutions are dislocated and always shifting. The mobilization of society is conditioned, above all, by the migration to the towns. Whilst the enclosures and the commercialization of agriculture lead to unemployment, the new industries create new opportunities for labour; the result is the depopulation of the village and the overpopulation of the

industrial city, which, with its dreary routine and its over-crowding, represents a completely unfamiliar and bewildering background to life for the uprooted masses. The cities are like great labour camps and prisons, they are uncomfortable, unclean, unhealthy and ugly beyond all conception.[62] The living conditions of the urban working class sink to such a low level that the existence of the medieval serf seems quite idyllic in comparison.

The amount of capital necessary to run an industrial undertaking capable of standing up to competition leads to the fundamental divorce between labour and the means of production, and brings about the typically modern struggle between capital and labour. Since the means of production are only within the reach of the capitalist, all the worker can do is to offer his labour for sale and make his existence entirely dependent on the chances of the prevailing market, in other words, to run the risk of a situation in which he is threatened by the constant fluctuation of wages and by periodical unemployment. It is not, however, only the destitute labouring class that succumbs in the competitive struggle against the factory, but also the small independent master craftsmen—they, too, lose their independence and the feeling of security. The new method of production also deprives the propertied classes of their peace of mind and their confidence. The most important form of wealth was formerly landed property, which became transformed only slowly and hesitantly into commercial and banking capital; but even mobile capital participated in industry only to a very small extent.[63] It is only from about 1760 onwards that the industrial undertaking becomes a popular form of capital investment. But the running of a factory, with its machines, its consumption of raw material and its army of workmen, presupposes more and more considerable means and leads to a more intense accumulation of capital than was required by the previous forms of goods production. With the new concentration of wealth and its investment in means of production the era of high capitalism truly begins.[64] But the highly speculative phase of capitalist development also begins. In the older agrarian economy capital risks and speculation were unknown, and to indulge in risky transactions even in industrial and financial business had hitherto been rather

exceptional; but the new industries gradually become too much for the capitalists, and factory owners often play with bigger stakes than they can afford to lose. An existence endangered in this way produces, for all its actual prosperity, an outlook on life from which the optimism of an earlier age vanishes beyond recall.

The new type of capitalist—the industrial leader—develops new talents with his new function in economic life and, above all, a new discipline and evaluation of labour. He allow-commercial interests to recede to a certain extent and concens trates on the internal organization of his factory. The principle of expediency, methodical planning and calculability, which had become very important in the economy of the leading countries since the fifteenth century, now becomes all-powerful. The employer disciplines himself just as ruthlessly as he does his work-men and employees, and becomes just as much the slave of his concern as his staff.[65] The raising of labour to the level of an ethical force, its glorification and adoration, is fundamentally nothing but the ideological transfiguration of the striving for success and profit and an attempt to stimulate even those elements who share least in the fruits of their labour into enthusiastic co-operation. The idea of freedom is part of the same ideo-logy. In view of the risky nature of his business, the industrial employer must enjoy absolute independence and freedom of movement, he must not be hampered in his activity by any out-side interference, must not be injured in favour of his rivals by any measures of state. The essence of the Industrial Revolution consists in the triumph of this principle over the medieval and mercantilist regulations.[66] Modern economy first begins with the introduction of the principle of *laissez-faire*, and the idea of individual freedom first succeeds in establishing itself as the ideo-logy of this economic liberalism. These connections do not, of course, prevent both the idea of labour and the idea of freedom from developing into independent ethical forces and from often being interpreted in a really idealistic sense. But to realize how small a part was played by idealism in the rise of economic liberalism, it is only necessary to recall that the demand for free-dom of trade was directed, above all, against the skilled master, in order to take away from him the only advantage he had over

the mere contractor. Adam Smith himself was still far from claiming such idealistic motives for the justification of free competition; on the contrary, he saw in human selfishness and the pursuit of personal interests the best guarantee for the smooth functioning of the economic organism and the realization of the general weal. The whole optimism of the enlightenment was bound up with this belief in the self-regulating power of economic life and the automatic adjustment of conflicting interests; as soon as this began to disappear, it became more and more difficult to identify economic freedom with the interests of the general weal and to regard free competition as a universal blessing.

The author's aloofness towards his characters, his strictly intellectual approach to the world, the reserve in his relationship to the reader, in a word, his classicistic-aristocratic restraint, comes to an end, as economic liberalism begins to establish itself. The principle of free competition and the right of personal initiative are paralleled by the author's desire to express his subjective feelings, to make the influence of his own personality felt and to make the reader the direct witness of an intimate conflict of mind and conscience. This individualism, however, is not simply the translation of economic liberalism into the literary sphere, but also a protest against the mechanization, levelling-down and depersonalization of life connected with an economy left to run itself. Individualism transfers the system of *laissez-faire* to the moral life, but, at the same time, protests against a social order in which human beings are severed from their personal inclinations and become the bearers of anonymous functions, the buyers of standardized goods and mere tools in a world growing more and more uniform every day. The two basic forms of social causality, imitation and opposition, now combine to produce the romantic mood. The individualism of this romanticism is, on the one hand, a protest of the progressive classes against absolutism and state interventionism, but, on the other, it is also a protest against this protest, that is to say, against the concomitant phenomena and consequences of the Industrial Revolution, in which the emancipation of the bourgeoisie was completed. The polemical character of romanticism is expressed, above all, in the fact that it does not merely move in individual-

istic forms, but makes its individualism the basis of a definite programme. To start with, it is able to formulate its ideal of personality and its world-view only in terms of contradiction and negation. There have always been strong, self-willed individuals, and Western man had already become conscious of his individuality in the Renaissance, but it is only since the middle of the eighteenth century that individualism as a challenge and a protest against the depersonalization inherent in the process of civilization has existed. It goes without saying that conflicts between the individual and the world, between the personality and society, between the citizen and the state, had also occurred in earlier periods of literature, but the antagonism had never been felt to flow from the individual character of the person in conflict with the collective unit. In the drama, for example, the conflict did not result from the motif of a fundamental estrangement of the individual from society or the conscious revolt of the individual against social ties, but from a concrete, personal antithesis between the different characters in the play. It is entirely arbitrary to explain the tragedy in the older drama as resulting from the idea of individuation; such an interpretation turns out on closer analysis to be an untenable, if ever so pleasant, construction of romantic aesthetics. Before the romantic period, individualism as an attitude had never become problematical, it could, therefore, not become the theme of a dramatic conflict either.

Like individualism, emotionalism, too, serves the middle class as a means of expressing its intellectual independence of the aristocracy. Sentiments are asserted and emphasized, not because they are suddenly experienced more strongly and more deeply, but are exaggerated by auto-suggestion, because they represent an attitude opposed to the aristocratic outlook on life. The so long despised bourgeois looks at himself admiringly in the mirror of his own spiritual life, and the more seriously he takes his feelings, moods and impulses, the more important he appears to himself. In the middle and lower strata of the bourgeoisie, where this emotionalism has the deepest roots, the cult of the sentiments is, however, not merely a premium put on success but, at the same time, a compensation for lack of success in practical life. As

soon, however, as the culture of the feelings has found its objective expression in art, it makes itself more or less independent of its origin and goes its own ways. The sentimentalism which was originally the expression of bourgeois class-consciousness, and due to the repudiation of aristocratic aloofness, leads to a cult of sensibility and spontaneity, the connection of which with the anti-aristocratic frame of mind of the middle class is increasingly lost to sight. At first people were sentimental and exuberant, because the aristocracy was reserved and self-controlled, but soon inwardness and expressiveness become artistic criteria, the validity of which is recognized even by the aristocracy. There is a deliberate hunt for spiritual shocks and gradually a real emotional virtuosity is achieved, the whole soul is dissolved in pity and, in the end, the only aim pursued in art is the excitement of the passions and the rousing of the sympathies. Sentiment becomes the most reliable medium between artist and public and the most expressive means of interpreting reality; to hold back from the expression of feeling now means to forgo artistic influence altogether, and to be without feeling means to be dull.

The moral rigorism of the middle class is, like its individualism and emotionalism, another weapon directed against the aristocratic outlook. It is not so much the continuation of the old middle-class virtues of simplicity, honesty and piety, as more a protest against the frivolity and extravagance of a social stratum whose levity has to be made good by others. The middle class plays off its prudery, especially in Germany, first of all against the immorality of the princes, which it only dares to attack in this indirect way. But it is quite unnecessary to mention their moral corruption directly; it is sufficient to praise the pure morals of the middle class, and everyone knows what is meant.[67] Now a regular occurrence in the eighteenth century repeats itself: the aristocracy accepts the viewpoint and standards of value of the middle class; virtue becomes a fashion in the upper classes, just as sentimentality had become a vogue. With the exception of a few specialists of obscenity, not even the French novelists have any longer a desire to be described as frivolous; what the public looks for now is the praise of virtue and the condemnation of vice. Perhaps Rousseau himself might not have given so

much space in his works to moralizing sermons, if he had not known that Richardson owed his success very largely to such digressions.[68]

But if the tendency to individualism, emotionalism and moralism still lay to some extent in the very nature of the middle-class mind, the literature of pre-romanticism called forth qualities in it which were foreign to its earlier disposition, thus, above all, the proneness to melancholy which was in contradiction to the former middle-class optimism, to elegiac moods and even to a decided pessimism. This phenomenon cannot be explained by a spontaneous change of mind, but only by social displacements and restratifications. The upholders of the romantic movement are, first of all, not quite the same elements of the middle class as in the first half of the century had formed the bourgeois contingent of the reading public. The new strata, which make themselves heard now, have no intellectual contacts with the aristocracy and less reason for optimism than the economically privileged bourgeoisie. But even the old reading public, the bourgeoisie which had intermingled with the aristocracy, has altered in its spiritual outlook. Its elation with victory, its confidence, its self-assurance, which were almost boundless at the time of its first successes, dwindle and evaporate. It now begins to take its achievements for granted, to become conscious of what has been denied it, and it already feels perhaps that it is menaced by the classes that are climbing up from below. The misery of the exploited has a disturbing and depressing effect in any case. A deep melancholy possesses men's souls; the shady sides and the inadequacies of life are seen everywhere; death, night, loneliness and the yearning for a distant, unknown world, removed from the present, become the main theme of poetry and literature, and a surrender is made to the intoxication of suffering, just as a surrender had been made to the voluptuousness of sentimentalism.

In the first half of the century middle-class literature still had a thoroughly practical and realistic character; it was borne by a healthy common sense and filled with a love for immediate reality. After the middle of the century it suddenly comes to consist of nothing but escapism, above all the attempt to escape from strict rationality and watchful consciousness into turbid

emotionalism, from culture and civilization into the irresponsi-
bility of the state of nature and from the clear present into the
infinitely ambiguous past. Spengler once remarked how strange
and unprecedented was the cult of the ruin in the eighteenth
century;[69] but the longing of the educated man for the primitive
state of nature was no less strange and the suicidal self-dissolution
of reason in the chaos of sentiment no less unprecedented—all
tendencies, however, which make themselves felt in English
literature even before the appearance of Rousseau. In contrast to
the yearning for the historical past, which was a product of
romanticism itself, the yearning for nature as an escape from
conventionality had a long history behind it. It had appeared
repeatedly, as we know, in the form of bucolic poetry at the
height of the urban and courtly cultures, and as an artistic trend
independent of naturalism, often indeed in opposition to it. Even
in the eighteenth century the love for nature bears more a
moral than an aesthetic character, and has practically nothing to
do with the later naturalistic interest in reality. For the poets of
pre-romanticism there is a direct relationship between the simple,
honest man, living in modest middle-class circumstances, who
now appears for the first time as an ideal in literature—for
example in Goldsmith—and the 'innocence of nature'; they re-
gard the countryside as the most suitable and most harmonious
background for the activities of such a man. But they do not
see nature more exactly nor do they enter into more intimate
details in their descriptions than would be in keeping with a
normally progressing development of the means of aristic expres-
sion. Their relationship to nature merely has different moral
presuppositions than that of their predecessors. Nature for them
is still the expression of the divine idea, and they continue to
interpret it according to the principle of 'Deus sive natura'; it is
not until the nineteenth century that a more direct, more un-
prejudiced approach to nature was achieved. But the generation
of the pre-romantics experiences nature, in contrast to earlier
times, in any case, as the revelation of moral powers, ruling in
accordance with human moral concepts. The changing seasons of
the day and year, the quiet moonlit night and the raging tempest,
the mysterious mountain landscape and the unfathomable sea,

all this they see as a great drama, a play in which the manifesta-
tions of human destiny are transferred to the wider setting of
nature. Nature now takes up much more space in literature than
formerly, and in this respect, too, romanticism paves the way for
a new development, in opposition to classicism, which is limited
to the purely human world; it still does not signify, however, a
break with the anthropocentrism of older literature, but, at most,
the transition from the humanism of the enlightenment to the
naturalism of the present time. The heterogeneous make-up of
the pre-romantic conception of nature is also expressed in the
English garden, the great symbol of the age, that combines
within itself perfectly natural and thoroughly artificial char-
acteristics. It is a protest against all straight lines, against every-
thing rigid and geometrical, and it is a profession of faith in
the organic, the irregular and the picturesque; but with its
artificial hills, ponds, islands, bridges, grottoes and ruins, it also
represents just as unnatural a pattern as the French park, the
only difference being that it is guided by different rules of taste.
How far removed this generation still was from a clear rejection
of classicism is best shown by the fact that the same artists who
design romantically picturesque gardens follow the manneristic
trend of Palladio when they have to build palaces. The Gothiciz-
ing style, which now emerges, is used, to start with, only in
buildings of lesser importance, such as villas and country-house-
like castles.[70] The upper classes make a fundamental distinction
in art between public and private purposes, and realize that
the anti-classicistic and romantic form is only suitable for the
latter. A Horace Walpole, who has his castle, Strawberry Hill, built
in the Gothic style and, at the same time, introduces the fashion
of medieval subjects in the novel with his *Castle of Otranto*, is
anything but a romantic spirit; as far as grand, representative
art is concerned, he continues to acknowledge traditional classical
ideals. But even if his experimenting with medieval themes is
only the expression of a fondness for innovation, the romantic
trend of these experiments is no less significant as a symptom of
the age.[71]

In the case of intellectual movements, such as the romantic,
it is almost impossible to establish a definite beginning; they

often have their source in tendencies which suddenly emerge and, for lack of adequate response, are dropped again, in a word, in tendencies which remain individual experiments with no particular sociological relevance. There are already 'romantic' phenomena in the style of the seventeenth century, and in the first half of the eighteenth century we meet them on every hand. But it is hardly possible to speak of a romantic movement in the real sense before the appearance of Richardson; he is the first to combine the most essential characteristics of the style. And he finds such a felicitous formula for the new trend of taste that the whole of romantic literature, with its subjectivism and sentimentalism, seems to depend on him. At any rate, such a mediocre artist has never exerted such a deep and lasting influence; or, to put it in other words, the historical importance of an artist has never been determined by reasons lying so entirely outside his own artistic genius. The decisive reason for Richardson's influence was that he was the first to make the new middle-class man, with his private life, living within the framework of the home, absorbed by his family affairs, unconcerned with fictitious adventures and marvels, the centre of a literary work. The stories he tells are those of ordinary middle-class people, not heroes and rogues, and what he is concerned with are the simple, intimate affairs of the heart, not lofty and heroic deeds. He forgoes the amassing of colourful and fantastic episodes and concentrates on the spiritual life of his heroes. The epic material of his novels is based on a slender plot, which is nothing more than a pretext for analysing the emotions and examining the conscience. His characters are thoroughly romantic, but free of all romanesque and picaresque traits.[72] He is also the first to stop creating exactly definable types; he portrays the mere flow and fluctuation of feelings and passions—the characters as such do not interest him particularly.

With the contraction of the world of the novel to the modest and often idyllic private life of the middle class, with the limitation of the motifs to the great and simple fundamentals of family life and the fondness for unpretentious, unobtrusive destinies and characters, in a word, with the reduction of the novel to the domestic scene, it also becomes more ethical in its purpose. This

process is connected not merely with the shift in the composition of the reading public and the entry of the middle classes into the literary world, but also with the general 'repuritanization' of English society, which takes place about the middle of the century and adds substantially to the public for the new literature.[73] The main purpose of the family novel and the novel of manners is didactic, and Richardson's novels are fundamentally moral tracts in the form of pathetic love stories. The author takes on the rôle of a spiritual adviser, discusses the great problems of life, forces the reader to examine himself, clears up his doubts and helps him with fatherly counsel. He has been rightly called a 'Protestant father confessor', and it was not for nothing that his books were recommended from the pulpit. Their influence can only be understood if one takes into account their double function as light reading and as devotional literature, and remembers that, as the family reading of the middle class, they not only satisfied a new need but eliminated an old one and displaced the reading of the Bible and Bunyan.[74] Today, in an age in which the subjective approach in literature has long since established itself, it is difficult to explain what it was in these novels that fascinated the contemporary public so greatly and affected it so deeply; but one must not forget that there was as yet nothing in the literature of the time to compare with the directness and intensity of the psychological descriptions in these novels. Their expressionism acted as a revelation and the frankness of the self-exposure of their characters seemed to be unsurpassable, however affected and forced the tone of these confessions seems to us today. But at that time it was a new tone, a tone sounding from the depth of a Christian soul that had lost its bearings in the struggle of life and was seeking a new foothold. The middle class immediately grasped the importance of the new psychology and understood that its own deepest qualities were finding expression in the emotional intensity and inwardness of these novels. It knew that a specifically middle-class culture could only be constructed on this foundation and it therefore judged Richardson's novels not according to traditional criteria of taste, but according to the principles of the bourgeois ideology. It developed new standards of aesthetic value from them, such as

subjective truth, sensibility and intimacy, and laid the foundations of the aesthetic theory of modern lyricism. But the upper classes were also perfectly conscious of the significance of this confessional literature, and rejected its plebeian exhibitionism with disgust. Horace Walpole calls Richardson's novels dreary tales of woe, which describe life as if through the eyes of a bookseller or a Methodist preacher. Voltaire is silent about Richardson and even a d'Alembert is very reserved about him. Good society does not adopt the subjective view of art held by the romantics until its social origins have already become effaced and its social function has partly changed.

Richardson's success-morality is just as foreign to the upper classes as his subjectivism. The recommendations and admonitions which he bestows, to show the aspiring middle class how to make its way in society, form a moral philosophy which means nothing to the aristocracy and the upper bourgeoisie. It is the morality of the hard-working apprentice who marries his master's daughter, as Hogarth portrayed him, or of the virtuous maiden who is finally married by her master, as Richardson himself describes her, establishing one of the most popular themes of modern literature. *Pamela* is the prototype of all such modern wish-fulfilment stories. The development of the motif leads from Richardson to the films of our day, in which the irresistible private secretary withstands all the wiles of seduction and induces her presumptuous boss to marry her in the proper manner. Richardson's moralizing novels contain the germ of the most immoral art that has ever existed, namely the incitement to indulge in those wish-fantasies in which decency is only a means to an end, and the inducement to occupy oneself with mere illusions instead of striving for the solution of the real problems of life.[75] They also, for that reason, denote one of the most important dividing lines in the history of modern literature; previously the works of an author were either really moral or immoral, but since his time the books which want to appear moral in most cases merely moralize. In the struggle against the upper classes the bourgeois loses his innocence, and, as he has to emphasize his virtue all too often, he becomes a hypocrite.

The autobiographical form of the modern novel, whether a

story told in the first person or in letter or diary form, merely serves to intensify its expressionism and is only a means of stressing the shift of attention from outside to inside. From now onwards the diminution of the distance between the subject and the object becomes the principal aim of all literary effort. With the striving for this psychological directness, all the relations between the author, the hero and the reader are changed: not only the author's relation to his public and the characters of his work, but also the reader's attitude to these characters. The author treats the reader as an intimate friend and addresses himself to him in a direct, so to say, vocative style. His tone is constrained, nervous, embarrassed, as if he were always speaking about himself. He identifies himself with his hero and blurs the dividing line between fiction and reality. He creates a middle-kingdom for himself and his characters, which is sometimes remote from the reader's world, sometimes fused with it. Balzac's attitude to the characters of his novels, of whom he was in the habit of speaking as if they were personal acquaintances, has its origin here. Richardson falls in love with his heroines and sheds bitter tears over their fate; but his readers also speak and write about Pamela, Clarissa and Lovelace as if they were real, living persons.[76] There arises a hitherto unheard of intimacy between the public and the heroes of novels; the reader not only invests them with a greater spaciousness of life than the life enclosed within the limits of the particular work, he not only imagines them in situations which have nothing to do with the work itself, he also brings them constantly into relationship with his own life, his own problems and ambitions, his own hopes and disappointments. His interest in them becomes entirely personal, and in the end he can only understand them at all in relation to his own personality. It is true that even in earlier times the heroes of the great novels of knighthood and adventure were taken as models; they were ideals—idealizations of real men and ideal patterns for men of flesh and blood. But it would never have occurred to the ordinary reader to measure himself by their standards and to relate their privileges to himself. The heroes moved *ab ovo* in a different sphere; they were mythical figures and their stature in matters of good and evil was of superhuman quality. The

remoteness of the symbol, of the allegory, of the legend, separated them from the reader's own world and prevented an all too direct relationship with them. Now, on the contrary, the reader has the feeling that the hero of the novel is merely consummating his— the reader's—unfulfilled life and realizing his neglected opportunities. For, at some time or other, everyone has been on the point of experiencing a novel in real life and of becoming something like the hero of a novel. From such illusions the reader derives his right to put himself on the same level as the hero and to claim for himself his exceptional position, his extra-territorial rights in life. Richardson invites the reader to put himself in the position of the hero, to romanticize his existence, and encourages him to absent himself from the fulfilment of the duties of the unromantic daily round. In this way, the author and the reader become the principal actors in the novel; they flirt with each other all the time and maintain an illegal relationship in which all the rules of the game are broken. The author speaks to the public over the footlights and the readers often find him more interesting than his characters. They enjoy his personal comments, reflections, 'stage directions' and do not take it amiss, for example, when Sterne becomes so preoccupied with his marginal comments that he never reaches the story itself.

Both for the author and the public the work is, above all, the expression of a spiritual situation, the value of which lies in the immediacy and personal quality of the experiences described. The reader is moved only by what is represented as a stirring, exciting, introverted event involving the destiny of a well-defined, interesting individual. To make an impression, the work must be a homogeneous, self-contained drama, made up entirely of a series of smaller 'dramas', each of which moves towards its own particular climax. In other words, an effective work develops in a rising crescendo, from point to point, from climax to climax. Hence the loaded, forced, often violent quality of expression that characterizes the productions of modern art and literature. Everything is bent on immediate effect, on surprise and stupefaction. Novelty is desired for novelty's sake; the piquant and the extraordinary is sought after, because it stimulates the nerves. It is this need which gives rise to the first thrillers and the first 'historical'

novels with their mysterious atmosphere, filled with the false grandeur of history. All this signifies a lowering of the prevailing standard of taste and heralds the beginning of a decline in quality. In many respects the artistic culture of the nineteenth century is superior to that of the eighteenth, but it shows a weakness which was unknown to the age of the rococo: it lacks the safe and balanced, if not always the most flexible criteria of courtly art. It goes without saying that even before the romantic movement weak and unimportant artistic products existed, but everything that was not purely dilettante had a certain level and there arose neither literary works which had anything in common with the cheap psychology and trashy sentimentality of later light fiction, nor works in the plastic arts which had anything in common with the insipidity of the neo-Gothic, for example. These phenomena do not appear until leadership in cultural affairs passes from the upper classes to the middle class, although they do not always arise in the lower classes themselves. But in judging a turning point like the one under consideration here, the criterion of taste proves perhaps to be too narrow and sterile to be worth abiding by. 'Good taste' is not merely an historically and sociologically relative concept, but it has also only limited significance as a category of aesthetic valuation. The tears which are shed in the eighteenth century over novels, plays, musical compositions, are not only the sign of a change in taste and of the shift of aesthetic value from the exquisite and the reserved to the drastic and the importunate, they mark, at the same time, the beginning of a new phase in the development of that European sensibility of which the Gothic was the first triumph and of which the nineteenth century was to be the climax. This turning point signifies a much more radical break with the past than the enlightenment itself, which, in fact, represents merely the continuation and completion of a development that had been in progress since the end of the Middle Ages. The criterion of mere taste breaks down in face of a phenomenon like the beginning of this new emotional culture, which leads to a wholly new concept of poetry. 'La poésie veut quelque chose d'énorme et sauvage', as Diderot says,[77] and although this wildness and audacity is not realized immediately, nevertheless, it stands before the poet as

an artistic ideal, as the imperative demand that poetry should move, overwhelm and infatuate the human heart. The 'bad taste' of the pre-romantics is the origin of a development to which we owe, to some extent, the most valuable qualities of nineteenth-century art. Balzac's impetuosity, Stendhal's complexity, Baudelaire's sensibility, are just as inconceivable without it as Wagner's sensualism, Dostoevsky's spirituality or Proust's neurasthenia.

The romantic tendencies which appear in Richardson were first given European significance and a universally applicable form by Rousseau. The irrationalism, which was able to make its way in England only slowly, was developed by a Swiss, whom Mme de Staël described with good reason as the representative of the Nordic, that is, of the German spirit in French literature. The Western European nations were permeated so deeply by the ideas of the enlightenment, by its rationalism and materialism, that the emotional and spiritualistic trend met with strong opposition, to begin with, and found a bitter enemy even in a man like Fielding, who, after all, represented the same middle class as Richardson. Rousseau approached the problems of the time with much less prejudice than the intellectual leaders of the enlightened West. He not only belonged to the comparatively traditionless petty bourgeoisie, he was also a déclassé who did not feel tied even to the conventions of this class. Such conventions were, moreover, on the whole more elastic in Switzerland, which had remained unaffected by court life and uninfluenced by the aristocracy, than in France or England. The emotionalism which in Richardson and the other representatives of English pre-romanticism was not always directly aimed at the rationalism of the enlightenment, and in which the antithesis to this movement was often only latent, assumed the character of open rebellion in Rousseau. His *Back to Nature!* had only one motive in the last analysis: to strengthen resistance to a development which had led to social inequality. He turned against reason, because he saw in the process of intellectualization also that of social segregation. Rousseau's primitivism was only a variant of the Arcadian ideal and a form of those dreams of redemption which one meets in all exhausted cultures,[78] but in Rousseau that feeling of 'discomfort

with culture', which so many generations before him had felt, became conscious for the first time and he was also the first to develop a philosophy of history from this cultural weariness. The real originality of Rousseau consisted in his thesis, so monstrous in its implications for the humanism of the enlightenment, that the cultured man is degenerate and the whole history of civilization a betrayal of the original destination of mankind, that, therefore, the basic doctrine of the enlightenment, the belief in progress, turned out on closer examination to be a superstition. Such a revaluation of standards could only take place along with a radical change in the whole social philosophy of the time, and can only be explained by the fact that the strata represented by Rousseau no longer considered it possible to fight the artificiality and mendacity of court culture with the instruments of the enlightenment; they sought for weapons which did not derive from the intellectual arsenal of their enemies. In the criticism which Rousseau directed against the culture of the rococo and the enlightenment, in his exposure of their mechanical and often soulless formalism, to which he opposed the idea of the spontaneous and the organic, he was not merely expressing his awareness of the cultural crisis in which Europe had been involved ever since the destruction of the Christian unity of the Middle Ages, but also the modern concept of culture in general, with its inherent antagonism of spirit and form, spontaneity and tradition, nature and history. The discovery of this tension is Rousseau's epoch-making achievement. But the danger of his teaching was that, with his one-sided championing of life against history, his escape to the state of nature which was nothing more than a leap into the unknown, he prepared the way for those nebulous 'philosophies of life' which, out of despair at the apparent powerlessness of rational thinking, argue that reason should commit suicide.

Rousseau's ideas were in the air; he only expressed what many of his contemporaries knew, namely that they were faced with a choice and had to decide either for Voltairianism, with its reasonableness and respectability, or for the surrender of historical traditions and a completely new beginning. There is no personal relationship in the whole history of European culture

with more profound symbolic significance than that between Voltaire and Rousseau. These two contemporaries, if not precisely members of the same generation, who were bound to one another by innumerable material and personal ties, who had mutual friends and supporters, both of whom were contributors to such an ideologically sharply defined literary undertaking as the *Encyclopédie* and were regarded as the most influential precursors of the Revolution, stood on the two opposite sides of the great watershed which divided modern, individualistic and anarchic Europe from a world in which the ties of the old formalistic culture were not yet wholly dissolved. Rousseau's naturalism implies the denial of everything that Voltaire considered the quintessence of civilization, above all, of the limitations of a subjectivism which, in his opinion, was only permitted as long as it was reconcilable with the rules of decency and self-respect. Before Rousseau, except in certain forms of lyric poetry, a writer had spoken only indirectly about himself, but after him writers spoke of hardly anything else, and in the most free and easy manner. It is since that time that that idea of a literature of experience and confession first arose which was uppermost in Goethe's mind when he declared that all his works were only the 'fragments of a great confession'. The mania for self-observation and self-admiration in literature and the view that a work is the more true and the more convincing, the more directly the author reveals himself in it, are part of the intellectual inheritance of Rousseau. In the next hundred to hundred and fifty years everything of importance in European literature is stamped with this subjectivism. Not only Werther, René, Obermann, Adolphe, Jacopo Ortis, are among the successors of Saint-Preux, but also the heroes in later novels—from Balzac's Lucien de Rubempré, Stendhal's Julien Sorel, Flaubert's Frédéric Moreau and Emma Bovary to Tolstoy's Pierre, Proust's Marcel and Thomas Mann's Hans Castorp—are derived from it. They all suffer from the discrepancy between dream and reality and are the victim of the conflict between their illusions and practical, commonplace, middle-class life. The motif first finds full expression in *Werther* —and one must recall the impact of this new experience, to understand the unparalleled impression the work made on the

contemporary public—but the antithesis is already latent in the *Nouvelle Héloïse*. Here, too, the hero no longer faces individual opponents but a necessity, which he does not yet, however, regard as absolutely soulless and bereft of all intelligible purpose, like the hero of the later novel of disillusionment, but which he also by no means raises to a higher level than himself, as does the tragic hero the fate that destroys him. But without Rousseau's pessimistic approach to history and without his doctrine of the depravity of the present, the nineteenth-century novel of disillusionment is just as inconceivable as the conception of tragedy held by Schiller, Kleist and Hebbel.

The depth and extent of Rousseau's influence are without precedent. He is one of those minds which, like Marx and Freud in more recent times, change the thinking of millions within a single generation, and of many who do not even know them by name. By the end of the eighteenth century, at any rate, there were very few thinking men who had remained unaffected by Rousseau's ideas. Such an influence is possible only when a writer is in the deepest sense the representative and spokesman of his generation. With Rousseau the wider classes of society, the petty bourgeoisie and the undifferentiated mass of the poor, the oppressed and the outlawed, found expression for the first time in literature. It is true that the 'philosophes' of the enlightenment often sided with the common people, but they merely came forward as its intercessors and protectors. Rousseau is the first to speak as one of the common people himself, and to speak for himself when he is speaking for the people; the first to induce others to rebellion, because he is a rebel himself. His predecessors were reformers, world-improvers, philanthropists—he is the first real revolutionary. They hated 'despotism', agitated against the Church and positive religion, were enthusiastic about England and freedom, but continued to live the life of the upper class and felt that they belonged to it, in spite of their democratic sympathies; Rousseau, on the other hand, not only stands on the side of the poorest and lowliest, not only fights for absolute equality, but remains all his life the same petty bourgeois as he was born and the déclassé into which the conditions of his life had made him. In his youth he comes to know the real misery

which none of the gentleman 'philosophers' knew from personal experience, and even later on he continues to lead the life of a man from the lower ranks of the middle class, for a time even that of a peasant. Before him, however lowly their origins may have been, writers were considered as belonging to the higher ranks of society; however deep their sympathy with the common people, they tried rather to keep their descent from the common people a secret than to make a show of it. Rousseau, on the other hand, stresses on every possible occasion that he has nothing at all in common with the upper classes. Whether this is simply 'plebian pride' and whether it is a mere feeling of resentment are questions which may be left undecided, the decisive point is that the differences between Rousseau and his opponents are not merely questions of opinion but vital class antagonisms. Voltaire said of Rousseau that he wanted to make civilized mankind creep on all fours again; and that must have been the opinion of the whole of the educated and conservative upper class. For them Rousseau was not only a fool and a charlatan but also a dangerous adventurer and criminal. But Voltaire was protesting not merely, as the bourgeois and the rich gentleman that he was, against Rousseau's plebeian emotionalism, vulgar enthusiasm and lack of historical understanding, he was also resisting, as a sober, critical, realistically-minded citizen and scholar, the abyss of irrationalism which Rousseau had torn open and which threatened to swallow up the whole structure of the enlightenment. How great this danger in fact was, and how justified Voltaire's fears were, is shown by the fate of the enlightenment in Germany. In France, Voltaire under-estimated perhaps the fruits of his own influence; here the achievements of rationalism and materialism could no longer be undermined.

In spite of his unmixed democratic feelings, to classify Rousseau sociologically is not easy. Social relationships are now so complicated that a writer's subjective attitude is not always an adequate criterion when it is a question of considering his rôle in the social process. Voltaire's rationalism turned out to be in some respects more progressive and more fruitful than Rousseau's irrationalism. The latter takes up a more radical point of view than the encyclopaedists, it is true, and represents wider circles of

society politically not only than Voltaire but also than Diderot, yet in his religious and moral views he is less progressive than they.[79] Just as his sentimentalism is profoundly middle-class and plebeian, but his irrationalism reactionary, so his moral philosophy also contains an inner contradiction: on the one hand, it is saturated with strongly plebeian characteristics, but on the other, it contains the germ of a new aristocratism. The concept of the 'beautiful soul' presupposes the complete dissolution of kalokagathia and implies the perfect spiritualization of all human values, but it also implies an application of aesthetic criteria to morality and is bound up with the view that moral values are the gift of nature. It means the recognition of a nobility of soul to which everyone has a right by nature, but in which the place of irrational birthrights is taken by an equally irrational quality of moral genius. The way of Rousseau's 'spiritual beauty' leads, on the one hand, to characters like Dostoevsky's Myshkin, who is a saint in the guise of an epilectic and an idiot, on the other, to the ideal of individual moral perfection which knows no social responsibility and does not aspire to be socially useful. Goethe, the Olympian, who thinks of nothing but his own spiritual perfection, is a disciple of Rousseau just as much as the young freethinker who wrote *Werther*.

The change of style which takes place in literature with English pre-romanticism and the work of Rousseau, the replacement of objective and normative by more subjective and less restrained forms, is probably expressed most clearly of all in music, which now, for the first time, becomes an historically representative and leading art. In no other form did the change-over occur so suddenly and so violently as here, and to such a degree that even the contemporary public spoke of a 'great catastrophe' having taken place in music.[80] The acute conflict between Johann Sebastian Bach and his immediate successors, above all the irreverent way in which the younger generation made fun of his out-of-date fugal form, reflects not only the change from the lofty and conventional style of the late baroque to the intimate and simple style of the pre-romantics, but also the transition from a still fundamentally medieval method of juxtaposition, which the rest of the arts had already overcome in the Renaissance, to an

73

emotionally homogeneous, concentrated, dramatically developed form. Not only Bach himself but the whole music of his time seems, measured by the standard of the other arts, conservative. Bach's immediate successors could rightly describe the master's style as 'scholastic', for however deeply felt this style is and however often its very emotional depth thrills the listener, the rigid, rigorous form, the learned, pedantic counterpoint and the whole impersonally conventional mode of expression of Bach's compositions could not but appear antiquated to the representatives of the new subjective trend, if they took their own concept of simplicity, directness and intimacy as the criterion. The essential point for them, as for the representatives of the romantic movement in literature, was the expression of the flow of the emotions as a unified process with a gradual intensification and a climax, if possible with a conflict and a solution, in contrast to a constant feeling spreading itself out equally over the whole movement.[81] Their feelings were neither deeper nor more intensive than those of their predecessors, they merely took them more seriously and wanted to make them seem more important, and for that reason they dramatized them. This tendency towards dramatization was the real distinction between the new self-contained forms of the Lied and the sonata and the old sequential forms of the fugue, the passacaglia, the chaconne and the other forms based on imitation and variation.[82] The impression made by the older music was controlled and measured, if only as a result of the uniform treatment of the emotional content, whereas that made by the more modern music, with its constant rising and falling, tension and solution, exposition and development, was intrinsically disturbing and exciting. The 'dramatic' mode of expression, aiming at piquant climaxes, is to be explained, first of all, by the fact that the composer found himself faced with a public whose attention had to be roused and captivated by more effective means than those to which the older public had responded. Simply because he was afraid of losing contact with his audience, he developed the musical composition into a series of constantly renewed impulses, and worked it up from one expressive intensity to another.

Until the eighteenth century all music was written more or less for a specific occasion; it was commissioned by a prince, by the

Church or by a town council, and had the task of entertaining a court society, of adding depth to public worship or enhancing the splendour of public festivities. Composers were court musicians, church musicians or town musicians; their artistic activity was limited to the fulfilment of the duties connected with their office, —it probably occurred to them but rarely to compose on their own responsibility, without a commission. Apart from church services, festivities and dance entertainments, the middle class had seldom any opportunity of hearing music; it was only by way of an exception that they were able to attend the performances of the orchestras in the employ of the nobility and the courts. About the middle of the century people began to feel that this was a weakness and town concert societies were founded.[83] The originally private 'Collegia musica' paved the way for public concerts and with them there developed a musical life which the middle class could call its own. The concert societies hired large halls and the musicians played for payment to ever-increasing audiences.[84] This led to the creation of a free market for musical products, corresponding to the literary market with its newspapers, periodicals and publishers. But whereas literature, like painting, had already made itself more or less independent of the practical utilization of its products, music remained functional until the eighteenth century. Anything in the nature of useless music had not existed at all before this time and pure concert music, the only purpose of which was to express feelings, only existed from the eighteenth century onwards. The audiences which attended the public concerts were different in several essential respects from those before whom musical performances at court were given: they had, first of all, less practice in the criticism of music written for its own sake and not for a religious purpose; it was a public which paid for its music from concert to concert and, therefore, one that had to be satisfied and won over again and again; it gathered simply to enjoy the music as music, that is to say, unrelated to any other purpose, such as had hitherto been the case in church, at the dance, at civic festivities or even in the social framework of court concerts. These peculiar characteristics of the new concert public brought about that fight for success in which the main weapon was the concentration, the

forcing and piling up of effects and which conditioned that loaded style struggling constantly to intensify the expressiveness of the composition, which typifies the music of the nineteenth century.

The middle class becomes the chief consumer of music and music the favourite art of the middle class, the form in which it can express its emotional life more directly and with less hindrance than in any other. And as music now comes to be written not for a set purpose, but to express feelings, the composer not only begins to feel a dislike for all music written for specific occasions and in fulfilment of commissions, but to despise composition as an official activity altogether. Philip Emmanuel Bach already considers the pieces he writes merely for himself his best. This announces a conflict of conscience and a crisis where in earlier times no antithesis of any kind had been suspected to exist. The best-known and the most blatant example of the conflicts to which the new subjectivism leads is the estrangement of Mozart from his employer, the Archbishop of Salzburg. Nothing is more typical of the opposition which now arises between the musician in official employment and the creative artist than the differentiation of the virtuoso from the composer and the ordinary orchestral player from the leader of the orchestra. The development proceeds extraordinarily quickly and it is surprising that the lack of absolute mastery of even a single instrument, which is so characteristic of the modern composer, is already evident in the case of Haydn.[85]

But the rise of the middle-class concert public changes not merely the nature of artistic effects and the social position of the artist, but also gives a new direction to musical composition and a new significance to the individual work within the total output of a composer. The fundamental difference between composing for a nobleman or a personal patron in general and working for the anonymous concert public is that the commissioned work is usually intended for a single performance, whereas the concert piece is written for as many repeats as possible. That explains not only the greater degree of care with which such a work is often composed but also the more exacting way in which the composer presents it. Now that it is possible to create works which would not be consigned to oblivion so quickly as commissioned works, he

sets out to create 'immortal' works. Haydn already composes much more cautiously and slowly than his predecessors. But even he writes over a hundred symphonies; Mozart writes only half as many and Beethoven only nine. The final change-over from objective composing done to commission to composition as a personal confession takes place somewhere between Mozart and Beethoven, or still more precisely, at the beginning of Beethoven's maturity, that is, immediately before the 'Eroica'—at a time, therefore, when the organization of public concerts is already fully developed and the music trade, which first gains ground with the need for repeat performances, forms the composer's chief source of income. In the case of Beethoven, from this time onward every new work of any size is the expression not only of a new idea but also of a new phase in the artist's development. Such a development can, of course, also be discerned in the case of Mozart, but with him the precondition of a new symphony is by no means always to be sought in a new stage of his artistic evolution; he writes a new symphony when he has use for one or when something new occurs to him, but this novelty need not be in any way stylistically different from his earlier symphonic ideas. Art and craft, which are not wholly divorced in him, are completely separate in Beethoven, and the idea of the unique, unrepeatable, utterly individual work of art is realized even more purely in music than in painting, although the latter had made itself independent of craftwork centuries ago. In literature, as well, the emancipation of the artistic purpose from the practical task had already been perfectly accomplished in Beethoven's day and become so much a matter of course that Goethe was able to assert with something of the pride of the practical craftsman that all his poetry was occasional in its origins. Beethoven, who was still the direct pupil of Haydn, the servant of princes, would not have been so proud of the fact.

3. THE ORIGINS OF DOMESTIC DRAMA

The middle-class novel of manners and family life represented a complete innovation compared with the various forms of

heroic, pastoral and picaresque novel, which had dominated the whole field of light fiction until the middle of the eighteenth century, but it was by no means so deliberately and methodically opposed to the older literature as the middle-class drama, which arose in conscious antithesis to classical tragedy and became the mouthpiece of the revolutionary bourgeoisie. The mere existence of an elevated drama, the protagonists of which were all members of the middle class, was in itself an expression of the claim of this class to be taken just as seriously as the nobility from which the heroes of tragedy had sprung. The middle-class drama implied from the very outset the relativizing and belittling of the heroic and aristocratic virtues and was in itself an advertisement for bourgeois morality and the middle-class claim to equality of rights. Its whole history was determined by its origins in bourgeois class-consciousness. To be sure, it was by no means the first and only form of the drama to have its source in a social conflict, but it was the first example of a drama which made this conflict its very theme and which placed itself openly in the service of a class struggle. The theatre had always propagated the ideology of the classes by which it had been financed, but class differences had never before formed more than the latent, never the manifest and explicit content of its productions. Such speeches as, shall we say, the following had never been heard before: 'Ye Athenian aristocrats, the injunctions of your kinship morality are inconsistent with the principles of our democratic state: your heroes are not only fratricides and matricides, they are also guilty of high treason.' Or: 'Ye English barons, your reckless manners threaten the peace of our industrious cities; your crown-pretenders and rebels are no more than imposing criminals.' Or: 'You Paris shopkeepers, money-lenders and lawyers, know that if we, the French nobility, go under, a whole world will go under which is too good to compromise with you.' But now such things were stated quite frankly: 'We, the respectable middle class, will not and cannot live in a world dominated by you parasites, and even if we ourselves must perish, our children will win the day and live.'

Because of its polemical and programmatical character, the new drama was burdened from the very outset with problems unknown to the older forms of the drama. For, although these

also were 'tendentious', they did not result in plays with a thesis to propound. It is one of the peculiarities of dramatic form that its dialectical nature makes it a ready vehicle for polemics, but the dramatist himself is prevented from taking sides in public by its 'objectivity'. The admissibility of propaganda has been disputed in this form of art more than in any other. The problem first arose, however, after the enlightenment had turned the stage into a lay-pulpit and a platform and had in practice completely renounced the Kantian 'disinterestedness' of art. Only an age which believed as firmly as this one in the educable and improvable nature of man could commit itself to purely tendentious art; every other age would have doubted the effectiveness of such clumsy moral teaching. The real difference, however, between the bourgeois and the pre-bourgeois drama did not consist exactly in the fact that the political and social purpose which was formerly latent was now given direct expression, but in the fact that the dramatic conflict no longer took place between single individuals but between the hero and institutions, that the hero was now fighting against anonymous forces and had to formulate his point of view as an abstract idea, as a denunciation of the prevailing social order. The long speeches and indictments now usually begin with a plural 'Ye' instead of the singular 'You'. 'What are your laws, of which you make your boast,' declaims Lillo, 'but the fool's wisdom, and the coward's valour, the instrument and screen of all your villainies? By them you punish in others what you act yourselves, or would have acted, had you been in their circumstances. The judge who condemns the poor man for being a thief, had been a thief himself, had he been poor.'[86] Speeches like that had never been heard before in any serious play. But Mercier goes even further: 'I am poor, because there are too many rich'—says one of his characters. That is already almost the voice of Gerhart Hauptmann. But, in spite of this new tone, the middle-class drama of the eighteenth century no more implies the criteria of a people's theatre than does the proletarian drama of the nineteenth; both are the result of a development in which all connection with the common people has long been lost, and both are based on theatrical conventions which have their source in classicism.

In France the popular theatre, which had masterpieces like *Maître Pathelin* to its credit, was completely forced out of literature by the court theatre; the biblical-historical play and the farce were supplanted by high tragedy and the stylized, intellectualized comedy. We do not precisely know what had survived of the old medieval tradition on the popular stage in the provinces in the age of classical drama, but in the literary theatre of the capital and the court hardly any more of it had been preserved than was contained in the plays of Molière. The drama developed into the literary genre in which the ideals of court society in the service of absolute monarchy found the most direct and imposing expression. It became the representative genre, if only for the reason that it was suitable for presentation with an impressive social framework and theatrical performances offered a special opportunity for displaying the grandeur and splendour of the monarchy. Its motifs became the symbol of a feudalistic-heroic life, based on the idea of authority, service and loyalty, and its heroes the idealization of a social class which, thanks to its exemption from the trivial cares of everyday life, was able to see in this service and loyalty the highest ethical ideals. All those who were not in a position to devote themselves to the worship of these ideals were regarded as a species of humanity beyond the pale of dramatic dignity. The tendency to absolutism, and the attempt to make court culture more exclusive and more like the French model, led in England, too, to the displacement of the popular theatre that, at the turn of the sixteenth century, had been still completely fused with the literature of the upper classes. Since the reign of Charles I, dramatists had limited themselves more and more to producing for the theatre of the court and the higher ranks of society, so that the popular tradition of the Elizabethan age had soon been lost. When the Puritans proceeded to close down the theatres, the English drama was already on the decline.[87]

The peripeteia had always been regarded as one of the essentials of tragedy and until the eighteenth century every dramatic critic had felt that the sudden turn of destiny makes the deeper impression, the higher the position from which the hero falls. In an age like that of absolutism this feeling must have been parti-

cularly strong, and in the poetic theory of the baroque, tragedy is simply defined as the genre whose heroes are princes, generals and suchlike notabilities. However pedantic this definition may appear to us today, it does lay hold of a basic characteristic of tragedy and even points perhaps to the ultimate source of the tragic experience. It was, therefore, really a decisive turning point when the eighteenth century made ordinary middle-class citizens the protagonists of serious and significant dramatic action and showed them as the victims of tragic fates and the representatives of high moral ideas. In earlier times this kind of thing would never have occurred to anyone, even though the assertion that middle-class persons had always been portrayed on the older stage merely as comic figures is by no means in accordance with the facts. Mercier is slandering Molière when he reproaches him for having tried to 'ridicule and humiliate' the middle class.[88] Molière generally characterizes the bourgeois as honest, frank, intelligent and even witty. He usually combines such descriptions, moreover, with a sarcastic thrust at the upper classes.[89] In the older drama, however, a person from the middle class had never been made to bear a lofty and soul-stirring destiny and to accomplish a noble and exemplary deed. The representatives of the bourgeois drama now emancipate themselves so completely from this limitation and from the prejudice of considering the promotion of the bourgeois to the protagonist of a tragedy as the trivialization of the genre, that they can no longer understand a dramaturgical sense in raising the hero above the social level of the average man. They judge the whole problem from the humanitarian angle, and think that the high rank of the hero only lessens the spectator's interest in his fate, since it is possible to take a genuinely sympathetic interest only in persons of the same social standing as oneself.[90] This democratic point of view is already hinted at in the dedication of Lillo's *Merchant of London*, and the middle-class dramatists abide by it on the whole. They have to compensate for the loss of the high social position held by the hero in classical tragedy by deepening and enriching his character, and this leads to the psychological overloading of the drama and creates a further series of problems unknown to earlier playwrights.

Since the human ideals followed by the pioneers of the new middle-class literature were incompatible with the traditional conception of tragedy and the tragic hero, they emphasized the fact that the age of classical tragedy was past and described its masters, Corneille and Racine, as mere word-spinners.[91] Diderot demanded the abolition of the tirades, which he considered both insincere and unnatural, and in his fight against the affected style of the *tragédie classique*, Lessing also attacked its mendacious class character. It was now discovered for the first time that artistic truth is valuable as a weapon in the social struggle, that the faithful reproduction of facts leads automatically to the dissolution of social prejudices and the abolition of injustice, and that those who fight for justice need not fear the truth in any of its forms, that there is, in a word, a certain correspondence between the idea of artistic truth and that of social justice. There now arose that alliance, so familiar in the nineteenth century, between radicalism and naturalism, that solidarity which the progressive elements felt existed between themselves and the naturalists even when the latter, as in the case of Balzac, thought differently from them in political matters.

Diderot already formulated the most important principles of naturalistic dramatic theory. He requires not merely the natural, psychologically accurate motivation of spiritual processes but also exactness in the description of the milieu and fidelity to nature in the scenery; he also desires, as he imagines, still in accordance with the spirit of naturalism, that the action should lead not to big scenic climaxes but to a series of optically impressive tableaux, and here he seems to have in mind 'tableaux vivants' in the style of Greuze. He obviously feels the sensual attractiveness of the visual more strongly than the intellectual effects of dramatic dialectics. Even in the linguistic and acoustic field he favours purely sensual effects. He would prefer to restrict the action to pantomime, gestures and dumb-show and the speaking to interjections and exclamations. But, above all, he wants to replace the stiff, stilted Alexandrine by the unrhetorical, unemotional language of every day. He attempts everywhere to tone down the loudness of classical tragedy and to curb its sensational stage effects, guided as he is by the bourgeois fondness for the inti-

mate, the direct and the homely. The middle-class view of art, which sees in the representation of the immanent, self-sufficient present the real aim, strives to give the stage the character of a self-contained microcosm. This approach also explains the idea of the fictitious 'fourth wall', which is first hinted at by Diderot. The presence of spectators on the stage had been felt to be a disturbing influence in earlier times, it is true, but Diderot goes so far as to desire that plays should be performed as if no audience were present at all. This marks the beginning of the reign of total illusion in the theatre—the displacement of the play-element and the concealment of the fictitious nature of the representation.

Classical tragedy sees man isolated and describes him as an independent, autonomous intellectual entity, in merely external contact with the material world and never influenced by it in his innermost self. The bourgeois drama, on the other hand, thinks of him as a part and function of his environment and depicts him as a being who, instead of controlling concrete reality, as in classical tragedy, is himself controlled and absorbed by it. The milieu ceases to be simply the background and external framework and now takes an active part in the shaping of human destiny. The frontiers between the inner and the outer world, between spirit and matter, become fluid and gradually disappear, so that in the end all actions, decisions and feelings contain an element of the extraneous, the external and the material, something that does not originate in the subject and which makes man seem the product of a mindless and soulless reality. Only a society that had lost its faith in both the necessity and the divine ordinance of social distinctions and in their connection with personal virtue and merit, that experiences the daily growing power of money and sees men becoming merely what external conditions make them, but which, nevertheless, affirms the dynamism of human society, since it either owes its own ascendancy to it or promises itself that it will lead to its ascendancy, only that kind of society could reduce the drama to the categories of real space and time and develop the characters out of their material environment. How strongly this materialism and naturalism was conditioned by social factors is shown most strikingly by Diderot's doctrine of

the characters in the drama—namely, the theory that the social standing of the characters possesses a higher degree of reality and relevance than their personal, spiritual habitus and that the question whether a man is a judge, an official or a merchant by profession is more important than the sum total of his individual qualities. The origin of the whole doctrine is to be found in the assumption that the spectator is able to escape from the influence of a play much less easily, when he sees his own class portrayed on the stage, which he must acknowledge to be his class if he is logical, than when he merely sees his own personal character portrayed, which he is free to disown if he wants to.[92] The psychology of the naturalistic drama, in which the characters are interpreted as social phenomena, has its origin in this urge which the spectator feels to identify himself with his social compeers. Now, however much objective truth there may be in such an interpretation of the characters in a play, it leads, when raised to the status of an exclusive principle, to a falsification of the facts. The assumption that men and women are merely social beings results in just as arbitrary a picture of experience as the view according to which every person is a unique and incomparable individual. Both conceptions lead to a stylization and romanticizing of reality. On the other hand, however, there is no doubt that the conception of man held in any particular epoch is socially conditioned and that the choice as to whether man is portrayed in the main as an autonomous personality or as the representative of a class depends in every age on the social approach and political aims of those who happen to be the upholders of culture. When a public wishes to see social origins and class characteristics emphasized in the human portraiture, that is always a sign that that society has become class-conscious, no matter whether the public in question is aristocratic or middle-class. In this context the question whether the aristocrat is only an aristocrat and the bourgeois only a bourgeois is absolutely unimportant.

The sociological and materialistic conception of man, which makes him appear to be the mere function of his environment, implies a new form of drama, completely different from classical tragedy. It means not only the degradation of the hero, it makes the very possibility of the drama in the old sense of the term

questionable, since it deprives man of all autonomy and, therefore, to some extent of responsibility for his actions. For, if his soul is nothing but the battle-ground for contending anonymous forces, for what can he himself still be called to account? The moral evaluation of actions must apparently lose all significance or at least become highly problematical, and the ethics of the drama become dissolved into mere psychology and casuistry. For, in a drama in which the law of nature and nothing but the law of nature predominates, there can be no question of anything beyond an analysis of the motives and a tracking down of the psychological road at the end of which the hero attains his deed. The whole problem of tragic guilt is in question. The founders of the bourgeois drama renounced tragedy, in order to introduce into the drama the man whose guilt is the opposite of tragic, being conditioned by everyday reality; their successors deny the very existence of guilt, in order to save tragedy from destruction. The romantics eliminate the problem of guilt even from their interpretation of earlier tragedy and, instead of accusing the hero of wrong, make him a kind of superman whose greatness is revealed in the acceptance of his fate. The hero of romantic tragedy is still victorious in defeat and overcomes his inimical destiny by making it the pregnant and inevitable solution of the problem with which his life confronts him. Thus Kleist's Prince of Homburg overcomes his fear of death, and thereby abolishes the apparent meaninglessness and inadequacy of his fate, as soon as the decisive power over his life is put into his own hands. He condemns himself to death, since he recognizes therein the only way to resolve the situation in which he finds himself. The acceptance of the inevitability of fate, the readiness, indeed the joyfulness, with which he sacrifices himself, is his victory in defeat, the victory of freedom over necessity. The fact that in the end he does not have to die, after all, is in accordance with the sublimation and spiritualization which tragedy undergoes. The acknowledgement of guilt, or of what remains over of guilt, that is, the successful struggle to escape from the throes of delusion into the clear light of reason, is already equivalent to expiation and the restoration of the balance. The romantic movement reduces tragic guilt to the wilfulness of the hero, to his mere personal

will and individual existence, in revolt against the primal unity of all being. According to Hebbel's interpretation of this idea, it is absolutely indifferent whether the hero falls as a result of a good or evil action. The romantic conception of tragedy, culminating in the apotheosis of the hero, is infinitely remote from the melodramas of Lillo and Diderot, but it would have been inconceivable without the revision to which the first bourgeois dramatists submitted the problem of guilt.

Hebbel was fully aware of the danger by which the form of the drama was threatened by the middle-class ideology, but, in contrast to the neo-classicists, he in no way failed to recognize the new dramatic possibilities inherent in middle-class life. The formal disadvantages of the psychological transformation of the drama were obvious. The tragic deed was an uncanny, inexplicable, irrational phenomenon in Greek drama, in Shakespeare and still, to some extent, in French classical drama; its shattering effect was due, above all, to its incommensurability. The new psychological motivation gave it a human measure and, as the representatives of the domestic drama intended, it was made easier for the audience to sympathize with the characters on the stage. The opponents of the domestic drama forget, however, when they deplore the loss of the terrors, the incalculability and inevitability of tragedy, that the irrational effect of tragedy went not as a consequence of the invention of psychological motivation and that the irrational content of tragedy had already lost its influence, when the need for that kind of motivation was first felt. The greatest danger with which the drama, as a form, was threatened by psychological and rational motivation was the loss of its simplicity, of its overwhelmingly direct, brutally realistic character, without which 'good theatre' in the old sense was impossible. The dramatic treatment became more and more intimate, more and more intellectualized and withdrawn from mass effects. Not merely the action and stage procedure but also the characters themselves lost their former sharpness of definition; they became richer but less clear, more true to life but less easy to grasp, less immediate to the audience and more difficult to be reduced to a directly evident formula. But it was precisely in this element of difficulty that the main attraction of the new drama

resided, though it thereby became increasingly remote from the popular theatre.

The ill-defined characters were involved in obscure conflicts, situations in which neither the opposing figures nor the problems with which they were concerned were fully brought to light. This indefiniteness was conditioned, above all, by the comprehensive and conciliatory bourgeois morality which attempted to discover explanatory and extenuating circumstances and stood for the view that 'to understand everything is to forgive everything'. In the older drama a uniform standard of moral values had prevailed, accepted even by the villains and scoundrels;[93] but now that an ethical relativism had emerged from the social revolution, the dramatist often wavered between two ideologies and left the real problem unsolved, just as Goethe, for example, left the conflict between Tasso and Antonio undecided. The fact that motives and pretexts were now open to discussion weakened the element of inevitability in the dramatic conflict, but this was compensated for by the liveliness of the dramatic dialectic, so that it is by no means possible to maintain that the ethical relativism of the domestic drama merely had a destructive influence on dramatic form. The new bourgeois morality was all in all dramatically no less fertile than the feudal-aristocratic morality of the old tragedy. The latter knew of no other duties than those owed to the feudal lord and to honour, and it offered the impressive spectacle of conflicts in which powerful and violent personalities raged against themselves and each other. The domestic drama, on the other hand, discovers the duties which are owed to society,[94] and describes the fight for freedom and justice waged by men who are materially more narrowly tied, but are, nevertheless, spiritually free and brave—a fight which is perhaps less theatrical but in itself no less dramatic than the bloody conflicts of heroic tragedy. The outcome of the struggle is not, however, inevitable to the same degree as hitherto, when the simple morality of feudal loyalty and knightly heroism allowed of no escape, no compromise, no 'having it both ways'. Nothing describes the new moral outlook better than Lessing's words in *Nathan der Weise*: 'Kein Mensch muss muessen'—words which do not, of course, imply that man has no duties at all, but that he is inwardly free,

that is to say, free to choose his means, and that he is accountable for his actions to none but himself. In the older drama inward, in the new drama outward ties are stressed; but oppressive as the latter are in themselves, they allow absolutely free play to the dramatically relevant action. 'The old tragedy rests on an unavoidable moral duty'—Goethe says in his essay *Shakespeare and No End*: '. . . All duty is despotic . . . the will, on the other hand, is free . . . It is the god of the age . . . Moral duty makes tragedy great and strong, the will makes it weak and slight.' Goethe here takes a conservative standpoint and evaluates the drama according to the pattern of the old, quasi-religious immolation, instead of according to the principles of the conflict of will and conscience into which the drama has developed. He reproaches the modern drama for granting too much freedom to the hero; later critics usually fall into the opposite error and think that the determinism of the naturalistic drama makes any question of freedom, and therefore of dramatic conflict, impossible. They do not understand that it is dramaturgically completely irrelevant where the will originates, by what motives it is guided, what is 'intellectual' and what 'material' in it, provided that a dramatic conflict takes place one way or another.[95]

These critics put quite a different interpretation on the principle which they oppose to the hero's will from that of Goethe; it is a matter of two entirely different kinds of necessity. Goethe is thinking of the antinomies of the older drama, the conflict of duty and passion, loyalty and love, moderation and presumption, and deplores that the power of the objective principles of order has diminished in the modern drama, in comparison with that of the subjectivity. Later, necessity is usually taken as meaning the laws of empirical reality, especially those of the physical and social environment, the inescapability of which was discovered by the eighteenth century. In reality, therefore, three different things are in question here: a wish, a duty and a compulsion. In the modern drama individual inclinations are confronted by two different objective orders of reality: an ethical-normative and a physical-factual order. Philosophical idealism described the conformity to law of experience as accidental, in contrast to the universal validity of ethical norms, and in accordance with this

idealism, modern classicistic theory regards the predominance of the material conditions of life in the drama as depraving. But it is no more than a prejudice of romantic idealism to assert that the hero's dependence on his material environment thwarts all dramatic conflict, all tragic effects and makes the very possibility of true drama problematical. It is true, however, that, as a consequence of the conciliatory morality and non-tragic outlook of the middle class, the modern world offers tragedy less material than former ages. The modern bourgeois public likes to see plays with a 'happy ending' more than great, harrowing tragedies, and feels, as Hebbel remarks in his preface to *Maria Magdalene*, no real difference between tragedy and sadness. It simply does not understand that the sad is not tragic and the tragic not sad.

The eighteenth century loved the theatre and was an extraordinarily fertile period in the history of the drama, but it was not a tragic age, not an epoch which saw the problems of human existence in the form of uncompromising alternatives. The great ages of tragedy are those in which subversive social displacements take place, and a ruling class suddenly loses its power and influence. Tragic conflicts usually revolve around the values which form the moral basis of the power of this class and the ruinous end of the hero symbolizes and transfigures the ruinous end which threatens the class as a whole. Both Greek tragedy and the English, Spanish and French drama of the sixteenth and seventeenth centuries were produced in such periods of crisis and symbolize the tragic fate of their aristocracies. The drama heroizes and idealizes their downfall in accordance with the outlook of a public that still consists for the most part of members of the declining class itself. Even in the case of the Shakespearian drama, the public of which is not dominated by this class, and where the poet does not stand on the side of the social stratum threatened with destruction, tragedy draws its inspiration, its conception of heroism and its idea of necessity from the sight afforded by the fate of the former ruling class. In contrast to these ages, the periods in which the fashion is set by a social class which believes in its ultimate triumph are not favourable for tragic drama. Their optimism, their faith in the capacity of reason and right to achieve victory, prevents the tragic outcome of dramatic entangle-

ments, or seeks to make a tragic accident out of tragic necessity and a tragic error out of tragic guilt. The difference between the tragedies of Shakespeare and Corneille, on the one hand, and those of Lessing and Schiller, on the other, is that in the one case the destruction of the hero represents a higher and in the other case a mere historical necessity. There is no conceivable order of society in which a Hamlet or Antony would not inevitably come to ruin, whereas the heroes of Lessing and Schiller, Sara Sampson and Emilia Galotti, Ferdinand and Luise, Carlos and Posa, could be happy and contented in any other society and any other time except their own, that is to say, except that of their creator. But an epoch which sees human unhappiness as historically conditioned, and does not consider it an inevitable and inescapable fate, can certainly produce tragedies, even important ones; it will, however, in no way utter its final and deepest word in this form. It may, therefore, be right that 'every age produces its own necessity and thus its own tragedy',[96] yet the representative genre of the age of the enlightenment was not tragedy but the novel. In the ages of tragedy the representatives of the old institutions combat the world-view and aspirations of a new generation; in times in which the non-tragic drama prevails, a younger generation combats the old institutions. Naturally, the single individual can be wrecked by old institutions just as much as he can be destroyed by the representatives of a new world. A class, however, that believes in its ultimate victory, will regard its sacrifices as the price of victory, whereas the other class, that feels the approach of its own inevitable ruin, sees in the tragic destiny of its heroes a sign of the coming end of the world and a twilight of the gods. The destructive blows of blind fate offer no satisfaction to the optimistic middle class which believes in the victory of its cause; only the dying classes of tragic ages find comfort in the thought that in this world all great and noble things are doomed to destruction and wish to place this destruction in a transfiguring light. Perhaps the romantic philosophy of tragedy, with its apotheosis of the self-sacrificing hero, is already a sign of the decadence of the bourgeoisie. The middle class will, at any rate, not produce a tragic drama in which fate is resignedly accepted until it feels threatened with the loss of its very life; then, for the first

WATTEAU: EMBARKATION FOR CYTHERA. Paris, Louvre. Between 1716 and 1718.—Watteau's art signifies the triumph of the stylistic freedom which, with the Régence, supersedes the formalism and academicism of the "grand siècle".

1. BOUCHER. NUDE ON A SOFA. *Munich, Alte Pinakothek. 1752.—Works of this kind are most in demand with the rich bourgeoisie and the aristocracy in process of emancipating itself from the court.*

2. BOUCHER: THE BREAKFAST. *Paris, Louvre. 1738.—Boucher, the leading master of the rococo, already shows a certain emphasis on the bourgeois elements in art. His 'Breakfast' in the Louvre expresses an intimacy reminiscent of Chardin.*

1. CHARDIN: LA POURVOYEUSE. *Paris, Louvre. 1739.—Chardin was the great, unduly neglected bourgeois painter of the 18th century whom not even Diderot adequately appreciated.*

2. GREUZE: THE PUNISHED SON. *Paris, Louvre. About 1761.— Diderot saw in pictures of this kind the genuine artistic expression of the bourgeois attitude to life.*

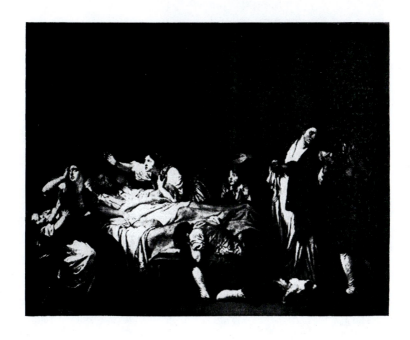

IV

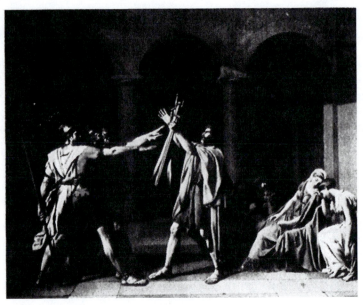

1. DAVID: THE OATH OF THE HORATII. *Paris, Louvre. 1784.—The*
work of the classicism of the revolutionary period.

2. CONSTABLE: STUDY FOR 'THE HAY WAIN'. *London, Victoria and A*
Museum. About 1821.—With Constable the decisive turning-point in
development towards the modern naturalistic landscape takes place.

time, it will see, as happens in Ibsen's play, fate knocking at the door in the menacing shape of triumphant youth.

The most important difference between the tragic experience of the nineteenth century and that of earlier ages was that, in contrast to the old aristocracies, the modern middle class felt itself threatened not merely from outside. It was a class made up of such multifarious and contrary elements that it seemed menaced by the danger of dissolution from the very outset. It embraced not only elements siding with reactionary groups and others who felt a sense of solidarity with the lower ranks of society, but, above all, the socially rootless intelligentsia that flirted now with the upper now with the lower classes, and, accordingly, stood partly for the ideas of the anti-revolutionary and anti-rationalist romantics, partly agitated for a state of permanent revolution. In both cases it aroused in the mind of the middle class doubts about its right to exist at all and about the lasting quality of its own social order. It bred a 'super-bourgeois' attitude to life—a consciousness that the middle class had betrayed its original ideals and that it now had to conquer itself and struggle to attain a universally valid humanism. On the whole, these 'super-bourgeois' tendencies had an anti-bourgeois origin. The development through which Goethe, Schiller and many other writers passed, especially in Germany, from their revolutionary beginnings to their later, conservative and often anti-revolutionary attitude, was in accordance with the reactionary movement in the middle class itself and with its betrayal of the enlightenment. The writers were merely the spokesmen of their public. But it often happened that they sublimated the reactionary convictions of their readers and, with their less robust conscience and their greater readiness to sham, simulated higher, super-bourgeois ideals, when they had really sunk back to a pre- and anti-bourgeois level. This psychology of repression and sublimation created such a complicated structure that it is often difficult to differentiate the various tendencies. It has been possible to establish that in Schiller's *Kabale und Liebe*, for example, three different generations and, therefore, three ideologies intersect each other: the pre-bourgeois of the court circles, the bourgeois of Luise's family and the 'super-bourgeois' of Ferdinand.[97] But the super-

bourgeois world here differs from the bourgeois merely by reason of its greater breadth and lack of bias. The relation between the three attitudes is really much more complicated in a work like *Don Carlos*, in which the super-bourgeois philosophy of Posa enables him to understand Philip and even to sympathize to a certain degree with the 'unhappy' king. In a word, it becomes increasingly difficult to ascertain whether the dramatist's 'super-bourgeois' ideology corresponds to a progressive or a reactionary disposition, and whether it is a question of the middle class achieving victory over itself or simply one of desertion. However that may be, the attacks on the middle class become a basic characteristic of the bourgeois drama, and the rebel against the bourgeois morality and way of life, the scoffer at bourgeois conventions and philistine narrow-mindedness, becomes one of its stock figures. It would shed an extraordinarily revealing light on the gradual alienation of modern literature from the middle classes, to examine the metamorphoses this figure underwent from the 'Storm and Stress' right up to Ibsen and Shaw. For he does not represent simply the stereotyped insurgent against the prevailing social order, who is one of the basic types of the drama of all times, nor is he merely a variant of rebellion against the particular ruler of the moment, which is one of the fundamental dramatic situations, but he represents a concrete and consistent attack on the bourgeoisie, on the basis of its spiritual existence and on its claim to stand for a universally valid moral norm. To sum up, what we are here confronted with is a literary form which from being one of the most effective weapons of the middle class developed into the most dangerous instrument of its self-estrangement and demoralization.

4. GERMANY AND THE ENLIGHTENMENT

All over Europe the romantic movement of the eighteenth century was a very conflicting phenomenon sociologically. On the one hand, it represented the continuation and the climax of that emancipation of the middle class which began with the enlightenment; it was the expression of plebeian emotionalism and, there-

fore, the opposite of the fastidious and unobtrusive intellectualism of the higher levels of society. On the other hand, however, it represented the reaction of these same higher levels against the undermining influences of the rationalism and the reformative tendencies of the enlightenment. It developed, to begin with, in the broad middle sections of the bourgeoisie which had been only superficially influenced by the enlightenment, and amongst that section which regarded the enlightenment as still all too closely allied with the old classical culture; gradually, however, it became the property of those classes which were using the emotional tendencies of the age for the attainment of their own anti-rational, socially and politically reactionary ends. But whilst the middle class in France and England remained fully conscious of its own position in society and never entirely abandoned the achievements of the enlightenment, the German middle class came under the sway of romantic irrationalism before it had passed through the school of rationalism. That is not to say that rationalism as a doctrine was without its protagonists in Germany; as a matter of fact, it was probably championed more vigorously in the German universities than anywhere else, but, characteristically, it remained a doctrine and the speciality of professional scholars and academic poets. Rationalism in Germany had never completely penetrated public life, the social and political thinking of the broad masses or the attitude to life of the middle classes. Germany could certainly boast the possession of several quite outstanding representatives of the enlightenment, such as Lessing, to name the greatest of them all and perhaps the most genuine and the most attractive personality in the whole movement, but the honest, clear-sighted and steadfast supporters of the ideas of the enlightenment were here always exceptions even among the intellectuals. The majority of the middle class and the intelligentsia were incapable of grasping the significance of the enlightenment in relation to their own class interests; it was easy to present a distorted picture of the nature of the movement to them and to caricature the limitations and inadequacies of rationalism. We must not, of course, think of the process as a kind of conspiracy, in which writers were acting as the hirelings and accomplices of the politicians in office. Probably not even the

real controllers of public opinion admitted to themselves that an ideological falsification of the facts was taking place; at any rate, the intellectual leaders of the middle classes were far from any awareness that they were perpetrating a fraud, nor in fact were they even remotely aware of anything fraudulent or treasonable in the whole proceeding.

Now, how did this faulty awareness, this political naïvety of the intelligentsia, which led in the end to the final German tragedy, come about? Why was the enlightenment never properly assimilated by the German middle classes, and why did the progressively-minded class-conscious intelligentsia fail so completely as a compact social unit? We may call the enlightenment the political elementary school of the modern middle class, without which the part it has played in the cultural history of the last two centuries would be inconceivable. It was Germany's calamity that she missed attending this school at the time and was unable to make up for lost time later on. When the enlightenment became the leading intellectual movement in Europe, the German intelligentsia was not yet sufficiently mature to take part in it, and later on it was no longer so easy to overlook the limitations and prejudices of the movement. The backwardness of the German intelligentsia is, naturally, no explanation, it must first be explained itself. In the course of the sixteenth century the German middle classes had lost their economic and political influence, which had been rising steadily since the end of the Middle Ages, and, consequently, they forfeited their importance in the cultural sphere as well. International trade shifted from the Mediterranean to the Atlantic Ocean, the Hanseatic League and the North German cities were displaced by the Dutch and English trading centres, and the South German cities, particularly Augsburg, Ratisbon and Ulm, then the main centres of German culture, declined at the same time as the Italian trading centres had their lines of communication in the Mediterranean cut off by the Turks. This decline of the German cities meant the decline of the German middle classes; the princes no longer had anything to hope or to fear from them. It is true that the power of the princes was also considerably strengthened in the West from the end of the sixteenth century and a new process of

aristocratization took place, but the Western monarchies derived part of their support in the struggle against the feudal nobility from the bourgeoisie, and as for the nobility itself, it either left trade and industry entirely to the middle classes, as happened in France, or allied itself with them, in order to make the most of the economic boom, as was the case in England. The German princes, on the other hand, who after the suppression of the peasant revolts were the undisputed masters of the country, saw a possible threat to their sovereignty not in the nobility, to which they themselves belonged and whose policies they defended before the Emperor, but in the peasantry and the middle classes. Unlike the French and English kings, the German territorial princes were great landowners with predominantly feudal interests and no particular concern for the prosperity of the bourgeoisie and the peasantry. The Thirty Years War had brought the final collapse of German commerce and destroyed the German cities economically as well as politically.[98] The Peace of Westphalia set the seal on German particularism and confirmed the sovereignty of the territorial princes; by so doing, it sanctioned conditions in contrast to which the West, where the king represented to some extent the unity of the nation and in certain circumstances defended its interests even against the nobility, can be described as progressive. Even after their reconciliation, there still remained a certain tension between the king and the stubborn nobility, from which the middle classes profited in any case. In Germany, on the other hand, the princes and the nobility always stood together, when it was a question of depriving other classes of their rights. In the West the middle classes had established themselves in the administration and could in future never be completely forced out of it again; but in Germany, where the loyalty of the army and the bureaucracy was the basis of a new feudalism, government posts were reserved, except for subordinate offices, for the nobility and the junkers. The common people were oppressed by the officials of the Crown, high and low, as much and even more than by the manorial stewards in former days. The German peasants had never known anything but serfdom, but now the middle classes, as well, lost everything they had gained in the course of the fourteenth and

fifteenth centuries. First of all, they were impoverished and deprived of their privileges, then they lost their self-confidence and self-respect. Finally, out of their misery, they developed those ideals of submissiveness and unquestioning loyalty which made it possible for any cringing philistine to think of himself as the servant of a 'higher Idea'.

Just as the development of mercantilism into free trade took place only very slowly in Germany and was hardly complete before 1850,[99] centralized political control over the territorial princes came to full fruition only in the second half of the nineteenth century. In fact, as a French historian has remarked, the interregnum lasted until 1870.[100] In the sixteenth century, the Empire recovered for a time and, supported by the absolutist tendency of the age, Charles V succeeded in consolidating the imperial power, but even he did not succeed in breaking the authority of the princes. His activities were too widely dispersed to devote himself properly to the improvement of conditions in Germany. Furthermore, with his European interests, he had to sacrifice the cause of the German Reformation out of consideration for the pope and so he missed the unique opportunity of creating a unified Germany out of a genuinely popular movement.[101] He ceded the advantages accruing to the patrons of the Reformation to the German princes, to whom Luther readily surrendered the instruments of spiritual power. He made them the heads of the established Churches and gave them authority to control the spiritual life of their subjects and to take upon themselves the cure of souls. The princes seized the ecclesiastical properties, made the official ecclesiastical appointments, took over the control of religious education, and it is, therefore, not surprising that the established Churches developed into the most reliable supports of the power of the princes. They preached the duty of obedience to the government, confirmed the 'divine right' of their illustrious overlords, and bred the stuffy, strait-laced conservative mentality which is so typical of seventeenth-century Lutheranism in Germany. The despotic particularism, which was now completely unopposed, thus estranged the progressive strata of society from the Church.

The bourgeois spirit of the fifteenth and sixteenth centuries

disappeared from German art and culture, in so far as any art and culture survived the Peace of Westphalia at all. For the Germans not only followed the courtly-aristocratic style of the French, but adopted it quite openly by importing artists and works of art from France or by slavishly imitating French models. All the two hundred petty principalities made it their great ambition to emulate the French king and the court of Versailles. Thus arose, in the first half of the eighteenth century, the most magnificent castles and palaces of the German princes: Nymphenburg, Schleissheim, Ludwigsburg, Pommersfelden, the Zwinger in Dresden, the Orangery in Fulda, the Residence in Würzburg, Bruchsal, Rheinberg, Sanssouci—all built to the same overriding pattern and furnished with a luxury out of all proportion to the means and resources of the mostly very small and very poor principalities. Thanks to this extravagance, there developed, however, something approaching a German species of the Italian and French rococo. Literature, on the other hand, gained little support and inspiration from them, except from a few outstanding patrons of the arts, and that was only towards the end of the century. 'Germany is swarming with princes, of whom three-quarters are mentally sub-normal and a disgrace to mankind,' writes a contemporary, 'small as their kingdoms are, they imagine, nevertheless, that humanity was made for them.'[102] There was, of course, a variety of different types among the German princes, more or less cultured, despotic and less despotic, art-loving and merely splendour-loving persons, but probably not a single one among all of them doubted for one moment that the only purpose in life for the average mortal was to be ruled and exploited by them.

What resources were left after the princes had indulged in all this insane luxury and extravagant building, and had covered the expense of the upkeep of the court and of their mistresses, were spent on the army and the bureaucracy. The army could, of course, only perform police duties and cost comparatively little; the burden of maintaining an expensive bureaucracy lay all the heavier on the nation. All this petty particularism occasioned in itself a multiplication of official machinery, and this was still more intensified by the bureaucratization of the state, by the

transfer of the functions of autonomous corporations to government offices, by the fondness for issuing decrees and orders and by the general tendency to regiment the whole of public and private life. It is true that the same political, economic and social system predominated in France and that the citizen was hampered by the same kind of interventionism in his business undertakings, injured by the same kind of governmental mismanagement and had to endure the same deprivation of his rights and the same lack of consideration as in Germany. In the small-scale conditions which prevailed in the German principalities, however, all these restrictions were far more oppressive and humiliating than in France. Living in direct proximity to the court, suffering from the pressure of a petty governmental machine and of a pretentious and extravagant prince, watched and supervised by less influential but no less inhuman officials, the German citizen lived an even more harassed and even more threatened life. It is true that the civil service, on its lower levels, absorbed a considerable part of the middle class, but these petty officials were corrupted from the very beginning, because government employment was the only opening compatible with their status in society. For a member of the middle class not engaged in trade or in craft, there was nothing else possible but to become a civil servant, a legal official in government service, a clergyman of the established Church or a teacher in a publicly controlled school.

The powerlessness of the middle class, their exclusion from the government of the country and from practically every kind of political activity, induced a passive mentality which affected the whole cultural life of the time. The intelligentsia, which consisted of subordinate officials, schoolmasters and unpractical poets, accustomed itself to drawing a line of demarcation between its private life and the world of politics, and to renouncing any kind of practical influence on public affairs. It made up for all this by an excess of idealism, by the emphatic disinterestedness of its ideas, and by leaving the direction of state affairs to the holders of power. This renunciation was the expression of not only a complete indifference towards apparently unalterable social conditions but also of a definite contempt for professional politics. In this way, the middle-class intelligentsia lost all contact with

social reality and became more and more isolated, eccentric and crack-brained. Its thinking became purely contemplative and speculative, unreal and irrational, its mode of expression self-willed, high-flown, incommunicable, incapable of taking others into consideration and always resisting any correction from outside. These people retired to what they called the level of the 'universally human', a level above all classes, ranks and groups, made a virtue of their lack of practical-mindedness and called it 'idealism', 'inwardness', triumph over the limitations of time and space. Out of their involuntary passivity, they developed an ideal of the idyllic private life, and out of their lack of external freedom, the idea of inward freedom and of the sovereignty of the spirit over common empirical reality. The result of this development in Germany was the complete divorce of literature from politics, and the disappearance of that representative of public opinion, so well known in the West, the writer who is a politician, a scholar and a publicist, a good philosopher and a good journalist, all at the same time.

The social development which had divided the German middle class since the end of the Middle Ages into different clearly graduated strata came to a halt in the sixteenth century. The retrograde process of a new integration set in, and led to the formation of the somewhat undifferentiated middle class that we meet in the seventeenth century. The broader strata had given up their cultural pretensions and the upper middle class had diminished to such an extent that it no longer had much significance as a cultural factor in society. It was hardly any longer possible to speak of a special select middle-class way of life, or of a special middle-class outlook as expressed in art and literature. What developed was rather a uniformly low and unpretentious level of culture reminiscent of the primitive conditions of the early Middle Ages. The revolutionary events of the sixteenth century, in particular the shifting of the centres of world economy and the strengthening of the power of the princes, destroyed the fruits of the bourgeois late Gothic and Renaissance. There was nothing left of the culture based on the middle-class standard of life; nothing left of the standards of a specifically middle-class education and of a specifically middle-class conception of art; nothing

of the intellectual atmosphere of an age in which the main stream of cultural development and the most progressive artistic and philosophical tendencies were expressed in the idiom of the middle class, and in which the leading personalities, like Dürer and Altdorfer, Hans Sachs and Jacob Böhme, were, above all, representatives of the middle-class outlook.

The middle classes which acquired wealth and esteem, as a result of the development of a money economy and as a result of the rising prosperity of the cities and the decline of the feudal aristocracy, obtained control, by a hard struggle and by using their financial power, of the larger urban municipalities, took over the administration and occupied important positions in the state government, in the princes' privy councils and in the legal senates as well. The later decline of the German cities, the consequent loss of prestige sustained by the middle classes and the steadily advancing economic ruin of the aristocracy led, however, as early as the end of the sixteenth century, to the exclusion of the middle-class element from official positions in the state and at the courts and to their replacement by members of the nobility.[103] The Thirty Years War, which also worsened the position of the feudal classes, renewed and accelerated the drift of the nobility into official posts and closed the higher reaches of the bureaucracy to the middle classes. In France the official aristocracy, which had mostly worked its way up from the middle class, developed side by side with the landed and court aristocracy; in Germany, however, the land-owning nobility itself became an official caste and the middle class was pushed back in an even more ruthless fashion than anywhere else into the ranks of the subordinate civil service. The victory of the princes meant the end of the estates as a political factor, that is to say, it meant the liquidation of the rights of both the nobility and the middle class; from that time on, there was only *one* political force, that of the princes. What happened, however, was what usually happens in such cases: the princes indemnified the nobility and sent the middle classes away empty-handed. German society was now dominated by two groups: the high state and court officials, forming a kind of new vassalage around the princes, and the lower bureaucracy, consisting of the princes' most obedient ser-

vants. Some made up for servility towards superiors by unlimited brutality towards inferiors, whilst others made a cult of discipline, regarding their superiors as spiritual directors of their own conduct and making a religion of their performance of official duty.

In the long run, however, it was impossible to hold up the progress of trade and industry for ever, despite the obstacles placed in the way of economic development by particularism with its petty interests and neglected finances. The middle classes enriched themselves once again and began to divide up into income-groups. First of all, there arose a bourgeoisie, distinct from the lower middle class, which could afford to pay for the patronage of court officials and follow the French fashions of the court. Through the influence of this upper middle class, which became, together with the court nobility, the only cultured élite left, French taste and a contempt for all native traditions spread amongst the whole intelligentsia. French literature dominated the universities and found its most fervid advocate in Gottsched, the best-known academic poet of the age; the bourgeois art of the German Renaissance, and the few traces still surviving as a living tradition, seemed coarse, undeveloped and in bad taste as compared with French ideals in art. Nevertheless, it would be quite wrong to describe Gottsched as the literary spokesman of the aristocracy; he was rather the protagonist of the bourgeoisie, which still had no artistic ideals of its own, however, and neither a distinct national character nor a clearly defined class-consciousness. It must not be forgotten, of course, that the aristocratic culture which served as a model for the middle classes and even the culture of the court aristocracy itself was merely a pseudo-culture based on stereotyped and often completely lifeless patterns.[104] The secular light reading, the only cultural need of these classes of society, was still confined around 1700 to those genres which were also popular in the French court aristocracy, above all the heroic, the pastoral and the love novel and heroic tragedy. Their authors were, however, unlike their French and English counterparts, in most cases academically educated persons, that is to say, university teachers, lawyers and court officials generally belonging to the upper middle class. Some of them were aristocrats, like Baron von Canitz, Friedrich von Spee

and Friedrich von Logau, but hardly any were representatives of the lower classes.[105] Apart from the men of high social degree, who wrote poetry for their own amusement and to pass the time, all these writers were directly or indirectly dependent on the courts. They were either in the immediate service of the princes or they worked at one of the universities and were thus hangers-on.

The first German professional poet, in the European connotation of the term, was Klopstock, although even he was unable to make himself completely independent of private patronage. The fact is that before the arrival of Lessing and the development of the metropolis as fertile literary soil, there were no independent writers in Germany at all. The upper middle class long remained loyal to French taste and the courtly forms of poetry. We know that even in a commercial city like Leipzig, and as late as the period when Goethe was a student there, rococo taste still prevailed in undisputed supremacy. Nevertheless, it was such commercial cities, as above all Hamburg and Zürich, which were the first to free themselves from the tyranny of the courts in matters of taste, and which had provided a home for middle-class literature. After the middle of the century there still existed residences where poetry was cultivated—Weimar is the classical example—but there was no more court poetry. Not only because of his origins and sympathies but also because of the very nature of his literary activity, which was chiefly critical and journalistic, Lessing was the representative of the middle classes and of urban life. When he settled in Berlin, that city was already beginning to assume the appearance of a great metropolis. It had a hundred thousand inhabitants and, partly as an after-effect of the Seven Years War, it enjoyed a certain freedom of criticism and discussion, which was suppressed, however, by Frederick II as soon as it bordered on provinces beyond the confines of religion.[106] Lessing himself referred to this characteristic limitation of the questions allowed for discussion, in a letter to Nicolai: 'Your Berlin freedom', he writes, 'reduces itself . . . to the freedom to bring to market as many absurdities against religion as you like . . . But let someone come on the scene who wants to raise his voice on behalf of the rights of subjects and against exploitation and despotism . . . and you will soon discover which is the most

servile land in Europe to this very day.' Nevertheless, Lessing knew very well what made him go to Berlin; in this great city the air was different, when all is said and done, from the air in the stuffy residences and in the walled-up universities, which were the only choice open to a writer who wanted somewhere to work.[107] It is true that Lessing led the life of a literary hack, put libraries in order, carried out secretarial duties, prepared translations, but, on the whole, he was independent. One does not begin to realize what his independence cost him, until one reads the answer he once gave to someone who asked him why he wrote such small letters; his reply was that his income from fees would not cover the expense of the paper and ink he would require, if he wrote his letters bigger. When he was over forty, nothing remained even for him, however, but to take upon himself the yoke against which he had resisted for a lifetime. He entered the service of a prince and spent the last tortured years of his life in Wolfenbüttel as librarian to the Duke of Brunswick. German literature was, nevertheless, on the upward grade by now. The number of writers increased (in 1773 there were about 3,000 authors in Germany, but in 1787 already twice as many) and in the final decades of the eighteenth century many of them could live on the proceeds of their literary work.[108] Right into the romantic period, however, most of them still found it necessary to take up a professional career. Gellert, Herder and Lavater were clergymen, Hamann, Winckelmann, Lenz, Hoelderlin and Fichte were private tutors, Gottsched, Kant, Schiller, Goerres, Schelling and the Grimm brothers were university professors, whilst Novalis, A. W. Schlegel, Schleiermacher, Eichendorff and E. T. A. Hoffmann were state officials.

With the 'Storm and Stress' movement, German literature becomes entirely middle-class, even though the young rebels are anything but lenient towards the bourgeoisie. But their protest against the encroachments of despotism and their enthusiasm for freedom is just as genuine and sincere as their anti-rationalist attitude. And even if they are merely a loosely connected group of fantasts, ignorant of the world and crazy social misfits, they are deeply rooted in the middle class and cannot deny their origins. The whole period of German culture which extends from

the 'Storm and Stress' to the romantic movement is borne by this class; the intellectual leaders of the age think and feel in accordance with middle-class attitudes and the public to which they turn consists mainly of middle-class elements. It does not by any means embrace the whole of the middle class, it is true, and is often restricted, in fact, to a not very numerous élite, but it, nevertheless, represents a progressive tendency and accomplishes the final dissolution of courtly culture. The bourgeoisie develops into a cultured class, distinct not only from the nobility but also from the academic class, and provides a bridge between the intellectual leaders and the broad masses of the nation. Germany now becomes the 'land of the middle class', in which the aristocracy shows itself to be increasingly unproductive, whereas the bourgeoisie makes its way intellectually, in spite of its political weakness, and undermines the non-bourgeois forms of culture with its rationalism. The rationalism of the eighteenth century is one of those movements the progress of which can be retarded but not brought to a standstill by reactionary counter-currents. No social group is able to keep itself wholly aloof from it, and the German intelligentsia all the less, as its irrational tendencies are derived from a misunderstanding of its real interests. The situation in Germany is, therefore, briefly as follows: the attitude to life of the upholders of culture becomes middle-class, their ways of thinking and modes of experience become rationalized and revolutionized, a new type of intellectual arises, who is inwardly without ties, that is, free of traditions and conventions, without being able or often even wanting to exert a corresponding influence on political and social reality. He fights against the rationalism of which he is the involuntary supporter, and becomes, to some extent, the pioneer of the conservatism which he imagines he is struggling against. Thus conservative and reactionary are everywhere mixed up with progressive and liberal tendencies.[109]

Lessing knew that the 'overcoming' of rationalism by the 'Storm and Stress' was an aberration of the middle class; that also explains the reserve he showed towards Goethe's early works, especially *Goetz* and *Werther*.[110] The criticism of the rationalistic popular philosophy was certainly justified, but, in the given

situation, it needed more intelligence to disregard the inade-
quacies of rationalism than to be obsessed by them. In its fight
against the Church, which was inseparably allied with absolutism,
the enlightenment had become insensitive to everything con-
nected with religion and the powers of the irrational in history.
The representatives of the 'Storm and Stress' movement now
played off these powers against the 'disenchanted', sober reality
of their time, to which they felt themselves to be in no way
bound. But in so doing, they merely conformed to the wishes of
the ruling classes, who were endeavouring to divert attention
from the reality of which they had made themselves masters.
They encouraged any idea representing the purpose of the world
as inexplicable and incalculable, and promoted the spiritualizing
of the problems, hoping thereby to deflect the revolutionary
tendency of developments in the intellectual sphere and to induce
the middle class to content itself with an ideological instead of a
practical solution.[111] Under the influence of this opiate, the
German intelligentsia lost its feeling for positive and rational
knowledge and replaced it by intuition and metaphysical vision.
Irrationalism was certainly a universal European phenomenon,
but it was expressed everywhere essentially as a form of emotion-
alism, and first received its special quality of idealism and
spiritualism in Germany; it was only here that it developed into
a philosophy of contempt for empirical reality, based on the time-
less and the infinite, on the eternal and the absolute. As a form
of emotionalism, the romantic movement still had a direct link
with the revolutionary tendencies at work in the middle class,
as a form of idealism and super-naturalism, on the other hand,
it became increasingly remote from progressive middle-class
thought. It is true that the starting point of German idealism was
Kant's anti-metaphysical theory of knowledge, with its roots in
the enlightenment, but it developed the subjectivism of this doc-
trine into an absolute renunciation of objective reality and
reached a position of decided opposition to the realism of the
enlightenment. German philosophy in the person of Kant had
already become estranged from the cultured lay public of the
period, above all because of its jargon, which it was simply im-
possible for the uninitiated to understand and which identified

profundity with difficulty. German scientific style successively assumed that often vague, coquettish character, iridescent with half-expressed intimations, which differentiates it so sharply from the style of Western European scientific language. At the same time, the Germans also lost the feeling for the simple, sober and certain truths which are so highly honoured in the West, and their fondness for speculative constructions and complications developed into a real passion.

The intellectual habit, described as 'German thinking', 'German science', 'German style', must not, however, be regarded as the expression of an unchanging national character, but merely as a mode of thinking and writing which arose in a definite period of German history, that is to say, in the second half of the eighteenth century, and was created by a definite social stratum, the middle-class intelligentsia which was excluded from the government of the country and was practically without influence. This stratum played just as important a part in the development of the German cultured class as did the litterateurs of the enlightenment in that of the French reading public. What Tocqueville asserts of the origins of the typical French mentality, namely that it owes its tendency to rational, evident and general ideas to the enormous influence of the literature of the enlightenment,[112] can also be applied mutatis mutandis to the origins of the German frame of mind with its eccentricity and its passion for surprises and complications. Both are the creation of an epoch in which the literary class in process of self-emancipation exerted a more lasting influence than ever before on the intellectual development of the nations. In the whole of the West, in France and England as well as in Germany, the eighteenth century was the age which saw the beginnings of modern scientific thinking and of the criteria of education to some extent still regarded as valid today. They arose with the modern middle class and to it owe their tenacity. Thus, for example, in his *Zauberberg*, Thomas Mann still judges the enlightenment from the same point of view as did the 'Storm and Stress'. He, too, speaks of the 'shallow optimism' of the pedagogical century, and, in the character of Settembrini, he typifies the West European rationalist as an idle speechifier and complacent humanitarian.

106

The unreality expressed in the abstract thinking and esoteric language of the German poets and philosophers is also apparent in their exaggerated individualism and mania for originality. Their desire to be absolutely different from everyone else is, like their jargon, merely a symptom of their a-social nature. Mme de Staël's words, 'trop d'idées neuves, pas assez d'idées communes', are a most succinct diagnosis of the German mind. What the Germans lacked was not Sunday cake but daily bread. They lacked that healthy, alert, universally acknowledged public opinion, which in the Western European countries set a limit on individual aspirations from the very beginning and created a common trend of thought. Mme de Staël already recognized that the individual freedom, or as Goethe called it, the 'literary sansculottism', of the German poets was nothing more than a compensation for their exclusion from active political life. But their esoteric language and their 'profundity', their cult of the difficult and the complicated, were derived from the same source. It was all the expression of an attempt to make up for the political and social influence, denied to the German intelligentsia, by cultivating intellectual exclusiveness and making the higher forms of intellectual life just as much the reserve of an élite as political rights.

The German intellectuals were incapable of grasping that rationalism and empiricism were the natural allies of the progressive middle class and the best preparation for a social order in which oppression would sooner or later have to come to an end. They could have done the forces of conservatism no greater service than to bring the 'sober language of the reason' into discredit. These intellectuals were confused in their aims, on the one hand, because the German princes took a patronizing interest in the enlightenment for the sake of appearance and adapted the rationalism of the old absolute régime to the new cultivation of the reason, and on the other hand, because of the religious traditions of the petty bourgeois homes from which they came and which were often intellectually conditioned by the father's pastoral calling. Most of the representatives of the intelligentsia inherited these traditions, which now see an important revival under the influence of Pietism. In its campaign against the

107

enlightenment, the intelligentsia confined itself, above all, to those fields in which anti-rationalism had the broadest scope, and borrowed its intellectual weapons mainly from the religious and aesthetic sphere. The religious experience was in itself irrational and the experience of art became irrational to the extent that the aesthetic criteria of court culture were left behind. Following the example of Neoplatonism, the two spheres were first of all allowed to merge into each other, but later the primacy in the new world-view was given to the aesthetic categories. The features of a work of art, which are impenetrable by the reason and not to be defined in logical terms, had already been observed and emphasized by the Renaissance: they did not have to wait until now to be discovered; but the eighteenth century first drew attention to the fundamental irrationality and irregularity of artistic creation. This anti-authoritarian age, with its deliberate and planned opposition to courtly academicism, was the first to deny that the reflexive and rationalized intellectual functions, the artistic intelligence and the critical faculty, had any part in the origins of a work of art. The establishment of anti-rationalism met, at any rate, with less opposition in this sphere than in the theoretical field. The tendencies opposed to the enlightenment, therefore, withdrew, to begin with, to the aesthetic line, and conquered the intellectual world from this vantage ground. The harmonious structure of the work of art was transferred from the aesthetic sphere to the whole cosmos, and an artistic plan was ascribed to the creator of the universe, as had already been done by Plotinus. That 'the beautiful is a manifestation of secret powers of nature' was asserted even by the otherwise in no way mystically inclined Goethe, and the whole natural philosophy of the romantic movement revolved around this idea. Aesthetics became the basic discipline and the organ of metaphysics. Even in Kant's theory of knowledge, experience was the creation of the knowing subject, just as the work of art had always been considered the product of the artist tied to but master of reality. Kant thought he was in a position to say practically nothing about the constitution of the object in itself but a great deal about the spontaneity of the subject, and he transformed knowledge, which had been understood by the whole of classical antiquity and the Middle

Ages as an image of reality, into a function of the reason. The opposition of objectivity to the freedom of the subject diminished in the course of time, and reality, as the object of knowledge, finally became the unrestricted domain of the creative subject. How could such a change in the conception of the world take place? Philosophical systems are committed to paper in libraries and studies, it is true, but they do not originate in them; and if this, nevertheless, does occur once in a while, as it actually did in the case of German idealism, then there are solid, practical reasons for that too. The studies of the German philosophers were impenetrably walled up and the experience out of which these philosophers developed their systems was precisely their isolation, their loneliness, their lack of influence on practical affairs. Their aestheticism was partly the expression of their aloofness from the world in which the 'mind' had proved itself to be powerless, partly the roundabout way towards the realization of a human ideal that could not be realized by the direct way of political and social education.

Voltaire and Rousseau became household words in Germany almost simultaneously, but the influence of Rousseau was incomparably deeper and wider than that of Voltaire. Even in France, Rousseau did not find so many and such enthusiastic supporters as he did in Germany. The whole 'Storm and Stress' movement, Lessing, Kant, Herder, Goethe and Schiller were dependent on him and acknowledged their indebtedness to him. Kant saw in Rousseau the 'Newton of the moral world', and Herder called him a 'saint and prophet'. The authority which Shaftesbury attained in Germany stood in a similar relationship to the fame he enjoyed in his own country. English specialists of the eighteenth century ascribe no particular importance to him and find it impossible to understand how this 'second-rate' writer was able to acquire such celebrity in Germany.[113] But with a closer knowledge of conditions there, it is not so difficult to explain why an anti-rationalist like Shaftesbury, with his belief in spiritual values and his opposition to Locke, his Platonic enthusiasm and his Neoplatonic idea of beauty as the innermost essence of the divine, made such a deep impression on the Germans. Shaftesbury was a typical Whig aristocrat and his

intellectual peculiarity was best expressed in the kalokagathia of his pedagogic ideal and his aestheticizing moral philosophy. His 'self-breeding' was nothing more than the translation of aristocratic selection from the physical to the intellectual and moral sphere. The sociological origin of his ideal of personality was just as unmistakably reflected in the idea that the conflict between egoistic and altruistic instincts, by which the lower classes of humanity are morally depraved, is settled in the higher 'educated' classes, as in the identification of the true and the good with the beautiful. The idea that life is a work of art at which one works, guided by an infallible instinct ('moral sense'), just as the artist is guided by his genius, was an aristocratic conception which was taken up with such enthusiasm by the German intelligentsia, merely because it was so completely open to misunderstanding and its aristocratic quality could be interpreted as an awareness of intellectual nobility.

To the enlightenment the world appeared as something thoroughly intelligible, explicable and open to explanation, whereas the 'Storm and Stress' regarded it as something fundamentally incomprehensible, mysterious and, from the standpoint of the human reason, without meaning. Such views are not simply the product of excogitation and are not conditioned by logical rules. The one is the result of a consciousness of being able to control or, at any rate, to conquer reality, the other is the expression of the feeling of being lost and forsaken in this reality. Whole classes of society and generations do not voluntarily relinquish the world; and if they are forced into doing so, they often invent the most beautiful philosophies, fairy tales and myths, in order to raise the compulsion to which they have succumbed into the sphere of freedom, spirituality and pure inwardness. In this way, there arose the theories of the self-realization of the Idea in history, of the categorical imperative of the moral person, the self-imposed law of the creative artist and other similar doctrines. But perhaps nothing reflects so acutely and comprehensively the motives from which the 'Storm and Stress' develops its world-view as the concept of the artistic genius, which it places at the summit of human values. The concept contains, first of all, the criteria of the irrational and the

subjective, which pre-romanticism emphasizes in opposition to the generalizing and dogmatic enlightenment, the conversion of external compulsion into inward freedom, which is rebellious and despotic at one and the same time, and, finally, the principle of originality, which, in this natal hour of the free man of letters and of an hourly increasing competitiveness, becomes the most important weapon in the intelligentsia's struggle for existence. Artistic creation, which was a clearly definable intellectual activity, based on explicable and learnable rules of taste, for both courtly classicism and the enlightenment, now appears as a mysterious process derived from such unfathomable sources as divine inspiration, blind intuition and incalculable moods. For classicism and enlightenment the genius was a higher intelligence bound by reason, theory, history, tradition and convention; for pre-romanticism and the 'Storm and Stress' he becomes the personification of an ideal characterized, above all, by the lack of all these ties. The genius is rescued from the wretchedness of everyday life into a dream-world of boundless freedom of choice. Here he lives not merely free from the fetters of reason, but in possession of mystic powers which enable him to dispense with ordinary sense experience. 'The genius has presentiments, that is to say, his feelings outrun his powers of observation. The genius does not observe. He *sees*, he feels'—says Lavater. To be sure, the irrational and unconscious aspects of the concept of genius are to be found, to begin with, in the pre-romanticism of Western Europe, first of all, in Edward Young's *Conjectures on Original Composition* (1759), but here the genius still appears alongside the mere talent, as a 'magician' alongside a good 'master builder', whereas in the art philosophy of the 'Storm and Stress' he becomes the rebellious, godlike Titan. We are no longer confronted with a necromancer, whose tricks are impossible to follow, though by no means unnatural, but with the guardian of a mysterious wisdom, the 'speaker of unspeakable things' and the law-giver of a world of his own, with laws of its own.[114] What distinguishes this concept of genius from that of Young is, above all, the extreme subjectivism which it owes to the special German situation. The personal aspects of artistic creativity were already well known both to Hellenism and the Renaissance, but neither of

these epochs attained a concept of art comparable in its subjectivity to that of the eighteenth century.[115] It is, however, even in the eighteenth century only in Germany that artistic subjectivism developed into that mania for originality, which cannot be explained merely as a protest against the dogmatism of the enlightenment and as the self-advertisement of literary men competing against each other. To understand it, one must also consider the boundless veneration in which the 'energetic man', the 'fine fellow' was held. This overstrained subjectivism, which has been called, not without justification, an 'excess of bourgeois frenzy',[116] could, naturally, only arise in a relatively free bourgeois world, independent of the class morality and solidarity of the aristocracy and dominated by the spirit of free competition, but without the psychological antagonism of the suppressed, intimidated German intelligentsia, which was always searching for compensations and wavered irresolutely between submissiveness and presumption, pessimism and exuberance, it would hardly have assumed the pathological form peculiar to the 'Storm and Stress'. Without this inner contradiction and this tendency to overcompensate for the limitations of practical life, however, not only subjectivism but also the dissolution of formal structures in art which took place in German pre-romanticism, its escape into extravagance and shapelessness, its doctrine of the fundamental falsehood and inadequacy of any form, would be unthinkable. The world that had become foreign and inimical did not propose to offer itself as material for the pre-romantics to mould into a finished shape, and so they made the atomized structure of their world-view and the fragmentary nature of their motifs symbols of life itself. Goethe's dictum on the mendacity of all forms is derived from the outlook of this generation and is absolutely in harmony with the words of Hamann, who said that all systems are 'in themselves an obstruction of the truth'.[117]

The 'Storm and Stress' was even more complicated in its sociological structure than the West European forms of pre-romanticism, and not merely because the German middle class and the German intelligentsia had never identified themselves closely enough with the enlightenment to keep their eyes sharply fixed on the aims of the movement and not to deviate from it, but

also because their struggle against the rationalism of the absolutist régime was at the same time a struggle against the progressive tendencies of the age. They never became aware of the fact that the rationalism of the princes represented a less serious danger for the future than the anti-rationalism of their own compeers. From being the enemies of despotism they, therefore, became the instruments of reaction and merely promoted the interests of the privileged classes with their attacks on bureaucratic centralization. To be sure, their struggle was not directed against the social levelling tendencies of the system, with which aristocratic and upper middle-class interests were in conflict, but against its generalizing influence and violation of all intellectual distinction and variety. They championed the rights of life, of individual being, natural growth and organic development, against the rigid formalism of the rationalized administration, and meant not only the denial of the bureaucratic state with its mechanical generalization and regimentation, but also the repudiation of the planning and regulating reformism of the enlightenment. And although the idea of the spontaneous, irrational life was still of an indefinite and fluctuating nature and certainly hostile to the enlightenment, but not yet markedly conservative in its purpose, nevertheless, it already contained the essence of the whole philosophy of conservatism. It did not need much now to ascribe a mystical superrationality to this principle of 'life', in contrast to which the rationalism of enlightened thought seemed unnatural, inflexible and doctrinaire, and to represent the rise of political and social institutions from historical 'life' as a 'natural', that is to say, superhuman and superrational growth, in order to protect these institutions against all arbitrary attacks and to secure the continuance of the prevailing system.

At first sight it is surprising that conservatism, which we are in the habit of associating with the idea of continuity and persistency, here stresses the value of life and growth, whereas liberalism, which we usually connect with the idea of movement and dynamics, bases its claims on reason. The attempt has been made to attribute this apparent paradox to the fact that the revolutionary thinking of the middle class developed in a clear, unambiguous alliance with rationalism and that the counter-

current took up the opposite ideological standpoint for the sake of 'mere opposition'.[118] But the difficulty of the problem is that the relation to rationalism of the various political tendencies of the eighteenth century is by no means clear-cut, and that even the conservatism of the age contains a certain streak of rationalism. The peculiar situation of the 'Storm and Stress' between the enlightenment and the romantic movement is conditioned by the fact that it is impossible simply to identify rationalism and anti-rationalism with progress and reaction, and that modern rationalism is not an unequivocal and specific phenomenon, but, to some extent, a general characteristic of modern history. Since the Renaissance it has made its influence felt in all periods of development and all classes of society and has sometimes shown a tendency to intellectual flexibility and mobility, at others a striving for the permanent and the universally valid. The rationalism of the Italian Renaissance was of a different kind from that of French classicism, and that of the enlightenment was again completely different from that of the court aristocracy and the absolute monarchy. There was a progressive middle-class rationalism, but there was also a rationalism peculiar to the conservative class. The middle class of the Renaissance had to fight against paralysing habits and traditions; its rationalism was, therefore, dynamic and anti-traditional in character, tending towards maximum efficiency. The aristocracy of the same period was of a knightly-romantic, unreasoning and unpractical nature, but, chiefly under the pressure of economic developments, from the end of the sixteenth century onwards, it adapted itself increasingly to the rationalism of the middle class, though not without modifying certain manifestations of this mode of thought and experience. Thus, first of all, it dropped the anti-traditionalism of the middle-class rationalist ideology, making up for that by eliminating all the elements of the fanciful and the romanesque from its own medieval conception of the world, and, in the course of the seventeenth century, it developed a philosophy of order and discipline, that was fundamentally as 'undynamic' as it was 'reasonable'. To begin with, the middle class of the enlightenment period was under the influence of this rationalistically thinking aristocracy and took over from it the ideal of a strictly

regulated, normative standard of life, even though, in other respects, it held fast to the older form of rationalism derived from the Renaissance and consistently developed the doctrine of economic efficiency and competition. But the middle class of the second half of the eighteenth century turned away from rationalism in some respects and, for the time being, left its interpretation to the nobility and the upper middle class. The middle sections of the bourgeoisie became Rousseauistic, sentimental and romantic, whereas the upper classes despised all this sentimental rubbish and remained loyal to their own intellectualism. The progressive middle class, nevertheless, preserved the anti-traditionalist and dynamic character of its outlook on life, just as the conservative classes held fast to the traditionalism of their social philosophy, in spite of the rationalism of their moral principles and their attitude to art. On closer examination, however, the specifically dynamic character, which is habitually ascribed to the liberal and progressive outlook, turns out to be just as metaphorical as the static quality ascribed to rationalism. Liberalism and conservatism are both dynamic and rationalistic at the same time, and in this phase of development, in which the Middle Ages are liquidated once and for all, it is quite impossible for them to be anything else. The only anti-rationalists left now are the idealists, who have become confused by the complex social situation, and—according to what they pass themselves off for—the propagandists of conservatism. The latter champion the rights of 'life' against reason, not because rationalism had in fact lost its authority and influence, but because concrete thinking, based on reality, of which both parties will soon claim to have a monopoly, has won a new and enhanced value.

Herder is perhaps the most characteristic figure in eighteenth-century German literature. He combines within himself the most important currents of the age and expresses most clearly that ideological conflict, that mixture of progressive and reactionary tendencies, by which the society of this time is dominated. He despises the 'matter-of-fact intellectual culture' of the enlightenment, but, on the other hand, he speaks of his age as 'a truly great century' and imagines that it is possible to reconcile his anti-rationalist convictions with an enthusiasm for the French Revolu-

tion, just as the majority of the German intelligentsia and most German writers, including Kant, Wieland, Schiller, Friedrich Schlegel and Fichte, are unconditional supporters of the Revolution, to begin with, and only renounce it after the Convention. Herder's development follows the course taken by the German intelligentsia from the rebelliousness of the 'Storm and Stress' to the more clear-sighted, though more resigned, bourgeois attitude of the classical period. His example sheds the clearest possible light on the significance of Weimar for German literature. Goethe's influence on him displaces that of Hamann and Jacobi and brings him nearer to rationalism. He writes an enthusiastic obituary notice of Lessing, the fearless fighter for the truth, and not only overcomes his earlier orthodoxy, but even gives his religion an aesthetic twist and applies his theory of the nature of folk song to the original documents of religion, so that, in the end, the Bible becomes for him merely a prototype of folk poetry. On the other hand, he finds it impossible entirely to renounce his past; the ecclesiastical ties of his youth are transformed into a moralizing philistinism, and how deeply rooted he remains in the world of conservative thought is proved by his philosophy of history, which comes very close to the ideas of Burke. What he has in common with him is, above all, his desire not to domineer, change and violate, but to understand, interpret and surrender himself to the varied forms of historical life.[119] In spite of his loving piety, Herder's morphological conception of history, which takes vegetal rotation as its starting point and sees a development from seed into bud and blossom and from flowering to withering and dying, wherever it looks, is the expression of an intrinsically pessimistic outlook on the world, that already contains the germ of Spengler's theory of the decline of civilizations.[120]

The classicism of Herder, Goethe and Schiller has been described as the belated German Renaissance and the equivalent of French classicism. But its main difference from all similar movements outside Germany is that it represents a synthesis of classicistic and romanticizing tendencies and, especially from the French point of view, appears to be absolutely romantic.[121]. But the German classicists, almost all of whom were members of the 'Storm and Stress' movement in their youth and would be incon-

ceivable without Rousseau's gospel of nature, also represent a renunciation of Rousseau's hostility to culture and to his nihilism. They live in a frenzy of culture and education, like hardly any generation of writers since the humanists, and regard the civilized society, not the gifted individual, as the real upholder of culture.[122] Above all, Goethe's educational ideal finds its true realization only in the culture of a society as a whole, and the measure in which the individual achievement fits into the bourgeois pattern of life becomes for him the very criterion of its value. Now that is the conception of culture held by a literary class which has already attained success and esteem, which is resting on its laurels and no longer feels any kind of resentment towards society. But this success in no way implies that the German classicists ever became popular; their works did not even penetrate so deeply into the national life as did the classical creations of French and English literature. And Goethe was the least popular writer of them all. In his lifetime his fame extended only to a quite exiguous cultured stratum, and even later on his writings were hardly read at all outside the ranks of the intelligentsia. He repeatedly complains about his loneliness, in spite of the fact that he was really, as Schiller says, 'the most communicative of all men' and longed for sympathy, understanding and influence on others. The mass of letters that have survived and the conversations that have been recorded show what intellectual communication, exchange and the mutual development of ideas meant to him. Goethe was, however, perfectly aware of his lack of influence, and attributed not only the character of German literature in general but also that of his own writings to the lack of social intercourse in German intellectual life. The period of his real popularity was his youth, when he published *Goetz* and *Werther*. After his move to Weimar and the beginning of his official activities, he disappeared to some extent from literary life.[123] In Weimar his public was made up of half a dozen persons —the Duke, the two Duchesses, Frau von Stein, Knebel and Wieland—to whom he read aloud his new and not particularly numerous or extensive works, that is to say, single chapters and fragments from his works. One must not imagine that even this public was especially understanding.[124] The incident with the

dog-trainer, who, in spite of Goethe's energetic protests, was allowed to perform in the court theatre, best describes the situation. One can imagine the state of affairs at the other courts, if things were as bad as this in Weimar! No particular attention was paid to German literature as such in Weimar; here, too, as in court circles and the nobility in general, reading was mostly confined to the latest French books.[125] In the wider public, in so far as it took any notice of serious literature at all, Schiller became the centre of interest during the time that Goethe spent in Italy; *Don Carlos*, for example, was received much more warmly than *Tasso*. But the greatest literary success was achieved not by Goethe or Schiller, but by Gessner and Kotzebue. It was not until the appearance of the romantics and their enthusiasm, above all, for *Wilhelm Meister* that Goethe attained his unique position in German literature.[126] The romantics' championing of Goethe is the most striking symptom of the deep and, in spite of all personal and ideological disagreements, inviolable community of interest which binds together into a single unity not only the classical and romantic movements, but the whole period of German culture from the 'Storm and Stress' onwards. Art is the great experience which they share in common, and not only as the object of supreme intellectual delight, not only as the one remaining practicable road to personal perfection, but also as the instrument by which humanity is to regain its lost innocence and achieve the simultaneous possession of nature and culture. For Schiller, aesthetic education is the only salvation from the evil recognized by Rousseau, and Goethe actually goes still further, when he maintains that art is the individual's attempt 'to preserve himself against the destructive power of the whole'. The experience of art here acquires the function which up till then only religion had been able to fulfil; it becomes the bulwark against chaos.

A sentence like this is sufficient to give one an idea of Goethe's absolutely a-religious, though perhaps not irreligious outlook on life. For, in spite of his 'Faustian' idealism, his aristocratic aestheticism and his fanatically conservative worship of order, he was one of the most uncompromising representatives of the enlightenment in Germany, and even if he cannot exactly be called a matter-of-fact rationalist, he must be considered, never-

theless, the sworn enemy of all obscurantism and the impassioned opponent of all nebulosity and mysticism, of all reactionary and retarding forces. In spite of his connection with the 'Storm and Stress', he felt a deep dislike for all romanticism, for all reckless suppression of reason, and an equally deep sympathy for the solid realism, discipline, moral appreciation of work and tolerance of the middle class. The impetuosity of the Werther period, its blazing protest against the prevailing social order and conventional morality, calmed down in the course of time, but Goethe remained an enemy of all oppression and a fighter against all injustice that threatened the middle class as a living intellectual community. It was only later in his life that he recognized the real value of this community and only in *Wilhelm Meister* that he gave an appreciation of it. It is not at all necessary to deny or to conceal Goethe's intellectually aristocratic inclinations and ambitions at court, his Olympian egocentricity and his political indifference, or even the embarrassing phrase 'rather injustice than disorder'. In spite of everything, Goethe remained a man of freedom and progress, and not only as a writer and poet whom the very realism of his art, his 'ins Reale verliebte Beschraenktheit', made into such. There are, in fact, different ways in which the fight against reaction and for progress can be carried on. One man hates the pope and parsons, another the princes and their vassals, a third the exploiters and oppressors of the people, but there are also those who experience the meaning of reaction most intensely in the deliberate obscuration of human minds and the prevention of truth, for whom all forms of social injustice are felt most acutely to be the 'sin against the spirit', and who, when they stand up for freedom of conscience, of thought and speech, fight for the indivisible freedom which is the same in all forms of life. Goethe had not much sympathy for tyrannicides, but he was very sensitive to threats to freedom of thought, and was never a party to its restriction. When, in 1794, the German intelligentsia, and especially Goethe himself, were called upon by the conservatives to place themselves at the disposal of the new league of princes, and thereby rid the country of the threatening 'anarchy', Goethe answered that he considered it impossible to bring together princes and writers in this way.[127]

Everything that contributed to the education of the young Goethe, his descent, his childhood impressions, the imperial city of Frankfurt, the commercial and university town of Leipzig, Gothic Strasburg, the Rhineland milieu, Darmstadt, Duesseldorf, the home of Fraeulein Klettenberg and the Schoenemanns, was thoroughly middle-class in the best sense, partly upper middle-class, and often bordering on the sphere of the aristocracy, but never without an inner connection with the spirit of the middle class.[128] Goethe's middle-class character was, however, not a militant attitude of mind, was never directed against the nobility as such, not even in his youth, not even in *Werther*.[129] He regarded it as more important to preserve the bourgeois way of life from obscurantism and unreality than from the influence of the higher ranks of society. The most interesting and original point about Goethe's conception of the bourgeois attitude to life was that it reflected the modern artist's awareness of his own middle-class frame of mind and that it stressed the ethical standards of ordinary work even in relation to artistic production. Goethe repeatedly emphasizes the workmanlike nature of poetic creation and demands from the artist, above all, professional reliability. Since the Renaissance, art and literature had been practised mostly by middle-class persons. The workmanlike relationship of the producer to his art was taken so much for granted that it would have been senseless to lay special stress on it. What had to be done was rather to stimulate artists and writers to raise themselves above the level of mere technical skill. It was not until the eighteenth century when, on the one hand, the middle class became more intensely conscious of its class characteristics, and, on the other hand, the unbridled subjectivism of the 'original geniuses', their repudiation of all rules and disciplines, began to act as an excrescence of bourgeois emancipation and a kind of wild competition, that it seemed advisable to remind them of the bourgeois and artisan-like origins of their profession. It was certainly no longer necessary to draw special attention to the high rank of a writer, but it was expedient to preserve the literary class from the spread of dilettantism and charlatanism. Behaving like a 'genius' was a competitive method used by writers when they were fighting for emancipation; pro-

tests against the application of such methods were first heard when they were no longer needed. To be allowed to be 'genius-like' was a symptom of the attainment of independence; no longer to want and have to be 'genius-like' was the mark of a situation in which artistic freedom had become a matter of course. The self-consciousness of the respectable burgher and recognized artist is already so strong in Goethe that he strives to avoid all extravagance both in his art and in his behaviour and feels a particular aversion for the lack of solidity and thoroughness, for the tendency to the chaotic and the patho-logical, which are, to some extent, constant traits in the artist's character.[130] He thereby anticipates a feature of the nineteenth century and of the successful modern artist, who reacts against the nonsense of bohemianism with exaggerated prudence, and adopts a normal bourgeois, indeed an almost petty bourgeois, way of life for fear of seeming unreliable.

In accordance with the dislike of successful classes for all wil-fulness and exaggerated individualism, the art ideal of German classicism shows a predominant trend towards the typical and the universally valid, the regular and the normative, the permanent and the timeless. In contrast to the 'Storm and Stress', it feels form to be the expression of the essence and the very idea of the work of art, in no sense any longer identical with a purely external harmony of relationships, with euphony and beauty of line. By form it understands 'inward form', the microcosmic equivalent of the totality of existence. Goethe finally succeeds in overcoming even this variety of aestheticism, and finds the road to a more realistic philosophy based on the idea of the bourgeois society. The content of *Wilhelm Meister* is precisely this way lead-ing from art to society, from the artistic-individualistic attitude to life to the experience of intellectual community, from the aesthetic-contemplative relation to the world to an active, socially useful life.[131] In his later period, Goethe turns away from the purely personal approach to literature and comes nearer to a super-individual, super-national conception of art, concentrated on tasks of general importance to civilization. The name and partly the concept of 'world literature' comes from him; but the thing had existed before anyone was conscious of it. The literature

of the enlightenment, the works of Voltaire and Diderot, Locke and Helvétius, Rousseau and Richardson, were already 'world literature' in the strictest sense of the word. Since the first half of the eighteenth century a 'European conversation' had been in progress, in which all civilized nations had been participating, though most of them only in a passive capacity. The literature of the period was that of Europe as a whole, the expression of a European community of ideas, such as had not been known since the end of the Middle Ages. But it was almost as acutely different from medieval literature as it was from the international literary movements of more recent times. The literature of the Middle Ages owed its universality to the Latin, that of the baroque and the rococo to the French language; the former was limited to the learned clerical class, the latter to aristocratic court cricles. Both were undifferentiated products originating in a more or less uniform intellectual outlook, not the consort of several voices, as Goethe desired, and as the enlightenment produced from the literatures of the great nations of Europe. The theory and practice of world literature was the creation of a civilization dominated by the aims and methods of world trade. The words of Goethe himself, when he compares the exchange of intellectual goods between the nations with international trade, touch on this connection and point to the origin of the concept. When Goethe goes on to speak of the 'velociferic' character of intellectual and material production and the accelerated tempo with which intellectual and material goods are exchanged, one sees how directly the whole orbit of ideas is connected with the experience of the Industrial Revolution.[132] The only curious thing is that the Germans, who of the great nations had contributed least of all to this world literature, were the first to understand its significance and to develop the idea.

5. REVOLUTION AND ART

The eighteenth century is full of contradictions. It is not only that its philosophical attitude wavers between rationalism and anti-rationalism, but its artistic aims are also dominated by two

opposite tendencies and at some times approach a strictly classi-
cistic, at others a more unrestrained pictorial conception. And like
the rationalism of the period, its classicism is also difficult to
define and open to various sociological interpretations, since it is
sustained alternately by courtly-aristocratic and middle-class
strata of society and ends by developing into the representative
artistic style of the revolutionary bourgeoisie. The fact that
David's painting becomes the official art of the Revolution only
seems strange or even inexplicable, if one conceives the concept
of classicism too narrowly and restricts it to the artistic aims of
the upper, conservatively-minded classes. Classicistic art certainly
tends towards conservatism and is well suited to represent
authoritarian ideologies, but the aristocratic outlook often finds
more direct expression in the sensualistic and exuberant baroque
than in abstemious and matter-of-fact classicism. The rational-
istically-minded, moderate and disciplined middle class, on the
other hand, often favours the simple, clear, uncomplicated forms
of classicistic art and is no more attracted by the indiscriminate
and shapeless imitation of nature than by the whimsical imagina-
tive art of the aristocracy. Its naturalism moves in most cases
within relatively narrow limits and is usually restricted to the
rationalistic portrayal of reality, that is to say, of a reality without
internal contradictions. Naturalness and formal discipline are
almost one and the same thing here. It is only in the classicism
of the aristocracy that the bourgeois principle of order becomes
transformed into a strict conformity to rigid norms, its striving
for simplicity and economy into coercion and subordination, and
its healthy logic into a cool intellectualism. In Greek classicism
or in that of Giotto, fidelity to nature is never felt to be incom-
patible with formal concentration; it is only in the art of the
court aristocracy that form holds sway at the expense of natural-
ness, and only here that it is regarded as a limitation and a
barrier. But, intrinsically, classicism no more represents an ex-
pansive, naturalistic tendency than a typical bourgeois out-
look,[133] although it often begins as a bourgeois movement and
derives its formal principles from conformity to nature. It extends,
however, beyond both the frontiers of the bourgeois view of art
and the presuppositions of naturalism. The art of Racine and

123

Claude Lorrain is classicistic without being either bourgeois or naturalistic.

The history of modern art is marked by the consistent and almost uninterrupted progress of naturalism; the tendencies towards rigorous formalism emerge comparatively seldom and never for more than a short period at a time, although they are always present as an undercurrent. The consistent association of naturalism and classical form in the work of Giotto is already dissolved in the Trecento, and in the essentially bourgeois art of the following two centuries naturalism is developed at the expense of form. The High Renaissance turns its attention again to the principles of form, without regarding the composition, however, as Giotto did, merely as an instrument of clarification and simplification but, in accordance with its aristocratic temper, as a means of enhancing and idealizing reality. And yet the art of the High Renaissance is, as we know, by no means anti-naturalistic; it is only poorer in naturalistic details and less concentrated on the differentiation of the empirical material than the art of the preceding period, but it is in no way less true and exact. Mannerism, on the other hand, which corresponds to the further progress of the process of aristocratization, connects its classicism with a series of anti-naturalistic conventions, and thereby influences the taste of the upper classes so deeply that its arty concept of beauty is accepted more or less as the standard by which all later courtly art is judged. In the second half of the sixteenth century mannerism is the leading style just as much in France as in Italy and Spain. In France its progress is suddenly interrupted, however, by the religious and civil wars under Henry IV, and this disturbance, which is prolonged by the anti-aristocratic government policy of the succeeding period, makes it possible for the middle class to exert a decisive, albeit passing influence on the further development of art. The Renaissance tradition of court culture breaks down and with the retrogression of court life, first of all, theatrical performances at court become more and more infrequent and finally come to an end altogether. The popular theatre, on the other hand, continues its modest existence even during this time of crisis. In addition to the mysteries and moralities, humanist plays are now performed on

the popular stage, though they have to adapt themselves to the scenic mobility of the medieval theatre and assume its characteristic shapelessness. The middle class that enjoys the favour of the Crown under Louis XIII, and Richelieu and even in the first period of the reign of Louis XIV and gives employment to the literary men of the period, finally succeeds in reforming this theatre, which was still suffering from a medieval lack of rules and restrictions. It develops a literary style of its own fundamentally different from the mannerism of the aristocracy, and establishes in the genre with which it has the longest and deepest connections—the drama—a new classicism based on naturalness and reasonableness. The *tragédie classique* is, therefore, not the creation of the learned humanists with their courtly taste and of the aristocratic Pléiade, as has so often been asserted, but grows out of the living and commonplace bourgeois theatre. Its formal limitations, especially its unities of time and place, do not result from the study of classical tragedy, or at least not directly, but develop, first of all, as the artistic means by which an attempt is made to heighten the stage effect and the probability of the action. Increasing bewilderment is felt that the scenery of actions taking place in different houses, cities and countries should be separated by a mere board and that the short interval between two acts should be supposed to represent months and years. On the basis of such rationalistic considerations, a dramatic action begins to be regarded as all the more probable the shorter the time and the more uniform the space is in which it takes place. The duration of the events and the distances between the various scenes is, therefore, reduced, in order to attain a more perfect illusion, and a gradual approach is made to the most obvious form of illusionism: the identification of the actual time of the performance with the imaginary time of the action. The unities accordingly conform to a perfectly naturalistic requirement, and are also represented by the dramaturgists of the period as the criteria of dramatic probability. But it is, to say the least, strange that an artistic device which led to the most far-reaching stylization and most ruthless violation of reality originally meant the victory of the naturalistic outlook and of rationalistic thought over the unbridled and indiscriminate

125

curiosity of a theatre public whose feelings were still essentially medieval.

And as in the drama, so also in the other arts, classicism is synonymous with the triumph of naturalism and rationalism: on the one hand, over the fantasy and lack of discipline, on the other hand, over the affectedness and conventionalism of art as practised hitherto. To the poetry of du Bartas, d'Aubigné and Théophile de Viau the middle class opposes the drama of men like Hardy, Mairet and Corneille and follows up the mannerism of Jean Cousin and Jacques Bellange with the naturalism and classicism of Louis Le Nain and Poussin. The fact that naturalistic classicism never becomes so predominant in the plastic arts as in the drama is to be attributed, above all, to the much less close historical relationship of the French bourgeoisie with painting than with the theatre and to the fact that it still has not the resources at its disposal necessary in order to exert such an overwhelming influence. It is true that mannerism gradually falls out of fashion in painting and sculpture too, but, in this case, it is superseded by a style that inclines more to the baroque than to classicism. In the drama, however, bourgeois classicism is entirely successful with its enforcement of the unities. The *Cid* by the Rouen solicitor Corneille, which appears in 1636, can be regarded as its final triumph. To begin with, it meets with the opposition of court circles, but the realistic and rationalistic thinking that dominates the economic and political life of the age proves to be irresistibly victorious. The aristocracy, which is subject to the influence of Spanish taste, is forced to overcome its penchant for the adventurous, the extravagant and the fantastic and to resign itself to the aesthetic criteria of the matter-of-fact and unpretentious bourgeoisie. This does not take place, however, without this philosophy of art being modified by the aristocracy, to fit in with its own ideals and aims. It preserves the harmony, the regularity and the naturalness of bourgeois classicism, since the new court etiquette regards all shrillness, noisiness and wilfulness as in bad taste, in any case, but it reinterprets the artistic economy of this aesthetic trend, in order to bring it into line with a philosophy in which concentration and precision are understood not as principles of puritanical discipline but as fastidious rules

of taste and in which they are opposed to 'coarse', unruly and incalculable nature as the norms of a higher, purer reality. Classicism, which was originally intended only to preserve and stress the organic unity and stern 'logic' of nature, in this way becomes a brake on the instincts, a defence against the flood of the emotions and a veil over the ordinary and the all-too-natural.

This reinterpretation was already partly achieved in the tragedies of Corneille, which are among the ripest manifestations of the new artistic rationalism, but which arose obviously not without regard for the requirements of the court theatre. In the succeeding period the sober, matter-of-fact, puritanical tendencies recede increasingly in court art, on the one hand, because alongside and often against its severity, the desire for a heightened display makes itself felt, on the other hand, because a general change is taking place in the whole conception of art in this century, and this leads to the freer, more emotional, more sensualistic aspirations of the baroque gaining the upper hand. In this way, there arises in French art and literature a curious proximity and interaction of classicistic and baroque tendencies, and a resulting style that is a contradiction in itself—baroque classicism. The high baroque of Racine and Le Brun contains—in the one case absolutely resolved, in the other absolutely unresolved—the conflict between the new courtly ceremonial style and the formal severity that has its roots in bourgeois classicism. It is classicistic and anti-classicistic at the same time it acts; equally through the material and the form, through fullness and restriction, expansion and concentration. Around 1680 a counter-tendency sets in against this courtly and academic style: in opposition as much to its grandiose attitudes and pretentious themes as to its alleged fidelity to classical models. The conception of art that now holds good, as a result, is less restrained, more individualistic, more intimate and it turns its liberalism, above all, against the classicism, not the baroque tendencies of court art. The success of the modernists in the 'Quarrel between the Ancients and the Moderns' is merely a symptom of this development. The Régence decides the victory of the anti-classical trend and brings about an absolute re-orientation of the prevailing

127

fashions of taste. The social origins of the new art, however, are not wholly evident. The change is carried through partly by the liberal-minded aristocracy, partly by the upper middle class. But as the art of the Régence gradually develops into the rococo, it more and more assumes the characteristics of a courtly-aristocratic style, although it bears within it from the very outset the elements of the dissolution of court culture. At any rate, it loses the concentrated, precise and solid character of classicism, shows an increasingly strong dislike for everything regular, geometrical and tectonic, and tends more and more to favour the improvization, the aperçu and the epigram. 'Si quelqu'un est assez barbare —assez classique!'—as even the by no means courtly-minded Beaumarchais says. Since the Middle Ages, art had never been so far removed from classical purity, never had it been more sophisticated and more artificial. And then, around 1750, in the midst of the rococo, a new reaction sets in. The progressive elements of society stand, in opposition to the prevailing trend, for an artistic ideal which once again bears a rationally classicistic character. No classicism had ever been more strict, more sober, more methodical than this; in none had the reduction of forms, the straight line and the tectonically significant been carried through more consistently, in none had the typical and the normative been emphasized more strongly. None had possessed the unmistakable clarity of this classicism, because none had had its strictly programmatical character, its aggressive determination to break up the rococo. Even now it is not immediately clear by which strata of society the new movement is initiated. Its first representatives, men like Caylus and Cochin, Gabriel and Soufflot, are rooted in courtly-aristocratic culture, but it soon becomes perceptible that the most progressive elements of society are the motive power behind them. The sociological derivation of the new classicism is so difficult, because the tradition of the old baroque classicism had never entirely broken down, and is just as active in the elegance of Vanloo or Reynolds as in the correctness of Voltaire or Pope. Certain classicistic formulae remain current both in painting and literature during the whole period of courtly style covering the seventeenth and eighteenth centuries, and, as regards poetic diction, the following passage from Pope, for

example, illustrates the classicism of this period just as perfectly as any text from the century of Louis XIV:

> See, through this air, this ocean, and this earth,
> All matter quick, and bursting into birth,
> Above, how high, progressive life may go!
> Around, how wide! how deep extend below!
> Vast chain of being! which from God began,
> Natures ethereal, human, angel, man,
> Beast, bird, fish, insect, what no eye can see,
> No glass can reach; from infinite to thee,
> From thee to nothing.[134]

The aloof rationalism and smooth crystalline form of these lines are different, however, even at first sight, from the vibrant tone of the following lines by Chénier which are just as perfectly classicistic but are filled with a new passion:

> Allons, étouffe tes clameurs;
> Souffre, o cœur gros de haine, affamé de justice.
> Toi, Vertu, pleure, si je meurs.

Pope's lines are still a reminiscence of the intellectual culture of the court aristocracy, whereas Chénier's are already the expression of the new bourgeois emotionalism and come from the lips of a poet who stands in the shadow of the guillotine and becomes the victim of that revolutionary middle class whose classicistic taste finds in him its first important, though involuntary, mouthpiece.

The new classicism does not arrive so unheralded as has often been assumed.[135] Ever since the end of the Middle Ages conceptions of art had developed between the two poles of a strictly tectonic trend and formal freedom, that is, between an outlook related to classicism and one opposed to it. No change in modern art represents a completely new beginning; they all link up with one or other of these two tendencies, each of which takes over the lead from the other, but neither of which is ever entirely supplanted. Those scholars who represent neo-classicism as a complete innovation usually regard it as peculiar that the development does not proceed from the simple to the complicated, in

other words, from the linear to the pictorial, or from the pictorial to the more pictorial, but that the process of differentiation 'breaks off' and the development 'jumps back' to a certain extent. Woelfflin is of the opinion that in this retrogression 'the initiative is more clearly grounded in outward circumstances' than in the uninterrupted process of increasing complication. In reality, there is no fundamental difference, however, between the two types of development, the influence of 'outward circumstances' is only more obvious in the case of an intermittent than in that of a straightforward development. In fact, outward circumstances always play the same decisive rôle. At every point and in every moment of the development it is an open question what direction artistic creation will take. The maintenance of the course already set represents a dialectical process which is just as much the result of 'outward circumstances' as a change in the prevailing trend. The attempt to hold up or interrupt the progress of naturalism does not presuppose any factors fundamentally different from those underlying the desire to maintain or accelerate its progress. The art of the age of the Revolution differs from earlier classicism, above all, by the fact that it leads to a more exclusive predominance of the strictly formal conception of art than had ever occurred since the beginning of the Renaissance, and that it represents the final conclusion of the three hundred year long development extending from the naturalism of Pisanello to the impressionism of Guardi.[136] It would, nevertheless, be unjustifiable to assert a complete lack of tension and stylistic conflict in the art of David; the dialectic of the various trends of style pulsates in it just as feverishly as in the poetry of Chénier and all the important artistic creations of the revolutionary period.

The classicism which extends from the middle of the eighteenth century to the July revolution is not a homogeneous movement but a development that, although it proceeds without interruption, takes place in several clearly distinguishable phases. The first of these phases, which lasts roughly from 1750 to 1780 and is usually called 'rococo classicism' on account of the mixed character of its style, represents what is historically probably the most important of the tendencies united in the 'Louis-Seize', but

is only an undercurrent in the real artistic life of the period. The heterogeneousness of the competing stylistic tendencies is expressed most forcibly of all in the architecture of the age, in which rococo interiors are combined with classicistic façades, a mixture of styles which never disturbs the contemporary public. In no phenomenon is the indecision of the period, its inability to choose between the given alternatives, expressed so clearly as in this eclecticism. The baroque was already marked by a wavering between rationalism and sensualism, formalism and spontaneity, classical and modern, but it still attempted to resolve the conflict in a single, albeit not wholly uniform style. Here, on the other hand, we are confronted with an art in which there is not even an attempt to reduce the different stylistic elements to a common denominator. For just as in architecture stylistically different façades and interiors are combined, so in painting and poetry works of utterly different formal character stand side by side— the works of Boucher, Fragonard and Voltaire beside those of Vien, Greuze and Rousseau. The age produces, at most, hybrid forms, but no adjustment of the opposing formal principles. This eclecticism corresponds to the general structure of a society in which the different classes intermingle and often co-operate, but still remain absolute strangers to each other. The prevailing power relationships are expressed in the world of art above all in the fact that the courtly rococo is, in practice, still the predominant style and enjoys the favour of the overwhelming majority o the art public, whereas classicism merely represents the art of an artistic opposition and constitutes the programme of a comparatively sparse group of amateurs hardly big enough to make any difference in the art market.

This new movement, which has also been called 'archaeological classicism', is more directly dependent on the antiquarian approach to Greek and Roman art than the older cognate tendencies. But even here, the theoretical interest in classical antiquity is not the primary factor; it rather presupposes a change of taste, which in its turn presupposes a shift of values in the whole outlook on life. Classical art acquires a topical interest for the eighteenth century, because once again the attraction of a more stern, more serious and more objective artistic style is felt after

the reign of a pictorial technique that had become all too flexible and fluid, and all too playful with charming colours and tones. When the new classicistic trend emerged around the middle of the century, the classicism of the 'grand siècle' had been dead for fifty years; art had surrendered itself to the voluptuousness that dominates the whole century. The anti-sensualism of the classicistic ideal, which now comes into its own again, is not a question of taste and aesthetic evaluation, or not primarily, but a matter of morals, the expression of a striving for simplicity and sincerity. The change of taste which consigns to oblivion the charms of the sensual, richness and gradations of colour, the streaming profusion and sweeping flight of impressions, and questions the value of everything that all connoisseurs had for half a century considered the quintessence of art, this unheard of simplification and levelling down of aesthetic criteria, signifies the triumph of a new puritanical idealism directed against the hedonism of the age. The yearning for the pure, clear-cut, uncomplicated line, for regularity and discipline, harmony and rest, for Winckelmann's 'noble simplicity and calm greatness', is above all a protest against the insincerity and sophistication, the empty virtuosity and brilliance, of the rococo, qualities that now begin to be regarded as depraved and degenerate, diseased and unnatural.

Beside the artists who, like Vien and Falconet, Mengs and Battoni, Benjamin West and William Hamilton, support the new trend with enthusiasm all over Europe, there are innumerable artists and amateurs, critics and collectors, who only flirt with the revolt against the rococo and join in the fashionable imitation of classical antiquity in a purely superficial way. For the most part they are merely the supporters of a movement the real origin and ultimate aim of which remains hidden from them. Theoretically, Antoine Coypel, the Director of the Academy, takes his stand alongside classicism, and Count Caylus, the cultured art patron and archaeologist, even places himself at the head of the movement. The Surintendant de Marigny, the brother of Madame de Pompadour, sets out on a journey to Italy in 1748 with Soufflot and Cochin for purposes of study and thereby initiates the new series of pilgrimages to the South. Systematic archaeological research begins with Winckelmann, through Mengs the new

classicistic trend becomes predominant in Rome, and in Piranesi's work the experience of archaeology becomes the very subject of artistic treatment. The main difference between the new classicism and the older classicistic movements is that it regards the classical and the modern as two hostile, mutually irreconcilable tendencies.[137] Whilst in France, however, a compromise between the conflicting trends is reached, and classicism represents, above all in the work of David, at the same time an advance of naturalism, the new movement produces, in the other countries of Europe, mostly an anaemic, academic art, which regards the imitation of classical antiquity as an aim in itself.

It is usual to look on the excavations of Pompeii (1748) as the decisive stimulus to the new archaeological classicism; but this enterprise must itself have been stimulated by a new interest and a new point of view, to have made such an impression, since the first excavations, which took place in Herculaneum in 1737, had had no results worth mentioning. The change in the intellectual climate does not occur in fact until around the middle of the century. From this time onward the international scientific pursuit of archaeology first begins alongside the international movement of classicism, which is no longer dominated by the French, even though the school of David will have its affiliations all over Europe. The 'scavi' become the slogan of the day; the whole intelligentsia of Western Europe shows an interest in them. The collecting of 'antiques' becomes a real passion; considerable sums are spent on classical works of art, and everywhere collections of works of sculpture and of gems and vases are started. A journey to Italy is now not only a mark of good breeding, but is looked upon as an essential part of the training of a young man of the world. There is no artist, no writer, no person of intellectual interests who does not promise himself the supreme enhancement of his capabilities from the direct experience of the monuments of classical art in Italy. Goethe's Italian journey, his collection of antiques, the Hera-room in his house in Weimar, with the colossal bust of the goddess threatening to explode the walls of the bourgeois interior, serve as a symbol of this cultural epoch. But the new cult of antiquity is, precisely like the almost simultaneous enthusiasm for the Middle Ages, an essentially romantic

movement; for even classical antiquity now seems to have become an inaccessible springtime of human culture, that has, as Rousseau would have it, disappeared for ever. Winckelmann, Lessing, Herder, Goethe and the whole of German romanticism are absolutely unanimous in holding this conception of antiquity. They all see in it a source of recovery and renewal—an example of genuine and full, though never again to be realized, humanity. It is no accident that the pre-romantic movement coincides with the beginnings of archaeology and that Rousseau and Winckelmann are contemporaries; the basic intellectual characteristic is expressed in one and the same nostalgic philosophy of culture—concentrated in the one case on classical antiquity, in the other on the Middle Ages. The new classicism is just as much directed against the frivolity and sophistication of the rococo as is the pre-romantic movement; both are inspired by the same bourgeois outlook on life. The Renaissance conception of classical antiquity was conditioned by the ideology of the humanists and reflected the antischolastic and anticlerical ideas of the intellectual stratum; the art of the seventeenth century interpreted the world of the Greeks and Romans according to the feudal standards of morality professed by the absolute monarchy; the classicism of the revolutionary period is dependent on the stoic ideals of the progressive and republican middle class and remains faithful to them in all its manifestations.

The third quarter of the century was still pervaded by the conflict of styles. Classicism found itself involved in a fight and was the weaker of the two competing tendencies. Until about 1780, it limited itself for the most part to a theoretical dispute with court art; only after this date, especially after the appearance on the scene of David, can the rococo be considered vanquished. The success of David's 'Oath of the Horatii', in 1785, signifies the end of a thirty years' conflict and the victory of the new monumental style. With the art of the revolutionary era, which extends roughly from 1780 to 1800, a new phase of classicism begins. On the eve of the Revolution, generally speaking, the following tendencies were represented in French painting: (1) the tradition of the sensualistic-coloristic rococo in the art of Fragonard; (2) the sentimentalism represented in the work of

Greuze; (3) the bourgeois naturalism of Chardin; and (4) the classicism of Vien. The Revolution chose this classicism as the style most in harmony with its outlook, although one would have thought the artistic trends represented by Greuze and Chardin would have been more in accordance with its taste. But the decisive factor in its choice was not the question of taste and form, not the principle of intimacy and inwardness derived from the bourgeois philosophy of art of the late Middle Ages and the early Renaissance, but the consideration as to which of the existing trends was best able to portray the ethos of the Revolution with its patriotic-heroic ideals, its Roman civic virtues and republican ideas of freedom. Love of freedom and fatherland, heroism and the spirit of self-sacrifice, Spartan hardness and stoic self-control, are now set in the place of the moral concepts developed by the bourgeoisie in the course of its climb to economic power, which were finally so weakened and undermined that it was possible for the bourgeoisie to be one of the most important supporters of rococo culture. The pioneers and precursors of the Revolution, therefore, had to turn just as sharply against the ideals of the *fermiers généraux* as against the 'douceurs de vivre' of the aristocracy. But they were also unable to rely on the easygoing, patriarchal, unheroic bourgeois attitude of earlier centuries and could expect their aims to be promoted only by an absolutely militant art. But of all the trends they had to choose from, the classicism of Vien and his school was most qualified to meet their requirements.

The art of Vien himself was, however, still full of triviality and prettiness, and just as closely connected with the rococo as the bourgeois sentimentality of Greuze. Classicism was in this case nothing more than a tribute to the fashion in which the artist joined with pedantical zeal. In his coquettishly erotic paintings only the motifs were classical and the manner pseudoclassical, the spirit and the disposition were pure rococo. No wonder that the young David began his Italian journey with the determination not to be taken in by the seductions of classical antiquity.[138] Nothing shows more strikingly how deep was the gulf between rococo classicism and the revolutionary classicism of the following generation than this resolution of David's. If, in

spite of it, David became the pioneer and greatest representative of classicistic art, then the reason for this was the change of meaning which classicism had undergone and as a result of which it lost its aestheticizing character. David did not, however, immediately succeed in imposing his new interpretation of classicism. To begin with, there was nothing to suggest that he would ever occupy the unrivalled position which he held after the 'Horatii' and did not lose until after the Restoration. At the same time as David, a whole group of young French artists sojourned in Rome, and they went through a similar development to David himself. The Salon of 1781 was dominated by these young 'Romans' who were moving towards a stricter classicism, and of whom Ménageot was considered the real leader. David's pictures were still too severe, too serious for contemporary taste. Criticism only gradually realized that these very pictures meant the triumph of the ideas which were being proclaimed in the attempts to destroy the rococo.[139] But the times soon became ripe for David and the amends that were made to him left nothing to be desired. The 'Oath of the Horatii' was one of the greatest successes in the history of art. The triumphant progress of the work already began in Italy where David exhibited it in his own studio. Pilgrimages were made to the picture, flowers placed before it, and Vien, Battoni, Angelika Kaufmann and Wilhelm Tischbein, that is to say, the most esteemed artists in Rome, joined in the universal praise of the young artist. In Paris, where the public became acquainted with the work in the Salon of 1785, the triumph continued. The 'Horatii' was described as the 'most beautiful picture of the century' and David's achievement was regarded as really revolutionary. The work appeared to the contemporary world as the most novel and daring feat imaginable— as the perfect realization of the classicistic ideal. The scene portrayed was here reduced to a few figures, almost without 'supers', without accessories. The protagonists of the drama were, as a sign of their unanimity and determination, if necessary, to die together for their common ideal, brought into one single, unbroken, rigid line; this formal radicalism enabled the painter to achieve an effect unparalleled by anything in the artistic experience of his generation. He developed his classicism into a purely

136

linear art, completely renouncing mere pictorial effects and all the concessions that would have made the picture a pure feast for the eyes. The artistic means which he employed were strictly rational, methodical, puritanical, and subordinated the whole organization of the work to the principle of economy. The precision and the objectivity, the restriction of the work to the barest essentials and the intellectual energy expressed in this concentration were more in harmony with the stoicism of the revolutionary bourgeoisie than any other artistic trend. Here was the unity of greatness and simplicity, dignity and sobriety. The 'Horatii' have rightly been called the 'classicistic picture par excellence'.[140] The work represents the stylistic ideal of its age just as perfectly as, for example, Leonardo's 'Last Supper' represents the Renaissance conception of art. If it is admissible to interpret pure artistic form sociologically, then here is a case in point. This clarity, this uncompromising rigour, this sharpness of expression, has its origin in the republican civic virtues; form is here really only the vehicle, the means to an end. The fact that the upper classes join in this classicism is, in view of what we know of the infectious power of successful movements, nothing like so astonishing as the fact that even the government gave their support to it. 'The Oath of the Horatii' was, as is known, painted for the Ministry of Fine Arts. The general attitude to the subversive tendencies in art was just as unsuspecting or undecided as in politics.

When 'Brutus', the picture with which David attains the height of his fame, is exhibited in 1789, formal considerations no longer play any conscious part in the reception of the work. Roman costume and Roman patriotism have become the ruling fashion and a universally acknowledged symbol of which use is made all the more readily as any other analogy, any other historical parallel, would be a reminder of the knightly-heroic ideal. The presuppositions from which modern patriotism arose are not, however, connected with the Romans. This patriotism is the product of an age in which France no longer has to defend her freedom against a greedy neighbour or a foreign feudal sovereign but against a hostile surrounding world of which the whole social structure is different from hers, and which is up in arms against

the Revolution. Revolutionary France quite ingenuously enlists the services of art to assist her in this struggle; the nineteenth century is the first to conceive the idea of 'l'art pour l'art' which forbids such a practice. The principle of 'pure', absolutely 'useless' art first results from the opposition of the romantic movement to the revolutionary period as a whole, and the demand that the artists should be passive derives from the ruling class's fear of losing its influence on art. In the attainment of its practical aims, the eighteenth century continues to exploit art as unscrupulously as all previous centuries had done; but until the outbreak of the Revolution artists themselves had hardly become conscious of this practice and they thought much less of turning it into a programme. It is only with the Revolution that art becomes a confession of political faith, and it is now emphasized for the first time that it has to be no 'mere ornament on the social structure', but 'a part of its foundations'.[141] It is now declared that art must not be an idle pastime, a mere tickling of the nerves, a privilege of the rich and the leisured, but that it must teach and improve, spur on to action and set an example. It must be pure, true, inspired and inspiring, contribute to the happiness of the general public and become the possession of the whole nation. The programme was ingenuous, like all abstract reforms of art, and its sterility proved that a revolution must first change society before it can change art, although art itself is an instrument of this change and stands in a complicated relationship of reciprocal action and reaction to the social process. The real aim of the Revolution was, incidentally, not the participation in the enjoyment of art of the classes excluded from the privileges of culture, but the alteration of society, the deepening of the feeling of community and the arousing of an awareness of the achievements of the Revolution.[142] From now on the cultivation of art constituted an instrument of government and enjoyed the attention given only to important affairs of state. As long as the Republic was in danger and fighting for its very existence, the whole nation was called upon to serve it with all its combined strength. In an address given to the Convention by David, we find these words: 'Each one of us is responsible to the nation for the talents he has received from nature.'[143] And Hassenfratz,

a juror of the Salon of 1793, formulates the corresponding aesthetic theory in the following terms: 'The whole talent of an artist dwells in his heart; what he achieves with his hands is without significance.'[144]

David plays an unprecedented part in the art politics of his time. He is a member of the Convention and as such already exerts a considerable influence; but, at the same time, he is the confidant and mouthpiece of the Revolutionary government in all matters of art. Since the days of Le Brun no artist had had such a wide sphere of activity; but David's personal prestige is incomparably greater than was the respect in which Louis XIV's factotum was held. He is not merely the artistic dictator of the Revolution, not merely the authority to whom all artistic propaganda, the organization of all great festivities and ceremonies, the Academy with all its functions, the whole system of museums and exhibitions, are subject, he is the creator of a revolution of his own, of that 'révolution Davidienne' which was, to some extent, the starting point of modern art. He is the founder of a school, the authority, extent and stability of which are almost without parallel in the history of art. Nearly all the talented young artists of the time belong to it and, in spite of the adversities which the master had to suffer, in spite of flight and banishment and the dwindling of his own creative powers, it remains, right up to the July revolution, not only the most important school but *the* 'school' of French painting. In fact, it becomes the school of European classicism as a whole, and its founder, who has been called the Napoleon of painting, thereby exercises an influence which may, in his own sphere, be compared to that of the world conqueror. The master's authority outlasts the 9 Thermidor, the 18 Brumaire and Napoleon's accession to the throne, and not simply because David is the greatest contemporary French painter, but because his classicism represents the conception of art most in harmony with the political aims of the Consulate and the Empire. The uniform development of artistic work and policy is interrupted only during the Directoire, which, in contrast to both the Revolution and the Empire, is frivolous, hedonistic and aesthetically epicurean in character.[145] Under the Consulate, when the French are constantly being reminded of the heroic

virtues of the Romans, and under the Empire, in whose political propaganda the comparison with the Roman Imperium plays a similar rôle to the analogy with the Roman Republic during the Revolution, classicism remains the representative style of French art. But, despite the consistency of its development, David's painting bears the marks of the transformation which the society and government of the country are undergoing. Even during the Directoire his style shows, above all in the 'Sabine Women', a softer and more pleasing character, a turning away from the uncompromising artistic severity of the revolutionary period. And under the Empire, although he again surrenders the flattering elegance and artistry of his Directoire style, he diverges from the aims of his early period in a different direction. The master's Empire style contains, translated into artistic terms, the whole internal conflict implicit in Napoleon's rule. For, just as this régime never altogether denies its origins in the Revolution and destroys the hope of a revival of the hereditary privileges once and for all, but relentlessly continues the liquidation of the Revolution which had begun with the 9 Thermidor, and not only guarantees the powerful position of the capitalistic bourgeoisie and the landed peasantry, but sets up a political dictatorship which restricts the freedoms of these very classes to the code of civil law, so the Empire art of David is likewise an unbalanced synthesis of contradictory tendencies in which the ceremonial and the conventional gradually gain the upper hand over naturalism and spontaneity.

The tasks imposed on David as Napoleon's 'premier peintre' further his art by bringing him into direct touch with historical reality again and by offering him an opportunity of grappling with the formal problems of great official historical pictures, but at the same time they stiffen his classicism and bring out in him the marks of that academicism which was to become so fateful for himself and his school. Delacroix called David 'le père de toute l'école moderne' and that he was in a double respect: not only as the creator of the new bourgeois naturalism which, especially in the portrait, gave expression to the seriousness and dignity of a stern, simple, absolutely untheatrical outlook on life, but also and above all as the man who restored the narrative

painting and the pictorial representation of great historical occasions. Thanks to such tasks, David regains, after the superficial elegance and trifling treatment of formal problems, characteristic of his Directoire period, much of his earlier objectivity and simplicity. The problems which he now has to solve no longer hover in the air, like the theme of the 'Sabine Women', but result from direct, topical reality. In commissions like those that lead to the painting of the 'Sacre' (1805–8) or to the 'Distribution of the Eagles' (1810), he finds more artistic stimulation than he himself would have perhaps expected. What these pictures lack in verve and dramatic quality, compared with the 'Oath in the Tennis Court', they make up for by the more simple, more realistic treatment of the subject. With them David turns farther away from the eighteenth century and the rococo tradition and creates, in contrast to the prevailing individualism of his early works, a more objective style, which it was possible to misappropriate academically, but which it was, at any rate, possible to continue. Even now, however, he does not entirely overcome the inner conflict which had been threatening the intellectual unity of his art since the Directoire. Besides the official ceremonies, for which he finds a thoroughly satisfactory solution, he paints scenes from the ancient world, such as the 'Sappho' (1809) or the 'Leonidas' (1812), which are just as affected and mannered as were the 'Sabine Women'. The classical world has ceased to be a source of inspiration for David and becomes a mere convention, as it does with all his contemporaries. When he is confronted with practical tasks, he continues to produce masterpieces, but when he tries to soar above reality, he fails.

The conflict in David's art between the abstract, anaemic idealism of his mythological and antique-historical compositions and the full-blooded naturalism of his portraits, becomes still more intense during his exile in Brussels. Whenever he enters into direct contact with real life, that is to say, when he has to paint portraits, he is still the great old master, but in so far as he gives way to his classical illusions, which lack all relationship to the present and have become an artistic game, the impression he makes is not only old-fashioned but often also in bad taste. The case of David is of special importance for the sociology of art, for

he probably provides the most convincing refutation of the thesis according to which practical political aims and genuine artistic quality are incompatible. The more intimately connected he was with political interests and the more completely he placed his art at the service of propagandistic aims, the greater was the artistic worth of his creations. During the Revolution, when all his thoughts revolved around politics and he painted his 'Oath in the Tennis Court' and his 'Marat', he was at the height of his powers artistically. And under the Empire, when he was at least able to identify himself with Napoleon's patriotic aims and was doubtless aware what the Revolution owed to the dictator, in spite of everything, his art remained creative and alive, whenever it was concerned with practical tasks. Later, however, in Brussels, when he had lost all connection with political reality and was nothing but a painter, he sank to the lowest point in his artistic development. Now, although these correlations do not prove that an artist must be politically interested and progressively-minded to paint good pictures, yet they do, none the less, prove that such interests and such aims by no means prevent the creation of good pictures.

It has often been asserted that the Revolution was artistically sterile and that its creations moved within the limits of a style which was nothing more than the continuation and culmination of the old rococo classicism. It has been emphasized that the art of the revolutionary epoch can be described as revolutionary only in relation to its subjects and ideas but not in relation to its forms and stylistic principles.[146] It is a fact that the Revolution had found classicism more or less ready-made when it came on the scene, but it gave it a new content and a new meaning. The classicism of the Revolution seemed unoriginal and uncreative only from the levelling perspective of posterity; the contemporary world was quite aware of the stylistic difference between the classicism of David and that of his predecessors. How daring and revolutionary David's innovations appeared to them is best proved by the words of the Academy Director Pierre, who described the composition of the 'Horatii' as an 'attack on good taste' because of their deviation from the usual pyramidal pattern.[147] The real stylistic creation of the Revolution is, however,

not this classicism but romanticism, that is to say, not the art that it actually practised but the art for which it prepared the way. The Revolution itself was unable to realize the new style, because it possessed new political aims, new social institutions, new standards of law, but so far no new society speaking its own language. Only the bare presupposition for the rise of such a society existed at that time. Art lagged behind political developments and still moved partly, as Marx already noted, in the old antiquated forms.[148] Artists and writers are, in fact, by no means always prophets and art falls behind the times just as often as it hastens on in advance of them.

Even the romanticism for which the Revolution prepared the way is based on an earlier kindred movement; but pre-romanticism and romanticism proper have not even as much in common with each other as have the two forms of modern classicism. They represent in no sense a uniform romantic movement, which merely happened to be interrupted in its development.[149] Pre-romanticism suffers a decisive and final defeat at the hands of the Revolution. It is true that anti-rationalism revives again, but the sentimentality of the eighteenth century does not outlast the Revolution. Post-revolutionary romanticism reflects a new outlook on life and the world and, above all, it creates a new interpretation of the idea of artistic freedom. This freedom is no longer a privilege of the genius, but the birthright of every artist and every gifted individual. Pre-romanticism allowed only the genius to deviate from the rules, romanticism proper denies the validity of objective rules of any kind. All individual expression is unique, irreplaceable and bears its own laws and standards within itself; this insight is the great achievement of the Revolution for art. The romantic movement now becomes a war of liberation not only against academies, churches, courts, patrons, amateurs, critics and masters, but against the very principle of tradition, authority and rule. The struggle is unthinkable without the intellectual atmosphere created by the Revolution; it owes both its initiation and its influence to the Revolution. The whole of modern art is to a certain degree the result of this romantic fight for freedom. However much talk there is about supra-temporal aesthetic norms, of eternally human artistic

values, of the need of objective standards and binding conventions, the emancipation of the individual, the exclusion of all extraneous authority, a reckless disregard for all barriers and prohibitions, is and remains the vital principle of modern art. However enthusiastically the artist of our time acknowledges the authority of schools, groups, movements, and professes faith in his companions in arms, as soon as he begins to paint, to compose or to write, he is and feels alone. Modern art is the expression of the lonely human being, of the individual who feels himself to be different, either tragically or blessedly different, from his fellows. The Revolution and the romantic movement mark the end of a cultural epoch in which the artist appealed to a 'society', to a more or less homogeneous group, to a public whose authority he acknowledged in principle absolutely. Art ceases to be a social activity guided by objective and conventional criteria, and becomes an activity of self-expression creating its own standards; it becomes, in a word, the medium through which the single individual speaks to single individuals. Until the romantic period it was more or less irrelevant whether and in what measure the public consisted of real connoisseurs; artists and writers made it their endeavour at all costs to meet the wishes of this public, in contrast to the romantic and post-romantic period, in which they no longer submit to the taste and demands of any collective group and are always on the point of appealing against the verdict of one forum of opinion to another. Their work brings them into a constant state of tension and opposition towards the public; certainly, groups of connoisseurs and amateurs are constantly being formed, but this formation of groups is in a state of endless flux and destroys all continuity in the relationship between art and public.

That David's classicism and romantic painting have a common source, namely the Revolution, is also expressed in the fact that romanticism does not begin as an attack on classicism and does not undermine the David school from outside, but first comes on the scene in the work of the nearest and most gifted pupils of the master himself, Gros, Girodet and Guérin. The rigid separation of the two trends does not begin until the period from 1820 to 1830, when romanticism becomes the style of the

artistically progressive, whilst classicism becomes that of the elements who still swear by the absolute authority of David. The hybrid of classicism and romanticism invented by Gros was most in accordance with Napoleon's personal taste and with the nature of the problems which he set his artists to solve. Napoleon sought relaxation from his practical rationalism in romantic works of art and inclined to sentimentalism, when he was not judging art as an instrument of propaganda and display. That explains his fondness for Ossian and Rousseau in literature and for the picturesque in painting.[150] When Napoleon made David his court painter, he was merely following public opinion; his own sympathies belonged to Gros, Gérard, Vernet, Prudhon and the 'anecdotal painters' of his time.[151] They were, by the way, all compelled to paint his battles and victories, festivities and ceremonies—the supersensitive Prudhon just as much as the robust David. The real painter of the Empire, Napoleon's painter par excellence, however, was Gros, who owed his fame, of which both the supporters and the opponents of the David school approved, partly to his ability to represent a scene strikingly, often with a waxwork-like directness, partly to his new moral conception of the battle picture. He was, in fact, the first to portray war from a humanitarian point of view and to show the unspectacular sides of battle. The miseries of war were so great that they could no longer be glossed over; the most sensible thing was to make no attempt at all to do so.

The Empire found the artistic expression of its outlook on life in an eclecticism which combined and permuted already existing stylistic trends. The contradictory characteristics of this art were in accordance with the political and social antinomies of the Napoleonic government. The great problem that the Empire tried to solve was the reconciliation of the democratic achievements of the Revolution with the political forms of the absolute monarchy. To return to the *ancien régime* was just as unthinkable for Napoleon as to remain tied to the 'anarchy' of the Revolution. A form of government had to be found which would combine them both and create a compromise between the old and the new state, the old and the new nobility, and between the process of social levelling and the new wealth. The idea of free-

dom was as foreign to the *ancien régime* as the idea of equality. The Revolution undertook to realize both of them but, finally, dropped the principle of equality. Napoleon wanted to rescue this principle, but only succeeded in establishing it juridically; economically and socially the old, pre-revolutionary inequality continued to prevail. What political equality there was consisted in the fact that all were equally without rights. Of the achievements of the Revolution nothing remained but the civic freedom of the person, equality before the law, the abolition of feudal privileges, freedom of belief and the 'carrière ouverte aux talents'. That was no mean attainment, but the logic of Napoleon's authoritarian government and court ambitions led to the rehabilitation of the nobility and the Church and created, in spite of the attempt to hold fast to the basic principles of the Revolution, an anti-revolutionary atmosphere.[152] The romantic movement received an enormous impetus from the conclusion of the Concordat and the religious renaissance connected with it. Romanticism had already gone hand in hand with the idea of a Catholic revival and monarchist tendencies in the work of Chateaubriand. The 'Génie du Christianisme', which appeared a year after the Concordat had been concluded and which was the first representative work of French romanticism, had a more stupendous success than any literary production of the eighteenth century. The whole of Paris read it and the 'premier consul' had parts of it read aloud to him on several evenings. The appearance of the book marks the initiation of the clerical party and the end of the reign of the 'philosophes'.[153] With Girodet the romantic-clerical reaction spreads to art and speeds up the dissolution of classicism. During the years of the Revolution no pictures with a religious content were seen at all in exhibitions.[154] David's school began by taking a thoroughly negative attitude to the genre; but with the spread of romanticism the number of religious paintings increased and religious motifs finally invaded academic classicism itself.

The religious renaissance begins at the same time as the political reaction under the Consulate. It, too, is part of the liquidation of the Revolution and is taken up with enthusiasm by the ruling class. The general rejoicing soon becomes silent,

however, under the burden of the oppressive sacrifices which the Napoleonic adventure imposes on the nation, and the high spirits of the bourgeoisie are also substantially restrained by the creation of the new military nobility and the attempts at conciliation with the old aristocracy. The golden days of the army contractors, corn merchants and speculators are only just beginning, however, and in the fight for supremacy in society the bourgeoisie remains victorious after all, even though it is no longer quite the old revolutionary bourgeoisie. The aims which it pursued through the Revolution were, incidentally, never so altruistic as they are usually made out to be. The well-to-do middle class had already been the creditor of the state long before the Revolution and, in view of the persistent mismanagement of the court, it had more and more to fear the collapse of the state finances. If it was fighting for a new order, then its main purpose was to make certain of its rents. This circumstance explains the apparent paradox that the Revolution was realized by one of the richest and not least privileged of all classes.[155] It was in no sense a revolution of the proletariat and the propertyless petty bourgeoisie but of the rentiers and the commercial contractors, that is to say, of a class that was certainly harassed in its economic expansion by the privileges of the feudal nobility but in no way vitally menaced by them.[156] The Revolution was fought for, however, with the help of the working class and the lower strata of the middle class and would scarcely have been successful without their help. Yet as soon as the bourgeoisie had achieved its aims, it left its former comrades in arms in the lurch and wanted to enjoy the fruits of the common victory alone. In the end, all the classes deprived of civic rights and all the oppressed did benefit, nevertheless, from the victory of the Revolution, which after so many unsuccessful rebellions and revolts was the first to lead to a radical and lasting reconstruction of society. The immediate after-effect of the events was, however, by no means encouraging. Hardly had the Revolution ended, than a boundless disillusion seized men's souls and not a trace remained of the optimistic philosophy of the enlightenment. The liberalism of the eighteenth century had been based on the idea of the identity of freedom and equality. The belief in this equation was the source of liberal optimism, and the loss of

faith in the compatibility of the two ideas the origin of the pessimism of the post-revolutionary period.

The most striking sign of the victory of the liberal idea is that the influence of the coercion, limitation and regimentation of the mind is not felt to be a paralysing one until after the Revolution. Hitherto the greatest achievements of art had often been connected with the most rigid despotism; from now on all attempts to set up an authoritarian culture meet with invincible resistance. The Revolution had demonstrated that no human institution is unalterable; any idea imposed on the artist had lost its claim to represent a higher norm, and all compulsion only awakened his doubts and suspicion. The principles of order and discipline lost their stimulating influence and the liberal idea became from now on—yes, indeed, only from now on—a source of artistic inspiration. In spite of the prizes, gifts and distinctions which he bestowed on them, Napoleon was unable to spur on his artists and writers to achieve anything of importance. The really productive authors of his time, people like Mme de Staël and Benjamin Constant, were dissidents and outsiders.[157]

The most important achievement of the Empire in the sphere of art consisted in the stabilization of the relations between producer and consumer which had been created by the enlightenment and the Revolution. The middle-class public that had arisen in the eighteenth century became consolidated and from now on it also played a leading part as a party interested in the plastic arts. The public of the seventeenth-century French literature consisted of a few thousand people; it was a group of amateurs and connoisseurs estimated by Voltaire to number some two to three thousand.[158] That did not mean, of course, that this public was made up exclusively of people capable of independent artistic judgement and an assured sense of quality, but merely that it was in possession of certain aesthetic criteria which enabled its members to distinguish the valuable from the valueless within definite, usually rather restricted, limits. The public for the plastic arts was, naturally, even more circumscribed than the literary public and was made up purely of collectors and connoisseurs. It was not until the period in which the quarrel between the Poussinistes and the Rubénistes took place, that an art public

arose no longer consisting entirely of such specialists,[159] and not until the eighteenth century that it embraced people interested in pictures with no thought of buying them. This trend of development becomes more and more marked after the Salon of 1699, and in 1725 the Mercure de France already reports that an enormous public of every class and every age is to be seen in the Salon admiring, praising, criticizing and finding fault.[160] According to contemporary reports, the crowds are unprecedented, and even if most of them only want to be there because visiting Salons has become a fashion, nevertheless, the number of serious art lovers is also growing. That is indicated, first of all, by the mass of new art publications, art journals and reproductions.[161]

Paris, which had long been the centre of social and literary life, now becomes the art capital of Europe and takes over in its totality the rôle played by Italy since the Renaissance in the artistic life of Western Europe. It is true that Rome continues to be the centre of the study of classical art, but Paris is the place where people go to study modern art.[162] Parisian art life, which now keeps the whole educated world busy, gains its strongest impulse, however, from the art exhibitions which are by no means limited to the Salon. Exhibitions had been held in Italy and the Netherlands in earlier times, but it was only in seventeenth- and eighteenth-century France that they became an indispensable factor in artistic activity.[163] It was only after 1673 that art exhibitions were arranged regularly, that is to say, from the time when diminished state support forced French artists to look round for buyers. Only members of the Academy were allowed to exhibit in the Salon, non-academicians had to show their works to the public in the much less distinguished 'Academy' of the Guild of St. Luke or in the 'Exposition de la Jeunesse'. These secessionist exhibitions did not become superfluous until the Revolution opened the Salon to all artists in the year 1791 and artistic life, which had acquired its restless and stimulating character from them and from the many private, studio and pupils' exhibitions, became more organized and healthy, though less lively and interesting.

The Revolution meant the end of the dictatorship of the Academy and the monopolization of the art market by the court,

the aristocracy and high finance. The old ties which had stood in the way of the democratization of art were loosened; they vanished with rococo society and rococo culture. It is, however, by no means accurate to claim, as has been done so often, that all the strata of the public which had had the keys of culture in its hands and had represented 'good taste' disappeared overnight. As a result of the far-reaching participation of the middle class in artistic life long before the Revolution, there was a certain continuity of development, in spite of the profound revulsion. It is true that an unprecedented democratization of artistic life took place, that is to say, not merely an enlargement but also a levelling down of the public—even this tendency had begun, however, before the Revolution. In his *Thoughts on Beauty and on Taste* (1765), Mengs had already asserted that the beautiful is what appeals to the majority. The real change that came to light after the Revolution consisted in the fact that the old public represented a class in which art fulfilled a direct function in daily life and was one of those forms by means of which this class expressed, on the one hand, its aloofness from the lower classes of society and, on the other, its fellowship with the court and the monarch, whereas the new public developed into one of amateurs with aesthetic interests, for whom art became an object of free choice and changing tastes.

After the Legislative Assembly had abolished the privileges of the Academy as early as 1791 and bestowed on all artists the right to exhibit in the Salon, two years later the Academy itself was completely suppressed. The decree corresponded in the sphere of art to the abolition of feudal privileges and the realization of democracy. But this development had, like the corresponding social development, also begun before the Revolution. The Academy had always been regarded as the quintessence of conservatism by all liberals; in reality, it had been, especially since the end of the seventeenth century, by no means so narrow-minded and inaccessible as it was represented to be. The question of admission to membership was treated very liberally in the eighteenth century. That is a well-known fact. Only the limitation of the right to exhibit in the Salon to members of the Academy was strictly observed. But it was precisely against this practice that

progressive artists under David's leadership fought most bitterly of all. The Academy was dissolved abruptly, but it was much more difficult to find a substitute for it. As early as 1793, David founded the 'Commune des Arts', a free and democratic artists' association without special groups, classes and privileged members. But owing to the subversive activities of the royalists in its midst, it had to be replaced in the very next year by the 'Société populaire et républicaine des Arts', the first truly revolutionary association whose duty it was to take over the functions of the suppressed Academy. It was, however, in no sense an Academy but a club of which anyone could become a member without regard to position and calling. In the same year the 'Club revolutionnaire des Arts' arose to which, amongst others, David, Prudhon, Gérard and Isabey belonged and which, thanks to its famous members, enjoyed great prestige. All these associations were directly dependent on the 'Committee for Public Instruction' and were under the aegis of the Convention, the Welfare Committee and the Paris Commune.[164] The Academy was suppressed, to begin with, merely as owner of the monopoly of exhibition, it continued to exercise its monopoly of instruction for some time and thereby preserved much of its influence.[165] Soon, however, its place was taken by the 'Technical School for Painting and Sculpture' and art instruction began to be given in private schools and evening classes as well. In addition, drawing instruction was also introduced into the curriculum of the high schools (*écoles centrales*). Nothing, however, had probably contributed so much to the democratization of art education as the formation and extension of the museums. Until the Revolution those artists who were not in a position to undertake a journey to Italy had had little chance of seeing much of the works of the famous masters. They had mostly been kept in the private galleries of the king and the great collectors, and were not accessible to the general public. The Revolution changed all that. In 1792 the Convention decided to create a museum in the Louvre. Here, in the immediate neighbourhood of the studios, young artists could henceforward daily study and copy the great works of art and here, in the galleries of the Louvre, they found the best completion of the teaching of their own masters.

After the 9 Thermidor the principle of authority was also gradually restored in the sphere of art and the Academy of Fine Arts was finally replaced by the IVth section of the Institute. Nothing is more characteristic of the undemocratic spirit in which the reform was carried through than the fact that the old Academy had 150, whereas the new one had only 22 members. Nevertheless, David, Houdon and Gérard belonged to it and it soon regained its old authority. The whole body of artists revised its relation to the Revolution, of course, but it was never an entirely uniform relationship. Some artists were honest and sincere revolutionaries from the outset, and not only those, like David, who had his wife's money to fall back on and did not have to worry about the momentary state of business on the art market, but also such men as Fragonard, who was financially ruined by the turn of events, and remained loyal to the Revolution all the same. It goes without saying that convinced anti-revolutionists were also to be found among artists, such as Mme Vigée-Lebrun, for instance, who left the country with her high-born clientèle. Most of them were, however, on the right as well as on the left, merely fellow-travellers who sided with the émigrés or the revolutionaries according to the way they judged their chances. Artists as a whole saw themselves profoundly menaced by the Revolution, to begin with; the emigration robbed them of their wealthiest and most competent buyers.[166] The number of émigrés grew from day to day and the old art public that stayed behind was neither in a position nor in a mood to buy works of art. Most artists were exposed to dire privation at the outset, and thus it was no wonder that they were not always able to feel enthusiastic about the Revolution. If they, nevertheless, took up their stand on its side in such great numbers, then it was because they had felt humiliated and exploited during the old régime, under which they had usually been regarded as domestic servants. The Revolution meant the end of this situation and it also brought them, after all, material compensation. For, apart from the government's growing interest in art, the number of private persons interested also grew, and suddenly a new public existed with a lively interest in the work of famous artists.[167] During the Revolution attendances at the Salon in no way diminished, in

fact, they increased. At auctions works of art soon reached just as high prices as before the Revolution, and under the Empire prices even rose considerably.[168] The number of artists increased and critics complained that there were already too many artists. Artistic life had recovered quickly—too quickly—from the shocks of the Revolution. The art machine was back to normal, before a new art had come into existence. The old institutions were revived, but those who revived them had no aesthetic criteria of their own and not even the courage to have them. That explains the artistic decadence of the post-revolutionary period, and the reason why it was another twenty years before romanticism could be realized in France.

6. GERMAN AND WESTERN ROMANTICISM

Nineteenth-century liberalism identified romanticism with the Restoration and reaction. There may have been a certain justification for this emphasis, especially in Germany, but in general it led to a false conception of the historical process. It was not corrected until scholars began to distinguish between German and Western romanticism and to derive the one from reactionary and the other from progressive tendencies. The resulting picture certainly came much nearer to the truth but still contained a considerable simplification of the facts, for, from a political point of view, neither the one nor the other form of romanticism was clear and consistent. In the end a distinction was made, in accordance with the real situation, between an early and a later phase both in German and in French and English romanticism, a romanticism of the first and another of the second generation. It was ascertained that the development followed different directions in Germany and Western Europe and that German romanticism proceeded from its originally revolutionary attitude to a reactionary standpoint, whereas Western romanticism proceeded from a monarchist-conservative point of view to liberalism. This account of the situation was intrinsically correct, but it did not prove to be particularly fruitful for the task of defining romanticism. The characteristic feature of the romantic movement was

153

not that it stood for a revolutionary or an anti-revolutionary, a progressive or a reactionary ideology, but that it reached both positions by a fanciful, irrational and undialectical route. Its evolutionary enthusiasm was based just as much on ignorance of the ways of the world as its conservatism, its enthusiasm for the 'Revolution, Fichte and Goethe's Wilhelm Meister' was just as ingenuous, just as remote from an appreciation of the real motives behind the historical issues, as its frenzied devotion to the Church and the Crown, to chivalry and feudalism. Perhaps events themselves would have taken a different turn, if the intelligentsia had not, even in France, left it to others to think and act realistically. Everywhere there was a romanticism of the Revolution, just as there was a romanticism of the Counter-Revolution and the Restoration. The Dantons and the Robespierres were just as unrealistic dogmatists as the Chateaubriands and the de Maistres, the Goerres and Adam Muellers. Friedrich Schlegel was a romantic in his youth with his enthusiasm for Fichte, Wilhelm Meister and the Revolution, as he was in his old age with his enthusiasm for Metternich and the Holy Alliance. But Metternich himself was no romantic, despite his conservatism and traditionalism; he left it to the literary men to consolidate the mythos of historicism, legitimism and clericalism. A realist is a man who knows when he is fighting for his own interests and when he is making concessions to those of others; and a dialectician is one who is aware that the historical situation at any given moment consists of a complex of different irreducible motives and tasks. Despite all his appreciation of the past, the romantic judges his own time unhistorically, undialectically; he does not grasp that it stands midway between the past and the future and represents an indissoluble conflict of static and dynamic elements.

Goethe's definition, according to which romanticism embodies the principle of disease—a verdict that is hardly to be accepted in the way it was meant—gains a new significance and a new confirmation in the light of modern psychology. For, if romanticism, in fact, sees only one side of a total situation fraught with tension and conflict, if it always considers only one factor in the dialectic of history and stresses this at the expense of the other, if, finally, such a one-sidedness, such an exaggerated, over-

compensating reaction, betrays a lack of spiritual balance, then romanticism can rightly be called 'diseased'. Why should one exaggerate and distort things, if one does not feel disturbed and frightened by them? 'Things and actions are what they are, and the consequences of them will be what they will be; why then should we wish to be deceived?' says Bishop Butler, and thereby gives the best description of the serene and 'healthy' eighteenth-century sense of reality with its aversion to all illusion.[169] From this realistic point of view, romanticism always seems a lie, a self-deception, which, as Nietzsche says in reference to Wagner, 'does not want to conceive antitheses as antitheses', and shouts the loudest about what it doubts the most profoundly. The escape to the past is only one form of romantic unreality and illusionism —there is also an escape into the future, into Utopia. What the romantic clings to is, in the final analysis, of no consequence, the essential thing is his fear of the present and of the end of the world.

Romanticism was not only of epoch-making importance, it was also aware of its importance.[170] It represented one of the most decisive turning points in the history of the European mind, and it was perfectly conscious of its historical rôle. Since the Gothic, the development of sensibility had received no stronger impulse and the artist's right to follow the call of his feelings and individual disposition had probably never been emphasized with such absoluteness. The rationalism that had been steadily progressing since the Renaissance, and was given a position of dominating importance in the whole civilized world by the enlightenment, suffered the most painful setback in its history. Never since the dissolution of the supernaturalism and traditionalism of the Middle Ages had reason, alertness and sobriety of mind, the will to and the capacity for self-control, been spoken of with such contempt. 'Those who restrain desire do so because theirs is weak enough to be restrained'—as is said even by Blake, who was in no sense in agreement with the uncontrolled emotionalism of a Wordsworth. Rationalism, as a principle of science and practical affairs, soon recovered from the romantic onslaught, but European art has remained 'romantic'. Romanticism was not merely a universal European movement, seizing one

nation after another and creating a universal literary language which was finally just as intelligible in Russia and Poland as in England and France, it also proved to be one of those trends which, like the naturalism of the Gothic or the classicism of the Renaissance, have remained a lasting factor in the development of art. There is, in fact, no product of modern art, no emotional impulse, no impression or mood of the modern man, which does not owe its delicacy and variety to the sensitiveness which developed out of romanticism. The whole exuberance, anarchy and violence of modern art, its drunken, stammering lyricism, its unrestrained, unsparing exhibitionism, is derived from it. And this subjective, egocentric attitude has become so much a matter of course for us, so absolutely inevitable, that we find it impossible to reproduce even an abstract train of thought without talking about our feelings.[171] The intellectual passion, the fervour of reason, the artistic productivity of rationalism have been so completely forgotten that we are only able to understand classical art itself as the expression of a romantic feeling. 'Seuls les romantiques savent lire les ouvrages classiques, parce qu'ils les lisent comme ils ont été écrits, romantiquement,' says Marcel Proust.[172]

The whole nineteenth century was artistically dependent on romanticism, but romanticism itself was still a product of the eighteenth century and never lost the consciousness of its transitional and historically problematical character. Western Europe had gone through several other—similar and more serious—crises, but it had never had so much the feeling of having reached a turning point in its development. This was by no means the first time that a generation had taken a critical attitude to its own historical background and rejected the traditional patterns of culture, because it was unable to express its own outlook on life in them. Previous generations had had the feeling of growing old and the desire for renewal, but to none had it occurred to make a problem of the meaning and *raison d'être* of its own culture and to ask whether it was entitled to its own frame of mind and whether it represented a necessary link in the total chain of human culture. The romantic feeling of rebirth was by no means new; the Renaissance had already experienced it and even the Middle Ages had toyed with ideas of renewal and visions

of resurrection of which ancient Rome had been the theme. But no generation had had such a strong awareness of being the heir and descendant of previous ages, none had had so decidedly the desire simply to repeat and to awaken to new life a past age and a lost culture. The romantics are constantly searching for reminiscences and analogies in history and they derive their greatest inspiration from ideals which they believe have already been realized in the past. Their relationship to the Middle Ages does not completely correspond, however, to the classicistic sense of antiquity, since classicism simply takes the Greeks and Romans as an example, whereas romanticism always has the feeling of 'déjà vécu' in connection with the past. It remembers past time as if it were a previous existence. But this feeling by no means proves that romanticism had more in common with the Middle Ages than classicism had with classical antiquity—it proves rather the contrary. 'When a Benedictine studied the Middle Ages', we read in a recent and very clever analysis of romanticism, 'he did not ask himself how it could be of service to him and whether people lived happier and more pious lives in the Middle Ages. As he himself stood within a continuity of faith and ecclesiastical organization, he could take up a more critical attitude to religion than a romantic living in a century of revolution, in which all faith had been shaken and laid open to question.'[173] It is unmistakable that the romantic experience of history gives expression to a psychotic fear of the present and an attempt to escape into the past. But no psychosis has ever been more fruitful. Romanticism owes it its historical sensitivity and clairvoyance, its feeling for relationships, however remote and however difficult to interpret. Without this hypersensitiveness, it would hardly have succeeded in restoring the great historical continuities of culture, in marking the boundary between modern culture and classical antiquity, in recognizing in Christianity the great dividing line in the history of the West and discovering the common 'romantic' nature of all the individualistic, reflective, problematical cultures derived from Christianity.

Without the historical consciousness of romanticism, without the constant questioning of the meaning of the present, by which the thinking of the romantics was dominated, the whole histori-

cism of the nineteenth century and one of the deepest revolutions in the history of the human mind would have been inconceivable. In spite of Heraclitus and the Sophists, the nominalism of scholastic philosophy and the naturalism of the Renaissance, the dynamic approach of capitalism and the progress of historical science in the eighteenth century, the world-view of the West had been essentially static, Parmenidean and unhistorical until the advent of romanticism. The most important factors in human culture, the principles of the natural and supernatural world order, the laws of morality and logic, the ideals of truth and right, the destiny of man and the purpose of social institutions, had been regarded as fundamentally unequivocal and immutable in their significance, as timeless entelechies or as innate ideas. In relation to the constancy of these principles, all change, all development and differentiation had appeared irrelevant and ephemeral; everything that occurred in the medium of historical time seemed to touch merely the surface of things. Only from the time of the Revolution and the romantic movement did the nature of man and society begin to appear as essentially evolutionistic and dynamic. The idea that we and our culture are involved in eternal flux and endless struggle, the notion that our intellectual life is a process with a merely transitory character, is a discovery of romanticism and represents its most important contribution to the philosophy of the present age.

It is a well-known fact that the 'historical sense' was not only alive and astir in the pre-romantic movement, but was a motive force in the intellectual development of the time. We know that the enlightenment produced not merely historians like Montesquieu, Hume, Gibbon, Vico, Winckelmann and Herder and emphasized the historical as opposed to the revealed source of cultural values, but that it already had an inkling of the relativity of these values. In any case, it was a familiar notion in the aesthetics of the time that there are several equivalent types of beauty, that the conceptions of beauty are just as varied as the physical conditions of life and that 'a Chinese god has just as stout a belly as a mandarin'.[174] But, in spite of these insights, the philosophy of history of the enlightenment was based on the idea that history reveals the unfolding of an immutable Reason and that the

development of history moves towards a fixed goal discernible from the very beginning. The unhistorical character of the eighteenth century was not, therefore, expressed in a lack of interest in history or a failure to recognize the historical character of human culture, but in the fact that it misunderstood the nature of historical development and thought of it as a straight-forward continuum.[175] Friedrich Schlegel and Novalis are the first to recognize that historical relationships are not of a logical nature and that 'philosophy is fundamentally anti-historical'. Above all, the insight that there is such a thing as historical destiny, and that 'we are precisely who we are, because we look back on a particular kind of past history', is an achievement of romanticism. Thoughts of this kind and the historicism they reflect were absolutely alien to the enlightenment. The idea that the nature of the human mind, of political institutions, of law, language, religion and art are understandable only on the basis of their history, and that historical life represents the sphere in which these structures become incarnate in the purest and most substantial form, would have been simply unthinkable before the romantic movement. Where this historicism led to, however, is seen most strikingly perhaps in the paradoxically exaggerated formulation which Ortega y Gasset has given to it: 'Man has no nature, what he has is history.'[176] That sounds by no means encouraging at first sight; but here, too, we are confronted, as in the whole romantic movement, with an ambivalent approach midway between optimism and pessimism, activism and fatalism, and which can be claimed by both.

With the hermeneutic art of romanticism, its eye for histori-cal affinities and its sensitiveness to the problematical and disput-able in history, we have also inherited its historical mysticism, its personification and mythologization of historical forces, in brief, the idea that historical phenomena are nothing but the functions, manifestations and incarnations of independent principles. This mode of thinking has been called, very illuminatingly and ex-pressively, an 'emanatistic logic',[177] and attention has thereby been drawn not merely to the abstract conception of history but, at the same time, to the often unconscious metaphysic that such a method involves. According to this logic, history appears as a

sphere dominated by anonymous powers, as a substratum of higher ideas, which are only incompletely expressed in the individual historical phenomena. And this Platonic metaphysic finds expression not only in the already out-of-date romantic theories of the folk-spirit, the folk epic of national literatures and Christian art, but even in the still current concept of the 'artistic intention' (Kunstwollen). For even Riegl is, to some extent, under the influence of the romantics and their pneumatic conception of history. He imagines the artistic approach of an epoch as if it were an active person obtaining recognition for his purposes often against the strongest resistance, and sometimes succeeding without the knowledge, even against the will, of his supporters. He regards the great historical styles as independent individuals, unexchangeable and incomparable, living or dying, going under and being replaced by another style. The concept of the history of art as the contiguity and succession of such stylistic phenomena, the value of which resides in their individuality and which have to be judged by their own standards, is in some respects the purest example of the romantic view with its personification of historical forces. In reality, the most significant and comprehensive creations of the human spirit are hardly ever the result of a deliberately willed, straightforward development directed towards a final goal from the very outset. Neither the Homeric epic and the Attic tragedy, nor the Gothic style of architecture and the art of Shakespeare, represent the realization of a uniform and clear-cut artistic purpose, but are the chance result of special needs, conditioned by time and place, and of a whole series of pre-existing, often extraneous and inadequate means. They are, in other words, the product of gradual technical innovations, leading away from the original aim as often as they approach it, of motifs derived from the passing moment, sudden whims and individual experiences, which sometimes have no connection at all with the underlying artistic problem. The theory of the 'artistic intention' hypostasizes as a leading idea what is, in fact, the final result of a thoroughly incoherent and heterogeneous development. But even the doctrine of the 'history of art without names' is, precisely because it excludes real personalities as influential factors from the development of art, only a form of this

hypostasis, in which historical forces are personified. The history of art thereby acquires the character of a process following its own inner principle, and no more tolerating the success of independent artistic personalities than, shall we say, an animal body the emancipation of its single organs. If one intends—finally—to imply by historical materialism that nothing but the quality of the actual means of production is expressed in cultural structures, and that economic reality reigns in history just as absolutely as, according to the idealistic interpretation of the romantics, Riegl, and Woelfflin, the 'artistic intention' or the 'immanent formal law', then one is still romanticizing and simplifying what is in reality a much more complex process, and making of historical materialism a mere variant of the emanatistic logic of history. The real meaning of historical materialism, and at the same time, the most important advance of the philosophy of history since the romantic movement, consists rather in the insight that historical developments have their origin not in formal principles, ideas and entities, not in substances which unfold and produce in the course of history mere 'modifications' of their fundamentally unhistorical nature, but in the fact that historical development represents a dialectical process, in which every factor is in a state of motion and subject to constant change of meaning, in which there is nothing static, nothing timelessly valid, but also nothing one-sidedly active, and in which all factors, material and intellectual, economic and ideological, are bound up together in a state of indissoluble interdependence, that is to say, that we are not in the least able to go back to any point in time, where a historically definable situation is not already the result of this interaction. Even the most primitive economy is already an organized economy, which does not, however, alter the fact that, in our analysis of it, we must start with the material preconditions, which, in contrast to the forms of intellectual organization, are independent and comprehensible in themselves.

Historicism, which was connected with a complete reorientation of culture, was the expression of deep existential changes, and corresponded to an upheaval which shook the very foundations of society. The political revolution had abolished the old

barriers between the classes and the economic revolution had intensified the mobility of life to a previously inconceivable degree. Romanticism was the ideology of the new society and the expression of the world-view of a generation which no longer believed in absolute values, could no longer believe in any values without thinking of their relativity, their historical limitations. It saw everything tied to historical suppositions, because it had experienced, as part of its own personal destiny, the downfall of the old and the rise of the new culture. The romantic awareness of the historicity of all social life was so deep that even the conservative classes were able to produce only historical arguments to justify their privileges, and based their claims on seniority and the fact of being firmly rooted in the historical culture of the nation. But the historical world-view was by no means the creation of conservatism, as has repeatedly been asserted; the conservative classes merely appropriated it to themselves and developed it in a special direction and one opposite to its original purpose. The progressive middle class saw in the historical origin of social institutions evidence against their absolute validity, whereas the conservative classes, who, in their endeavour to justify their privileges, had nothing to appeal to but their 'historical rights', their age and their priority, gave historicism a new meaning— they disguised the antithesis between historicity and supra-temporal validity, and created in its stead an antagonism between the product of historical growth and steady evolution, on the one hand, and the individual, rational, reform is tact of volition, on the other. The antithesis here was not between time and timelessness, history and absolute being, positive law and natural law, but between 'organic development' and individual arbitrariness.

History becomes the refuge of all the elements of society at variance with their own age, whose intellectual and material existence is threatened; and the refuge, above all, of the intelligentsia, which now feels disillusioned in its hopes and tricked out of its rights, not only in Germany but also in the countries of Western Europe. The lack of influence on political developments, which had hitherto been the fate of the German intellectuals, now becomes a European-wide fate shared by intellectuals in general. The enlightenment and the Revolution had encouraged

the individual to cherish exorbitant hopes; they had seemed to promise the unrestricted reign of reason and the absolute authority of writers and thinkers. In the eighteenth century, writers were the intellectual leaders of the West; they were the dynamic element behind the reform movement, they embodied the ideal of personality by which the progressive classes were guided. The upshot of the Revolution changed all that. They were now made responsible by turns for the Revolution having done too much and too little, and were in no way able to maintain their prestige in this period of stagnation and mental eclipse. Even when they were in agreement with the prevailing forces of reaction and were serving them faithfully, they felt none of the satisfaction enjoyed by the 'philosophes' of the eighteenth century. Most of them saw themselves condemned to absolute ineffectiveness and had the feeling of being quite superfluous. They took refuge in a past which they made the place where all their dreams and wishes came true and from which they excluded all the tensions between idea and reality, the self and the world, the individual and society. 'Romanticism is rooted in the torment of the world, and so one will find a people the more romantic and elegiac, the more unhappy its condition is' says a liberal critic of German romanticism.[178] The Germans were probably the most unhappy people in Europe; soon after the Revolution, however, no Western people—or at least the intelligentsia of no people—felt comfortable and secure in its own land. The feeling of homelessness and loneliness became the fundamental experience of the new generation; their whole outlook on the world was influenced by it. It assumed innumerable forms and found expression in a whole series of attempts to escape, of which turning to the past was merely the most pronounced. The escape to Utopia and the fairy tale, to the unconscious and the fantastic, the uncanny and the mysterious, to childhood and nature, to dreams and madness, were all disguised and more or less sublimated forms of the same feeling, of the same yearning for irresponsibility and a life free from suffering and frustration—all attempts to escape into that chaos and anarchy against which the classicism of the seventeenth and eighteenth centuries had fought at times with alarm and anger, at others with grace and wit, but always with the same

163

determination. The classicist felt himself to be master of reality; he agreed to be ruled by others, because he ruled himself and believed that life can be ruled. The romantic, on the other hand, acknowledged no external ties, was incapable of committing himself, and felt himself to be defencelessly exposed to an overwhelmingly powerful reality; hence his contempt for and simultaneous deification of reality. He either violated it or surrendered himself to it blindly and unresistingly, but he never felt equal to it.

Whenever the romantics describe their outlook on art and the world, the word or the idea of homelessness creeps into their sentences. Novalis defines philosophy as 'home-sickness', as the 'urge to be at home in all places', and the fairy tale as a dream of 'that homeland which is everywhere and nowhere'. He praises in Schiller all 'that is not of this earth' and Schiller himself calls the romantics 'exiles pining for a homeland'. That is why they speak so much of wandering, wandering aimlessly and endlessly, of the 'blue flower' which is unattainable and is to remain unattainable, of the solitude that one seeks and shuns, of the infinity which is nothing and everything. 'Mon coeur désire tout, il veut tout, il contient tout. Que mettre à la place de cet infini qu'exige ma pensée . . . ?'—we read in Senancour's *Obermann*. But it is clear that this 'tout' contains nothing and this 'infini' is to be found nowhere. A longing for home and a longing for what is far off—these are the feelings by which the romantics are torn hither and thither; they miss the near-at-hand, suffer from their isolation from men, but, at the same time, they avoid other men and seek zealously for the remote, the exotic and the unknown. They suffer from their estrangement from the world, but they also accept and desire it. Thus Novalis defines romantic poetry as 'the art of appearing strange in an attractive way, the art of making a subject remote and yet familiar and pleasant', and he asserts that everything becomes romantic and poetic, 'if one removes it in a distance', that everything can be romanticized, if one 'gives a mysterious appearance to the ordinary, the dignity of the unknown to the familiar and an infinite significance to the finite'. 'The dignity of the unknown'—what sensible man would have uttered such nonsense a generation or even only a few years before! People had spoken of the dignity of reason, of

knowledge, of common sense, of wise and sober matter-of-factness, but who would have dreamt of talking about the 'dignity of the unknown'! They wanted to master the unknown and make it harmless; to praise it and make it superior to man would have been intellectual suicide and self-destruction. Novalis here gives not merely a definition of the romantic, but also a recipe for 'romanticizing'; for the romantic is not content to be romantic, he makes romanticism an ideal and a policy for the whole of life. He not only wants to portray life romantically, he wants to adapt life to art and to indulge in the illusion of an aesthetic-Utopian existence. But this 'romanticization' means, above all, simplifying and unifying life, freeing it from the tormenting dialectic of all historical being, excluding from it all the indissoluble contradictions and mitigating the opposition which it offers to all romantic wish-fulfilment dreams and fantasies. Every work of art is a vision and a legend of reality, all art replaces actual life with a Utopia, but in romanticism the Utopian character of art is expressed more purely and more fully than elsewhere.

The concept of 'romantic irony' is based essentially on the insight that art is nothing but autosuggestion and illusion, and that we are always aware of the fictitiousness of its representations. The definition of art as 'deliberate self-deception'[179] has its source in romanticism and in ideas like Coleridge's 'willing suspension of disbelief'.[180] The consciousness and deliberateness of this attitude are, however, still a characteristic of the classicistic rationalism which romanticism only gives up in the course of time and replaces with *unconscious* self-deception, with the anaesthesia and intoxicating of the senses, with the forgoing of irony and critical aloofness. The effect of the film has been compared to that of alcohol and opium, and the crowds staggering out from the cinemas into the dark night have been described as drunken narcotics, neither able nor willing to account for the state in which they find themselves. But this effect is not peculiar to the film; it has its origin in romantic art in general. Classicism, naturally, also desired to be stimulating and arouse feelings and illusions in the reader or the beholder—what art has not desired to do so!—but its representations were always in the nature of an instructive example, an analogy or a symbol full of implications.

165

The audience reacted not with tears, raptures and fainting fits but with reflections, fresh insights and a deeper understanding of man and his destiny.

The post-revolutionary period was an age of general disappointment. For those who were only superficially connected with the ideas of the Revolution this disillusion began with the Convention, for the real revolutionaries with the 9 Thermidor. The first group gradually came to hate everything that reminded it of the Revolution, for the latter every new stage in the development only confirmed the treachery of their former confederates. But it was also a painful awakening for those for whom the dream of the Revolution had been a nightmare from the very beginning. To all of them the present age seemed to have become stale and empty. The intellectuals isolated themselves more and more from the rest of society, and the intellectually productive elements already lived a life of their own. The concept of the philistine and the 'bourgeois', in contrast to the 'citoyen', arose, and the curious and almost unprecedented situation came about that artists and writers were filled with hatred and contempt for the very class to which they owed their intellectual and material existence. For romanticism was essentially a middle-class movement, indeed, it was the middle-class literary school par excellence, the school which had broken for good with the conventions of classicism, courtly-aristocratic rhetoric and pretence, with elevated style and refined language. Despite its revolutionary trend, the art of the enlightenment was still based on the aristocratic tastes of classicism. Not only Voltaire and Pope, but also Prévost and Marivaux, Swift and Sterne, were nearer to the seventeenth than to the nineteenth century. Romantic art is the first to consist in the 'human document', the screaming confession, the open wound laid bare. When the literature of the enlightenment praises the bourgeois, it is always done merely in order to attack the upper classes; the romantic movement is the first to take it for granted that the bourgeois is the measure of man. The fact that so many of the representatives of romanticism were of noble descent no more alters the bourgeois character of the movement than does the anti-philistinism of its cultural policy. Novalis, von Kleist, von Arnim, von Eichendorff and von Chamisso, Vicomte de Chateau-

briand, de Lamartine, de Vigny, de Musset, de Bonald, de Maistre and de Lamennais, Lord Byron and Shelley, Leopardi and Manzoni, Pushkin and Lermontov, were members of aristocratic families and manifested aristocratic views to some extent, but from the time of the romantic movement, literature was intended exclusively for the free market, that is to say, for a middle-class public. It was occasionally possible to persuade this public to accept political opinions contrary to its real interests, but it was no longer possible to present the world to it in the impersonal style and abstract intellectual patterns of the eighteenth century. The world-view that was really suited to it was expressed most clearly of all in the idea of the autonomy of the mind and the immanence of the individual spheres of culture, which had predominated in German philosophy since Kant and which would have been unthinkable without the emancipation of the middle class.[181] Until the romantic movement the concept of culture had been dependent on the idea of the subordinate rôle of the human mind; no matter whether the world-view of the moment happened to be of an ecclesiastical-ascetic, a secular-heroic, or an aristocratic-absolutist nature, the mind had always been considered a means to an end and had never seemed to pursue immanent aims of its own. It was only after the dissolution of the earlier ties, after the disappearance of the feeling of the absolute nullity of the mind in relation to the divine order and its relative nullity in relation to the ecclesiastical and secular hierarchy, that is, after the individual had been referred back to himself, that the idea of intellectual autonomy became conceivable. It was in harmony with the philosophy of economic and political liberalism, and remained current until socialism created the idea of a new obligation and historical materialism again abolished the autonomy of the mind. This autonomy was, therefore, like the individualism of romanticism, the result and not the cause of the conflict which shook the foundations of eighteenth-century society. Neither of these ideas was absolutely new, but this was the first time that the individual had been incited to revolt against society and against everything that stood between him and his happiness.[182]

Romanticism pushed its individualism to extremes as a com-

pensation for the materialism of the world and as a protection against the hostility of the bourgeoisie and the philistines to the things of the mind. As the pre-romantics had already tried to do, the romantics proper wanted to create with their aestheticism a sphere withdrawn from the rest of the world in which they could reign unhindered. Classicism based the concept of beauty on that of truth, that is, on a universally human standard controlling the whole of life. But Musset turned Boileau's words inside out and proclaimed: 'Rien n'est vrai que le beau.' The romantics judged life according to the criteria of art, because they wanted thereby to raise themselves as a new aristocracy above the rest of men; but the ambivalent attitude on which their whole world-view was based also found expression in their relationship to art. The Goethean problem of the nature of the artist continued to torment them; art was looked upon, on the one hand, as an instrument of higher knowledge, of religious ecstasy, of divine revelation, but, on the other, its value in the practice of daily life was questioned. 'Art is a seducing, forbidden fruit'—as Wackenroder had already said—'whoever has once tasted its innermost, sweetest juice, is irretrievably lost for the active, living world. He creeps more and more closely into his own little corner of pleasure . . .' And: 'That is the poison of art that the artist becomes an actor who regards the whole of life as a part, his stage as the model world and the kernel, and real life as the husk, as a miserable patched-up imitation.'[183] Schelling's 'system of identity' was just as much an attempt to overcome this contradiction as Keats's message: 'Beauty is truth, truth beauty.' Nevertheless, aestheticism remains the basic characteristic of the romantic outlook, and Heine's summing up of classicism and romanticism as the 'art period' (Kunstperiode) of German literature is absolutely correct.

Nothing presented itself to the romantics free from conflicting features; the problematical nature of their historical situation and the inner strife of their feelings is reflected in all their utterances. The moral life of humanity has taken place in conflicts from time immemorial; the more differentiated man's social life has been, the more violent have been the clashes between the ego and the world, between instinct and reason, past and present. But

in romanticism these conflicts become the basic form of consciousness. Life and mind, nature and culture, history and eternity, solitude and society, revolution and tradition, no longer appear as logical correlatives or as moral alternatives, between which one has to choose, but as possibilities which one strives to realize simultaneously. They are not yet, however, set in dialectical opposition to one another, there is no search for a synthesis which would express their interdependence, they are merely experimented and played with. Neither idealism and spiritualism nor irrationalism and individualism reign unopposed; on the contrary, they alternate with an equally strong tendency to naturalism and collectivism. The spontaneity and consistency of philosophical attitudes has ceased; all that exist now are reflexive, critical, problematical attitudes, the antitheses of which are always present and capable of realization. The human mind has now lost even that last remnant of spontaneity which the eighteenth century was still able to call its own. The inner discord and ambivalence of spiritual relationships goes so far that it has been rightly asserted that the romantics, or at least the early German romantics, endeavoured to keep the 'romantic' itself at a distance from themselves.[184] Friedrich Schlegel and Novalis, at any rate, tried to overcome all the sensitivity inside them and, for all their subjectivity and sensibility, to found their world-view on something solid and universally valid. That was, in fact, precisely the great, basic difference between pre-romanticism and romanticism, that the sentimentalism of the eighteenth century was replaced by a heightened sensibility, an enhanced 'impressionability of the heart and the soul', and, although plenty of tears continued to be shed, emotional reactions began to lose their moral value and sank down to lower and lower cultural strata.

The inner strife of the romantic soul is reflected nowhere so directly and expressively as in the figure of the 'second self' which is always present to the romantic mind and recurs in innumerable forms and variations in romantic literature. The source of this *idée fixe* is unmistakable: it is the irresistible urge to introspection, the maniacal tendency to self-observation and the compulsion to consider oneself over and over again as one unknown, as an uncannily remote stranger. The idea of the 'second self' is,

of course, again merely an attempt to escape and expresses the inability of the romantics to resign themselves to their own historical and social situation. The romantic rushes headlong into his 'double', just as he rushes headlong into everything dark and ambiguous, chaotic and ecstatic, demonic and dionysian, and seeks therein merely a refuge from the reality which he is unable to master by rational means. On this flight from reality, he discovers the unconscious, that which is hidden away in safety from the rational mind, the source of his wish-fulfilment dreams and of the irrational solutions of his problems. He discovers that 'two souls dwell in his breast', that something inside him feels and thinks that is not identical with himself, that he carries his demon and his judge about with him—in brief, he discovers the basic facts of psychoanalysis. For him, the irrational has the inestimable advantage of not being subject to conscious control, which is why he praises the unconscious, obscure instincts, dreamlike and ecstatic states of soul, and looks in them for the satisfaction which is not vouchsafed him by the cool, cold, critical intellect. 'La sensibilité n'est guère la qualité d'un grand génie . . . Ce n'est pas son coeur, c'est sa tête qui fait tout', as even a writer as late as Diderot said;[185] now, on the other hand, everything is expected to come from the *salto mortale* of the reason. Hence the belief in direct experiences and moods, the surrender to the moment and the fleeting impression, hence that adoration of the 'chance occurrence' of which Novalis speaks. The more bewildering the chaos, the more radiant the star, it is hoped, that will emerge from it. Hence the cult of the mysterious and nocturnal, of the bizarre and the grotesque, the horrible and the ghostlike, the diabolical and the macabre, the pathological and the perverse. If one describes romanticism as 'hospital-poetry', as Goethe did, that is certainly to do it a great injustice, but a revealing injustice, even if one does not think just of Novalis and the aphorisms in which he says that life is a disease of the mind, and that it is disease that distinguishes man from the plants and animals. For the romantic disease is again only an escape from the rational mastery of the problems of life, and being ill only a pretext for withdrawing from the duties of daily routine. If one maintains that the romantics were 'diseased', one has not said

very much; but the statement that the philosophy of disease constituted an essential element of their world-view implies a good deal more. For them disease represented the negation of the ordinary, the normal, the reasonable and contained the dualism of life and death, nature and non-nature, continuance and dissolution, which dominated their whole conception of life. It meant the depreciation of everything sharply defined and abiding, and was in accordance with their hatred for all limitations, all solid and definite form.

We know that Goethe had already spoken of the untruth and inadequacy of forms, and if we recall his saying, we shall understand why the French have always reckoned him among the romantics. But Goethe felt the restricted forms of art to be untrue only when measured against the concrete richness of life; the romantics, on the other hand, considered everything clear-cut and definite as intrinsically of less value than the open, unfulfilled possibility, on which they bestowed the characteristics of infinite growth, of the eternal movement, change and fertility of life. They regarded all solid forms, all unequivocal thoughts, all determinate utterance as dead and false; hence they inclined, despite their aestheticism, to disparage the work of art as a controlled and self-sufficient form. Their extravagances and arbitrariness, their mingling and combining of the arts, the improvised and fragmentary nature of their style, were merely symptoms of this dynamic approach to life, to which they owed all their genius, all their intensified sensibility and historical clairvoyance. Since the Revolution, the individual had lost all external supports; he was dependent on himself, had to seek for help within himself, and became an object of infinite importance and infinite interest to himself. He replaced experience of the world more and more with self-experience and finally came to feel that spiritual activity, the current of thoughts and feelings, the way leading from one spiritual state to another, is more real than external reality. He regarded the world merely as the raw material and substratum of his own experiences and used it as a pretext for talking about himself. 'All the accidents of our life', Novalis thought, 'are materials out of which we can make what we like, everything is a link in an unending chain.' This implies a

disparagement of both the beginning and the end of the stream of experience, of both the content and the form of the finished work of art. The world becomes a mere occasion for spiritual movement, and art the accidental vessel in which the contents of experience achieve definition for a moment. There arises the mode of thought which has been called the 'occasionalism' of romanticism[186]—the approach which dissolves reality into a series of unsubstantial, inherently undefinable occasions, into mere stimuli to intellectual creation, into situations which apparently exist simply in order that the subject may make sure of his own existence, of his own substantiality. The more indefinite, iridescent, atmospherical and 'musical' the stimuli are, the more vigorously does the experiencing subject vibrate in response; the more intangible, inconstant, unsubstantial the world appears, the stronger, freer and more autonomous will be the feeling of the individual fighting for authority. Only in a historical situation in which the individual was already free and dependent on himself, but still felt that he was menaced and endangered, could such an attitude arise. The whole ostentatious subjectivism, the irresistible urge to spiritual enlargement, the never satisfied, self-surpassing lyricism of the new art, can only be explained by this split of the ego. Romanticism cannot be understood unless one's explanation of it is based on this dissension and on the over-compensations typical of the emancipated and disillusioned individual of the post-revolutionary period.

The political conversion of romanticism in Germany from liberalism to the monarchist-conservative point of view, the opposite trend of development in France and in England, too, in a probably more complicated way, wavering between Revolution and Restoration, but on the whole in harmony with the French development, was possible only because romanticism had an equivocal relationship to the Revolution and was at all times ready to change over to the opposite of its previous attitude. German classicism had sympathized with the ideas of the French Revolution, and this affection became still deeper in German romanticism, which, as Haym and Dilthey have already noted, was never wholly unpolitical.[187] It was only during the Napoleonic Wars that the ruling classes succeeded in winning over

the romantics to the side of reaction. Until Napoleon's invasion of Germany the conservative powers felt absolutely safe and were 'enlightened' and tolerant in their own way; but now that with the victorious French army the institutions of the French Revolution threatened to spread, they set to work to suppress every kind of liberalism, and fought against Napoleon, above all, as the exponent of the Revolution. The really progressively and independently minded people, like Goethe, did not allow themselves to be taken in by the anti-Napoleonic propaganda; but they formed only a vanishing minority of the middle class and the intelligentsia. The revolutionary spirit was always of a different character in Germany from what it was in France. The German poets' enthusiasm for the Revolution was abstract and fact-distorting in its approach and no more did justice to the meaning of events than the thoughtless tolerance of the ruling classes. The poets thought of the Revolution as a great philosophical discussion, the holders of power regarded it as a mere play that, in their opinion, could never become a reality in Germany. This lack of understanding explains the complete change that comes over the whole nation after the Wars of Liberation. The change of front of Fichte, the republican and rationalist, who suddenly sees the period of the Revolution as the age of 'absolute sinfulness', is supremely typical. The initial romanticization of the Revolution only brings about an all the more violent repudiation and results in the identification of romanticism with the Restoration. At the time when the romantic movement reached its really creative and revolutionary phase in the West, there was no longer a single romantic in Germany who had not transferred his allegiance to the conservative and monarchist camp.[188]

French romanticism, which in its beginnings was an 'émigré literature',[189] remained the mouthpiece of the Restoration until after 1820. It is only in the second half of the 20's that it develops into a liberal movement formulating its artistic aims after the analogy of the political Revolution. In England romanticism is, as in Germany, pro-revolutionary, to begin with, and becomes conservative only during the war against Napoleon; after the war years, however, it takes a fresh turn, and again approaches its earlier revolutionary ideals. Romanticism, there-

fore, finally turns against the Restoration and reaction both in France and England—and, indeed, much more decidedly than the course of political events themselves. For, although the liberal idea apparently gains the upper hand in the constitutions and institutions of the West, modern Europe, with its pro-capitalist economic policy, its militaristic-imperialistic monarchies, its centralistic-bureaucratic administrative systems, its rehabilitated Churches and state religions, is just as much the creation of the Restoration as it is of the enlightenment and it is equally justifiable to see in the nineteenth century a period of opposition to the spirit of the Revolution as the triumph of the ideas of freedom and progress.[190] If the Napoleonic empire had already meant the dissolution of the individualistic ideals of the Revolution, the victory of the allies over Napoleon, the Holy Alliance and the Restoration of the Bourbons led to the final break with the eighteenth century and with the idea of basing state and society on the individual. But the spirit of individualism could no longer be displaced from the modes of thought and experience of the new generation; that explains the contradiction between the anti-liberal politics and the liberal artistic tendencies of the age.

For the Restoration, Napoleon's military adventure was nothing more than the counterpart to the political crime of 1789 and the first Empire merely the continuation of lawlessness and anarchy. The monarchists regarded the whole revolutionary-Napoleonic epoch as a unity, as the consistent undermining of the old order, of the old hierarchy, of the old rights of property. And the Empire was, in spite of its reactionary tendencies, all the more dangerous, as it appeared to consolidate the achievements of the Revolution and to create a new state of equilibrium. In contrast to this whole revolutionary epoch, the Restoration meant the beginning of a new era. It rescued what there was to rescue, and tried to create an adjustment between what it was no longer possible to restore of the old institutions and what it was no longer possible to alter in the new. But in this respect, the Restoration was only the continuation of the Napoleonic period; it represented the same antagonism between the principles of the Revolution and the ideas of the *ancien régime*—though with the difference that Napoleon wanted to preserve as much as possible

of the achievements of the Revolution, whereas the Restoration wanted to undo them as much as possible. One must not underestimate this difference, although the Restoration began by introducing a certain relaxation in the use of force which both the Revolution, always in danger of losing its life, and the Empire, threatened from left and right, were compelled to apply. There was, of course, no question of a renaissance of middle-class freedom, in contrast to Napoleon's military dictatorship; the semblance of one arose only because now, instead of individual persons, whole classes and groups were persecuted and prejudiced, but within the framework of this class rule statutory freedom was considered to some extent. The Restoration was able to allow itself the luxury of being more tolerant than its predecessors. Reaction had triumphed in the whole of Europe and liberal ideas were losing their danger; the peoples of Europe were tired of revolutionary and warlike undertakings and yearned for peace and quiet. A freer exchange of ideas than hitherto became possible and it was no longer necessary to make the following of certain trends subject to sanctions, even though the political background of the various artistic approaches was perceived with great exactness.

In France the romantics profess themselves legitimists and clericalists, to begin with, whereas the classical tradition in literature is represented mainly by the liberals. Not all the classicists are liberal, but all the liberals are classicists.[191] There is probably no other example in the history of art which makes it so clear that a conservative political disposition is directly compatible with a progressive artistic outlook, indeed, that conservatism and progressiveness are, properly speaking, incommensurable in the two spheres. No understanding is possible between the classicistically-minded liberals and the romantic 'ultras', but amongst the legitimists there is a whole group of believers in the classicistic view of art, although, in contrast to the liberals, they have in mind not the classicism of the eighteenth century but that of the age of Louis XIV. In their fight against romanticism, however, the liberal and conservative classicists are in complete agreement; that is why the Academy rejects Lamartine, despite his conservatism. Incidentally, the Academy no longer represents the

taste prevailing among the literary public; a large section of the reading public supports the romantics and, indeed, with a hitherto unknown fervour. The success of Chateaubriand's *Génie du Christianisme* was already unprecedented for a work of its kind, but never before or since has a small collection of lyrical poems been received with such enthusiasm as Lamartine's *Méditations*. After the long stagnation of literature, there now begins a lively, extremely productive era, rich in unusual talents and successful works. To be sure, the reading public is not big, but it is a grateful public with a passionate interest in and enthusiasm for literature.[192] A relatively large number of books is bought, the press follows literary events with the greatest attention, the *salons* open up again and celebrate the intellectual heroes of the day. As a result of the relatively high degree of freedom, a disintegration of literary effort takes place and the homogeneous culture of the 'grand siècle' gradually recedes into a mythical past. It is true that there had already been a quarrel between the 'ancients' and the 'moderns' in the seventeenth century, a conflict between the academic trend of Le Brun and the pictorial conception of art of his opponents, and in the eighteenth century there was the far more violent antagonism between the courtly rococo and bourgeois pre-romanticism, but during the whole of the *ancien régime* a fundamentally homogeneous taste had prevailed in art —an orthodoxy the enemies of which had always been regarded as dissidents and outsiders. There had never been, in a word, any real rivalry between artistic tendencies. Now, on the other hand, there are two equally strong groups, or at least, two groups enjoying equal prestige. Neither of the competing trends has an authoritarian character and dominates the intellectual élite exclusively or overwhelmingly; and even after the victory of romanticism there is no standard 'romantic taste' in the sense that there had been a normative classicistic taste. Certainly, no one escapes from its influence, but by no means everyone acknowledges it, and a fight begins against this taste in the camp of its own representatives almost simultaneously with its victory. The conflict between competing aesthetic tendencies is now just as characteristic a feature of artistic life as the intolerance of the public towards the new movements. In everything that it cannot

understand the bourgeoisie scents the presence of scorn and contempt and finally rejects innovations on principle. The dividing line between aesthetic orthodoxy and unorthodoxy is gradually obliterated and the distinction ultimately loses all its significance. Soon there are merely literary 'parties' and something approaching a democracy of literary life comes into being. The sociological innovation of romanticism is the politicization of art and not merely in the sense that artists and writers join political parties, but also that they carry on party politics within artistic life itself. 'Vous verrez qu'il faudra finir par avoir une opinion' are the melancholy words of an eclectic of the period[193] and Balzac characterizes the situation in the *Illusions perdues* in the following terms: 'Les royalistes sont romantiques, les libéraux classiques . . . Si vous êtes éclectiques vous n'aurez personne pour vous.' The unavoidable necessity of taking sides in the great controversy was seen quite accurately by Balzac, only the situation was somewhat more complicated than he described it here.

The most important representative of the 'émigré literature' is Chateaubriand. With Rousseau and Byron, he is one of the most influential forces in the moulding of the new romantic type and, as such, he plays an incomparably more important rôle than would be justified by the intrinsic value of his works. Like his predecessor and his successor, he is merely the exponent, not the sustainer and creator, of an intellectual movement, and enriches it only with a new form of expression, not with a new content of experience. Rousseau's Saint-Preux and Goethe's Werther were the first embodiments of the disillusion which seized men's minds in the romantic era, Chateaubriand's René is the expression of the despair into which this disillusion now develops. The sentimentalism and melancholy of pre-romanticism was in accordance with the emotional condition of the bourgeoisie before the Revolution, the pessimism and weariness of life of the émigré literature is in accordance with the mood of the aristocracy after the Revolution. This mood becomes a universal European phenomenon after the fall of Napoleon and gives expression to the feelings of all the upper classes. Rousseau still knew why he was unhappy; the complaints from which he suffered were modern culture and the inability of conventional social forms to meet his

spiritual needs. He imagined a quite concrete, though unrealizable, situation in which he would be cured of his complaints. René's melancholy, on the other hand, is indefinable. For him the whole of life has become meaningless; he feels an infinite, exalted desire for love and fellowship, an everlasting yearning to embrace everything, to be embraced by everything; but he knows that this yearning is incapable of fulfilment and that his soul would still remain unsatisfied, if all his wishes could be fulfilled. Nothing is worth being desired, all striving and fighting is useless; the only sensible action is suicide. And the absolute separation of the internal and external world, of the poetry and prose of life, the solitude, the contempt for the world and the misanthropy, the unreal, abstract, desperately egoistic existence, which the romantic natures of the new century lead, is already suicide.

Chateaubriand, Mme de Staël, Senancour, Constant, Nodier, all stand alongside Rousseau and feel a marked dislike for Voltaire. But most of them feel themselves in opposition only to the rationalism of the eighteenth century, not to that of the seventeenth. Only because of this distinction does Chateaubriand succeed in combining his progressive view of art with his political conservatism, his royalism and clericalism, his enthusiasm for throne and altar. And only because romanticism feels its connection with the more distant more strongly than with the more recent past, is it possible to explain why Lamartine, Vigny and Hugo remained loyal to legitimism for so long. The first signs of a change in their political views do not become apparent until about 1824. It is then that the first of the romantic coteries ('cénacles') comes into being, the famous circle around Charles Nodier in the 'Arsenal', and it is not until then that the movement amalgamates into something in the nature of a school. The social framework within which eighteenth-century French literature had developed was the *salons*, that is, the regular meetings of writers, artists and critics with members of the upper classes in the homes of the aristocracy and the upper middle class. These were closed circles, in which the manners of cultured society set the fashion and which, however many concessions were made to the way of life of the intellectual 'stars', preserved their 'social'

character. But the influence of the *salons* on literature was, for all the stimulation which they gave to the writers of the time, not directly creative. They constituted a forum to which most people submitted without question, a school of good taste and a tribunal which was called upon to decide the fate of literary fashions, but in no way a suitable milieu for the creative co-operation of a group. The 'cénacles' of the romantics are, in contrast, friendly artistic gatherings, in which the 'social' element recedes very much into the background, above all because in every case they are formed round a particular artist and are much less strictly closed than even the most liberal *salons*. Here not only is every writer, artist and critic, who is prepared to join the movement, welcome, but sympathetic members of the public are also admitted. It is true that this open-mindedness and inter-mingling impairs the scholastic character of the movement, but it in no way prevents the development of a homogeneous concep-tion of art and of a common art policy. In contrast to earlier groupings, the circle in which literary life now develops is no centreless party, as in eighteenth-century France, nor a club or a coffee-house, as in England, but a group assembled round a personality, whom the group regards as its master, and whose authority it acknowledges unconditionally, though not always within the terms of a definite master-disciple relationship. This is the first time in the history of modern literature that the form of a school exerts a decisive influence on the course of events. This form is known neither to the seventeenth nor to the eighteenth century, although it would have been more in accord-ance with the normative character of classical literature. Romanticism, on the other hand, develops, in spite of or perhaps precisely because of the problematical validity of its artistic principles, a school with a strictly formulatable and teachable doctrine. In the age of classicism, the whole of French literature formed one great school, one uniform taste prevailed in the whole of France; the dissidents and rebels represented much too atomized a group to join forces within the framework of a common programme. But now that French literature has become the battleground of two great and almost equal parties, now that the example of political life induces writers to formulate party

programmes and rouses in them the desire for a leader, now that, finally, the artistic aims of the new trend are still so unclarified and contradictory that they have to be summarized and codified, now the time for the founding of literary schools has arrived.

In France the romantic movement was more in the nature of a literary school than in Germany, where the classical ideal in art had never been realized so purely, where the romantics still very largely continued to follow the cultural ideals of classicism and where even the outlook of classicism was to some extent romantic in character. At any rate, the party structure of literary life was much less marked than in France and, consequently, the grouping of writers according to literary 'schools' was also less pronounced. In England, where the distinction between classicism and romanticism had become pointless since the second half of the eighteenth century, because there was, so to say, nothing but romantic literature, no literary school of any kind was formed and no personality with the authority of an acknowledged master appeared on the scene.[194] Even the French 'cénacles', however, are often no more than literary cliques kept together only by a common jargon and seem from outside to be a conspiracy and from inside a jealous troop of actors. They are, indeed, often merely warlike sects or heated debating societies, for whom doctrine is more important than practice and being different from one another more interesting than mutual adaptation. Nevertheless, both in France and Germany the romantic movement is marked by a deep conception of community and a strong tendency towards collectivism. The romantics spend their lives in a fellowship of mutual philosophizing, writing, criticizing and discussion; they find the deepest meaning in life in the relationships of love and friendship; they found periodicals, publish year-books and anthologies, deliver lectures and hold courses, make propaganda for themselves and for one another; try, in a word, to work together in a community, even though this symbiotic urge is only the reverse side of their individualism and the compensation for their loneliness and rootlessness.

The amalgamation of the French romantics into a homogeneous group takes place at the same time as public opinion takes a turn to liberalism. About 1824 the *Globe* begins to strike

a new note and that is also the date of the first regular meetings in the 'Arsenal'. The leading romantics, above all Lamartine and Hugo, are, it is true, still loyal supporters of the Church and the Throne, but romanticism ceases from being exclusively clerical and monarchistic. The real change does not occur, however, until 1827, when Victor Hugo writes the famous Preface to his *Cromwell* and propounds the thesis that romanticism is the liberalism of literature. In this year, too, the pictures of the leading romantic painters are seen in the Salon for the first time in greater numbers; besides twelve paintings by Delacroix, representative works of Devéria and Boulanger are exhibited. The public is confronted with a broad, compact movement, which seems to be embracing the whole intellectual life of the country and to be securing complete and final victory for romanticism. The composition of the new 'cénacle' around Victor Hugo is in accordance with this quality of universality and he is regarded from now on as the master of the romantic school. The writers Deschamps, Vigny, Sainte-Beuve, Dumas, Musset, Balzac, the painters Delacroix, Devéria, Boulanger, the graphic artists Johannot, Gigoux, Nanteuil and the sculptor David d'Angers are among the regular guests in the rue Notre-Dame-des-Champs. To this circle Hugo reads aloud his dramas *Marion Delorme* and *Hernani* in 1829. It is true that the group is dissolved in the very same year, but the school continues. The movement becomes even more concentrated and clarified, more and more radical and clear-cut. From the second 'cénacle' in Nodier's home, which comes into being in 1829, the still semi-classical elements already disappear entirely, whereas the plastic artists become regular members of the circle. The absolute unity of the movement, as well as its anti-bourgeois tendency, which gradually hardens into a dogma, are expressed most incisively in the last romantic 'cénacle' which gathers in the studios inhabited by Théophile Gautier, Gérard de Nerval and their friends in the rue de Doyenné. This artists' colony with its anti-philisitinism and its theory of 'l'art pour l'art' is the hot-house of modern bohemianism.

The bohemian character with which romanticism is usually associated was by no means characteristic of the movement from the outset. From Chateaubriand to Lamartine, French romanti-

cism was represented almost exclusively by aristocrats, and if, after 1824, it no longer stood up unanimously for the monarchy and the Church, nevertheless, it remained to some extent aristocratic and clerical. Only very gradually does the leadership of the movement pass into the hands of the plebeians Victor Hugo, Théophile Gautier and Alexandre Dumas, and only shortly before the July revolution do the majority of the romantics change their conservative attitude. The emergence into prominence of the plebeian elements is, however, more a symptom than the cause of the political change. Formerly the middle-class writers adapted themselves to the conservatism of the aristocrats, whereas now even the aristocratic Chateaubriand and Lamartine go over to the opposition. The ever-advancing restriction of personal freedom under Charles X, the clericalization of public life, the introduction of the death penalty for blasphemy, the dissolution of the Garde Nationale and the Chamber, government by decree, only accelerate the radicalization of intellectual life. They only make more obvious what had already been unmistakable since 1815, namely that the Restoration meant the definitive end of the Revolution. Men's minds have now at last recovered from their post-revolutionary apathy and it was this change of mood which forced Charles X to take more and more reactionary measures, if he wanted to keep to the direction imperative for a government based on anti-revolutionary elements. The romantics, who gradually became conscious of where the Restoration was really leading to, recognized at the same time that the wealthy bourgeoisie was the strongest support of the régime—a much stronger support than the old, partly dispossessed, disabled aristocracy. Their whole hatred, their whole contempt, was now heaped on the middle class. The avaricious, narrow-minded, hypocritical bourgeois became their public enemy No. 1 and, in contrast to him, the poor, honest, open-hearted artist struggling against all the humiliating ties and conventional lies of society appears as the human ideal par excellence. The tendency to remoteness from practical life with firm social roots and political commitments, which had been characteristic of romanticism from the very beginning and had become apparent in Germany even in the eighteenth century,

now becomes predominant everywhere; even in the Western nations an unbridgeable gulf opens up between the genius and ordinary men, between the artist and the public, between art and social reality. The bad manners and impertinences of the bohemians, their often childish ambition to embarrass and provoke the unsuspecting bourgeois, their frantic attempt to differentiate themselves from normal, average men and women, the eccentricity of their clothes, their head-dress, their beards, Gautier's red waistcoat and the equally conspicuous, though not always so dazzling masquerade of his friends, their free and easy and paradoxical language, their exaggerated, aggressively formulated ideas, their invectives and indecencies, all that is merely the expression of the desire to isolate themselves from middle-class society, or rather of the desire to represent the already accomplished isolation as intentional and acceptable.

With the *Jeune-France*, as the rebels now call themselves, everything revolves around their hatred for philistinism, around their contempt for the strictly regulated and soulless life of the bourgeoisie, around their fight against everything traditional and conventional, everything capable of being taught and learnt, everything mature and serene. The system of intellectual values is enriched by a new category: the idea of youth as more creative than and intrinsically superior to age. This is a new idea, alien, above all, to classicism, but to a certain extent to all previous cultures. There had naturally been a competition between the generations and victorious youth had been the power sustaining artistic developments in earlier ages. But youth had not triumphed simply because it was 'young'; the general attitude to youth had been one rather of guarded prudence than of excessive confidence. It is not until the romantic movement that the idea prevails of regarding the 'young' as the natural representatives of progress, and not until the victory of romanticism over classicism that any mention is made of the fundamental injustice in the older generation's attitude to youth.[195] The emphasis on the unity of the arts is, incidentally, like this solidarity of youth, merely a symptom of the isolation of romanticism from the world of the inartistic philistine. Whilst the connection of belles-lettres with philosophy was stressed in the eighteenth century,

literature is now described, quite consistently, as an 'art'.[196] So long as the plastic artists had aspired to be reckoned as belonging to the upper middle class, they had underlined the similarity of their profession to that of the men of letters, but now writers themselves want to be different from the bourgeoisie and stress, therefore, their affinity to the craftsmanlike arts.

The complacency and vanity of the romantics goes so far that, in contrast to their former aestheticism, which turned the poet into a god, they now turn God into a poet. 'Dieu n'est peut-être que le premier poète du monde,' says Gautier. Even the theory of 'l'art pour l'art', which is, however, an extremely complex phenomenon, and gives expression, on the one hand, to a liberal, on the other, to a quietistic-conservative attitude, has its origin in the protest against bourgeois values. When Gautier stresses the pure formalism and play character of art, when he desires to free it from all ideas and all ideals, his supreme wish is to emancipate it from the dominion of the bourgeois order of life. When Taine once praised Musset at the expense of Hugo, Gautier is said to have remarked to him: 'Taine, you seem to have fallen into bourgeois idiocy. Fancy demanding feeling from poetry! That's not the main thing at all. Radiant words, words of light, full of rhythm and music, that's poetry.'[197] In the 'l'art pour l'art' of Gautier, Stendhal and Mérimée, in their emancipation from the ideas of the time, in their programme of pursuing art as a sovereign game and enjoying it as a secret paradise forbidden to ordinary mortals, opposition to the bourgeois world even plays a more important part than in the later 'l'art pour l'art', whose renunciation of all political and social activity is thoroughly welcomed by the parvenu bourgeoisie. Gautier and his comrades in arms refused the bourgeoisie their help in the moral subjugation of society; Flaubert, Leconte de Lisle and Baudelaire, on the other hand, promote the interests of the bourgeoisie by shutting themselves up in their ivory towers and not bothering any further about the course of the world.

The romantics' struggle to obtain control of the theatre, especially their fight for Victor Hugo's *Hernani*, was a war waged by the rue de Doyenné, the bohemians and youth. It did not in **any sense** end with a striking victory for the romantics; the

opposition had not disappeared overnight and it was a long time yet before it gave up its control of the most distinguished theatres in Paris. The movement's fate no longer depended, however, on the reception of a play; as a stylistic trend, romanticism had long since conquered the world. The period about 1830 brings about a change only in so far as romanticism now becomes entirely politicized and allies itself with liberalism. After the July revolution, the intellectual leaders of the time abandon their passivity and many of them exchange a literary for a political career. But even the writers who, like Lamartine and Hugo, remain faithful to their literary profession, take a more active and direct part in political events than hitherto. Victor Hugo is no rebel, no bohemian, and is not directly concerned in the romantic campaign against the bourgeois. In his political development he treads rather the path of the French bourgeoisie. To begin with, he is a loyal adherent of the Bourbons, then he takes part in the July revolution and is the devoted servant of the July monarchy, finally, he supports the aspirations of Louis Napoleon and becomes a radical republican only after the majority of the French bourgeoisie has already become liberal and anti-monarchistic. His relation to Napoleon is also merely in keeping with the changes in public opinion. In 1825 he is still an embittered opponent of Napoleon and curses his memory; it is only around 1827 that he alters his attitude and begins to speak of the glory that is bound up for France with the name of Napoleon. Finally, he becomes the noisiest spokesman of the Bonapartism that represents such a queer mixture of naïve hero-worship, sentimental nationalism and sincere, though not always consistently thought-out, liberalism. How extremely complex the motives of this movement are is best shown by the fact that such different spirits as Heine and Béranger are amongst its supporters and that it is based, on the one hand, on the genuine Voltairians and the heirs of the enlightenment, on the other hand, on the petty bourgeoisie that certainly has a tinge of Voltairianism about it, is anti-clerical and anti-monarchist but, at the same time, sentimental and inclined to build up legends. The fact that a single publisher, the famous Touquet, sells thirty-one thousand copies, that is, a million and six hundred

thousand volumes, of Voltaire's works between 1817 and 1824,[198] is the most striking token of the renaissance of the enlightenment and a proof that the middle class constitutes an important contingent of the buyers. It is characteristic of this class that it acquires Voltaire's collected works and sings the free-thinking, though intellectually and artistically not very exacting songs of Béranger. These songs are heard everywhere, their refrains sound in every ear and, as has been said, they contribute more to the undermining of the prestige of the Bourbons than all the other intellectual products of the age. It goes without saying that the middle class had had its songs in earlier ages: its table- and dancing-songs, its patriotic and political songs, its topical verses and street-ballads, which were in no respect more remarkable than the songs of Béranger. But they led their life outside 'literature' and exercised no more than a superficial influence on the poets of the cultured classes. The Revolution not only introduced a much richer production in this popular genre, but also promoted the infiltration of the taste which it expressed into the literature of more fastidious circles. Victor Hugo's development as a poet is the best example of the process by which literature assimilated this influence and shows with the greatest possible clarity the advantages and disadvantages which it involved. The patriotic poetry of later romanticism is just as inconceivable without Béranger's songs as is the romantic drama without the popular theatre. Victor Hugo even as a poet trod the bourgeois path; his lyrical style oscillated between the popular taste of the period of the Revolution and the lofty, ostentatious, pseudo-baroque approach of the Second Empire. Victor Hugo was in no sense a revolutionary, in spite of the conflicts which raged about him. Even the definition of romanticism as the liberalism of literature, as he formulated it, was no longer new; the idea occurs, before him, in Stendhal. The conformity between Hugo's conception of art and the taste of the ruling middle class became more and more complete. They coincide, finally, in the cult of grandiosity, from which they were, in reality, both entirely remote, and in the fondness for a pompous, noisy, rapturous and highly emotional style of which there are still echoes in Rostand, for example.

The most important achievement of the romantic revolution

was the renewal of the poetic vocabulary. The French literary language had become poor and colourless in the course of the seventeenth and eighteenth century, owing to the strict convention regarding permissible expressions and stylistic forms recognized as 'correct'. Everything that sounded commonplace, professional, archaic or provincial was taboo. The simple, natural expressions used in everyday language had to be replaced with noble, choice, 'poetic' terms or artistic paraphrases. It was not considered correct to say 'warrior' or 'horse', but 'héros' and 'coursier', it was not permitted to say 'water' and 'storm', one had to say 'the damp element' and 'the raging of the elements'. The conflict about *Hernani* broke out, as is well known, over the passage: 'Est-il minuit?'—'Minuit bientôt.' That sounded too commonplace, too direct, too listless. Stendhal thought that the answer should have run:

> ' . . . l'heure
> Atteindra bientôt sa dernière demeure'.

The advocates of the classical style knew quite well, however, what the fundamental issue was. Victor Hugo's language was really nothing new; it was, in fact, the language of the boulevard theatres. But the classicists were merely concerned with the 'purity' of the literary theatre; they did not bother themselves about the boulevards and the entertainment of the masses. So long as an elevated theatre and cultivated writing existed, it was possible confidently to disregard what was happening on the boulevards, but once it was permitted to speak from the stage of the Théâtre-Français as one chose, then there was no longer any recognizable difference between the various cultural and social strata. Since Corneille, tragedy had been the representative literary genre; one made one's début as a poet with a tragedy and reached the pinnacle of fame as a tragic poet. Tragedy and the literary theatre were the domain of the intellectual élite; as long as it remained inviolate, people were still able to feel themselves the heirs of the 'grand siècle'. What was at stake now, however, was the invasion of the literary theatre by a drama based on the popular theatre, which was indifferent to the psychological and moral problems of classical tragedy and was more

187

concerned to seek, in their stead, for exciting actions, picturesque scenery, piquant characters and highly coloured descriptions of sentiments. The fate of the theatre was a topic of daily conversation; the antagonists in both camps knew very well that they were fighting for the conquest of a key position. Owing to his theatrical temperament, his mania for the theatre, his loud and demonstrative nature and his feeling for the popular, the trivial, the brutally effective, Victor Hugo was the born exponent, though not entirely the motive power in the struggle for this position.

Romanticism found a very complex situation in the theatre when it arrived on the scene. The popular stage, as the heir of the old mime, the medieval farce and the *commedia dell'arte*, had been displaced by the literary theatre in the seventeenth and eighteenth century. During the Revolution, however, popular productions received a new impulse and again took possession of some of the Paris theatres with forms which still owed a good deal to the influence of the literary drama. It is true that in the Comédie-Française and the Odéon the tragedies and comedies of Corneille, Racine and Molière, and the works of writers who had either adapted themselves to the classical tradition and the court taste or had kept to the literary principles of the domestic drama, continued to be performed. In the theatres of the boulevards— in the Gymnase, the Vaudeville, the Ambigu-Comique, the Gaieté, the Variétés and the Nouveautés—on the other hand, plays were performed which were in accordance with the taste and cultural level of the broader masses. Contemporary records report in detail on the change that came over the theatre public during and immediately after the Revolution and stress the lack of artistic pretensions and culture in the ranks of society that now filled the Paris theatres. The new public is made up for the most part of soldiers, workers, shop-assistants and youngsters of whom, as one of our sources remarks, hardly a third are able to write.[199] And this auditorium dominates not merely the plebeian theatres of the boulevards but, at the same time, threatens the existence of the distinguished literary theatres, by absorbing the better public, so that the actors of the Comédie-Française and the Odéon play before empty houses.[200]

At the time of the first Empire, the Restoration and the July monarchy the following genres are represented in the repertoire of the Paris theatres: (1) The '*comédie en 5 actes et en vers*', which represents the literary genre par excellence and is intended, as such, for the Comédie-Française and the Odéon (as, for example, Ducis's *Othello*). (2) The '*comédie de mœurs en prose*', that is to say, the play of manners, which, as the heir of the domestic drama, occupies a more modest position, but still enjoys sufficient prestige to be performed in the leading theatres (example: Scribe's *Mariage d'argent*). (3) The '*drame en prose*', that is to say, the sentimental drama that likewise originates in the domestic drama, but stands on a lower level of taste than the '*comédie de mœurs*' (example: Bouilly's *L'Abbé et l'épée*). (4) The '*comédie historique*', which no longer treats historical events and personalities as examples to be followed, but as curiosities, and desires rather a review of spectacular scenes than a homogeneous dramatic process (examples are manifold: they embrace, from Mérimée's *Cromwell* to Vitet's *Barricades*, all the experiments to which Dumas's *Henri III* owes its origin). (5) The '*vaudeville*', that is, the musical comedy, or more exactly the comedy with songs interpolated, which is to be reckoned among the direct predecessors of the operetta (to this category belong most of the plays of Scribe and his collaborators). (6) '*mélodrame*', a mixed form which shares its musical accessories with the vaudeville, but its serious and often tragic plot with the other lowly genres, especially with the sentimental drama and the historical show-piece.

The enormous productivity in the popular genres, particularly in the two last-named, and the gradual displacement of the literarily more pretentious drama is to be explained, along with the fact that the Revolution opened the theatres to the broad masses of the people and that the success of the plays performed was determined by these classes, above all by the influence of the censorship on the development of the repertoire. The censorship of Napoleon and the Restoration prevented questions of the day and the manners of the ruling class being discussed and described in the serious literary drama. The farce, the musical comedy and the melodrama, on the other hand, enjoyed more freedom, because they were not taken so seriously and were not considered

worth bothering about. In the boulevard theatres no obstacles were put in the way of the ruthless description of manners and conditions which was forbidden in the Comédie-Française; this was the source of the attraction of these theatres both for the playwrights and the public.[201] The most important and interesting dramatic forms of the age are, from the historical point of view, the vaudeville and the melodrama; they represent the real turning point in the history of the modern stage and form the transition between the dramatic genres of classicism and romanticism. Through them the theatre regains its character, catering for entertainment, its bustle, its direct appeal to the senses and its obviousness. Of the two, the melodrama has the more complex structure and the more ramified pedigree. One of its many predecessors is the monologue delivered with musical accompaniment, the original form of the hybrid genre that one still comes across in the programmes of amateur performances and the first well-known example of which was Rousseau's *Pygmalion* (1775). This is the starting point of the revival of the dramatic recitation with musical accompaniment—an intrinsically very old form. Another, technically much more fertile, source of the 'mélodrame' is the domestic drama of de la Chaussée, Diderot, Mercier and Sedaine, that had become very popular with the lower classes since the Revolution, owing to its maudlin and moralizing nature. But the most important prototype of the melodrama is the pantomime. The *'pantomimes historiques et romanesques'*, as they are called, first appear in the last third of the eighteenth century. They begin by treating mythological and fairy-tale subjects, such as *Hercules and Omphale*, *The Sleeping Beauty* and *The Iron Mask*, but later on contemporary themes as well, such as the *Bataille du Général Hoche*. These pantomimes usually consist of agitated and stormy scenes put together revue fashion without organic coherence or dramatic development, and aim at creating situations in which the mysterious and miraculous element, ghosts and spirits, dungeons and graves play a leading part. In the course of time short explanatory notes and dialogues are inserted into the single scenes and in this way they develop during the Revolution into the curious *'pantomimes dialoguées* and, finally, into the *'mélodrame à grand spectacle'*, that gradu-

ally loses both its showpiece-like character and its musical elements, and becomes the play of intrigues which is of fundamental importance in the history of the theatre in the nineteenth century. The most important influence exerted on the melodrama in this transformation is that of the thrillers of Mrs. Radcliffe and her French imitators. This is the source not only of its *Grand Guignol*-like effects but also of its criminalistic touch.

All these influences, however, only result in the modification and amplification of the kernel of the melodramatic form, the kernel itself is the conflict of the classical drama. The melodrama is nothing but the tragedy popularized, or, if one likes, corrupted. Pixerécourt, the chief representative of the genre, is perfectly aware of the affinity of his art with the popular theatre, he is merely mistaken in assuming that there is an historical continuity and essential likeness between the melodrama and the mime.[202] He recognizes the real continuity between the medieval mysteries, the pastoral play, Molière's art and the mime, but he overlooks the fundamental difference between the genuinely popular nature of the mime and the derived character of the literary theatre that has sunk to the level of the broad strata of the urban public. The melodrama is anything but a spontaneous and naïve art; it follows rather the sophisticated formal principles of the tragedy, acquired in the course of a long and consistent development, even though it reflects them in a coarsened style lacking the psychological subtleties and poetic beauties of the classical form. On the purely formal plane, the melodrama is the most conventional, schematic and artificial genre imaginable— a canon into which new, spontaneously invented, naturalistically straightforward elements can hardly find an entry. It has a strictly tripartite structure, with a strong antagonism as the initial situation, a violent collision and a dénouement representing the triumph of virtue and the punishment of vice, in a word, an easily understood and economically developed plot; with the priority of plot over characters; with sharp figures: the hero, persecuted innocence, the villain and the comic;[203] with the blind and cruel fatefulness of events; with a strongly emphasized moral, which, owing to its insipid, conciliatory tendency based on reward and punishment, is not in accordance with the moral

191

character of tragedy, but shares with it a high, albeit exaggerated, solemnity. The melodrama betrays its dependence on tragedy above all in its observation of the three unities, or at least in its tendency to take them into consideration. Pixerécourt allows a change of scene to take place between two acts, but the jump is never a painful one and he does not introduce a change of scene within one and the same act until *Charles-le-Téméraire* (1814). On the other hand, he apologizes for it in a note the text of which is extremely revealing of his classicistic disposition: 'This is the first time that I have allowed myself this infringement of the rules,' he avers. On the whole, Pixerécourt preserves even the unity of time; in his plays everything usually takes place within twenty-four hours. It is not until 1818 that he introduces a new method in his *Fille de l'exilé ou huit mois en deux heures*, but, here again, he apologizes for it.[204] In contrast to these characteristics of the melodrama, the mime consisting of a naturalistic commonplace scene, or a loose sequence of such scenes, has no stereotyped plot reducible to a fixed pattern, no typical or extraordinary characters, no rigid moral, no idealized style differing from colloquial language. All that the melodrama has in common with the mime is the drive of its scenes and the crudeness of its effects, the lack of discrimination in its choice of means and the popular character of the motifs; otherwise it keeps to the stylistic ideal of classical tragedy. Obviously, the strict conventionality of a form is in itself by no means the sign of a higher purpose.

The modern species of the mime is not the melodrama but the vaudeville, which with its episodic plot divided into separate scenes, its interpolated songs, its popular types taken from daily life, its fresh, piquant, apparently spontaneous style, is much nearer to the old popular theatre than the melodrama, in spite of the literary influences which it by no means lacks. The period between 1815 and 1848 displays an unprecedented fertility in this genre, to which, apart from the numerous comedies by Scribe, an endless number of small, light, amusing plays and playlets belong. One can only get an idea of the literary practitioners' alarm at the extent and success of these productions by remembering the reaction which accompanied the triumphant progress of the film. During the Revolution and the Restoration,

comedy became exhausted, just as tragedy had already proved itself sterile in an earlier age. The vaudeville came forward as a corrupt, externalized form of comedy, just as the melodrama represented a corrupt, externalized form of tragedy. The vaudeville and the melodrama did not mean the end of the drama, however, but rather its revival, for the romantic drama—the form of Hugo's *Hernani* or Dumas's *Antony*—was nothing but the 'mélodrame parvenu' and the modern drama of manners of Augier, Sardou and Dumas *fils* only a species of the vaudeville.[205]

Between 1798 and 1814, Pixerécourt wrote about a hundred and twenty plays, of which some were performed many thousands of times. The melodrama dominated theatre life for three decades and its popularity did not abate until after 1830, when the level of public taste began to rise and the crudities of the plays, their lack of logic, the insufficiency of their motivation and unnatural language, were felt to be more and more upsetting. The romantics had a weakness for the melodrama, however, not only on account of their hostility to the conservative strata of the cultured public, but also because, owing to their less prejudiced outlook, they showed more understanding for the unliterary, purely theatrical qualities of this genre. Charles Nodier at once declared himself an enthusiastic supporter of the melodrama and called it 'la seule tragédie populaire qui convienne à notre époque';[206] and Paul Lacroix described Pixerecourt as the dramatist who was the first to finish the process begun by Beaumarchais, Diderot, Sedaine and Mercier.[207] The unprecedented success, the opposition of official circles, as well as the romantics' own fondness for melodramatic effects, for shrill colours, crudely sensational situations, violent accents, all this contributed to the preservation in the romantic drama of so many of the most characteristic features of the plebeian theatre. But romanticism only received back from the melodrama what had belonged to it from the very beginning, what had been contained in the bud in pre-romanticism and the 'Storm and Stress' and had been taken over by the theatre partly from English tales of horror, partly from German penny-dreadfuls, novels of brigandage and chivalry. The common elements between the romantic theatre and the melodrama are, above all, the sharp conflicts and violent clashes, the involved,

193

adventurous, bloody and brutal plot; the predominance of miracle and chance, the sudden, usually unmotivated twists and turns, the unforeseen encounters and recognitions, the constant alternation of tension and relaxation; the violent, irresistibly brutal tricks, the assaults on the audience by the horrible, the uncanny and the demonic; the ready-made mechanical development of the plot, the disguises and deceptions, the conspiracies and traps; finally, the *coups de théâtre* and stage requisites, without which a romantic drama is quite inconceivable: the arrests and seductions, the kidnappings and rescues, the attempts to escape and the assassinations, the corpses and coffins, the cellars and tombs, the castle-towers and dungeons, the daggers, swords and poison phials, the rings, amulets and family heirlooms, the intercepted letters, lost wills and stolen secret contracts. Romanticism was certainly not very fastidious, but one has only to think of Balzac, the greatest and, from the point of view of taste, most problematical writer of the century, to realize how narrow and, in the long run, unimportant the aesthetic criteria of classicism had become.

The development of the theatre in the direction of popular taste was not, however, expressed so much in the mere existence of the melodrama but in the good conscience with which Pixerécourt offered his wares for sale. He considered the romantics' plays bad, false, immoral and dangerous, and was profoundly convinced that his pretentious rivals had neither so much heart nor so much feeling of moral responsibility as he.[208] On this point Faguet comments quite rightly that one must believe in trash, to produce good, successful trash. D'Ennery, for example, was a better writer and a more intelligent person than Pixerécourt, but he wrote his melodramas without conviction, purely and simply to make money with them, and thus he did not even succeed in writing good melodramas.[209] Pixerécourt, on the other hand, believed in his mission and protested that he had not had anything to do with the rise of the wicked romantic drama. But the romantics owed him, first of all, their feeling for the requirements of the stage and their contact with the broader masses of the public. They owed him the part they played in the development of the 'pièce bien faite', and the whole nineteenth century owed him the rebirth of the living popular theatre, that certainly

1. DELACROIX: LIBERTY LEADING THE PEOPLE. *Paris, Louvre. 1831.—*
The great representative painting of the generation of 1830.

2. DELACROIX: THE DEATH OF SARDANAPAL. *Paris, Louvre. 1827.—The*
spirit of 'grand opera', of the demonism and molochism of the romantics is not
lacking even in the art of Delacroix.

1. COURBET: THE STONEBREAKERS. *Dresden Gemäldegalerie 1849.—An important work of the naturalism of the mid-century.*

2. DAUMIER: WASHERWOMAN. *Paris, Louvre. About 1863.—Like Courbet and Millet, Daumier also paints the praises of of manual labour.*

1. THEODORE ROUSSEAU: THE OAK TREES. *Paris, Louvre.*—*One of the most successful creations of the new naturalistic landscape painting.*

2. TROYON: OXEN GOING TO WORK. EARLY MORNING. *Paris, Louvre.*—*The 'Cuyp' of Barbizon.*

1. PAUL BAUDRY:
A L L E G O R Y.
*Paris, Musée de
L u x e m b o u r g.—
The ideal of beauty
cherished by the Second
Second Empire.*

2. D.G.ROSSETTI:
THE DAY-DREAM.
*London, Victoria and
Albert Museum.—
The ideal of beauty
cherished by the Pre-
Raphaelites.*

lacked discrimination and was often trivial in comparison with the seventeenth and eighteenth centuries, but prevented the development of the drama into mere literature. It was part of the fate of this century that every time the poetic element came into its own in the drama, its entertainment value, its theatrical effectiveness and the immediacy of its appeal threatened to wither. Even in the romantic movement the two elements came into conflict and their antagonism prevented either the stage success or the poetic perfection of the drama. Alexandre Dumas inclined to the good sturdy play, Victor Hugo to the linguistically overwhelming dramatic poem, and their successors were constantly faced with the same choice; it was not until Ibsen that the two antithetical tendencies were harmoniously resolved, and then only for a time.

England had its political revolution in the seventeenth century, its industrial and artistic revolution a century later; whilst the great war between classicism and romanticism was raging in France, hardly anything of the classical tradition survived in England. English romanticism developed more continuously, more consistently and met with less public resistance than French romanticism; its political evolution was also more homogeneous than the corresponding movement in France. To begin with, it was absolutely liberal and thoroughly well disposed towards the Revolution; it was only the war against Napoleon which led to an understanding between the romantics and the conservative elements and only after his fall that liberalism became predominant in romantic literature once again. The earlier uniformity, however, never returned. There was no desire to forget so soon the 'lessons' learnt from the Revolution and the rule of Napoleon, and many former liberals, among others the members of the Lake School, remained anti-revolutionary. Walter Scott was and remained a Tory; Godwin, Shelley, Leigh Hunt and Byron, on the other hand, represented the radicalism that was predominant in the younger generation. English romanticism had its origins essentially in the reaction of the liberal elements to the Industrial Revolution, whereas French romanticism arose from the reaction of the conservative classes to the political revolution. The connection between romanticism and

pre-romanticism was much closer in England than in France where the continuity between the two movements was completely disrupted by the classicism of the revolutionary period. In England the same relation existed between romanticism and the successful completion of the Industrial Revolution as between pre-romanticism and the preparatory stages of the industrialization of society. Goldsmith's *Deserted Village*, Blake's 'Satanic Mills' and Shelley's 'Age of Despair' are all the expression of an essentially identical mood. The romantics' enthusiasm for nature is just as unthinkable without the isolation of the town from the countryside as is their pessimism without the bleakness and misery of the industrial cities. They realize perfectly what is going on and are acutely aware of the significance of the transformation of human labour into a mere commodity. Southey and Coleridge see in periodical unemployment the necessary consequence of uncontrolled capitalist production and Coleridge already stresses the fact that, in accordance with the new conception of work, the employer buys and the employee sells something that neither of them has the right to buy or sell, namely 'the labourer's health, life and well-being'.[210]

After the end of the struggle against Napoleon, England finds herself, if in no sense exhausted, at least weakened and intellectually bewildered—in a condition especially calculated to make the middle class aware of the problematical bases of its existence. The younger romantics, the generation of Shelley, Keats and Byron, are the leading influences in this process. Their uncompromising humanism is their protest against the policy of exploitation and oppression; their unconventional way of life, their aggressive atheism and their lack of moral bias are the different modes of their struggle against the class that controls the means of exploitation and suppression. Even in its conservative representatives, Wordsworth and Scott, the English romantic movement is to some extent a democratic movement, aiming at the popularization of literature. Wordsworth's aim above all to bring poetic diction nearer to everyday language is a characteristic symptom of this popularizing tendency, even though the 'natural' poetic diction which he uses is, in reality, no more spontaneous than the older literary language which he renounces because of its

196

artificiality. If it is less learned, its subjective psychological pre-
suppositions are all the more complicated. And as for the enter-
prise of describing himself and his own intellectual development
in a poem the length of the Homeric epics, it certainly represents
a revolutionary experiment compared with the objectivity of
the older literature and is just as typical of the new subjectivism
as, for instance, Goethe's *Dichtung und Wahrheit*, but the 'popu-
larity' and 'naturalness' of such an undertaking is more than
doubtful. In his essay on Wordsworth, Matthew Arnold remarks,
in speaking of certain of the poet's inadequacies, that it goes
without saying that even Shakespeare has his weak passages, but
if one should call him to account for them in the Elysian Fields,
he would certainly reply that he was perfectly aware of them.
'After all'—he would add smilingly—'what is the harm in letting
oneself go occasionally!' In contrast, the modern poet's concentra-
tion on his own ego is bound up with a humourless over-estima-
tion of every personal utterance, with the appreciation of the
tiniest detail according to its expressive value and the loss of that
unconcerned facility with which the older poet simply let his
lines flow on.

For the eighteenth century, poetry was the expression of
ideas; the meaning and purpose of poetic images was the explana-
tion and illustration of an ideal content. In romantic poetry, on
the other hand, the poetic image is not the result but the source
of ideas.[211] The metaphor becomes productive and we feel as
though language were making itself autonomous and were com-
posing of its own accord. The romantics abandon themselves to
language without resistance and give expression in this way, too,
to their anti-rationalistic conception of art. The origin of Cole-
ridge's *Kubla Khan* may have been an extreme case; but it was,
at any rate, symptomatic. The romantics believed in a transcen-
dental, world-pervading spirit as the source of poetic inspiration
and identified it with the spontaneous creative power of language.
To allow oneself to be controlled by it was considered by them
to be the sign of the highest artistic genius. Plato had already
spoken of the 'enthusiasm', of the divine inspiration of poets, and
the belief in inspiration had always appeared on the scene when-
ever poets and artists had wanted to give themselves the appear-

ance of a priestly caste. But this was the first time that inspiration had ever been regarded as a self-kindling flame, as a light that has its source in the soul of the poet himself. The divine origin of inspiration was, therefore, now a purely formal, not a substantial attribute; it brought nothing into the soul that was not already there. Thus both principles, the divine and the individual, were preserved—and the poet became his own god.

Shelley's ecstatic pantheism is the classical example of this self-deification. It lacks all trace of self-forgetting devotion and any sign of readiness to obliterate the self before a higher being. The absorption of the self in the universe is now the expression of a desire to dominate, not a willingness to be dominated. The world ruled over by poetry and the poet is considered the higher, purer, more divine world, and the divine itself seems to have no other criteria than those derived from poetry. It is true that Shelley's world-view, wholly in accordance with that of Friedrich Schlegel and German romanticism, is based on a mythology; but not even the poet himself believes in this mythology. Metaphor now becomes myth and not the other way round, as with the Greeks. This mythologizing is again merely an instrument of flight from ordinary, common, soulless reality—a bridge to the poet's own spiritual depths and sensibility. It is only a means whereby the poet can come to himself. The myths of classical antiquity arose from a sympathy and a genuine relationship with reality; the mythology of the romantics arises from its ruins and to some extent as a substitute for reality. Shelley's cosmic vision revolves around the idea of a great, world-embracing conflict between the good and the evil principle and represents the monumentalization of the political antagonism which constitutes the poet's deepest and most decisive experience. His atheism is, as has been said, more a revolt against God than a denial of God; he is fighting an oppressor and a tyrant.[212] Shelley is the born rebel, who sees in everything legitimate, constitutional and conventional the work of a despotic will and for whom oppression, exploitation and violence, stupidity, ugliness and mendacity, kings, the ruling classes and the Churches, form a single compact power with the God of the Bible. The abstract, indefinite character of this conception best shows how similar English and

German poets had become. The anti-revolutionary hysteria has poisoned the intellectual atmosphere in which the English writers of the eighteenth century had freely developed their abilities; the intellectual manifestations of the period take on an unreal, world-shunning and world-denying character which was absolutely alien to earlier English literature. The most gifted poets of Shelley's generation are not appreciated by the public;[213] they feel homeless and they take refuge abroad. This generation is doomed in England as well as in Germany or Russia; Shelley and Keats are worried to death by their age just as mercilessly as Hoelderlin and Kleist or Pushkin and Lermontov. Ideologically, too, the result is the same everywhere: idealism in Germany, 'l'art pour l'art' in France, aestheticism in England. Everywhere the struggle ends with a turning away from reality and the abandonment of any effort to change the structure of society. In Keats this aestheticism is already accompanied by a profound melancholy, by a mourning for the beauty that is not life, that is, indeed, the negation of life, the negation of a life and reality which are everlastingly separated from the poet, the lover of beauty, and which remain beyond his grasp, like everything ingenuous, natural and purely instinctive. This is a foreshadowing of Flaubert's renunciation, the resignation of the last great romantic, who knew only too well that the price of poetry is life.

Of all the famous romantics, Byron exerts the deepest and most far-reaching influence on his contemporaries. But he is by no means the most original of them, he is merely the most successful in the formulation of the new ideal of personality. Neither the 'mal du siècle' nor the proud and lonely hero marked by destiny, in other words, neither of the two basic elements of his poetry, is his own original intellectual property. The Byronic *Weltschmerz* has its source in Chateaubriand and the French émigré literature, the Byronic hero in Saint-Preux and Werther. The incompatibility of the moral claims of the individual with the conventions of society had already been part of the new concept of man defined by Rousseau and Goethe, and the portrayal of the hero as an eternally homeless wanderer, doomed by his own unsociable nature, is already to be found in Senancour and Constant. But in these authors the estrangement

of the hero was still combined with a certain feeling of guilt and manifested itself in a complicated, inconsistent relationship to society; it is only in Byron that it becomes transformed into open, unscrupulous mutiny, into a self-righteous, self-pitying, doleful indictment of man. Byron externalizes and trivializes the spiritual problem of romanticism; he makes a social fashion of the spiritual disintegration of his time. Through him romantic restlessness and aimlessness becomes a plague, the 'disease of the century'; the feeling of isolation develops into a resentful cult of solitude, the loss of faith in the old ideals into anarchic individualism, cultural weariness and ennui becomes a flirtation with life and death. Byron bestows a seductive charm on the curse of his generation and turns his heroes into exhibitionists who openly display their wounds, into masochists who publicly load themselves with guilt and shame, flagellants who torment themselves with self-accusations and pangs of conscience and confess both their evil and their good deeds with the same intellectual pride of ownership.

The Byronic hero, this late successor of the knight-errant, who is just as popular and almost as hardy as the hero of the novels of chivalry, dominates the whole literature of the nineteenth century and still haunts the crime and gangster films of our own time. Certain features of the type are extremely old, that is to say, at least as old as the picaresque novel. For the outlaw, who declares war on society and is a fearless enemy of the great and the mighty but a friend and benefactor of the weak and the poor, is already a familiar figure in this genre; he seems an unpleasantly rough customer from outside, but turns out to be true-hearted and generous in the end, a man whom only society has made into what he is. On the journey from Lazarillo di Tormes to Humphrey Bogart, the Byronic hero merely marks an intermediary station. Long before Byron, the rogue had become the restless wanderer setting out for the starry heights, the eternal stranger among men seeking but not finding his lost happiness on earth, the embittered misanthrope bearing his destiny with the pride of a fallen angel. All these features were already present in Rousseau and Chateaubriand—the only really new characteristics in the picture painted by Byron are the

demonic and narcissistic. The romantic hero whom Byron intro-
duces into literature is a mysterious man; in his past there is a
secret, an awful sin, a disastrous error or an irreparable omission.
He is an exile—every one feels it, but no one knows what is
hidden behind the veil of time, and he does not lift the veil. He
goes around in the secret of his past as in a royal robe: lonely,
silent and unapproachable. Perdition and destruction go forth
from him. He is unsparing towards himself and merciless towards
others. He knows no pardon and asks no forgiveness, either from
God or man. He regrets nothing and, in spite of his disastrous
life, would not wish to have anything different, do anything
different from what he has been and from what has happened.
He is rough and wild but of high descent; his features are hard
and impenetrable but noble and beautiful; a peculiar charm
emanates from him which no woman can resist and to which all
men react with friendship or enmity. He is the man pursued by
destiny who becomes other men's destiny, the prototype not only
of all the irresistible and fateful love heroes of modern litera-
ture but, to some extent, of all the female demons from Mérimée's
Carmen to the vamps of Hollywood.

If Byron did not discover the 'demonic hero' who, possessed
and deluded, hurls himself and all who come in contact with him
to destruction, he turned him into the 'interesting' man par
excellence. He bestowed on him the piquant and enticing char-
acteristics which have stuck to him ever since, transformed him
into the immoralist and the cynic whose influence is so irre-
sistible, not despite but precisely because of his cynicism. The
idea of the 'fallen angel' possessed an incomparable power of
attraction for the disillusioned world of romanticism struggling
for a new faith. There was a general feeling of guilt, of having
fallen away from God, but at the same time, a desire to be
something like a Lucifer, if one was already damned anyway.
Even the seraphic poets Lamartine and Vigny went over to the
satanists in the end and became followers of Shelley and Byron,
Gautier and Musset, Leopardi and Heine.[214] This satanism
originated in the ambivalence of the romantic attitude to life and
undoubtedly proceeded from the feeling of religious dissatisfac-
tion, but, particularly in Byron, it turned into scorn for all the

sacred things venerated by the middle class. The only difference between the aversion of the French bohème to the bourgeoisie and Byron's attitude was that the plebeian anti-conventionalism of Gautier and his friends was an attack from below, whereas Byron's immoralism was directed from above. Every more or less important utterance of Byron's betrays the snobbishness which was combined with his liberal ideas, every record reveals the aristocrat who is no longer firmly rooted in his social position, but still preserves the pose of his class. Above all, the hysterical passion with which, in his later works, he rages against the aristocracy that is excommunicating him shows how deeply he feels tied to this class and how much of its authority and attractiveness it still holds for him, in spite of everything.[215] 'Death is no argument,' Hebbel says somewhere. Byron, at any rate, proved nothing by his heroic death. Despite the poet's revolutionary convictions, it was no appropriate death. Byron committed suicide, 'while the balance of his mind was disturbed', and died 'with vine-leaves in the hair', as Hedda Gabler wanted to die.

The fact that Byron always held to the classicistic view of art and that Pope was his favourite poet is in accordance with his aristocratic inclinations. He did not care for Wordsworth because of his soberly solemn, prosaically unctuous tone and he despised Keats on account of his 'vulgarity'. The supercilious, mocking spirit and playful form of his works, above all the easy-going conversational tone of *Don Juan*, was only an aspect of his classical ideal of art. The connection between the fluency of his style and Wordsworth's 'natural' poetic diction is, nevertheless, unmistakable; both are symptoms of the reaction against the high-flown rhetorical poetry of the seventeenth and eighteenth centuries. The common aim was a greater flexibility of language, and it was precisely as the master of such a fluid, brilliantly skilful, apparently improvised style that Byron made the greatest impression on his contemporaries. Neither the graceful ease of Pushkin nor the elegance of Musset would be conceivable without this new note. *Don Juan* became not only the model of the witty and insolent topical satire but, at the same time, the origin of the whole of modern feuilletonism.[216] Byron's first readers

may have belonged to the aristocracy and the upper middle class, but he found his real public in the ranks of that dissatisfied, resentful, romantically inclined middle class whose unsuccessful members regarded themselves as so many unrecognized Napoleons. The Byronic hero was so conceived that every disillusioned youth, every love-sick girl could identify him- or herself with him. The fact that Byron encouraged the reader to indulge in such intimacy with the hero, in doing which he was, of course, merely continuing a tendency already evident in Rousseau and Richardson, was the deepest reason for his success. With the closer personal relationship between the reader and the hero, the reader's interest in the author himself also increased. This tendency too already existed in the age of Rousseau and Richardson, but until the romantic movement the poet's private life had remained, on the whole, unknown to the public. It was only after the self-advertisement contrived by Byron that the poet became the 'favourite' of the public and it was only from then onwards that his readers, and especially his female readers, entered into the peculiar relationship with him which resembled the connection between the psycho-analyst and his patients, on the one hand, and the filmstar and his fans, on the other.

Byron was the first English poet to play a leading rôle in European literature, Walter Scott the second. Through them what Goethe understood by 'world literature' became a full reality. Their school embraced the whole literary world, enjoyed the highest authority, introduced new forms, new values, set intellectual traffic flowing backwards and forwards between the countries of Europe, carrying along with it new talents and often raising them above their masters. One only needs to think of Pushkin and Balzac to realize the extent and the importance of this school. The vogue of Byron was perhaps more feverish and more obtrusive, but the influence of Walter Scott, who has been described as the 'most successful writer in the world',[217] was more solid and more profound. It was his work that inspired the revival of the naturalistic novel, the modern literary genre par excellence, and thereby led to the transformation of the whole modern reading public. The number of readers had been rising steadily in England since the beginning of the eighteenth cen-

tury. One can distinguish three stages in this process of growth: the phase that begins around 1710 with the new periodicals and culminates in the novels of the middle of the century; the period of the pseudo-historical thriller from 1770 to roughly 1800; and the period of the modern romantic-naturalistic novel that begins with Walter Scott. Each of these periods produced a considerable increase in the reading public. In the first, only a comparatively small section of the middle class was enlisted for secular belles-lettres, people who up till then had never read books at all or at best the products of devotional literature; in the second, this public was enlarged by wide sections of the increasingly wealthy bourgeoisie, mostly women; in the third, elements belonging partly to the higher, partly to the lower strata of the middle class, looking for entertainment as well as instruction in the novel, were added. Walter Scott succeeded in achieving the popularity of the thriller by the more fastidious methods of the great novelists of the eighteenth century. He popularized the portrayal of the feudal past that had hitherto been exclusively the reading of the upper classes,[218] and, at the same time, raised the pseudo-historical shocker to a really literary level.

Smollett was the last great novelist of the eighteenth century. The wonderful development which corresponded in the English novel to the political and social achievements of the middle class comes to a standstill about 1770. The sudden growth of the reading public leads to a sharp decline in the general standard. The demand is much greater than there are good writers to meet it, and as the production of novels is an extremely paying concern, they are turned out in wild and indiscriminate profusion. The needs of the lending libraries dictate the pace and determine the quality of the output. Apart from the thriller, the subjects most in demand are the scandals of the day, famous 'cases', fictitious and semi-fictitious biographies, travel descriptions and secret memoirs, in a word, the usual types of sensational literature. The result is that cultured circles begin to speak of the novel with a disdain that was hitherto unknown.[119] The prestige of the novel is first restored by Scott, above all by the way he handles the genre to accord with the historicism and scientific outlook of the intellectual élite. He not only tries to give an inherently true

picture of a historical situation, but also provides his novels with introductions, notes and appendices, to prove the scientific trust-worthiness of his descriptions. Though Walter Scott cannot be regarded as the real creator of the historical novel, he is, without any doubt, the founder of the novel dealing with social history, a genre of which no one before him had had an inkling. The French novelists of the eighteenth century, Marivaux, Prévost, Laclos and Chateaubriand, enormously advanced the psycho-logical novel, but still placed their characters in a sociological vacuum or into a social milieu that had no essential share in their development. Even the English novel of the eighteenth century can be described as a 'social novel' only in so far as it lays more emphasis on human relationships; but it pays no particular atten-tion to class differences or to the social causality of character formation. Walter Scott's characters, on the other hand, always bear the marks of their social origin.[220] And as, on the whole, Scott describes the social background of his stories accurately, he becomes, in spite of his conservative outlook in politics, the pioneer of liberalism and progress.[221] However critical he was of the Revolution politically, his sociological method would be unthinkable without this change in affairs. For it was the Revolu-tion that first developed a feeling for class differences and made it imperative for the honest artist to describe reality in accordance with them. At any rate, as a writer, Scott, the conservative, is more deeply connected with the Revolution than Byron, the radical. On the other hand, one must not over-estimate this 'triumph of realism', as Engels called the trick of art which often makes conservative minds useful instruments of progress. The appreciation of and enthusiasm for the 'folk' is usually no more than a non-committal gesture with Scott and his description of the lower classes is, generally speaking, conventional and schematic. But Scott's conservatism is, at least, less aggressive than the anti-revolutionism of Wordsworth and Coleridge, which is the expression of a disillusionment and of an all too sudden change of mind. It is true that Scott is as enthusiastically devoted to medieval chivalry as the reactionary romantics in general and that he regrets its decline, but at the same time he also criticizes, as do Pushkin and Heine, for example, the whole effusiveness of

the romantics. He recognizes, with the same clear-sightedness with which Pushkin establishes the spuriousness of Onegin's character, 'the brilliant but useless character of a knight of romance' in Richard Coeur de Lion,[222] and by no means conceals his apprehensions in this connection.

Delacroix, the first great and, at the same time, greatest representative of romantic painting, is also one of the enemies and conquerors of romanticism. He already represents the nineteenth century, whilst romanticism is still an essentially eighteenth-century movement, not only because it is the continuation of pre-romanticism, but also because, although full of contradictions, it is by no means so disintegrated as the nineteenth century. The eighteenth century is dogmatic—there is a dogmatic streak even in its romanticism—the nineteenth century is sceptical and agnostic. The men of the eighteenth century strive to extract a clearly definable doctrine and world-view from everything, even from their emotionalism and irrationalism; they are systematists, philosophers, reformers, they make up their minds either for or against a cause, often they alternate between support and opposition, but they know where they stand, they follow principles and are guided by a plan for the improvement of life and the world. The intellectual representatives of the nineteenth century, on the other hand, have lost their faith in systems and programmes and see the meaning and purpose of art in a passive surrender to life, in seizing hold of the rhythm of life itself, in preserving the atmosphere and mood of it; their faith consists in an irrational, instinctive affirmation of life, their morality in a resigned acceptance of reality. They want neither to regiment nor to overcome reality; they want to experience it and to reproduce their experience as directly, as faithfully and perfectly as possible. They have the indomitable feeling that the life of the immediate present, the contemporary and the surrounding world, time and place, experience and impressions are slipping away from them daily and hourly and being lost for ever. For them, art becomes a pursuit of the 'temps perdu', of life which is for ever evaporating and beyond our grasp. The periods of absolute naturalism are not the centuries

in which men imagine they are in firm and secure possession of reality, but those in which they are afraid of losing it; hence the nineteenth is the classical century of naturalism.

Delacroix and Constable stand on the threshold of the new era. They are partly still romantic expressionists struggling to express ideas, but partly they are already impressionists striving to hold fast the fleeting object and no longer believing in any perfect equivalent of reality. Of the two, Delacroix is the more romantic artist; if one compares him with Constable, what connects classicism and romanticism in a historical unity, and distinguishes them from naturalism, becomes quite clearly apparent. As opposed to naturalism, the two older stylistic tendencies have in common, above all, the fact that they confer more than life-size dimensions on life and man, give them a tragi-heroic format and a passionately emotional expression, which is still present in Delacroix, but completely absent from Constable and nineteenth-century naturalism. In Delacroix this conception of art is also expressed in the fact that man still stands in the centre of his world, whilst in Constable he becomes a thing amongst other things, and is absorbed by his material environment. Hence Constable is, if not the greatest, at any rate, the most progressive artist of his time. With the displacement of man from the centre of art and the occupation of his place by the material world, painting not only acquires a new content, but is reduced more and more to the solution of technical and purely formal problems. The subject-matter of pictures gradually loses all aesthetic value, all artistic interest, and art becomes formalistic to a hitherto unknown extent. What is painted becomes quite unimportant; the only question is how it is painted. Not even the most flippant mannerism had ever shown such indifference to the motif. Never before had a head of cabbage and the head of a Madonna been considered of equal value as artistic subjects. It is only now, when the pictorial quality forms the real content of painting, that the old academic distinctions between the different subjects and genres come to an end. Even in Delacroix, in spite of his deep romantic affection for poetry, literary motifs constitute merely the occasion for, not the content of his pictures. He rejects the literary as the aim of painting and strives to

207

express, instead of literary ideas, something of his own, something irrational and similar to music.[223]

The transfer of the pictorial interest from man to nature has its source, apart from the shaken self-confidence of the new generation, its bewilderment and homelessness, above all in the victory of the dehumanized philosophy of natural science. Constable overcomes classical-romantic humanism more easily than Delacroix and becomes the first modern landscape painter, whilst Delacroix remains essentially a 'narrative painter'. But by their scientific approach to the problems of painting, and the preeminence which they give to optics over vision, they both embody the spirit of the new century in equal measure. The development of the 'painterly' style, which began in France with Watteau and was interrupted by the classicism of the eighteenth century, is taken up again and continued by Delacroix. Rubens revolutionizes French painting for the second time; for the second time an irrational, anti-classicistic sensualism emanates from him. Delacroix's dictum, that a picture should be above all a feast for the eyes,[224] was also the message of Watteau and remains the gospel of painting until the conclusion of impressionism. The vibrant dynamics of the composition, the movement of line and form, the baroque convulsion of the bodies and the dissolution of the local colours into their components, all this is merely the instrument of a sensualism which now makes it possible to combine romanticism with naturalism and to oppose both of them to classicism.

Delacroix was still to some extent subject to the romantic 'mal du siècle'. He suffered from serious fits of depression, knew the feeling of aimlessness and emptiness, fought against an indefinable and incurable ennui. He was the victim of melancholia, discontent and the feeling of eternal imperfection. The mood in which Géricault found himself in London and of which he wrote home: 'Whatever I do, I wish that I had done something different,' tormented Delacroix throughout his life.[225] He was still so deeply rooted in the romantic outlook on life that not even its most brutal temptations were foreign to him. It is sufficient to think of a work like the 'Sardanapal' (1829), to realize the place which the theatrical demonism and molochism of the romantics

occupied in his thought. But he was always fighting against romanticism as an attitude to life, acknowledged its representatives only with strong reservations, and accepted it as an artistic trend above all on account of the greater range of its subject-matter. Just as Delacroix undertook a voyage to the East, instead of the traditional journey to Rome, he also used, in place of the classics of antiquity, the poets of earlier and later romanticism, Dante and Shakespeare, Byron and Goethe, as his sources. This thematic interest was the only common element between him and artists like Ary Scheffer and Louis Boulanger, Decamps and Delaroche. He hated moonshine romanticism and the incorrigible dreamers, like Chateaubriand, Lamartine and Schubert, to repeat his own rather wilful assortment of names.[226] He himself had not the slightest desire to be called a romantic, and protested against being regarded as the master of the romantic school. Incidentally, he felt no inclination at all to train artists and never opened a generally available studio; at most, he took on a few assistants, but no pupils.[227] There was no longer anything in French painting corresponding to the David school; the master's place remained unoccupied. Artistic aims had become much too personal, the criteria of artistic quality much too differentiated, for schools in the old sense to arise.[228]

Delacroix's dislike of bohemianism is in line with his aversion to romanticism. Rubens is not only his artistic but also his human model and he is in fact, as has been said, the first and perhaps the only painter since Rubens and the great artistic personalities of the Renaissance to combine the highest intellectual culture with the mode of life of a grand seigneur.[229] His strictly upper-bourgeois and gentlemanly inclinations make all exhibitionism and ostentation odious to him. He only preserves one feature from the intellectual inheritance of bohemianism: contempt for the public. At twenty-six, he is already a famous painter, but a generation later he still writes: 'Il y a trente ans que je suis livré aux bêtes.' He had his friends, his admirers, his patrons, his state commissions, but he was never understood, never loved by the public. There was no trace of warmth in the recognition that was accorded him. Delacroix is a solitary and an isolated individual, and in a much stricter sense than the romantics in general. There

is only one contemporary whom he esteems and loves unre-
servedly: Chopin. Neither Hugo and Musset, nor Stendhal and
Mérimée are particularly near to him; he does not take George
Sand very seriously, the negligent Gautier repels him and Balzac
makes him nervous.[230] The extraordinary significance that music
holds for Delacroix, and which contributes most to his admiration
for Chopin, is a symptom of the new hierarchy of the arts and the
prominent position which music occupies in it. It is the romantic
art par excellence and Chopin the most romantic of all the
romantics. In his relation to Chopin, Delacroix's intimate connec-
tion with romanticism is brought most clearly to light. His
judgement of the other masters of music reveals, however, the
inconsistency of his relationship to romanticism. He always speaks
of Mozart with the greatest admiration, but Beethoven often
appears to him too despotic, too romantic. Delacroix has a classi-
cistic taste in music;[231] Chopin's stereotyped sentimentalism does
not disturb him, but Beethoven's 'despotism', which should, one
would think, appeal much more to him as an artist, he finds
bewildering.

Romanticism in music signifies the antithesis not merely to
classicism but also to pre-romanticism, in so far as they represent
the principle of formal unity and consistently developed musical
ideas. The concentrated structure of musical form, based on
dramatic climaxes, gradually breaks up in romanticism and gives
way again to the cumulative composition of the older music.
Sonata form falls to pieces and is replaced more and more often
by other, less severe and less schematically moulded forms—by
small-scale lyrical and descriptive genres, such as the Fantasy and
the Rhapsody, the Arabesque and the Étude, the Intermezzo and
the Impromptu, the Improvisation and the Variation. Even
extensive works are often made up of such miniature forms,
which no longer constitute, from the structural point of view, the
acts of a drama, but the scenes of a revue. A classical sonata or
symphony was the world in parvo: a microcosm. A succession of
musical pictures, such as Schumann's *Carnaval* or Liszt's *Années
de Pèlerinage*, is like a painter's sketch-book; it may contain
magnificent lyrical-impressionistic details, but it abandons the
attempt to create a total impression and an organic unity

from the very beginning. Even the fondness for the symphonic poem, which displaces the symphony in Berlioz, Liszt, Rimsky-Korsakov, Smetana and others, shows, above all, that the composers are unable or hesitate to represent the world as an organic whole. This change of form is accompanied by the literary inclinations of the composers and their bias towards programme music. The intermingling of forms also makes itself felt in music and is expressed most conspicuously in the fact that the romantic composers are often very gifted and important writers. In the painting and poetry of the period the disintegration of form does not proceed anything like so quickly, nor is it so far-reaching as in music. The explanation of the difference is partly that the cyclical 'medieval' structure had long since been overcome in the other arts, whereas it remained predominant in music until the middle of the eighteenth century, and only began to yield to formal unity after the death of Bach. In music it was therefore much easier to revert to it than, for example, in painting where it was completely out of date. The romantics' historical interest in old music and the revival of Bach's prestige had, however, only a subordinate part in the dissolution of strict sonata form, the real reason is to be sought in a change of taste which was in essentials sociologically conditioned.

Romanticism is the culmination of the development which began in the second half of the eighteenth century: music becomes the exclusive property of the middle class. Not only the orchestras move from the banqueting-halls of the castles and palaces into the concert-halls filled by the middle class, but chamber music also finds a home, not in aristocratic salons but in bourgeois drawing-rooms. The broader masses, who take a growing interest in musical entertainments, demand, however, a lighter, more ingratiating, less complicated music. This demand in itself promotes the creation of shorter, more entertaining, more varied forms, but leads, at the same time, to a division of musical output into serious and light music. Hitherto compositions serving purposes of entertainment had not been different qualitatively from the rest; there had been, of course, a great difference in quality between individual works, but this difference in no way corresponded to the difference in their respective

purposes. As we know, the generation immediately following that of Bach and Handel had already made a distinction between composing for one's own amusement and producing for the public; but now distinctions are made between the different categories of the public itself. In the oeuvre of Schubert and Schumann a corresponding division is already feasible;[232] in Chopin and Liszt regard for the musically less pretentious section of the public influences every single work; and in Berlioz and Wagner this regard often leads to definite flirtation. When Schubert declares that he knows no 'cheerful' music, it sounds as if he were trying to defend himself against the charge of frivolity from the very outset; for since the advent of romanticism all cheerfulness seems to have a superficial, frivolous character. The combination of carefree light-heartedness with the most profound seriousness, of playful exuberance with the highest, purest ethos transfiguring the whole of life, which was still present in Mozart, breaks up; from now on everything serious and sublime takes on a gloomy and careworn look. It is sufficient to compare the serene, clear and calm humanity of Mozart, its freedom from all mysticism and turbid emotionalism, with the violence of romantic music, to realize what had been lost with the eighteenth century.

With the concessions to the public there is combined, at the same time, a marked recklessness and arbitrariness of expression. Compositions become markedly difficult: they are no longer intended to be performed by middle-class amateurs. Even Beethoven's later piano and chamber music works were only able to be executed by professional artists, and appreciated by a musically highly educated public. With the romantics, first of all, the technical difficulties of performance increased. Weber, Schumann, Chopin, Liszt, compose for the virtuosos of the concert-halls. The brilliant execution which they presuppose in the performer has a double function: it restricts the practice of music to the expert, and it deludes the layman. In the case of the virtuoso-composers, the prototype of whom is Paganini; the dazzling style is intended above all to flabbergast the listener, but with the real masters the technical difficulty is merely the expression of an inner difficulty and complication. Both tendencies, the enlargement of the distance between the amateur and the

virtuoso as well as the deepening of the gulf between lighter and more difficult music, lead to the dissolution of the classical genres. The virtuoso mode of writing inevitably atomizes the big, massive forms; the bravura piece is relatively short, sparkling, pointed. But the intrinsically difficult, individually differentiated style, based on the sublimation of thoughts and feelings, also promotes the dissolution of universally valid, stereotyped and long-winded forms.

The inherent propensity with which music comes to meet this dissolution of forms, the irrationality of its content and the independence of its means of expression, explain the pre-eminence which it now enjoys among the arts. For classicism poetry was the leading art; early romanticism was partly based on painting; later romanticism is, however, entirely dependent on music. For Gautier painting was the perfect art, for Delacroix music is already the source of the deepest artistic experience.[233] This development reaches its climax in Schopenhauer's philosophy and Wagner's message. Romanticism celebrates its greatest triumphs in music. The fame of Weber, Meyerbeer, Chopin, Liszt and Wagner fills the whole of Europe, and surpasses the success of the most popular poets. Music remained romantic until the end of the nineteenth century, more completely, more unreservedly romantic than the other arts. And the fact that this century experienced the nature of art above all in music shows most conspicuously how deeply involved it was in romanticism. Thomas Mann's confession that it was the music of Wagner that first revealed to him the meaning of art is supremely symptomatic. The romantic intoxication of the senses and the *salto mortale* of reason signified the quintessence of art even at the turn of the century. The nineteenth century's struggle against the spirit of romanticism remained undecided; the decision was first achieved in the century to come.

NOTES

ROCOCO, CLASSICISM AND ROMANTICISM

1. PAUL HAZARD: *La Crise de la conscience européenne*, 1935, I, pp. i–v.
2. Cf. BÉDIER-HAZARD: *Hist. de la litt. franç.*, II, 1924, pp. 31–2.
3. GERMAIN MARTIN: *La Grande industrie en France sous le règne de Louis XV*, 1900, p. 15.
4. F. FUNCK-BRENTANO: *L'Ancien régime*, 1926, pp. 299–300.
5. ALEXIS DE TOCQUEVILLE: *L'Ancien régime et la Révolution*, 1859, 4th edit., p. 171.
6. HENRI SÉE: *La France écon. et soc. au 18^e siècle*, 1933, p. 83.
7. ALBERT MATHIEZ: *La Révolution franç.*, I, 1922, p. 8.
8. KARL KAUTSKY: *Die Klassengegensaetze im Zeitalter der franz. Rev.*, 1923, p. 14.
9. FRANZ SCHNABEL: 'Das XVIII. Jahrh. in Europa'. In *Propylaeen Weltgesch.*, VI, 1931, p. 277.
10. JOSEPH AYNARD: *La Bourgeoisie française*, 1934, p. 462.
11. F. STROWSKI: *La Sagesse française*, 1925, p. 20.
12. J. AYNARD, op. cit., p. 350.
13. Ibid., p. 422.
14. ANDRÉ FONTAINE: *Les Doctrines d'art en France*, 1909, p. 170.
15. PIERRE MARCEL: *La Peinture franç. au début du 18^e siècle*, 1906, pp. 25–6.
16. LOUIS RÉAU: *Hist. de la peint. franç. au 18^e siècle*, I, 1925, p. x.
17. LOUIS HOURTICQ: *La Peinture franç. au 18^e siècle*, 1939, p. 15.
18. WILHELM V. CHRIST: 'Gesch. d. griech. Lit.' In I. v. Mueller's *Handbuch d. klass. Altertumswiss.*, VII 2/1, 1920, p. 183.
19. FRANCESCO MACRÌ-LEONE: *La bucolica latina nella lett. ital. del sec. XIV*, 1889, p. 15.—WALTER W. GREG: *Pastoral Poetry and Pastoral Drama*, 1906, pp. 13–14.
20. T. R. GLOVER: *Virgil*, 1942, 7th edit., pp. 3–4.
21. M. SCHANZ-C. HOSIUS: 'Gesch. d. roem. Lit.' In I. v. Mueller's *Handbuch d. klass. Altertumswiss.*, II, 1935, p. 285.
22. W. W. GREG, op. cit., p. 66.
23. J. HUIZINGA: *The Waning of the Middle Ages*, 1924, p. 120.
24. M. FAURIEL: *Hist. de la poésie provençale*, 1846, II, pp. 91–2.
25. MUSSIA EISENSTADT: *Watteau's Fêtes galantes*, 1930, p. 98.
26. G. LANSON: *Hist. de la litt. franç.*, 1909, 11th edit., pp. 373–4.

NOTES

27. Cf. ALBERT DRESDNER: 'Von Giorgione zum Rokoko'. *Preussische Jahrbuecher*, 1910, vol. 140.—WERNER WEISBACH: 'Et in Arcadia ego'. *Die Antike*, VI, 1930, p. 140.

28. BOILEAU: *L'Art poétique*, III, vv. 119 ff.

29. P. MARCEL, op. cit., p. 299.

30. NIKOLAUS PEVSNER: *Academies of Art*, 1940, p. 108.

31. G. LANSON, op. cit., p. 374.

32. Cf. PETIT DE JULLEVILLE: *Hist. de la litt. franç.*, IV, 1897, p. 419.

33. Ibid., IV, p. 459; V, 1898, p. 550.

34. ÉMILE FAGUET: *Dixhuitième siècle*, 1890, p. 123.

35. ARTHUR ELOESSER: *Das buergerliche Drama*, 1898, p. 65.

36. DIDEROT: *Oeuvres*, 1821, VIII, p. 243.

37. PAUL MANTOUX: *La Révolution industrielle au 18e siècle*, 1906, p. 78.

38. *The English Revolution, 1640*. Three essays, edited by CHRISTOPHER HILL, 1940, p. 9.

39. R. H. GRETTON: *The English Middle Class*, 1917, p. 209.

40. W. WARDE FOWLER: *Social Life at Rome in the Age of Cicero*, 1922, pp. 26 ff.—J. L. and B. HAMMOND: *The Village Labourer* (1760–1832), 1920, pp. 306–7.

41. A. DE TOCQUEVILLE, op. cit., p. 146.—J. AYNARD, op. cit., p. 341.

42. G. LEFÈBVRE, G. GUYOT, PH. SAGNAC: *La Révolution française*, 1930, p. 21.

43. A. DE TOCQUEVILLE, op. cit., pp. 174–5.

44. HERBERT SCHOEFFLER: *Protestantismus und Literatur*, 1922, p. 181.

45. ALEXANDRE BELJAME: *Le Public et les hommes de lettres en Angleterre au 18e siècle*, 1881, p. 122.

46. H. SCHOEFFLER, op. cit., pp. 187–8.

47. Ibid., p. 192.

48. Ibid., pp. 59, 151 ff. and passim.

49. A. S. COLLINS: *The Profession of Letters*, 1928, p. 38.

50. G. M. TREVELYAN: *English Social History*, 1944, p. 338.

51. A. BELJAME, op. cit., pp. 236, 350.

52. LESLIE STEPHEN: *Engl. Lit. and Soc. in the 18th Cent.*, 1940, p. 42.

53. A. BELJAME, op. cit., pp. 229–32.

54. Ibid., p. 368.

55. A. S. COLLINS: *Authorship in the Days of Johnson*, 1927, p. 161.

56. LEVIN L. SCHUECKING: *The Sociology of Literary Taste*, 1944, p. 14.

57. A. S. COLLINS: *Authorship*, etc., pp. 269–70.

58. LESLIE STEPHEN, op. cit., p. 148.—GEORGE SAMPSON: *The Concise Cambridge Hist. of Lit.*, 1942, p. 508.

59. Quoted by F. GAIFFE: *Le Drame en France au 18e siècle*, 1910, p. 80.

60. L. L. SCHUECKING, op. cit., pp. 62 ff.

61. J. L. and B. HAMMOND: *The Rise of Modern Industry*, 1944, 6th edit., p. 39.

NOTES

62. J. L. and B. HAMMOND: *The Town Labourer* (1760–1832), 1925, pp. 37 ff.

63. PAUL MANTOUX, op. cit., pp. 376 ff.—JOHN A. HOBSON: *The Evolution of Modern Capitalism*, 1930, p. 62.

64. WERNER SOMBART: *Der moderne Kapitalismus*, II/1, 1924, 6th edit. —Cf. OTTO HINTZE: 'Der mod. Kapitalismus als hist. Individuum'. *Hist. Zschr.*, 1929, vol. 139, p. 478.

65. Cf. LEWIS MUMFORD: *Technics and Civil.*, 1934, pp. 176–7.

66. ARNOLD TOYNBEE: *Lectures on the Industrial Revolution of the 18th Cent. in Engl.*, 1908, p. 64.

67. LEO BALET-E. GERHARD: *Die Verbuergerlichung der deutschen Kunst, Lit. u. Musik im 18. Jahrh.*, 1936, pp. 116–17.

68. DANIEL MORNET: *La Nouvelle Héloïse de J.-J. Rousseau*, 1943, pp. 43–4.

69. OSWALD SPENGLER: *Der Untergang des Abendlandes*, I, 1918, pp. 362–3.

70. GEOFFREY WEBB: 'Architecture and Garden'. In *Johnson's England*, edited by A. S. Turberville, 1933, p. 118.

71. W. L. PHELPS: *The Beginnings of the English Romantic Movement*, 1893, pp. 110–11.

72. Cf. JOSEPH TEXTE: *J.-J. Rousseau and the Cosmopolitan Spirit in Lit.*, 1899, p. 152.

73. H. SCHOEFFLER, op. cit., p. 180.

74. W. L. CROSS: *The Development of the English Novel*, 1899, p. 38.— H. SCHOEFFLER, op. cit., p. 168.

75. Cf. Q. D. LEAVIS: *Fiction and the Reading Public*, 1932, p. 138.

76. W. L. CROSS, op. cit., p. 33.

77. DIDEROT: 'De la poésie dramat.' In *Oeuvres compl.*, edited J. Assézat, 1875–7, VII, p. 371.

78. Cf. IRVING BABBITT: *Rousseau and Romanticism*, 1919, pp. 75 ff.

79. Cf. JEAN LUC: *Diderot*, 1938, pp. 34–5.

80. J. S. PETRI: *Anleitung zur praktischen Musik.*, 1782, p. 104.—Quoted in HANS JOACHIM MOSER: *Gesch. d. deutschen Musik*, II/1, 1922, p. 309.

81. On the uniformity of theme and mood in a movement: HUGO RIEMANN: *Handb. d. Musikgesch.*, II/3, pp. 132–3.

82. On the antithesis of the 'sequential type' and the 'song type': WILHELM FISCHER: 'Zur Entwicklung des Wiener klass. Stils'. In *Beihefte der Denkmaeler der Tonkunst in Oesterreich*, III, 1915, pp. 29 ff.—On the antithesis of fugal and sonata form, cf. AUGUST HALM: *Von zwei Welten der Musik*, 1920.

83. H. J. MOSER, op. cit., pp. 314–15.

84. L. BALET-E. GERHARD, op. cit., p. 403.

85. H. J. MOSER, op. cit., p. 312.

86. GEORGE LILLO: *The London Merchant or the History of George Barnwell*, 1731, IV/2.

87. L. STEPHEN, op. cit., p. 66.

88. MERCIER: *Du Théâtre ou Nouvel essai sur l'art dramatique*, 1773.—Quoted by F. GAIFFE, loc. cit., p. 91.

89. CLARA STOCKMEYER: *Soziale Probleme im Drama des Sturmes und Dranges*, 1922, p. 68.

90. BEAUMARCHAIS: *Essai sur le genre dramatique sérieux*, 1767.

91. ROUSSEAU: *La Nouvelle Héloïse*, II, Lettre 17.

92. DIDEROT: 'Entretiens sur le Fils naturel'. *Oeuvres*, 1875–7, VII, p. 150.

93. GEORG LUKÁCS: 'Zur Soziologie des Dramas'. *Archiv f. Sozialwiss. u. Sozialpolit.*, 1914, vol. 38, pp. 330 f.

94. A. ELOESSER, op. cit., p. 13.—PAUL ERNST: *Ein Credo*, 1912, I, p. 102.

95. Cf. G. LUKÁCS, loc. cit., p. 343.

96. A. ELOESSER, op. cit., p. 215.

97. FRITZ BRUEGGEMANN: 'Der Kampf um die buergerliche Welt- und Lebensanschauung i.d. deutschen Lit. d. 18. Jahrh.' *Deutsche Viertelsjahrsschr. f. Literaturwiss. u. Geistesgesch.*, III/1, 1925.

98. KARL BIEDERMANN: *Deutschland im 18. Jahrh.*, 1880, 2nd edit., I, pp. 276 ff.

99. WERNER SOMBART: *Der Bourgeois*, 1913, pp. 183–4.

100. JACQUES BAINVILLE: *Hist. de deux peuples*, 1933, p. 35.

101. Cf. G. BARRACLOUGH: *Factors in German Hist.*, 1946, p. 68.

102. Count Mantaeuffel in a letter to the philosopher Wolf. Quoted by K. BIEDERMANN, loc. cit., II/1, p. 140.

103. Ibid., p. 23.

104. Ibid., p. 134.

105. W. H. BRUFORD: *Germany in the 18th Cent.*, 1935, pp. 310–11.

106. WILHELM DILTHEY: *Leben Schleiermachers*, I, 1870, pp. 183 ff.—The same, *Das Erlebnis und die Dichtung*, 1910, p. 29.

107. Ibid., p. 30.

108. JOHANN GOLDFRIEDRICH: *Gesch. des deutschen Buchhandels*, 1908–9, III, pp. 118 ff.

109. Cf. GEORG LUKÁCS: 'Fortschritt u. Reaktion i.d. deutschen Lit.' *Internationale Literatur*, 1945, XV, No. 8/9, p. 89.

110. FRANZ MEHRING: *Die Lessing-Legende*, 1893, p. 371.

111. Cf. KARL MANNHEIM: 'Das konservative Denken'. *Archiv f. Sozialwiss. u. Sozialpolit.*, 1927, vol. 57, p. 91.

112. A. DE TOCQUEVILLE, op. cit., pp. 247–8.—Cf. K. MANNHEIM, loc. cit.

113. CHRISTIAN FRIEDR. WEISER: *Shaftesbury u. d. deutsche Geistesleben*, 1916, pp. ix, xii.

114. Cf. RUDOLF UNGER: *Hamann u. d. Aufklaerung*, 1925, 2nd edit., I, pp. 327–8.

115. Cf. B. SCHWEITZER: *Der bildende Kuenstler u. der Begriff des*

Kuenstlerischen in der Antike, 1925, p. 130.—ALFRED STANGE: 'Die Bedeutung des subjektivistischen Individualismus fuer die europaeische Kunst von 1750–1850.' *Deutsche Vierteljahrsschrift f. Literaturwiss. u. Geistesgesch.*, vol. IX, No. 1, p. 94.

116. L. BALET-E. GERHARD, op. cit., p. 228.

117. HAMANN'S *Leben u. Schriften von C. H. Gildemeister*, 1857–73, vol. V, p. 228.

118. K. MANNHEIM, loc. cit., p. 470.

119. FRIEDRICH MEUSEL: *Edmund Burke u. d. franz. Revol.*, 1913, pp. 127–8.

120. HANS WEIL: *Die Entstehung des deutschen Bildungsprinzips*, 1930, p. 75.

121. JULIUS PETERSEN: *Die Wesensbestimmung der deutschen Romantik*, 1926, p. 59.

122. H. A. KORFF: 'Die erste Generation der Goethezeit'. *Zeitschr. f. Deutschkunde*, 1928, vol. 42, p. 641.

123. VIKTOR HEHN: *Gedanken ueber Goethe*, 1887, p. 65.

124. Ibid., p. 74.

125. Ibid., p. 89.

126. HEINE: *Die romantische Schule*, I, 1833.

127. THOMAS MANN: *Goethe als Repraesentant des Buergertums*, 1932, p. 46.

128. Cf. ALFRED NOLLAU: *Das lit. Publikum des jungen Goethe*, 1935, p. 4.

129. GEORG KEFERSTEIN: *Buergertum und Buergerlichkeit bei Goethe*, 1933, pp. 90–1.

130. Ibid., pp. 174–5.

131. Cf. H. A. KORFF: *Geist der Goethezeit*, II, 1930, p. 353.—LUDWIG W. KAHN: *Social Ideals in German Lit.* (1770–1830), 1938, pp. 32–4.

132. Cf. FRITZ STRICH: *Goethe und die Weltliteratur*, 1946, p. 44.

133. As in WILHELM HAUSENSTEIN: *Der nackte Mensch*, 1913, p. 151, and F. ANTAL: 'Reflections on Classicism and Romanticism'. *The Burlington Magazine*, 1935, vol. 66, p. 161.

134. POPE: *Essay on Man*, I, v. 233 ff.

135. HEINRICH WOELFFLIN: *Kunstgeschtliche Grundbegriffe*, 1927, 7th edit., p. 252.—HANS ROSE: *Spaetbarock*, 1922, p. 13.

136. Cf. H. WOELFFLIN, op. cit., p. 35.

137. CARL JUSTI: *Winckelmann u. seine Zeitgenossen*, 1923, 3rd edit., III, p. 272.

138. MAURICE DREYFOUS: *Les Arts et les artistes pendant la période révolutionnaire*, 1906, p. 152.

139. ALBERT DRESDNER: *Die Entstehung der Kunstkritik*, 1915, pp. 229–30.

140. WALTER FRIEDLAENDER: *Hauptstroemungen der franz. Mal. von David bis Cézanne*, I, 1930, p. 8.

NOTES

141. François Benoit: *L'Art franç. sous la Révol. et l'Empire*, 1897, p. 3.

142. Ibid., pp. 4–5.

143. Jules David: *Le Peintre David*, 1880, p. 117.

144. Edmond and Jules Goncourt: *Hist. de la société franç. pendant la Révol.*, 1880, p. 346.

145. Louis Madelin: *La Révolution*, 1911, pp. 490 ff.

146. George Plekhanov: *Art and Society*, 1937, p. 20.—Louis Hourticq: *La Peinture franç. au 18ᵉ siècle*, 1939, pp. 145 ff.—Albert Thibaudet: *Hist. de la litt. franç. de 1789 à nos jours.* (1936), p. 5.

147. Jules David, op. cit., p. 57.

148. Karl Marx: *Der 18. Brumaire des Louis Napoleon*, 1852.

149. Louis Hautecœur: 'Les Origines du Romantisme'. In *Le Romantisme et l'art*, 1928, p. 18.

150. Léon Rosenthal: *La Peinture romantique* (1903), pp. 25–6.

151. F. Benoit, op. cit., p. 171.

152. Louis Madelin: *La Contre-Révolution et la Révolution*, 1935, p. 329.

153. Ibid., pp. 162, 175.

154. Jules Renouvier: *Hist. de l'art pendant la Révol.*, 1863, p. 31.

155. Joseph Aynard: *La Bourgeoisie franç.*, 1934, p. 396.

156. Cf. Étienne Fajon: 'The Working Class in the Revolution of 1789'. In *Essays on the French Revolution*, edited by T. A. Jackson, 1945, p. 121.

157. Petit de Julleville, op. cit., VII, p. 110.

158. Henri Peyre: *Le Classicisme franç.*, 1942, p. 37.

159. A. Dresdner, op. cit., p. 128.

160. Ibid., pp. 128–9.

161. André Fontaine: *Les Doctrines d'art en France*, 1909, p. 186.—F. Benoit, op. cit., p. 133.

162. A. Dresdner, op. cit., p. 180.

163. Ibid., p. 150.

164. Joseph Billiet: 'The French Revol. and the Fine Arts'. In *Essays on the French Revolution*, edited by T. A. Jackson, 1945, p. 203.

165. F. Benoit, op. cit., p. 180.

166. M. Dreyfous, op. cit., p. 155.

167. F. Benoit, op. cit., p. 132.

168. Ibid., p. 134.

169. Quoted from F. L. Lucas: *The Decline and Fall of the Romantic Ideal*, 1937, p. 36.

170. Cf. on the concept of the 'epochal consciousness', Karl Jaspers: *Die geistige Situation der Zeit*, 1932, 3rd edit., pp. 7 ff.

171. G. Lanson, op. cit., p. 943.

172. Marcel Proust: *Pastiches et mélanges*, 1919, p. 267.

173. Joseph Aynard: 'Comment définir le romantisme?' *Revue de litt. comparée*, 1925, vol. V, p. 653.

174. F. Benoit, op. cit., pp. 62–3.

175. Cf. Albert Poetzsch: *Studien zur fruehromant. Politik u. Geschichtsauffassung*, 1907, pp. 62–3.

176. Ortega y Gasset: 'History as a System'. In *Philosophy and History*. Essays presented to Ernst Cassirer, edited by R. Klibansky and J. H. Paton, 1936, p. 313.

177. Emil Lask: *Fichtes Idealismus u. die Geschichte*, 1902, pp. 56 ff., 83 ff.—Cf. Erich Rothacker: *Einleitung i. d. Geisteswissenschaften*, 1920, pp. 116–18.

178. Arnold Ruge: *Die wahre Romantik. Ges. Schriften*, III, p. 134.—Quoted from Carl Schmitt: *Politische Romantik*, 1925, 2nd edit., p. 35.

179. Konrad Lange: *Das Wesen der Kunst*, 1901.

180. Coleridge: *Biographia Literaria*, chap. XIV.

181. Cf. Albert Salomon: 'Buergerlicher u. kapitalistischer Geist'. *Die Gesellschaft.*, 1927, IV, p. 552.

182. Louis Maigron: *Le Romantisme et les mœurs*, 1910, p. v.

183. Quoted from Ricarda Huch: *Ausbreitung u. Verfall der Romantik*, 1908, 2nd edit., p. 349.

184. Erwin Kirchner: *Die Philosophie der Romantik*, 1906, pp. 42–3.

185. Diderot: *Paradoxe sur le comédien*.

186. C. Schmitt, op. cit., pp. 24 ff., 120 ff., pp. 148–9.

187. A. Poetzsch, op. cit., p. 17.

188. Fritz Strich: 'Die Romantik als europaeische Bewegung'. *Woelfflin-Festschrift*, 1924, p. 54.

189. Georg Brandes: *Hauptstroemungen der Lit. des 19. Jahrhunderts*, 1924, I, pp. 13 ff.

190. Cf. Ernst Troeltsch: 'Die Restaurationsepoche am Anfang des 19. Jahrhunderts'. *Vortraege der Baltischen Lit. Ges.*, 1913, p. 49.

191. Charles-Marc des Granges: *La Presse litt. sous la Restauration*, 1907, p. 44.

192. A. Thibaudet, op. cit., p. 107.

193. Pierre Moreau: *Le Classicisme des romantiques*, 1932, p. 132.

194. Henry A. Beers: *A Hist. of Engl. Romanticism in the 19th Cent.*, 1902, p. 173.

195. A. Thibaudet, op. cit., p. 121.

196. G. Brandes, op. cit., III, p. 9.

197. Ibid., p. 225.

198. Ibid., II, p. 224.

199. Grimrod de la Reynière in *Le Censeur dramatique*, I, 1797.

200. Maurice Albert: *Les Théâtres des Boulevards* (1789–1848), 1902.

201. Ch.-M. des Granges: *La Comédie et les mœurs sous la Restauration et la Monarchie de Juillet*, 1904, pp. 35–41, 43–6, 53–4.

202. W. J. Hartog: *Guilbert de Pixerécourt*, 1913, pp. 52–4.

203. Paul Ginisty: *Le Mélodrame*, 1910, p. 14.

204. ALEXANDER LACEY: *Pixerécourt and the French Romantic Drama*, 1928, pp. 22–3.

205. ÉMILE FAGUET: *Propos de théâtre*, II, 1905, pp. 299 ff.

206. W. J. HARTOG, op. cit., p. 51.

207. Ibid.

208. PIXERÉCOURT: *Dernières réflexions sur le mélodrame*, 1843, quoted by HARTOG, op. cit., pp. 231–2.

209. FAGUET, loc. cit., p. 318.

210. ALFRED COBBAN: *Edmund Burke and the Revolt against the 18th Cent.*, 1929, pp. 208–9, 215.

211. C. DAY LEWIS: *The Poetic Image*, 1947, p. 54.

212. H. N. BRAILSFORD: *Shelley, Godwin and their Circle*, 1913, p. 226.

213. FRANCIS THOMPSON: *Shelley*, 1909, p. 41.

214. Cf. F. STRICH: *Die Romantik als europ. Bewegung*, p. 54.

215. H. Y. C. GRIERSON: *The Background of Engl. Lit.*, 1925, pp. 167–8.

216. JULIUS BAB: *Fortinbras oder der Kampf des 19. Jahrhunderts mit dem Geist der Romantik*, 1914, p. 38.

217. W. P. KER: *Collected Essays*, 1925, I, p. 164.

218. H. A. BEERS, op. cit., p. 2.

219. J. M. S. TOMPKINS: *The Popular Novel in England* (1770–1800), 1932, pp. 3–4.

220. LOUIS MAIGRON: *Le Roman historique à l'époque du romantisme*, 1898, p. 90.

221. GEORG LUKÁCS: 'Walter Scott and the Historical Novel'. *International Literature*, 1938, No. 12, p. 80.

222. *Ivanhoe*, chap. XLI.

223. LÉON ROSENTHAL, op. cit., pp. 205–6.

224. 'Le premier mérite d'un tableau est d'être une fête pour l'œil.'

225. DELACROIX: *Journal*, i.a. the entry of 26th April 1824.

226. Ibid., 14th February 1850.

227. L. ROSENTHAL, op. cit., pp. 202–3.

228. PAUL JAMOT: 'Delacroix'. In *Le Romantisme et l'art*, 1928, p. 116.

229. Ibid., p. 120.

230. Ibid., pp. 100–1.

231. ANDRÉ JOUBIN: *Journal de Delacroix*, 1932, I, pp. 284–5.

232. ALFRED EINSTEIN: *Music in the Romantic Era*, 1947, p. 39.

233. DELACROIX: *Journal*, passim, i.a. the entry of 30th January 1855.

INDEX

INDEX

INDEX

INDEX